NATIONAL GEOGRAPHIC

COMPLETE PHOTO GRAPHY

NATIONAL GEOGRAPHIC

COMPLETE
PHOTO
GRAPHY

National Geographic
Washington, D.C.

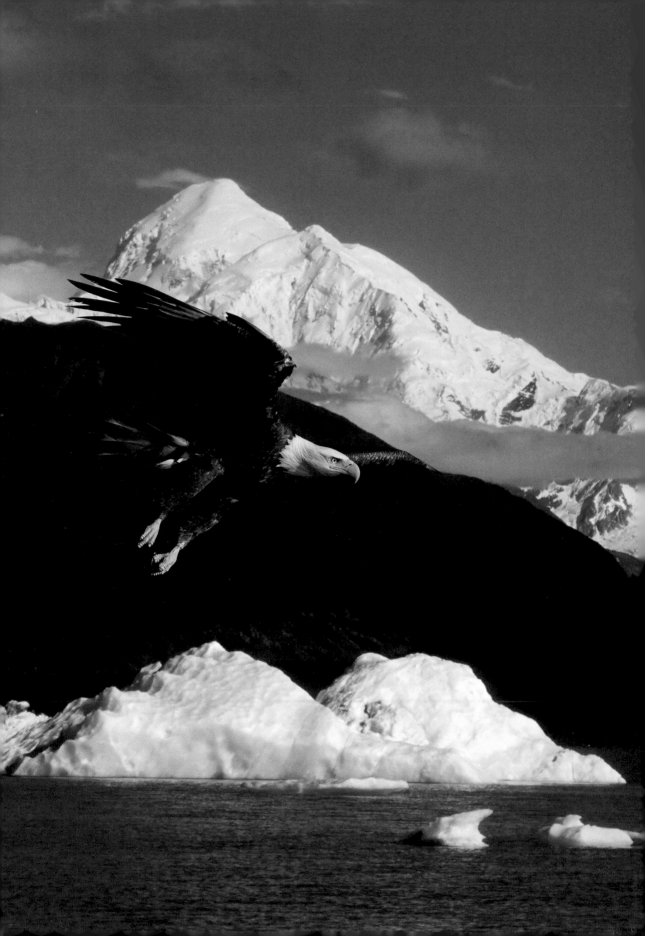

▶Contents

A LONE BALD EAGLE soars, framed expertly by the photographer, its white head echoed by the whites of ice and snowcapped peaks.

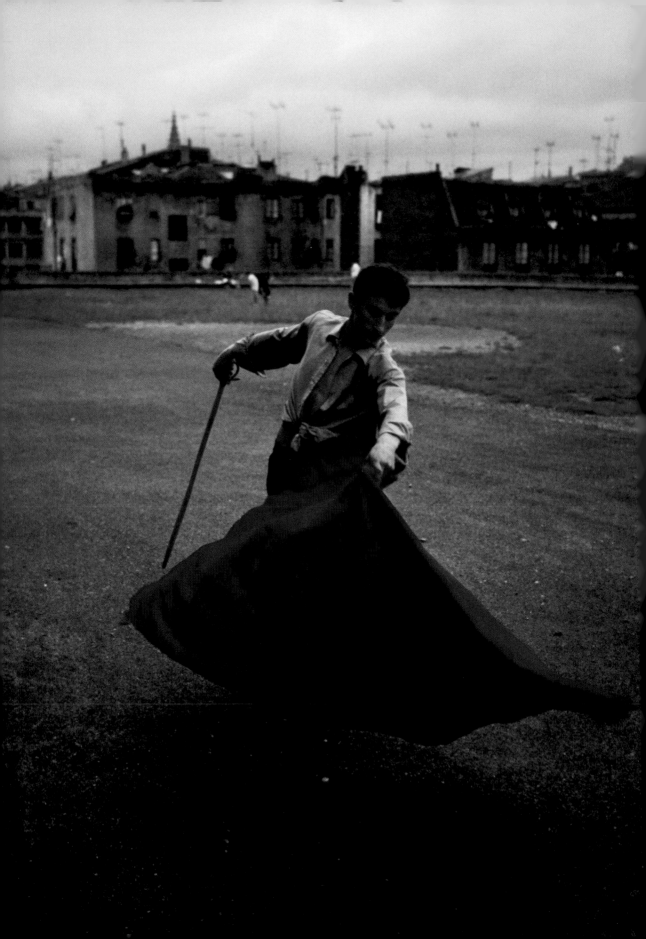

▶Introduction

PHOTOGRAPHY IS IN CONSTANT REVOLUTION. This book brings you up to date with the technical wizardry behind the latest advances. It also grounds you in the principles of taking good pictures, principles that will endure no matter what the next chapter in photographic history may bring.

Throughout that history—starting, for all practical purposes, with daguerreotypes back in 1839—breakthroughs in the mechanics of photography have always led to breakthroughs in its art and utility. The Brownie camera, for example, introduced in 1900 for the price of one dollar, opened the world of photography to everyone. Highly portable, the Brownie also let us take our photography on the road. Flashbulbs became available in 1925, and suddenly we could shoot indoors. Color negative film appeared in 1942, instant pictures (bypassing the lab) in 1948, and automatic cameras (no fussing with settings) in 1959. And let's not forget the Kodak Instamatic, introduced in 1963. No longer did we have to thread—or even touch—the film. Just drop in a cartridge, and off you go. It was a breakthrough in convenience.

THE DIGITAL REVOLUTION

Photography's latest—and by far most significant—revolution, of course, is digital. It has been under way now for at least two decades (with digital scanning of film coming before digital cameras themselves), and there's no end in sight, with new developments—bigger storage capacity, better "noise" reduction, articulated LCD screens—announced almost weekly. We no longer marvel that what was a novelty in 1994, when the first consumer digital camera appeared, has become the norm. I'll never forget, in 1996, getting an emailed photo from a friend. She had taken the picture with her new Apple QuickTake camera, one of the early digicams, for which she had paid $650. The camera stored only 32 images, and you had to connect it to a computer to view the pictures, which were fuzzy. But I was enchanted. I sensed that a sea change in photography was beginning. And it was. Digital cameras first outsold film cameras in 2004. That year, when many professional photographers were still clinging to the old ways, Jim Richardson, a veteran of dozens of assignments for *National Geographic* and *National Geographic Traveler* magazines, told me that he had dumped his film cameras "like Cortés burning his ships after he got to the New World."

Today, no one looks back. In 2010, consumers bought some 22 million compact digital cameras and another 2 million digital single-lens reflex (DSLR) cameras.

A FLOURISH OF RED counterbalances the right-angle regularity of buildings, windows, and antennas in this photograph of an aspiring bullfighter.

There's little mystery why. The digital revolution has brought unprecedented convenience (no film, no processing, no waiting), ease of use, and low cost. For under $40, you can buy a camera with which to document your life and your world in pixels—which never fade and never grow old. And the technology is constantly improving, with ever increasing resolution at ever decreasing prices, growing image-storage space on shrinking memory cards, and such digital wonders as geo-tagging, face recognition, and high-dynamic-range (HDR) photography, in which multiple exposures are combined into one image such that all parts of the picture—from bright areas to shadows—are properly exposed at once, creating a hyper-real effect. For years, many digital cameras—first, point-and-shoots, and now, DSLRs—have had a delightful bonus capability: video. Earlier digicams were limited to 30 seconds of soundless, grainy footage. The latest cameras can shoot in high definition with sound, producing videos of durations limited only by the size of the memory card.

The innovations keep coming. Nipping at the heels of digital cameras are smartphones with built-in cameras. Snap a picture and send it to a friend or upload it to the Web via cellular signal, no computer required. More pictures are still taken with stand-alone cameras than with smartphones, but soon the latter will commonly offer resolutions of five megapixels or higher, the rough equivalent of film. At that point, just about anybody with a cell phone will be a de facto photographer.

FROM DARKROOM TO LIGHTROOM

As digital cameras get easier to use, so do the software and techniques for enhancing your photos once you've taken them. What used to be tricky darkroom procedures—cropping, sharpening, dodging, burning, not to mention color correcting—can now be done in minutes by amateurs in their digital "lightrooms," and that's only the beginning. Now anyone, following instructions readily available on the Web, can tackle more advanced techniques, such as merging photographs into panoramas or combining elements (say, family members) from several exposures into one. What's more, you can perform heretofore impossible photographic feats. Design your own photo products on screen, for example—books, calendars, posters, collages, puzzles, T-shirts, you name it—and have them produced and delivered in a matter of days.

Two years ago my then six-year-old daughter, who inherited my first digital camera, an old two-megapixel point-and-shoot, held the camera at arm's length and shot a series of self-portraits, making silly faces all the while. I uploaded the pictures to an online photo lab, selected "poster" on the self-service website, and watched as the pictures arranged themselves into a collage before my eyes.

A few days later, a large print arrived with the title I had added, "The Many Faces of Corrinne." It's been on her wall ever since.

For several years, on the same website, I've been making personalized photo calendars that have each month and important dates highlighted with family pictures, and I prefer to capture major vacations that we take in a hardbound photo book—created online—rather than placing individual prints into a photo album. Personalized photo books like ours now account for 30 percent of the photo-publishing business. Even some professional photographers use these books to promote their work.

Photographic prints certainly have not been lost to the digital revolution, despite the invention of digital picture frames, which you can hang on the wall and watch as hundreds of pictures are displayed, in sequence, like an automated slide show. Last year, some 14 billion pictures were printed on paper. Of those, a third were printed at home, where consumer printers—offering rich color saturation and surprising sharpness—are steadily eating away at the local drugstore's photo-finishing business.

As impressive as those figures are, even more impressive are the number of pictures that aren't printed at all. "You can now share your photos online," Jim

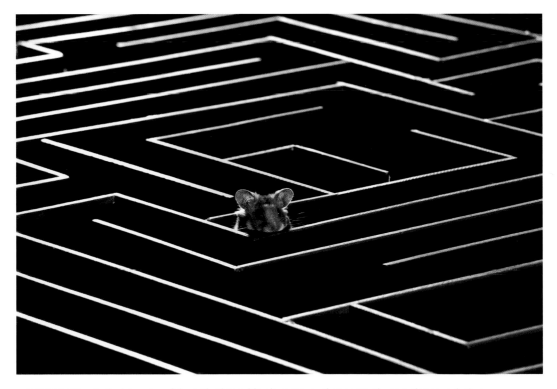

POPPING UP out of a laboratory labyrinth, this golden hamster evokes sympathy in a photograph that puts its subject just off-center and uses pattern to advantage.

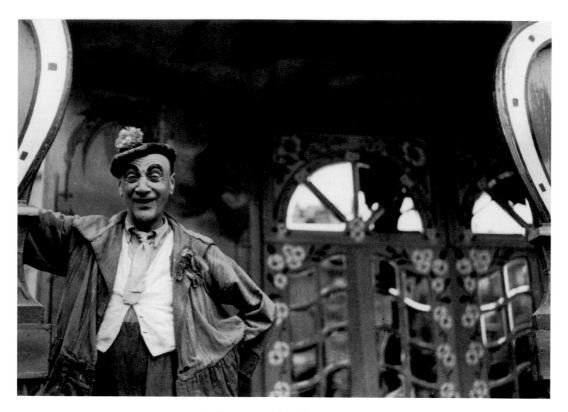

PORTRAIT OF A CLOWN in the Gingerbread Fair of Paris's Place de la Nation, circa 1930, illustrates effective control of depth of field, with foreground sharp and background intriguingly vague.

Richardson says, "instead of having them sit in a shoebox. Your photos only come to life when somebody else sees them." If that's true, then our pictures today are more alive than ever before. Social networking sites such as Facebook have exploded on the Web, and several center on photography. More than just galleries, these sites offer the chance to engage friends, family, and a community of serious and not-so-serious shooters. Here you can critique and be critiqued, find inspiration, or simply browse to your heart's content. Flickr, one of the big photo-sharing sites, hosts more than five billion images. Users can tag their photos with keywords, geographic coordinates, and even names to go with faces, as well as join groups of like-minded people interested in, say, travel or nature. "I am amazed by the creativity unleashed through Flickr," says amateur photographer Arnold Pouteau, who won an award in a *Traveler* magazine photo contest. "It's more than sharing a passion for photos. To me it's a way to share our passion for life."

You can also forgo the networking sites altogether and put up your own photographic website, as the pros do. "It's easier than a lot of people think," says

photographer Will Van Overbeek, who frequently shoots for *Traveler*. "Once you get the page up, circulate the URL among people you know who care about photography, and ask for their feedback."

This digital revolution in photography—in which cameras make it easier to take good pictures and the Internet makes it easier to share them—has, in effect, raised the bar on picture quality. Vacation photos of the Golden Gate Bridge, for example, will have to be awesome to stand out among the 327,132 images of that famous landmark posted on Flickr (at this writing). Shooting the Grand Canyon? Your shots can be measured against the more than 942,000 other pictures already up there.

"My job is to bring back a view nobody has photographed before," Justin Guariglia told me while he was explaining how hard he had worked on a *Traveler* assignment in China. One of his pictures, of the Pudong district of Shanghai—which is photographed by practically every tourist who goes to that city—was distinctive enough to make it onto the cover.

BACK TO BASICS

So how do you take memorable pictures? That brings us back to those timeless principles. "The more photography changes, the more it stays the same," says Van Overbeek. "The basic issues are still focus, exposure, and composition." This book covers those principles. It also offers an exhaustive collection of shooting strategies gathered from the ranks of National Geographic photographers and encompassing photographic subjects from weddings to wildlife. With practice (which is now so easy and cheap with a digital camera), you'll be able to implement these strategies in your own photography with potentially dramatic results.

Part I, "Photography & the Camera," starts off with an overview of the technology and the art of photography, discussing the mechanics of cameras and the core concepts of rendering great pictures—bringing together interesting subjects, strong composition, and compelling light. **Chapter 2** goes deeper into the workings of cameras, how they gather light and how you can control the process, including adjustments to aperture and shutter speed. You'll also get familiar with the fields of information presented on the camera's "dashboard"—that is, the viewfinder—and learn the main differences between point-and-shoot and single-lens-reflex cameras.

Chapter 3 delves into the most critical element in the art of photography, namely, composition. Composition boils down to two things: what elements to include in the picture and how to frame them. This is a part of photography that hasn't been automated yet—and may never be. It relies on the skill of the photographer, a skill that

one can improve by understanding the "rule of thirds," focal points, layering, framing, leading lines, and other principles of composition. (And don't forget rule number one: Never have a telephone pole coming out of someone's head!)

Chapter 4 covers other areas where skill is as important as the camera's circuitry: light and exposure. Sure, you can shoot in automatic mode and let the camera make all the decisions. But a savvy photographer will also use the aperture priority, shutter priority, or full manual settings to achieve desired effects of light, shadow, depth of field, and motion. Experimenting with these settings as well as various methods of using flash is a sure way to make your photography stand out. The following chapter, "Beyond Auto Mode," takes the discussion further, exploring lens choice, use of filters, and advanced techniques.

The final chapter of Part I, "The Digital Lightroom," offers a clear explanation of how you can enhance your photographs using image-editing software. It's a must-read in the digital age, when photographers are increasingly shooting in the raw file format. This type of image file, which has been compared to a film negative, captures the maximum amount of image data possible but requires some basic processing—using software that comes with your camera—after you transfer it into your computer. Don't think of this as a chore, but rather as an opportunity to make your pictures the best they can be. Once you get the hang of it, it takes only seconds to adjust a picture's color, contrast, brightness, and sharpness. "The goal is to correct the photograph to make it look exactly like what the eye saw," says photographer Jim Richardson. That's the photojournalist's goal, the one adhered to by National Geographic's magazines, which are ethically bound to accuracy and eschew photo manipulation beyond those basic corrections. Other photographers, however, are free to enhance their photos for artistic effect or for the pure fun of it.

Part II of this book, "Time Line of Photography," covers the crucial moments in photographic history—important background material for amateur and professional alike. Then, in **Part III,** "Photographing Your World," six chapters cover an enormous range of shooting situations, from photographing pets to covering adventure sports. There are sections on aerial photography, travel photography, and how to shoot scenics, buildings, or people—those you know and those you don't. The final chapter explores more specialized techniques, such as infrared and HDR photography.

In each chapter of this book, you'll find a profile of an accomplished National Geographic photographer, along with a selection of his or her work and some words of advice and inspiration. You'll also find a recurring feature called "What Makes This a Great Photograph?" in which longtime National Geographic photographer

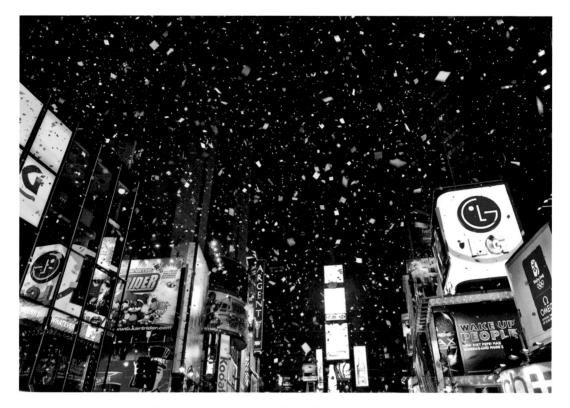

TO CAPTURE THE THRILL of the moment on New Year's Eve in Times Square, a photographer needed to make careful exposure decisions.

James P. Blair, with some 45 articles to his credit, analyzes a photo and explains what elements make the picture a success.

Why bother mastering photographic techniques? After all, with the cost of taking a digital picture effectively at zero, you can simply snap away—everyone gets lucky now and then, taking a good picture by sheer chance. The answer is that, with very little effort, you don't need to rely on chance. The fact that picture-taking is so inexpensive means that you can practice the techniques outlined in this book to your heart's content, chapter by chapter, until you've mastered them. Try to re-create the effects you see on these pages: blurry backgrounds, frozen motion, layered shots, and the rest. Also take the time to master the back end of the process: importing your files into the computer, tweaking them to perfection, and filing them logically. To take memorable photographs that stand out among the multitudes being shared online, you need to shoot intelligently and purposefully. This book will help.

—SCOTT S. STUCKEY, Managing Editor, *National Geographic Traveler*

▶ About This Book

WELCOME TO NATIONAL GEOGRAPHIC'S *Complete Photography*, a book designed to offer knowledge, advice, and food for thought for photographers of every age and ability.

For more than 100 years, National Geographic books and magazines, and now the National Geographic website *(nationalgeographic.com),* have included work by the world's greatest photographers. In this book we collect some of their finest accomplishments, side by side with photographs taken by many great amateur photographers.

Complete Photography is not only a how-to book on photography. It is also a how-it-works book. Throughout, our authors ask and answer three big questions: How does a camera work? How does a great photograph work? How does a professional photographer work? Every page of this book addresses these questions in a variety of ways.

NEW TOPIC WITH EACH TURN OF THE PAGE **CROSS-REFERENCE**

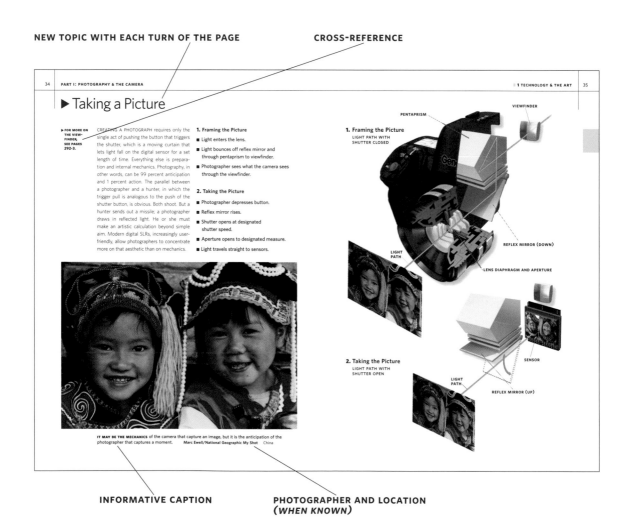

INFORMATIVE CAPTION **PHOTOGRAPHER AND LOCATION (WHEN KNOWN)**

Part I, Photography & the Camera, presents the basics. Every two pages introduces a **NEW TOPIC,** with clear explanations and captioned photographs. Frequent **CROSS-REFERENCES** point to pages with related information. Many pages also include a **TIP**—a tidbit of related advice.

Our editors have selected certain photographs throughout the book as worthy of special attention. They are signaled with **LONGER CAPTIONS** and, alongside the caption, one of the four **SYMBOLS** identified below and explained in full on page 38. These symbols stand for the four fundamentals of a great photograph. When one is attached to a photograph, it highlights the feature most important to its success.

SUBJECT **COMPOSITION** **LIGHT** **EXPOSURE**

TIP WITH ADVICE FOR BETTER PHOTOGRAPHS

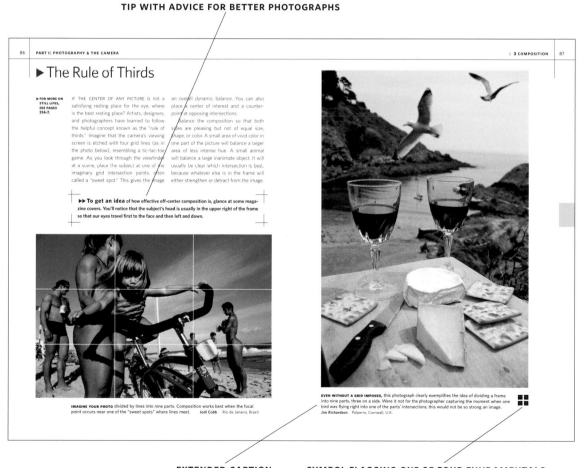

▶ The Rule of Thirds

▶▶ **FOR MORE ON STILL LIFES, SEE PAGES 314-7.**

IF THE CENTER OF ANY PICTURE is not a satisfying resting place for the eye, where is the best resting place? Artists, designers, and photographers have learned to follow the helpful concept known as the "rule of thirds." Imagine that the camera's viewing screen is etched with four grid lines (as in the photo below), resembling a tic-tac-toe game. As you look through the viewfinder at a scene, place the subject at one of the imaginary grid intersection points, often called a "sweet spot." This gives the image

an overall dynamic balance. You can also place a center of interest and a counterpoint at opposing intersections.

Balance the composition so that both sides are pleasing but not of equal size, shape, or color. A small area of vivid color in one part of the picture will balance a larger area of less intense hue. A small animal will balance a large inanimate object. It will usually be clear which intersection is best, because whatever else is in the frame will either strengthen or detract from the image.

▶▶ **To get an idea** of how effective off-center composition is, glance at some magazine covers. You'll notice that the subject's head is usually in the upper right of the frame so that our eyes travel first to the face and then left and down.

IMAGINE YOUR PHOTO divided by lines into nine parts. Composition works best when the focal point occurs near one of the "sweet spots" where lines meet. **Jodi Cobb** Rio de Janeiro, Brazil

EVEN WITHOUT A GRID IMPOSED, this photograph clearly exemplifies the idea of dividing a frame into nine parts, three on a side. Were it not for the photographer capturing the moment when one bird was flying right into one of the parts' intersections, this would not be so strong an image. **Jim Richardson** Polperro, Cornwall, U.K.

EXTENDED CAPTION **SYMBOL FLAGGING ONE OF FOUR FUNDAMENTALS OF GREAT PHOTOGRAPHY**

Part II tells the fascinating story of photography, from the camera obscura of the Renaissance to the digital revolution of today. A horizontal **TIME LINE** runs through these pages, beginning in the early Renaissance and coming up to the present day. On the time line, **DATES IN RED** refer to key events in the history of photography.

For each date pinpointed on the time line, you will find a corresponding passage that describes the **KEY EVENT.** Often a photograph—sometimes the very one that made history—accompanies the text. **QUOTATIONS** on each spread add voices from the period, showing the changing expectations and appreciation of photography through the years. It is interesting to note that the frequency of historic moments speeds up as we move forward toward the present day.

**DATE RANGE OF THIS PORTION
OF TIME LINE**

TIME LINE HIGHLIGHTING KEY EVENTS

▶1930-1939

**1930
Landscape
Photography**

ANSEL ADAMS, considered to be one of the best landscape photographers for his work in the American Southwest, decided to dedicate himself to photography. Within five years, Adams had made a name for himself, mostly for his articles on photography written for popular photography presses. As the popularity of his work increased, he used his position to help promote photography as fine art.

PHOTO BY ANSEL ADAMS

**1930
First Aerial Color
Photo**

NATIONAL GEOGRAPHIC Assistant Editor Melville Bell Grosvenor made the first aerial color photograph when he took this shot of the Statue of Liberty by circling the monument in a Navy Airship ZM C2. The photograph, which was published in the September 1930 issue, led the National Geographic Society to adopt the Finlay process, then the newest method for producing color photographs.

FIRST AERIAL COLOR PHOTO

**1930
▲**

**1935
Photographs of
Earth's Curvature**

THE EXPLORER II helium balloon rises to 72,395 feet—a world altitude record for human flight—and Capt. Albert Stevens's photos taken from it show the curvature of Earth for the first time.

1935

**1935
Photographing the
Depression**

THE FARM SECURITY ADMINISTRATION hires Roy Stryker to run a historical section, and Stryker eventually hires Walker Evans, Dorothea Lange, Gordon Parks, Arthur Rothstein, and others to photograph rural hardships over the next six years.

1936

**1936
Life Magazine
Appears**

LIFE—the first U.S. newsmagazine devoted to photojournalism—comes out weekly beginning with the November 23 issue. Its first cover shows the concrete pylons of a spillway connected to the U.S. Corps of Engineers' Fort Peck Dam in Montana, photographed by Margaret Bourke-White.

EARLY COVER OF LIFE

**1935
Kodachrome**

KODAK research laboratories invent Kodachrome film for color slides, or transparencies, ushering in a new era in photography. Coated with three emulsions sensitive to the three primary colors, Kodachrome is the first commercially available amateur color film.

DEPRESSION-ERA PHOTO BY DOROTHEA LANGE

"Photography takes an instant out of time, altering life by holding it still."
—Dorothea Lange

BALLOON FOR HIGH-ALTITUDE PHOTOGRAPHY

"The pictures are there, and you just take them. The truth is the best picture, the best propaganda." —Robert Capa, 1937

EVENT ENTRY **QUOTATION FROM THE ERA**

Part III, Photographing Your World, returns to the subject of how to take the best photographs. These chapters show the best ways to photograph your choice of subject in different settings, as well as ways to explore special techniques.

In this section, the pictures do more of the talking. A brief narrative explores the opportunities and challenges faced in doing that sort of photograph, followed by a quick set of **TIPS AND POINTERS** to keep in mind as you take camera in hand. Every photograph illustrates the principles discussed. **CROSS-REFERENCES** point back to sections in Part I of relevance to each field of photography as well as to related sections elsewhere in Part III. Here, as in Part I, the four **SYMBOLS** representing the fundamentals of a great photograph are used occasionally to emphasize the most important decisions that went into making a photograph particularly strong.

NEW TOPIC WITH EVERY TURN OF THE PAGE

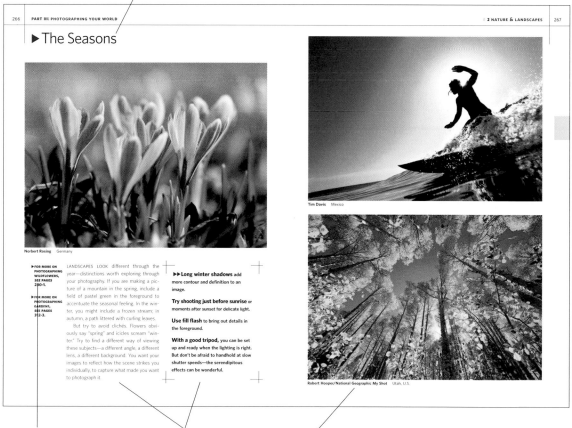

CROSS-REFERENCE **TEXT AND TIPS** **PHOTOGRAPHER AND LOCATION (WHEN KNOWN)**

Many of the photos used as examples in Part III came to our attention through **Your Shot,** a feature of *National Geographic* magazine by which photographers known and unknown from around the world submit their images for publication *(http://ngm.nationalgeographic.com/your-shot).* Find out more about Your Shot and other aspects of the growing National Geographic photography community in the rich list of Online Resources at the end of this book, beginning on page 394.

TWO SPECIAL FEATURES THROUGHOUT **Parts I and III** have been created to bring the work and wisdom of a number of favorite National Geographic photographers onto the pages of this book. Noticing and studying the photography of people such as these, who have made it their life work to take great photographs, is another essential way to hone your craft.

**PHOTO OF
PHOTOGRAPHER**

PERSONAL STATEMENT BY PHOTOGRAPHER

PART III: PHOTOGRAPHING YOUR WORLD 346

5 TRAVELING 347

Mike Yamashita: MY PERSPECTIVE

AS A YOUNG PHOTOGRAPHER, I grabbed any assignment in any location, eager to build my portfolio, but over time I have naturally been drawn back to Asia. It is there that I feel most at home. With rapid change overtaking most of Asia, I look for the permanent beauty in the natural world, to show nature as it is, and as I hope it will always be.

Before embarking on any assignment, I try to compose the images of a story in my mind. This is where the groundwork for photographer's luck is laid—it takes a lot of research to know what you're looking for.

Once I have my "shoot list," I begin the hunt. Sometimes that might involve hiking for hours or waiting a day for a mountain mist to clear. It might require returning to a site many times for just the right early morning light or even waiting for a change of seasons. Often, though, the real key to success is to be ready and open to seeing the photograph when you least expect it.

With film going the way of dinosaurs and change the only constant, photographers now need to think beyond the magazine page and embrace new media, new technology. But one thing about photography will never change: the ability of a powerful image to tell a story. —M.Y.

MICHAEL YAMASHITA has combined his dual passions of photography and travel for more than 25 years, shooting for *National Geographic* and, more recently, with his film production company, Saga Pictures. Specializing in Asia, Yamashita has covered Vietnam and the Mekong River, Marco Polo's journey to China, the DMZ between North and South Korea, and Japanese culture from samurai to fish markets. A frequent lecturer and teacher, Yamashita has received numerous awards, and his photography has been shown in major exhibitions throughout the world.

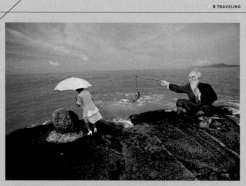

A tourist approaches China's southernmost point, Hainan.

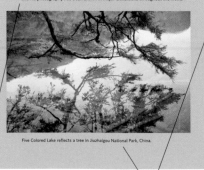

Five Colored Lake reflects a tree in Jiuzhaigou National Park, China.

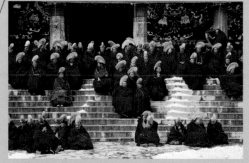

Monks of the Yellow Hat sect of Tibetan Buddhism gather for prayers at the Lebrang Monastery in Xiahe, China.

**BIOGRAPHICAL SKETCH
OF PHOTOGRAPHER**

THREE ICONIC PHOTOGRAPHS

First, in the middle of every chapter, you will meet 12 photographers as they offer **"My Perspective,"** a **BRIEF REFLECTION** about photography in the world today, accompanied by **THREE KEY PHOTOGRAPHS** created by that person.

Then, to conclude every chapter, acclaimed National Geographic photographer James P. Blair answers the question **"What Makes This a Great Photograph?"** From the thousands of great photographs in the National Geographic Image Collection, Blair has chosen 12 **ICONIC IMAGES**. Each is identified with a **CREDIT LINE** showing content, photographer's name, and location. Blair uses the four fundamentals, tagged with those same four **SYMBOLS,** and offers brief **COMMENTS** in which he explores how each image works as an outstanding example of the science and the art of photography.

ICONIC IMAGE MADE BY
NATIONAL GEOGRAPHIC PHOTOGRAPHER

COMMENTS ON THIS PHOTOGRAPH

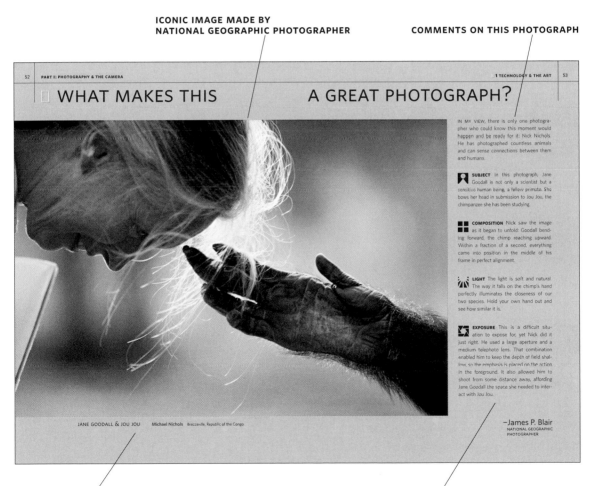

52 **PART I: PHOTOGRAPHY & THE CAMERA** **1 TECHNOLOGY & THE ART** 53

□ WHAT MAKES THIS A GREAT PHOTOGRAPH?

IN MY VIEW, there is only one photographer who could know this moment would happen and be ready for it: Nick Nichols. He has photographed countless animals and can sense connections between them and humans.

SUBJECT In this photograph, Jane Goodall is not only a scientist but a sensitive human being, a fellow primate. She bows her head in submission to Jou Jou, the chimpanzee she has been studying.

COMPOSITION Nick saw the image as it began to unfold: Goodall bending forward, the chimp reaching upward. Within a fraction of a second, everything came into position in the middle of his frame in perfect alignment.

LIGHT The light is soft and natural. The way it falls on the chimp's hand perfectly illuminates the closeness of our two species. Hold your own hand out and see how similar it is.

EXPOSURE This is a difficult situation to expose for, yet Nick did it just right. He used a large aperture and a medium telephoto lens. That combination enabled him to keep the depth of field shallow, so the emphasis is placed on the action in the foreground. It also allowed him to shoot from some distance away, affording Jane Goodall the space she needed to interact with Jou Jou.

–James P. Blair
NATIONAL GEOGRAPHIC
PHOTOGRAPHER

JANE GOODALL & JOU JOU Michael Nichols Brazzaville, Republic of the Congo

CONTENT, PHOTOGRAPHER, AND LOCATION

COMMENTS ALWAYS TOUCH ON
FOUR FUNDAMENTALS

Part I

PHOTOGRAPHY & THE CAMERA

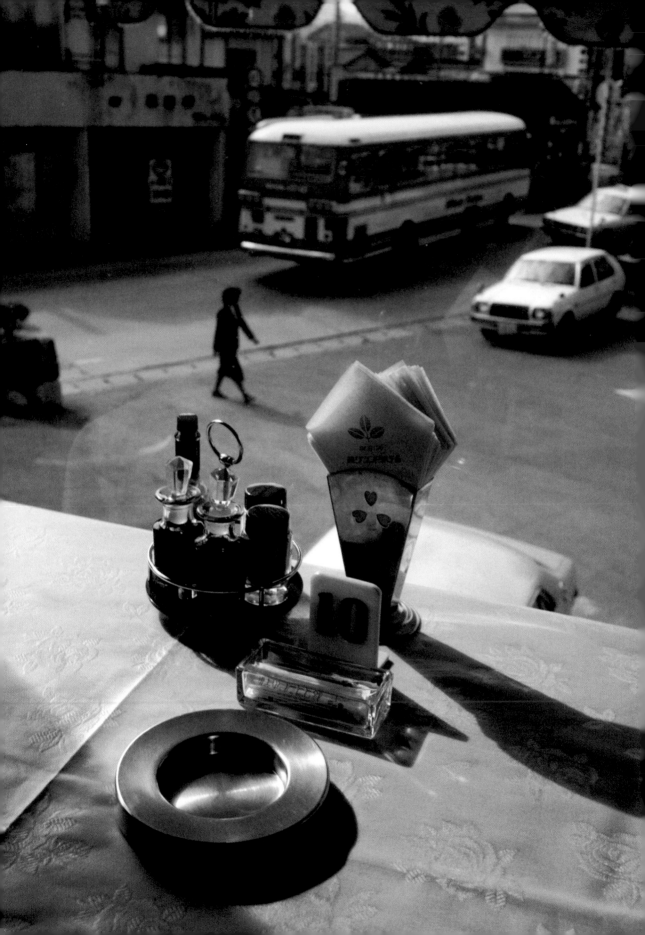

1 Technology & the Art

PHOTOGRAPHY DRAWS on both sides of our brains—the logical left and the intuitive right. The logical side helps operate the camera mechanism; the intuitive side helps direct the content, composition, and emotional intent of the picture. What the photographer sees is as important as what the camera sees. Experienced photographers know that the mechanical side needs to become almost reflexive to allow the artistic side to proceed uninterrupted. Inexperienced shooters may rely on today's digital cameras, which produce well-exposed frames with minimal fuss, to alleviate much of the worrisome part of picture taking. But most of us need to consider the collaboration between these two seemingly contradictory impulses—the mechanical and the artistic—every time we pick up the camera. We must become familiar with the machine before it can help us create images of memories and objects of art.

LIGHT AND SHADE, foreground and background, all combine in this photograph to produce a dynamically layered composition. **Sam Abell** Hagi, Japan

▶ Technology of a Camera

▶ FOR MORE ON
CAMERAS IN
HISTORY,
SEE PAGES
198-229.

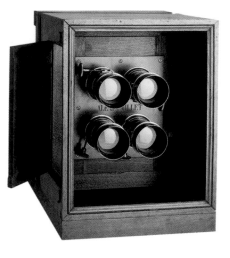

THE EARLIEST CAMERAS, such as this one from around 1860, were an innovation based on a technology that had been known for centuries.

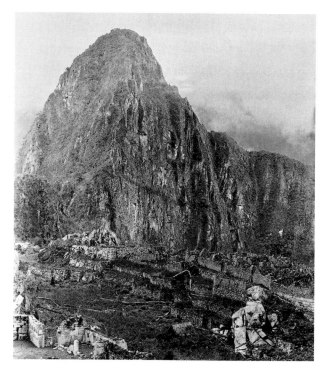

EVEN THOUGH EARLY PHOTOGRAPHY was monochrome—in shades of gray only—the vistas portrayed and information conveyed were amazing.
Hiram Bingham Machu Picchu, Peru

A BASIC CAMERA is not sophisticated in form; its principles have been understood for thousands of years. A camera is a light-tight enclosure with a small hole in it. The hole is usually covered. When the hole is opened, light reflecting from the scene outside squeezes through and projects a similar image on the inside back of the dark box. This device, also called a pinhole camera or a camera obscura ("dark chamber"), has been used at least since the time of Mo-Ti, a Chinese philosopher of the first millennium B.C., who first explained the process.

FIXING THE LIGHT

Not until the early 19th century did chemists find a way to "fix," or make permanent, the image that had been as ethereal as magic. They began to coat glass plates and eventually celluloid with light-sensitive chemicals and place them into the back of the box in darkness. When exposed to light from the aperture hole, each particle of the coating would darken by the amount of light that reached it from the reflected scene. The pinholes were replaced by glass lenses with diaphragm apertures that opened and closed like the iris of the human eye in order to focus the light more precisely.

FROM FILM TO DIGITAL

Over the past 150 years, photography has progressed through a succession of better apertures, faster shutters, and a wide variety of films. The digital revolution of the 21st century dramatically accelerated that progress. Film was largely replaced by digital image sensors. A sensor receives the light in thousands of pixels and sends the information to the camera's memory card. A memory card can store thousands of images that can be transferred to a computer screen in minutes.

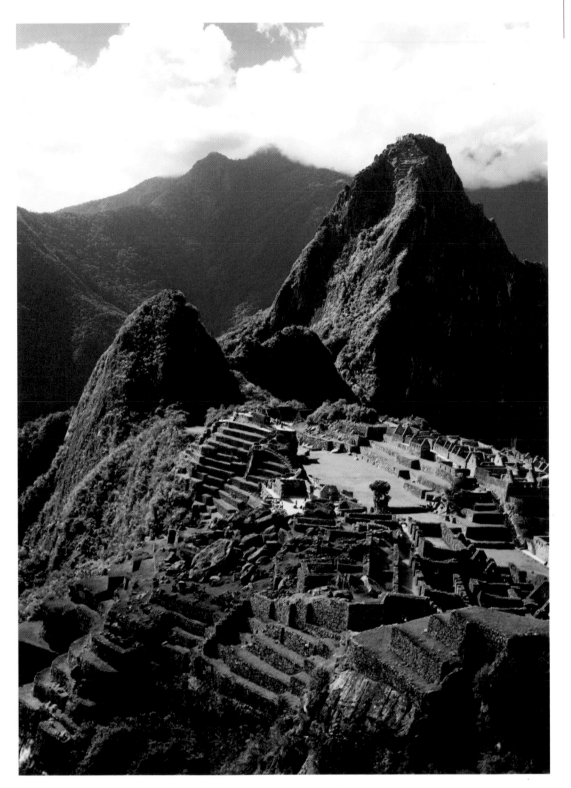

COLOR, PRECISION OF DETAIL, and an aerial point of view bring Machu Picchu more clearly to view for the world in 21st-century photography. The processes involved in color photography mimic those of the human eye. **Michael Hanson** Machu Picchu, Peru

▶Light & Color

A PHOTOGRAPH IS SIMPLY a gathering of light—reflected from a subject through the opening of the dark box and recorded as an image. The intensity and quality of light varies with the time of day, the weather, the direction, and the source. Many photographers prefer the soft light of morning or the amber shades of evening, but "good light" is subjective. Soft light can romanticize a scene, but harsh light can make it exciting. Changing light can dramatically change the quality and mood of the scene, and photographers often wait for hours for the ambient light to shift to its most compelling.

THE PHYSICS

Light travels as waves of electromagnetic radiation. Direct rays from the sun move in straight lines but vibrate in all directions perpendicular to their path. When they strike an object, some parts of the visible spectrum—the radiation we can see—are absorbed by the object. Others are scattered or reflected, and it is these we perceive as the various colors. A leaf, for example, absorbs all rays except green.

THE NATURE OF COLOR

The colors we see are based on varying wavelengths, the distances between crests in waves of light photons. Our perception of color is based on the interaction of red, green, and blue light. Mixed, these three can create any hue in the visible spectrum. The familiar colors of the rainbow include all those that can be produced by visible light, and each represents the light of a single wavelength. Visible colors interact in our eyes with the cone cells of our retinas, which act much as digital sensors in a camera. The cones send signals to our brains, which perceive, record, and replicate those signals, much as memory cards in cameras do.

▶FOR MORE ON LIGHT, SEE PAGES **114-21, 124-7.**

▶▶ **Take advantage of lighting conditions** created by bad weather. Look for reflections in windows and on the ground, and for sunlight breaking through the clouds.

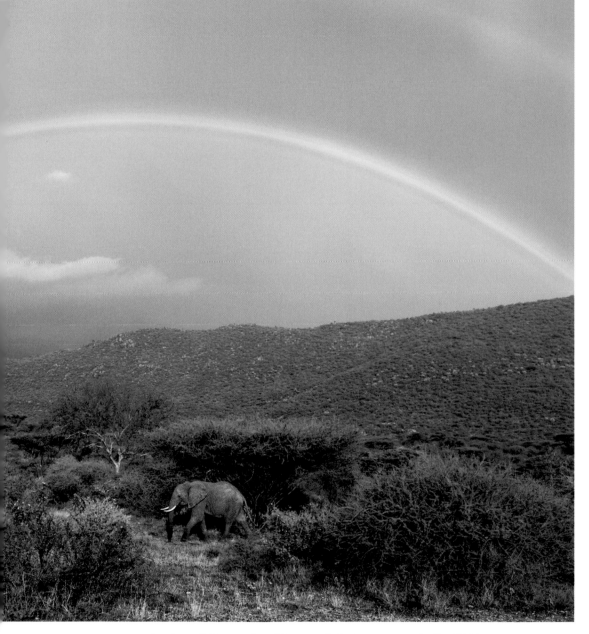

A LONE ELEPHANT meanders beneath the arc of a rainbow—an instantaneous opportunity of light noticed by the photographer's eye and then captured by the photographer's camera.
Michael Nichols Samburu National Reserve, Kenya

▶ What Is a Lens?

▶ FOR MORE ON LENSES, SEE PAGES 142-51.

A LENS IS COMPOSED of elements of optical glass, both concave and convex, designed to focus light rays on a common plane: the digital image sensor (or the film plane in older cameras). In order to produce an image that a viewer will perceive as "sharp," a lens must have high resolving power (an ability to clearly define intricate detail) and good contrast (well-defined distinction between light and dark areas). Lenses also carry the camera's aperture mechanism, which controls the amount of light entering the camera. Simpler cameras come with fixed lenses that cannot be removed, but many of these will zoom out to double as telephoto lenses, which make faraway subjects appear closer. More versatile cameras, such as digital single-lens reflex (DSLR) models, have multiple lenses that can be detached and exchanged in response to specific shooting situations.

Lenses are categorized by their "angle of view"—the amount of a scene they cover. This capability is expressed in focal length, the distance (expressed in millimeters/mm) from the center of the lens to where light rays focus on the digital sensor or film. Types of lenses include:

- **STANDARD** Provided by camera manufacturers along with the camera as a part of the kit; usually the equivalent of a 50mm focal length for a 35mm film camera.

- **TELEPHOTO** Focal length longer than standard; generally used to take photographs from a distance. Well suited for nature and wildlife, to fill the frame with a distant subject. Normally 70mm to 300mm, although different combinations can be used.

- **MIRROR** Special design of a telephoto in which mirrors replace some lens elements; lighter than other lenses of the same focal length, but fixed in aperture.

- **WIDE ANGLE** Shorter focal length than standard lenses to get more area of view in the frame from the same distance. Typically used for landscape photography. Downside: can increase the perspective distortion.

- **ZOOM** Lenses that have variable focal lengths; some telephoto lenses have zoom capabilities.

- **MACRO** Designed for close-ups; focusing movement is more refined than standard.

A VARIETY OF LENSES can aid a photographer in producing high-quality images out of different shooting situations.

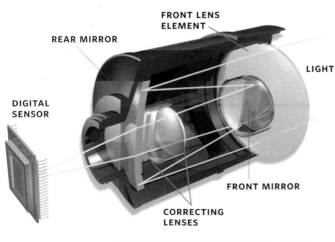

A COMPOUND PHOTOGRAPHIC LENS functions to focus light rays and reduce blurring before imprinting an image on the digital sensor.

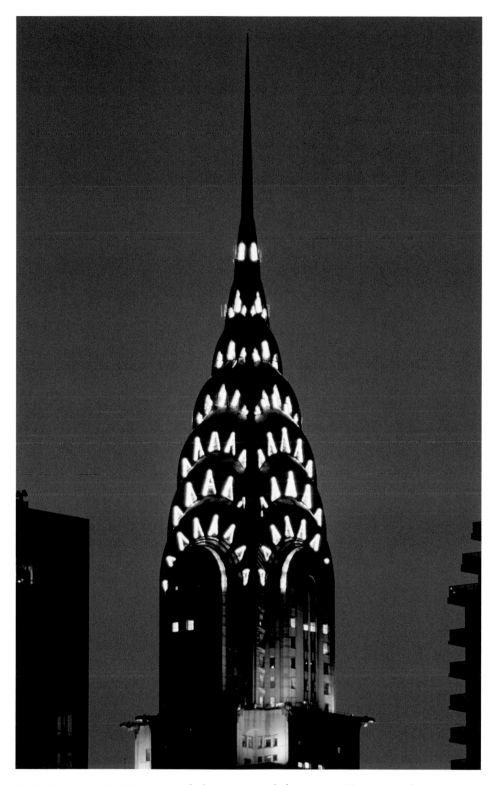

COLOR FILTERS, A TELEPHOTO LENS, and a knowing control of exposure settings can produce images that baffle the human eye, such as this one of the Chrysler Building at twilight.
Richard Nowitz New York, New York, U.S.

▶ Capturing & Storing the Image

▶ **FOR MORE ON STORING & SHARING, SEE PAGES 194-5.**

THE BASIC TOOLS of photography have long been cameras and film. Now, the mechanical process remains essentially the same—lens, aperture, and shutter—but the technology used to capture and store the image is different. Instead of film, an image sensor captures light and stores it on a memory card for recall and reproduction.

THE IMAGE SENSOR

All digital cameras use image sensors to capture pictures. A sensor is a light-sensitive electronic chip that sits behind the lens (a chip in computer terms is a self-contained microprocessor made up of many circuits).

When the camera is turned on, the sensor responds to light and affects the flow of electricity through it, depending on the amount of light hitting its surface. The circuits of the camera examine variations in power and map them to specific points on the chip. These data are then turned into photographs.

Every image sensor is made up of tiny individual sensors called pixels, and each pixel is capable of capturing information about the brightness and color of the light hitting it.

As more pixels get crammed into the sensor, a specific set of dimensions is associated with the sensor, such as 3,000 pixels wide by 2,000 pixels high. Multiply the two together to get the area dimension of pixels. In this example, it would be 6,000,000 pixels, which is the same as 6 megapixels (1 megapixel equals 1,000,000 pixels on a sensor).

IS BIGGER BETTER?

As a general rule, the larger the sensor, the better the image quality ("larger" here refers to memory capacity, not necessarily physical size). The advantage of a DSLR camera is that it typically has a much larger sensor than a point-and-shoot camera and therefore produces better quality photographs. With a good point-and-shoot, the difference may be negligible. It's better to have a photograph taken with a less-than-perfect camera than to have no photograph at all.

▶▶ **Make sure to carry more than one memory card** with you, and store the cards in a warm, dry place to keep them from being corrupted.

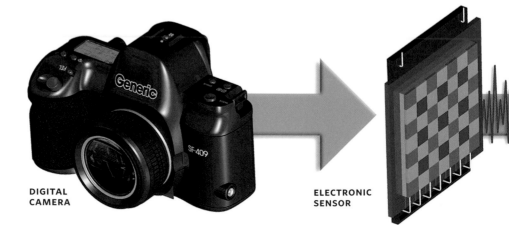

DIGITAL CAMERA

ELECTRONIC SENSOR

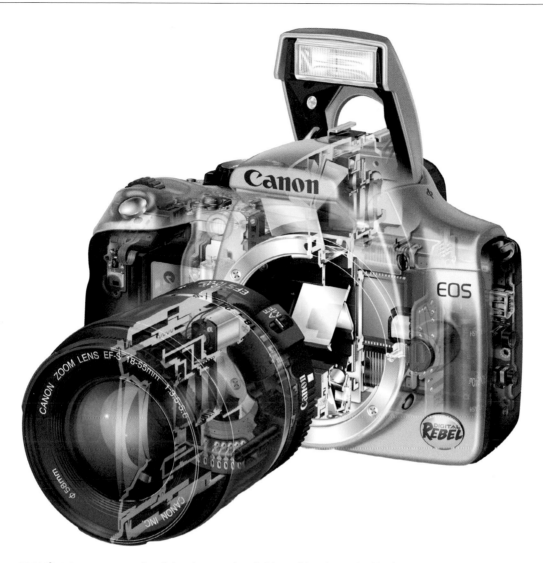

TODAY'S DIGITAL CAMERAS imprint an image onto a light-sensitive electronic chip that can recognize brightness and color and convert these qualities into digital signals called pixels (short for "picture elements"). The pixels are in turn relayed to a memory card, where the information is stored for later retrieval.

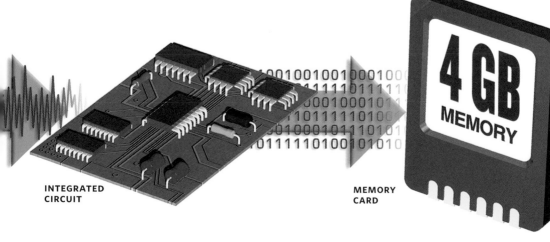

INTEGRATED CIRCUIT

MEMORY CARD

▶ Taking a Picture

▶ FOR MORE ON THE VIEW-FINDER, SEE PAGES 56-7.

CREATING A PHOTOGRAPH requires only the single act of pushing the button that triggers the shutter, which is a moving curtain that lets light fall on the digital sensor for a set length of time. Everything else is preparation and internal mechanics. Photography, in other words, can be 99 percent anticipation and 1 percent action. The parallel between a photographer and a hunter, in which the trigger pull is analogous to the push of the shutter button, is obvious. Both shoot. But a hunter sends out a missile; a photographer draws in reflected light. He or she must make an artistic calculation beyond simple aim. Modern digital SLRs, increasingly user-friendly, allow photographers to concentrate more on that aesthetic than on mechanics.

1. Framing the Picture

■ Light enters the lens.

■ Light bounces off reflex mirror and through pentaprism to viewfinder.

■ Photographer sees what the camera sees through the viewfinder.

2. Taking the Picture

■ Photographer depresses button.

■ Reflex mirror rises.

■ Shutter opens at designated shutter speed.

■ Aperture opens to designated measure.

■ Light travels straight to sensors.

IT MAY BE THE MECHANICS of the camera that capture an image, but it is the anticipation of the photographer that captures a moment. **Marc Ewell/National Geographic My Shot** China

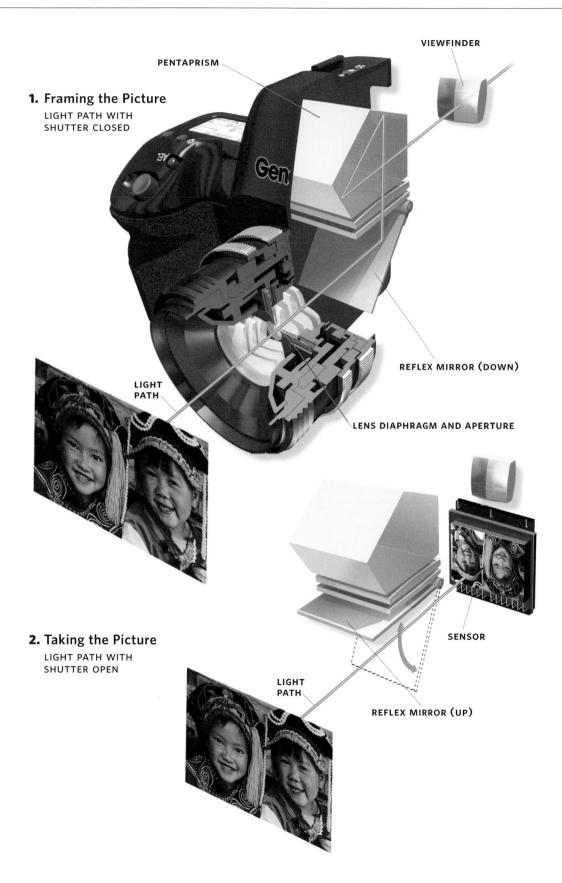

VIEWFINDER

PENTAPRISM

1. Framing the Picture
LIGHT PATH WITH
SHUTTER CLOSED

REFLEX MIRROR (DOWN)

LIGHT
PATH

LENS DIAPHRAGM AND APERTURE

2. Taking the Picture
LIGHT PATH WITH
SHUTTER OPEN

SENSOR

LIGHT
PATH

REFLEX MIRROR (UP)

☐ Annie Griffiths: **MY PERSPECTIVE**

THE MOST DIFFICULT TASK of any photographer may be connecting with our subjects—people—and photography has taught me how to truly listen. The intimacy I strive for in my images can only be reached in an atmosphere of trust and understanding. I have learned to listen with every fiber of my being, taking in not only the spoken word but also unspoken indicators.

Each culture has its own distinct gestures that indicate respect, aggression, humor, fear, kindness, suspicion. A photographer needs to know them. Whether photographing a Bedouin wedding, a Pakistani village, or a British farmer, I recognize that I am the guest in someone else's reality, the stranger who must abide by another culture's ways.

My job is to put my subjects completely at ease so that I can reveal them as human beings; as much as possible, I try to disappear and find ways to be nonthreatening. I never carry a camera bag or wear a camera vest. I blend in as much as I can. I often lower myself—crouching or kneeling with my camera, for example. I've actually found that people across cultures are generally less intimidated when I'm at their level or slightly below it. I avoid using interpreters and try to communicate in any way that I can on my own. I smile and laugh a lot. —A.G.

ONE OF THE FIRST WOMEN PHOTOGRAPHERS to work for National Geographic, **ANNIE GRIFFITHS** has photographed in more than a hundred countries. She has worked on dozens of magazine and book projects for the National Geographic Society, including stories on Lawrence of Arabia, Baja California, New Zealand, and Jerusalem. In 2008, Griffiths published *A Camera, Two Kids and a Camel,* a photo memoir, and her newest book, *Simply Beautiful Photographs,* was published in 2010.

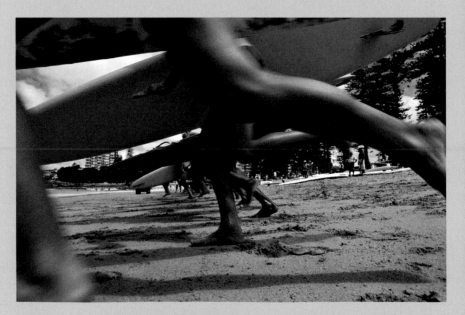

Competitors race for the water at a surf lifesaving event in Sydney, Australia.

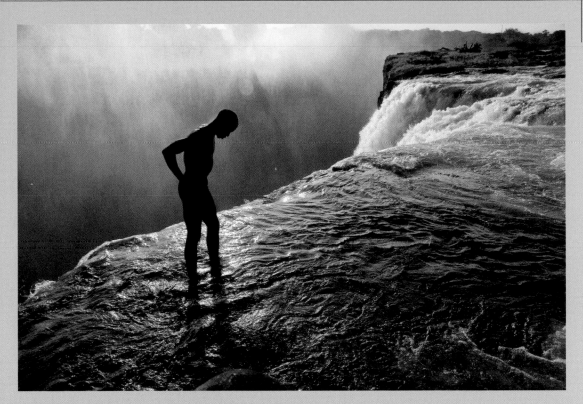

A swimmer tempts fate at the lip of Victoria Falls in Zambia.

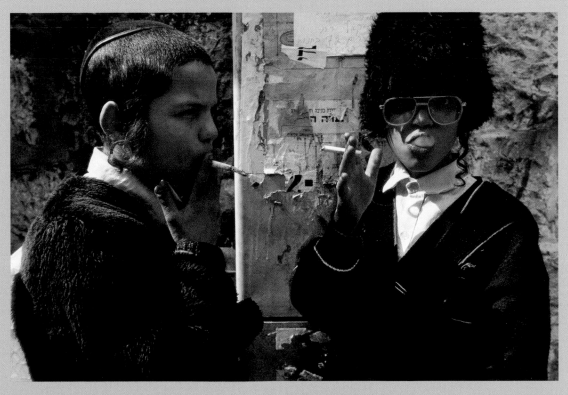

Two Israeli students play it cool in costume as part of their school's Purim festivities.

▶ The Art of Photography

PROFESSIONALS often say they "make," rather than take, pictures—a distinction that implies creative collusion between machine and operator, rather than a simple confluence of light and space.

In every carefully considered photographic accomplishment, four elements are vital: subject, composition, light, and exposure. In this book, we will use the shorthand of the icons below to highlight the choices that make a successful photograph.

SUBJECT
Most photographers document only family history—birthdays, weddings, graduations, or holidays. Others expand to nature or sporting events. A few make art. And some make art of all their pictures, no matter the subject. Shoot what's important to you.

COMPOSITION
Good composition usually means unity and balance in shapes, colors, and textures. But mood, emotion, and actions are often enhanced by flouting conventional photographic rules; if it works, it works.

LIGHT
Landscape photographers will say they're "waiting for the light." Photojournalists must often use ambient light. A studio photographer creates his or her own, with lamps. But all know that light—low, soft, harsh, warm, or diffuse—is critical.

EXPOSURE
The amount of light that falls on the sensor must be calibrated by the size of the aperture opening and the speed of the shutter. Proper exposure is considered to be a full range of tones, from deep shadows to bright highlights, all with good detail.

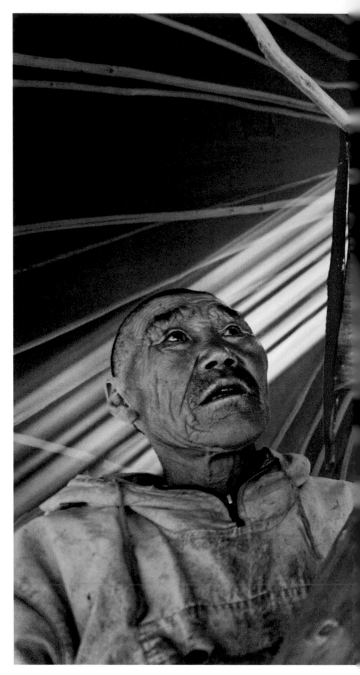

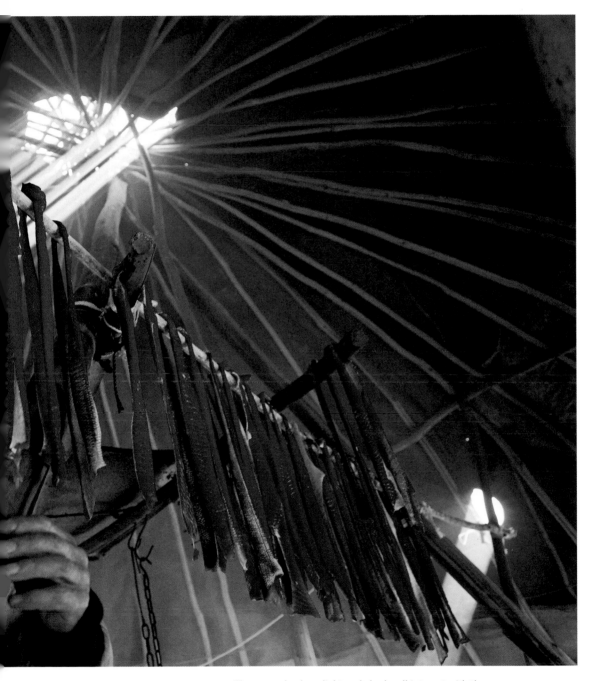

A PHOTOGRAPH IS AN ARTISTIC CREATION. Shapes and colors, light and shade, all interact with the content and its emotional impact, as in this image of an Arctic man drying strips of meat inside a tepee, shot with light from above. Randy Olson Khailino, Kamchatka Krai, Russia

▶Creating Your Own Subject Matter

▶FOR MORE ON
A SENSE
OF STORY,
SEE PAGES
292-3.

▶FOR MORE ON
SEEKING THE
AUTHENTIC,
SEE PAGES
338-9.

SUBJECT MATTER can mean the content of your photograph, literally, but it can also mean much more: mood, timing, context, juxtaposition.

The first question to ask is: *Why* am I taking this picture? The answer may be that you want a portrait of a friend, or a reminder of a place, or evidence of how you felt looking at a beautiful scene.

FITTING A PHOTO TO A SUBJECT

Next, ask yourself about the subject: What is this person like? What does this place mean to me? What makes this scene so beautiful? The answer will tell you the mood you want in your picture.

You can use the techniques in this book to help you create that mood. If you care about someone, for example, you will want to use light that will flatter that person. If you are outdoors, the time of day and quality of light can convey different moods. Select the red glow of sunset for romance, the cold gray of gloomy skies for melancholy, or a shaded setting with a shaft of sunlight for a bright, cheerful portrait.

▶▶**Great subject matter** is often a matter of noticing something that others don't within a familiar setting. Take a walk with that mind-set, and see what you can see.

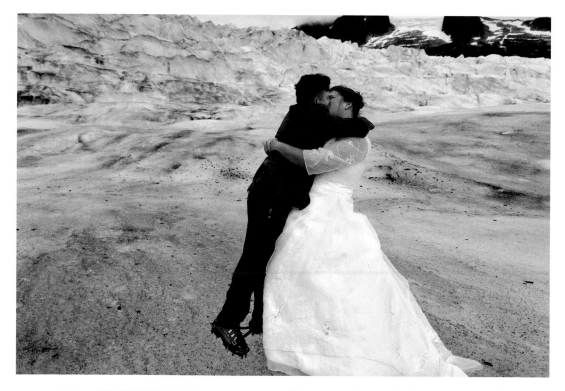

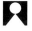 **THE SURPRISE IN SUBJECT MATTER** makes this photograph immediately exciting. It is anything but your typical wedding picture, with the bride lifting the groom for a nuptial kiss and its glacial backdrop, far different from your normal church lawn. Such surprise makes for excitement, even when set against an icy cool blue background. **Melissa Farlow** Hagi, Japan

LONG EXPOSURE TIME turns the rush-hour bustle of Boston into a stream of lights.
Richard Nowitz Boston, Massachusetts, U.S.

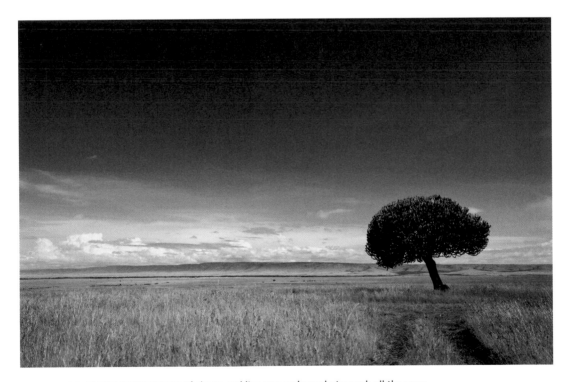

SOMETIMES A SIMPLE COMPOSITION of shape and line can make a photograph all the more
compelling. **Beverly Joubert** Masai Mara National Reserve, Kenya

▶Defining Composition

▶**FOR MORE ON
PHOTOGRAPHING
PEOPLE,
SEE PAGES
234-45.**

CENTERING YOUR SUBJECT and snapping the shutter isn't composition. Sometimes a picture just falls together, but not often. You have to edit in the viewfinder before you shoot, and you have to anticipate when any moving elements will converge into sync. Good composition means getting rid of the clutter in a photograph—that car bumper sticking into the frame or the fence running through someone's ears. Be aware of "hot spots"—extraneous patches of bright white or reflected sun glare. Don't leave partially blurred objects in the foreground. The best photographs will never need cropping, that is, cutting out part of the picture. Professionals fill the frame, leaving no distracting material.

SEEING IN TWO DIMENSIONS

Our two eyes see from different angles, so we perceive three dimensions—height, breadth, and depth—but a photograph has just two dimensions. Thus, a subject's grandeur that seems obvious to your eyes can be disappointing in a picture; your dramatic landscape may look flat and dull. But you can train yourself to view the world as the camera does, in two dimensions. Close one eye; hold up your hands to form a frame. Imagine the scene as if it were a picture printed in a book or hanging on your wall. Does it come alive? If not, try moving so that there is something in the foreground. This will usually add the feeling of depth or distance.

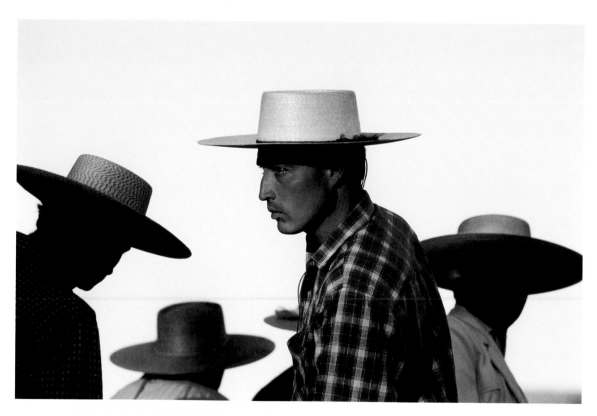

 THE INTERPLAY OF SHAPES gives this photograph its superb composition, particularly the recurring and yet always slightly different angle of the straw hats these four (even five) men wear. The figure in the center acts as an anchor for the other elements in the frame. We see his face in stark silhouette; we can only imagine the others. **Melissa Farlow** La Retuca, Chile

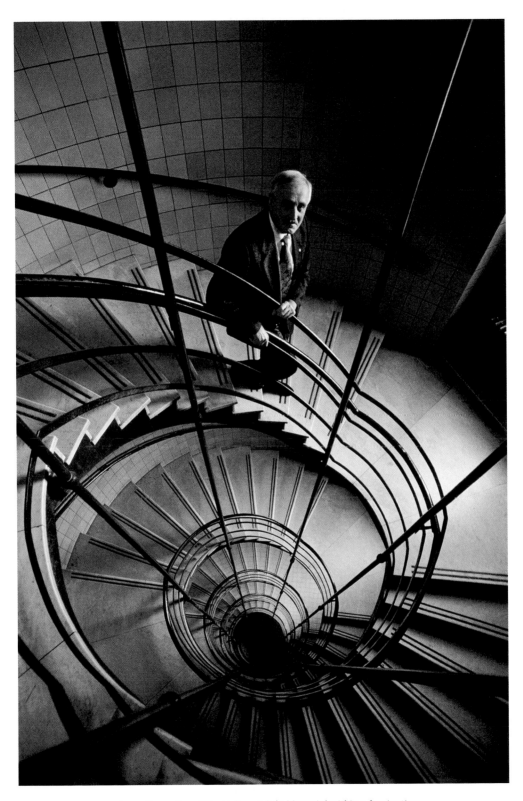

A VIEW FROM ABOVE places the rector of the Université de Montréal within a fascinating staircase spiral. **Sisse Brimberg** Montreal, Quebec, Canada

▶ Anticipating Composition

▶▶ **Don't miss the moment** because of equipment problems. Watch your battery levels; keep your camera set for shooting. If your memory card is nearly full, change it.

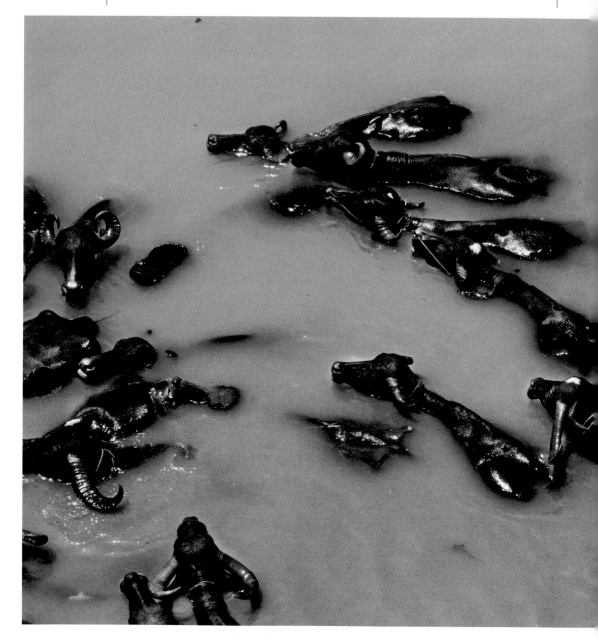

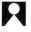 **CROSSING A BRIDGE** over the Turaq River, the photographer heard the laughter of children and set the camera for a high shutter speed, ready for action before the children spotted him. They were washing their water buffaloes. All of a sudden one of them did a back flip—*click!* One opportunity, and the photographer caught it. James P. Blair West of Dhaka, Bangladesh

▶ FOR MORE ON
TIMING,
SEE PAGES
290-1.

THINK OF YOUR SUBJECT as a single frame in life's epic motion picture. The Earth spins, the weather changes, and life moves around you like a dance. "Anticipating composition" means selecting one important moment from that ebb and flow—what photojournalist Henri Cartier-Bresson called the "decisive moment." The act of catching life at its most revealing is the secret of selecting, and thus creating, good composition.

WAIT FOR IT

Few images are sitting there waiting for a photographer. A good photographer, like a good fisherman, learns to wait. Photographers have been known to camp for days on a mountain slope until the light is right for the elements of the picture. The rising or the setting of the sun reveals more and different moods and details with every passing minute. Wildlife photographers hide in blinds for hours to wait for a skittish animal to enter their field of view. Anyone can trip the shutter of a camera. It takes practice to know *when* to do it.

MAKE IMAGES OF YOUR OWN

Another aspect of good anticipation and good framing is implied motion, where your subject is in the act of moving. For example, if you are photographing a little girl walking or running across the frame, or even looking across it, convention is to leave more room in front of her than behind, so she has space to "move" with the motion implied in the image.

But you can also make dramatic images by doing just the opposite, with the person moving out of the frame. Look carefully, think about what you want to say, consider whether to follow or break the rules of composition, and make images that are your own.

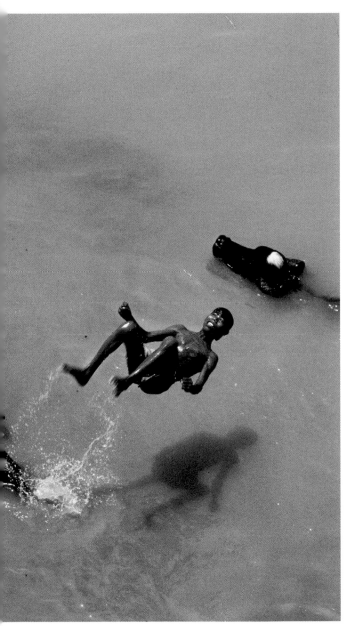

▶ Seeing the Light

▶ **FOR MORE ON
QUALITIES
OF LIGHT,
SEE PAGES
116-21.**

THE WORD "PHOTOGRAPHY" means "light drawing." Photographers at National Geographic often take that literally. They talk about their technique of taking 20 to 30 exposures of the same subject as "painting with light," in which they consider each exposure a brushstroke, until the subject fully reveals itself.

All photographers must think constantly about light. They must make frequent judgment calls not just about whether there is *enough* light to take the photograph they see but also about the *nature* of that light, and about the shapes made by light and dark as the highlights and shadows fall into the frame.

DIRECTION OF LIGHT

Light rays move in a straight line, illuminating only what they strike. Photographers must always assess the direction from which light is coming as they plan to take a picture. The rule of thumb for well-lit outdoor photographs is to shoot with the sun falling over your shoulder, at about a 45-degree angle to the subject.

Overhead light, often fine for landscapes, may cause deep shadows and distort the image. If someone is wearing a hat, her upper face may be a dark blob.

Sidelight may cast the opposite side of the subject into darkness, which can be artistically interesting for a portrait, but

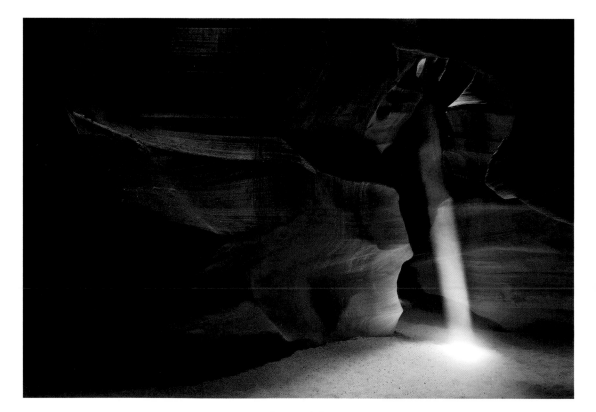

 A HUGE RANGE OF LIGHT makes this photograph fascinating, captured thanks to the broad exposure range possible with digital photography. The bright shaft of light and the cave shadows both have distinctly visible detail. The image's power comes from the extreme contrast of light, from bright to dark, and the shapes and shades in between. **Pete Ryan** Upper Antelope Canyon, Page, Arizona, U.S.

perhaps not for a child blowing out a birth-day candle.

Shooting with the light at your back, the traditional photographic pose, tends to make everything flat, without strong contrasts. Shooting toward the light, or back-lighting, can be dramatic, but often creates unwanted silhouettes of foreground subjects; correct this by fill-lighting the scene with a flash.

CHARACTER OF LIGHT

Clear light that emanates from a single source can be harsh, or hard, but a hazy sun can soften the light. During different times of day and in different seasons, sunlight varies in color. At dawn or dusk—the favorite times for most photographers—the nearly horizontal sunlight casts a soft golden glow. With overcast skies, the color of sunlight turns bluer.

▶▶**Be aware of shadows,** the patterns they make on buildings and pavement, and the way light at different times of day creates different shapes. Even the way a shadow moves across a face can add an important element to the image.

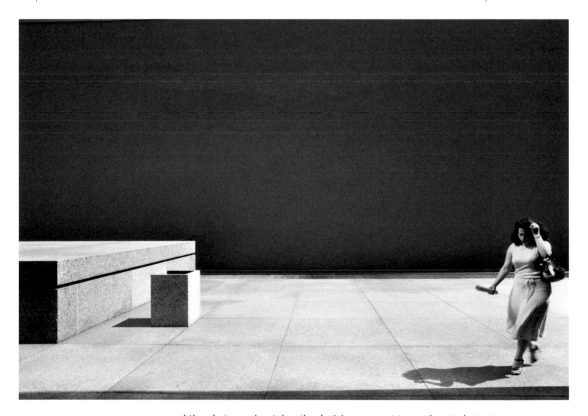

LIGHT DEFINES THIS PICTURE, and the photographer takes the decisive moment to an almost abstract level, with the human figure counterposed against the geometric architectural shapes. The lighting here is more complicated than it first appears, for the woman's face is lit from a source other than the sun, which casts such strong shadows. **Sam Abell** Toronto, Ontario, Canada

▶ Working With the Light

▶ FOR MORE ON
BRIGHT &
LOW LIGHT,
SEE PAGES
124-31.

THE RIGHT LIGHT is crucial to an effective photograph, but "right" is often in the eye of the shooter. Generally, the most desirable light conveys a three-dimensional effect and enhances the beauty of the photograph, but light can also convey more nuanced moods, emotions, or personal statements. Light is not only the necessary condition for photography but also its primary tool.

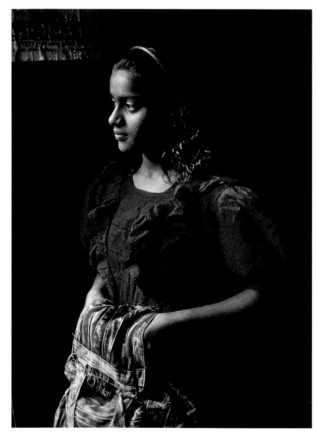

THE FEATURES AND COUNTENANCE of this young Bangladeshi woman are all the more striking as they emerge from the obscurity of darkness.
Karen Kasmauski Bangladesh

While every day presents unique light conditions, there are some generalizations that can be made:

- **MORNING LIGHT** In the early morning when the sun is still low in the sky, the light is clean and white. This is a good time for landscape photography, because the extra length of the shadows adds a three-dimensional effect to your pictures.

- **MIDDAY LIGHT** At high noon, when the sun is directly overhead, the shadows are short and deep and the light can be very contrasty. Portrait photography is especially difficult at this time because you must employ a fill flash or reflectors to soften the effect of the shadow.

- **AFTERNOON LIGHT** Late afternoon brings a warm, diffused light with long, soft shadows. It is an ideal time of day for most kinds of photography.

Light is dynamic. If possible, plan your photography around the light. If you see a picture but the light is too harsh, wait an hour for conditions to improve.

Good weather doesn't necessarily equate to good light. Overcast days soften light and reduce its contrast, while storms can create rare, surreal effects that if used well can transform an otherwise ordinary scene into an extraordinary photograph. A rocky coastline with crashing waves can be spectacular with menacing, cloudy, gray skies as a backdrop. A person looking through a rain-streaked window can communicate strong emotions.

▶▶ **Place your subject by a window** or an open door to create dramatic sidelighting. The light coming through a window is often diffuse and not as harsh as broad daylight.

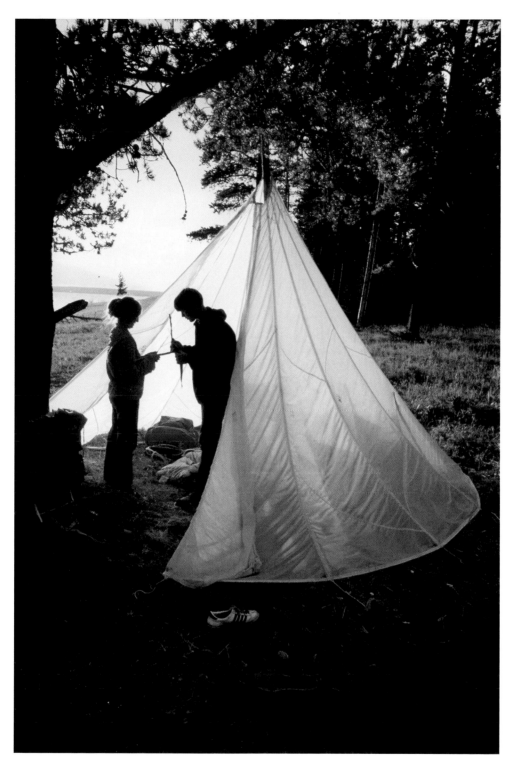

THIS PHOTOGRAPH WORKS because of the light coming at and through the tent that these two people are assembling and the angle at which the photographer found himself in relation to the light source and the translucent material. Perfect exposure was essential to capture a long depth of field and keep the various illuminated planes. **Sam Abell** Yellowstone National Park, Wyoming, U.S.

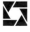

▶Defining Correct Exposure

▶**FOR MORE ON EXPOSURE CHALLENGES, SEE PAGES 134-5.**

EXPOSURE is the word used to indicate the amount of light that reaches the digital sensor (or emulsion film) as a picture is taken—a key factor in a picture's success. Exposure depends on two controls:

- The size of the lens opening, called the aperture
- The length of time light pours through the lens opening, controlled by shutter speed

When a photograph is said to show "correct exposure," it means that the photographer has found the best settings for the aperture and shutter speed, creating a balance.

BALANCING LIGHT AND TIME

National Geographic photographer Joel Sartore uses the analogy of baking, where temperature and time expose a cake to just the right amount of heat for just the right length of time. Inside a camera, a similar balance of light and time is needed. Too much light, and the picture will be bright and washed out; too little light, and the picture will be impossibly dark.

Like an oven, a camera must be properly set. The automatic setting allows it to make its best guess as to exposure but means the camera interprets what you're seeing—and cameras are only so smart. In average lighting conditions, an automatic setting can be

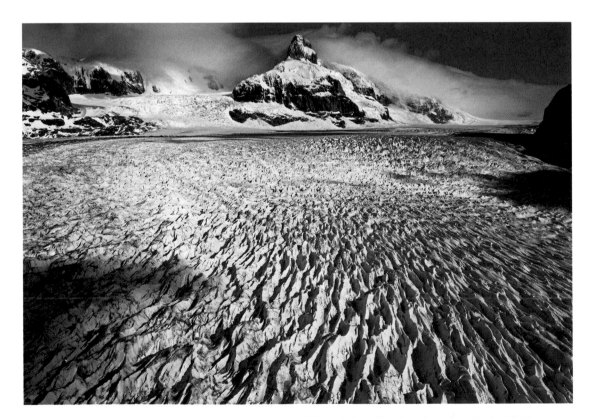

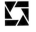
AN AERIAL PHOTOGRAPH TAKEN with a very wide-angle lens, this photo has a long depth of field: You see the ice in the foreground as clearly as the peak far away. For such depth, a photographer must decide between shutter speed and small aperture. Here, she chose shutter speed, perhaps as fast as 1/500 second. **Maria Stenzel** Laguna San Rafael National Park, Patagonia, Chile

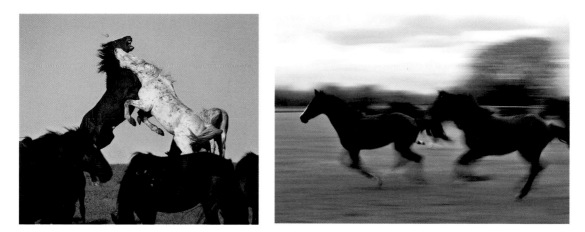

SIZE OF APERTURE, SHUTTER SPEED, AND DESIRED DEPTH OF FIELD in a photograph all involve decisions and produce distinct results, from stop-frame action (above left) to high-intensity blurred movement (above right) to day-in-the-life close-up portraiture (below).
Melissa Farlow Lantry, North Dakota, U.S. (above left) **Raul Touzon** Monterrey, Nuevo León, Mexico (above right) **Pete Ryan** Dawson City, Yukon Territory, Canada (below)

effective. But if the light begins to veer away from average, you may want to change the exposure settings yourself.

THINKING THROUGH EXPOSURE

Your camera works the same way your eyes do: If it's bright out, your pupils close down, letting in less light. Your camera's aperture acts as a pupil, letting in only a given amount of light. Its shutter opens and closes like an eye. Together, the aperture and shutter speed expose the photo. If they're not working in sync, your photos will suffer.

Modern cameras can calculate exposure on their own. But if you get to know your camera and learn how variations in exposure lead to variations in the photographs themselves, you'll be laying the groundwork for more advanced shooting.

▶▶ **Don't be afraid to experiment.** Shoot lots of pictures and practice with different exposure settings—overexposed and underexposed by a stop—to see the effects and be able to adapt quickly to different lighting situations when you're on the go.

☐ WHAT MAKES THIS

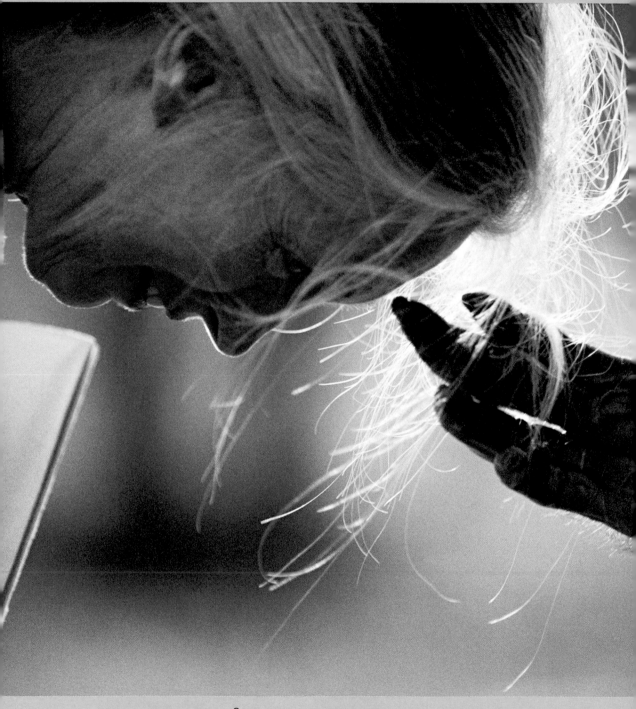

JANE GOODALL & JOU JOU **Michael Nichols** Brazzaville, Republic of the Congo

A GREAT PHOTOGRAPH?

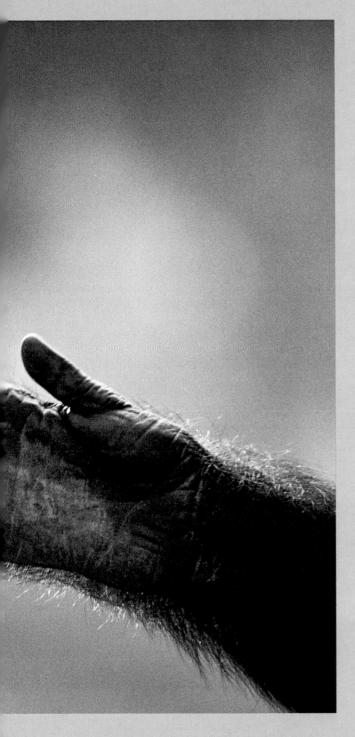

IN MY VIEW, there is only one photographer who could know this moment would happen and be ready for it: Nick Nichols. He has photographed countless animals and can sense connections between them and humans.

SUBJECT In this photograph, Jane Goodall is not only a scientist but a sensitive human being, a fellow primate. She bows her head in submission to Jou Jou, the chimpanzee she has been studying.

COMPOSITION Nick saw the image as it began to unfold: Goodall bending forward, the chimp reaching upward. Within a fraction of a second, everything came into position in the middle of his frame in perfect alignment.

LIGHT The light is soft and natural. The way it falls on the chimp's hand perfectly illuminates the closeness of our two species. Hold your own hand out and see how similar it is.

EXPOSURE This is a difficult situation to expose for, yet Nick did it just right. He used a large aperture and a medium telephoto lens. That combination enabled him to keep the depth of field shallow, so the emphasis is placed on the action in the foreground. It also allowed him to shoot from some distance away, affording Jane Goodall the space she needed to interact with Jou Jou.

–James P. Blair
NATIONAL GEOGRAPHIC
PHOTOGRAPHER

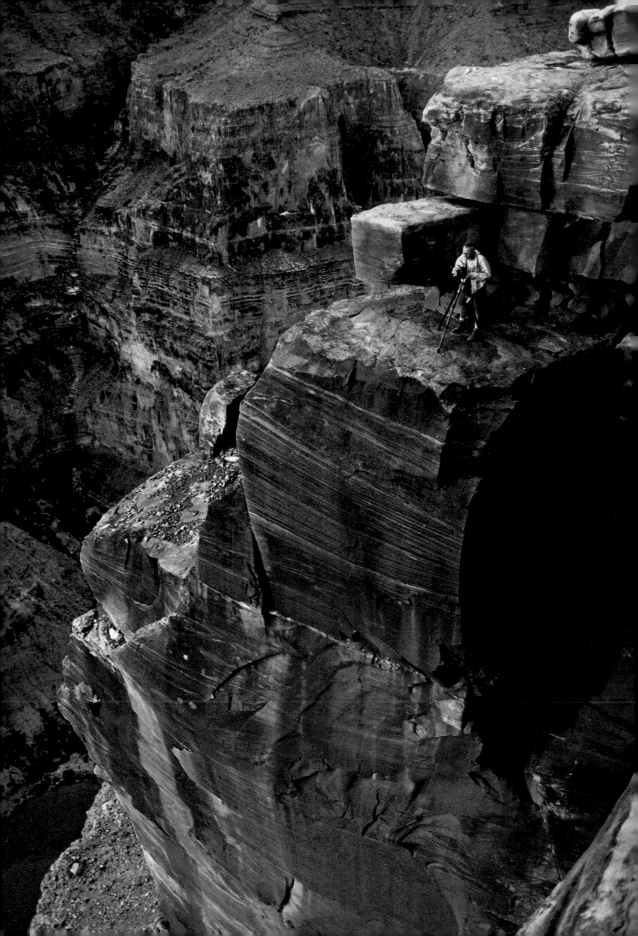

2 Camera Basics

THE CAMERA IS A COMPACT LITTLE MACHINE that can do nothing by itself. The camera is your tool. You must take charge of it. Just as a driver needs to understand the basics of a car before taking it out on the road, so the photographer needs to understand the basics of a camera before making successful pictures. Good photographers range from gear-heads whose technical knowledge exceeds their artistic ability, to "artists" whose interest in camera mechanics is minimal. But there is no ignoring the technical aspects of photography, and the better you understand the rich possibilities of the modern digital single-lens reflex (DSLR) camera, the more meaningful and artistic your photographs will be. This chapter will introduce the elements of photography in simple progression, from the moment the light leaves the subject to the moment it embeds in the memory card.

MANY PHOTOGRAPHERS GO TO EXTREMES to get the right shots, such as this diehard perched precipitously over the edge of the Grand Canyon.
John Burcham Toroweap Overlook, Grand Canyon National Park, Arizona, U.S.

▶The Viewfinder

▶**FOR MORE ON CAMERA MODES, SEE PAGES 76-7.**

PHOTOGRAPHERS can still frame their shots through a small, top-mounted viewfinder on a digital SLR, as on a film camera, but now they also have large images on the camera-back LCD (liquid-crystal display) panels. LCD panels have revolutionized the way we shoot. They serve not only as framing tools but also as instant proofing systems, allowing verification of composition, exposure, and lighting before a picture is taken.

Some cameras have LCD data screens on top and an LCD picture monitor on the back. Simpler cameras have only back LCD panels. They allow photographers to edit photographs in the field, a liberating feature. Photographers can now experiment, trying to discover right away what works for them and the subject, without wasting film. They don't have to worry about anyone seeing failed experiments, because they can instantly trash bad photos, which never make it out of the camera. The information contained on the panels varies with the camera, but a typical viewfinder panel might show these settings in the composite picture at right:

■ **METERING MODE**
The symbol shows where the exposure meters are reading light in the picture frame.

■ **SHUTTER SPEED**
Here, 60 means one-sixtieth second.

■ **APERTURE, OR F-STOP NUMBER**
Here, F2.8 means a relatively large aperture: 2.8.

■ **EXPOSURE COMPENSATION SCALE**
Here, the tick mark just left of 0 suggests that proper exposure would require one-third stop more light.

■ **NUMBER OF FRAMES**
Here, 23 means 23 frames.

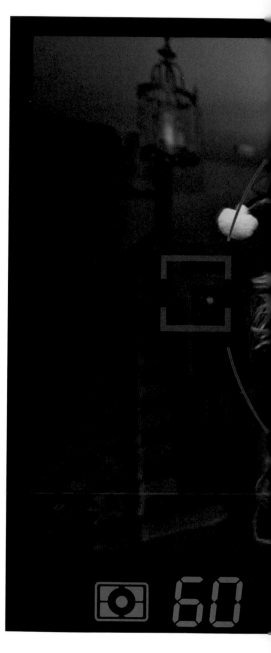

▶▶ **Remember that few DSLR cameras** show 100 percent of the actual image on the viewing screen. More of the scene will be recorded on the image sensor than you see when you shoot.

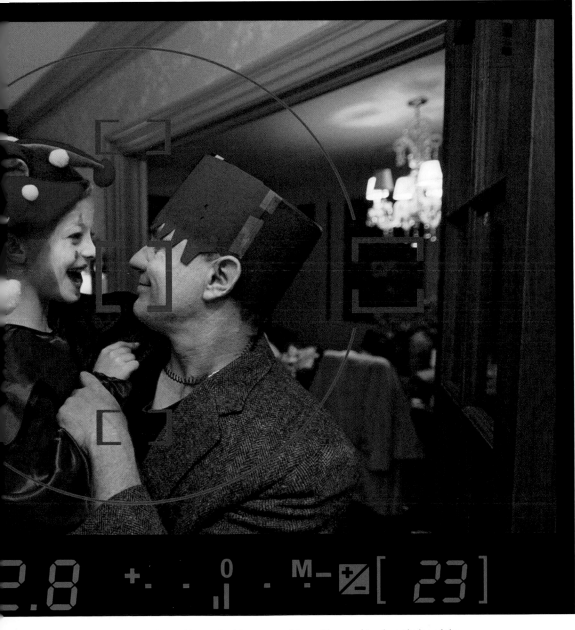

A SKILLED PHOTOGRAPHER combines a feel for composition with a working knowledge of the information presented in the camera's viewfinder. **Joel Sartore** Nebraska, U.S.

▶Focus: How Does It Happen?

▶ FOR MORE ON FOCAL POINT, SEE PAGES 82-3.

▶ FOR MORE ON LAYERING, SEE PAGES 104-5.

PHYSICALLY, FOCUS is the point at which rays of light meet after being refracted or reflected. In photography, the light rays are refracted through glass lenses and focus on the sensor or film plane. Focus is attained when outlines are sharp, details are clear, and elements are easy to distinguish.

It really is the lens—along with the creative vision of the photographer—that makes the image, as well as the focus. When a point of reflected light enters a convex lens, as in the illustration below, it changes direction (refracts) as it travels through the lens. If the distance between subject and lens is properly set, all the points of light will focus on the sensor plane. The image will be upside down and flipped, but an internal mirror will reverse the image to become upright in the viewfinder.

DON'T RULE OUT AUTOMATIC

Most beginning photographers leave their autofocus (AF) function turned on most of the time, as they do most of the other automatic settings on a digital camera. This is a good setting to use before you have learned the other functions and facilities of the camera, but many professionals also make extensive use of this setting under fast-moving or rough conditions. Automatic focus even has an option that gives it versatility: An AF setting usually reads objects in the middle of the image frame, but if your subject is markedly off to the side, you can override the automatic focus with the camera's built-in focus lock.

To apply the focus lock mechanism, turn the camera and focus on the off-center subject. Push the shutter halfway down and hold it, locking the focus. Keeping your finger on the shutter, turn the camera back to the original composition and complete the shutter snap motion. The offset subject will remain in focus.

Some scenes—snow, wide-open blue skies, very low light, extremely backlit subjects—are difficult for autofocus to handle. Shooting through a screen or netting will also fool the autofocus mechanism. In these cases, you simply turn to manual control (M), twisting the focus ring until the image is clear and sharp.

▶▶ **The zone of acceptably sharp focus** will seem more extensive in small prints than in enlargements. A foreground object that appears sharp in a 4x6 print may look partly blurred in a 16x20 or even an 8x10 blowup.

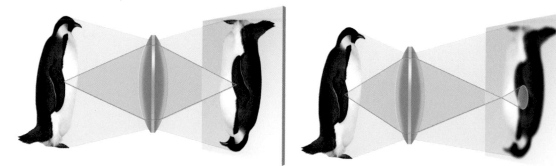

PRECISE FOCUS occurs when the rays of light gathered by the lens converge on the sensor plane.

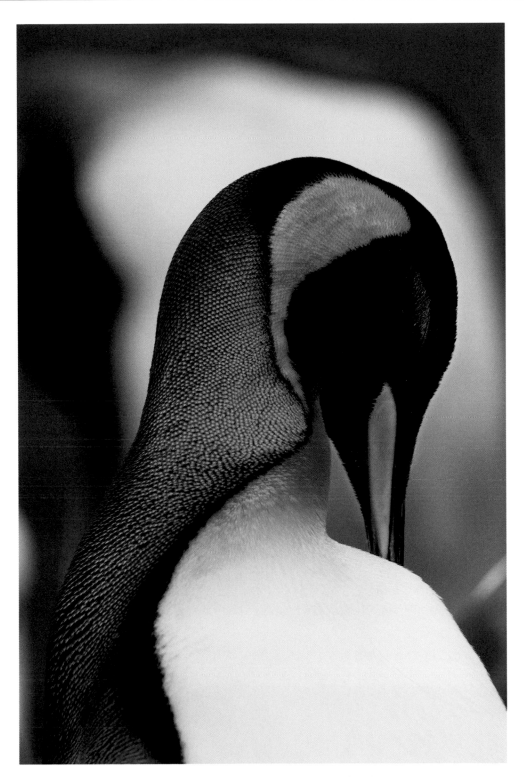

THE COLOR AND SHAPE in this photograph create a beautiful abstract image. There is no motion, but there is a sense of motion, created by the interplay of the focused portion, close up, and the out-of-focus portion with similar colors and shapes farther away. The parts work together in perfect balance. **Paul Nicklen** South Georgia

▶Choosing Your Lens

▶**FOR MORE ON TYPES OF LENSES, SEE PAGES 144-51.**

CAMERAS CARRY TWO TYPES OF LENSES, differentiated by focal lengths, the distances in millimeters (mm) at which the lenses will begin to focus in front of the camera. Fixed lenses come in set focal lengths, such as 35mm. Zoom lenses can be adjusted; a typical range is 50mm to 200mm for a 35mm film camera or equivalent digital sensor.

Wide-angle lenses (for a 35mm film camera or equivalent digital sensor) vary between 10mm (fish-eye) and 35mm. "Normal" lenses, at the same angle as our eyes, are 50mm.

Fixed telephoto lenses start at 85mm and can go to 600mm or more. DSLRs usually have a versatile zoom lens, such as 18mm–200mm.

FASTER LENSES FOR DARK SHOTS

Lenses are also classified according to speed, an indication of how wide their apertures can be opened and thus how much light can enter the camera. This becomes important in dark situations. Fast lenses, however, are more expensive because of their greater complexity.

▶▶**Buy the best lenses you can,** and be aware of their limitations. Making large, fine prints demands fine optics. If you use tele-extenders, buy the ones designed for particular lenses, not all-purpose ones.

24 mm

70 mm

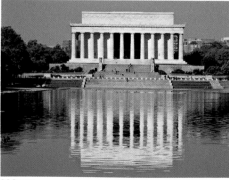

200 mm

400 mm

FOUR SETTINGS on one zoom lens, pointing at the same subject from the same position, create four very different results, from wide to narrower view. **Matt B. Propert** Washington, D.C., U.S.

SITUATION OR SUBJECT	APPROPRIATE LENS	OTHER LENS CHOICES	OTHER CHOICES
A SMALL COIN, BUTTERFLY, OR SINGLE BLOSSOM	TRUE MACRO LENS FOR HIGH MAGNIFICATION	MACRO ZOOM LENS FOR LOWER MAGNIFICATION	EXTENSION TUBE OR SUPPLEMENTARY CLOSE-UP LENS (SEE GLOSSARY)
DISTANT SPORTS OR RACING ACTION	TELEPHOTO LENS OF 400MM OR LONGER	ZOOM LENS INCLUDING 300MM OR LONGER FOCAL LENGTH	2X OR 1.4X TELECONVERTER ON A SHORTER TELEPHOTO LENS; TRIPOD OR MONOPOD
TALL BUILDINGS OR TREES	24MM TO 35MM PERSPECTIVE-CONTROL OR TILT-SHIFT LENSES	CONVENTIONAL WIDE-ANGLE LENS, OR SHORT TELEPHOTO FROM A GREATER DISTANCE	N/A
DISTANT BIRD OR SMALL ANIMAL	500MM TELEPHOTO	500MM F/8 MIRROR LENS OR ZOOM INCLUDING 400MM FOCAL LENGTH	TELECONVERTER ON A 200MM OR 300MM LENS; TRIPOD IN ALL CASES
GENERAL WILDLIFE	300MM LENS OR ZOOM WITH 300MM	400MM LENS OR ZOOM WITH 400MM	TELECONVERTER ON 300MM LENS; TRIPOD
CRAMPED INTERIORS	ULTRAWIDE-ANGLE LENS, E.G., 20MM FULL-FRAME FISH-EYE LENS IF DISTORTION IS ACCEPTABLE	WIDE-ANGLE LENS, E.G., 28MM	MAY NEED TRIPOD
INDOORS, WHERE FLASH AND TRIPOD ARE NOT ALLOWED	"FAST" 50MM F/1.4 OR F/1.8 LENS	ANY F/2.8 LENS	TABLETOP TRIPOD; "FAST" 400 ISO OR ABOVE
SPORTS SUBJECTS AT VARIOUS DISTANCES	100-300MM (OR SIMILAR ZOOM)	LONGER ZOOM	TELECONVERTER WITH A 200MM OR LONGER LENS; 400 ISO OR ABOVE
LANDSCAPE OR CITYSCAPE FROM A FIXED POSITION	20-35MM FOCAL LENGTH	28-80MM ZOOM OR 80-200MM FOR COMPRESSED PERSPECTIVE	N/A
HEAD AND SHOULDERS PORTRAITS OF PEOPLE	85MM TO 135MM	70-210MM (OR SIMILAR) ZOOM LENS	1.4X TELECONVERTER ON A SHORTER LENS
LARGE GROUPS OR FAMILY GATHERING	28MM LENS OR WIDE-ANGLE ZOOM	24MM OR SHORTER FOCAL LENGTH IN CRAMPED QUARTERS	N/A

FOCAL LENGTHS ARE GIVEN IN 35MM EQUIVALENTS.

▶Aperture & Depth of Field

▶**FOR MORE ON CORRECT EXPOSURE, SEE PAGES 50-1.**

THE APERTURE is the size of the opening in the diaphragm of the lens, that is, how wide the camera's "pupil" is open. The wider the aperture, the more light enters to expose the sensor or film. A series of f-stops (see diagram, opposite page) denotes aperture size; standard f-stops are, from largest to smallest, f/1.4, f/2, f/2.8, f/4, f/5.6, f/8, f/11, f/16, and f/22.

Counterintuitively, the values of aperture openings get bigger as the opening itself gets smaller: A very small aperture opening is f/16; a very large one is f/1.4. Similarly, the "speed" of lenses gets faster as

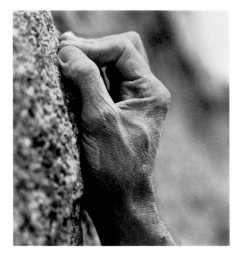

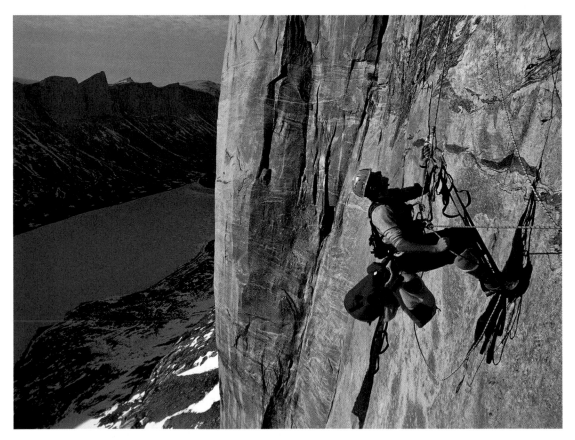

TO GET A HIGHLY FOCUSED, DETAILED IMAGE like the rock climber's hand shown above, a narrow aperture is a must. Depending on the light, the aperture can widen in proportion to the depth of field you want to show. **Gordon Wiltsie** Sierra Nevada, California, U.S. (above); **Gordon Wiltsie** Stewart Valley, Baffin Island, Nunavut, Canada (below)

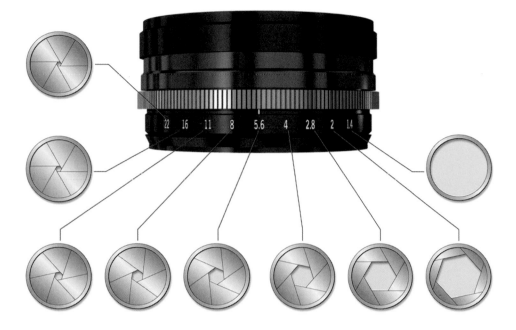

THINK OF APERTURE AS how wide your camera's eye opens as you snap the picture. A very wide opening (f/2) will mean little depth of field, while a very small opening (f/32) will mean lots of depth.

the values get smaller. A "35mm f/1.4" is a wide-angle, fast lens that offers a larger hole, f/1.4, on its aperture ring so you can shoot in darker conditions.

F-stop numbers seem confusing, but they are logical: Each value is actually the ratio of the focal length of the lens to the diameter of the aperture. If you're using a 50mm lens and set the aperture to f/2, the diameter of the aperture will be 25mm. The ratio is 50/25, or 2, so the f-stop is called f/2. If you "open up" the lens to f/1.4, the ratio of the focal length to the aperture diameter becomes 1.4, or 50/35.7. This is why an f/1.4 aperture is larger than an f/2.

DEPTH OF FIELD

Depth of field is the distance between the nearest and the farthest objects that are in acceptable focus in an image. Depth of field is determined by the size of the aperture opening and the focal length of the lens, as well as the distance at which the camera is focused. All else being equal, the larger the aperture or the longer the focal length, the shorter the depth of field. A long depth of field (most of the image in focus, close up to far away) is gained by using the widest lens with the smallest aperture hole. The shortest depth of field (a small range of distances in the image in focus) is gained by using a very long lens with the largest opening.

▶▶**You can change** shutter speed or aperture in manual mode to increase or decrease exposure from the indicated meter reading. Which variable to control depends on which consideration is more important—depth of field or the depiction of motion.

▶ Controlling Depth of Field

▶ **FOR MORE ON FOCAL LENGTHS OF LENSES, SEE PAGES 142-3.**

KNOWING HOW TO CONTROL the depth of field enables you to dictate the elements in the frame that are in focus. Focus puts the emphasis on a subject; viewers are drawn to objects that are sharp, and tend to overlook those that are not. With a wide-angle lens and a small aperture, almost everything in the picture can be in focus, enabling you to photograph a subject in the foreground while still keeping a sense of place with a sharp background. That beautiful landscape photograph hanging on a wall in a gallery was very likely shot on a very small aperture (large f-stop number) to get as much depth of field as possible and show every detail. In contrast, that portrait with a blurry background was probably shot with a longer lens and a relatively open aperture in order to compel the viewer to concentrate on the subject. A rule of thumb in portrait photography is that if the eyes of a subject are in focus, the rest of the face can be artistically blurry.

DEPTH OF FIELD PREVIEW

Some of the more expensive SLR camera models are equipped with a depth-of-field preview button. Its function is to reduce the lens aperture to the set value before the shutter button is pressed, so that the approximate depth of field can be seen on the viewfinder. What you see is what you get. But it's very difficult—if not impossible—to judge the depth of field accurately in a viewfinder. The smaller the aperture opening, the dimmer the viewfinder.

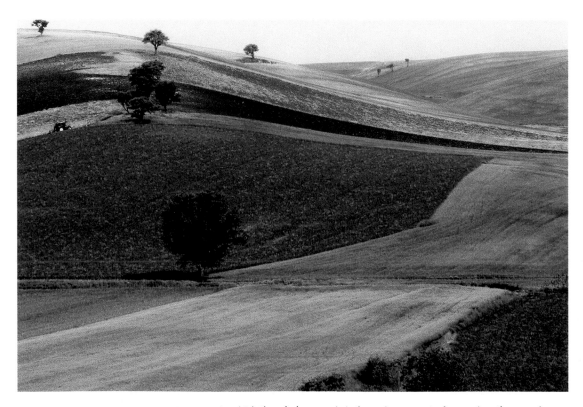

LANDSCAPE PHOTOGRAPHY in which the whole scene is in focus from near to far requires the use of a narrow aperture and, ideally, a wide-angle lens. **Rita Mantarro/NG My Shot** Puglia, Italy

DEPTH OF FIELD AS A FUNCTION OF APERTURE

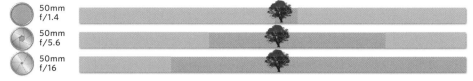

DEPTH OF FIELD AS A FUNCTION OF FOCAL LENGTH

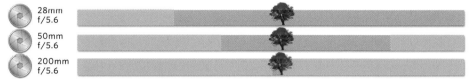

DEPTH OF FIELD AS A FUNCTION OF FOCUSING DISTANCE

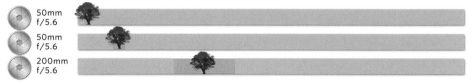

A PHOTOGRAPHER CAN CHOOSE which variable to control in order to achieve the desired depth of field. Even more often, however, the choice is a balance between two or three of these variables.

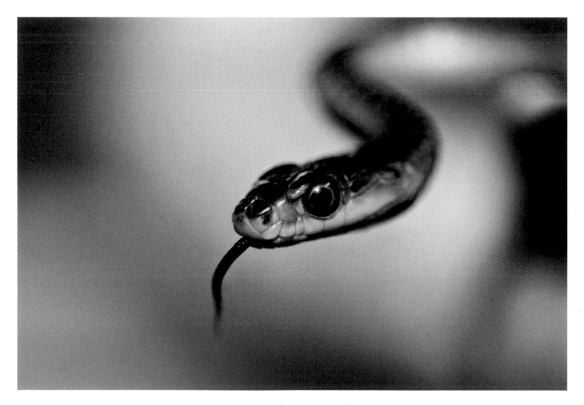

A GREEN TREE SNAKE inches toward the camera. The photographer chose a shallow depth of field, with only the snake's face in focus. **Brooke Whatnall** Cape York, Queensland, Australia

Michael Nichols: MY PERSPECTIVE

PHOTOGRAPHY AND CONSERVATION have been intertwined since their respective beginnings. In the late 19th century, images of the singular landscapes of Yosemite and Yellowstone in the United States provided the inspiration and evidence for the preservation of those areas. Saving these remarkable places would lay the foundation for the American national park system.

National Geographic has seen countless examples of the power of the photograph throughout its century-long history. In 1906, it published 70 pictures by George Shiras, who used a flashlight to illuminate animals at night. They caused a sensation; letters poured in from readers demanding more. The images would launch the magazine's association with wildlife photography. Half a century later, National Geographic's images of the magnificent redwood trees in California raised awareness of their vulnerability to logging and industrial interests.

In 2009, I returned to those redwoods for a story on the remaining stands and the quest for a smarter forest management strategy. The reward for me is that my work has in turn helped conservation to work; in some small way, we halted the seemingly insatiable appetite we have for the resources of our planet. It takes time and imagination to realize that our Earth's resources are limited and that our planet is all we have. And photography can help all of us to use our imagination, to imagine a better world. —M.N.

MICHAEL "NICK" NICHOLS became a National Geographic staff photographer in 1996 and was named editor at large for National Geographic magazine in 2008. From 1999 to 2001, he documented conservationist Mike Fay's Megatransect expedition across Africa, resulting in three articles and a book, The Last Place on Earth.

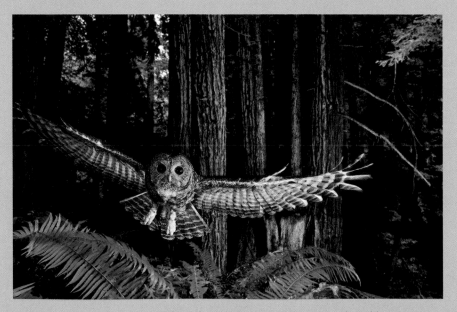

A northern spotted owl darts through the undercanopy of a redwood forest.

A lone elephant bellows a warning to the African sky.

A mother tigress moves her cub by the nape to safer quarters.

▶ISO/Sensor Sensitivity

▶ **FOR MORE ON CAPTURING & STORING THE IMAGE, SEE PAGES 32-3.**

▶ **FOR MORE ON LOW LIGHT SITUATIONS, FOG & HAZE, SEE PAGES 126-9.**

ISO, the level of light receptivity of a given digital sensor, sets the base sensitivity for the camera. ISO is the standard measure for digital still cameras, replacing the ASA and DIN of film. In the days of film cameras, photographers had to choose a film type based on its color character and ASA/DIN "speed." The digital photographer has more immediate options and can set various ISO levels on the camera.

On a sunny day, a "slower" ISO, such as 100, would be appropriate. Indoors or under clouds, 400 or 800 might be right. The quality of photographs will be better with a lower ISO, as they were with a lower-ASA film, but digital cameras have far surpassed film in terms of sensitivity to light, with ISO equivalent speeds of more than 100,000.

METERING

Finding the correct amount of light to fall on the sensor or film plane is the essence of exposure. Handheld exposure meters, separate from the camera, have largely been replaced by sophisticated automatic exposure meters in DSLRs. The manual setting (M) is of course always an artistic option. Automatic meters can be set to read a few f-stops higher or lower on the "exposure compensation" scale on the camera menu. They also offer a variety of methods to read the light:

- **EVALUATION METERING,** the camera's standard mode.

- **PARTIAL METERING,** effective when the background is much brighter than the subject.

- **CENTER-WEIGHTED AVERAGE METERING,** where the meter concentrates on the middle of the frame.

▶▶ **If you are setting ISO manually,** here is a basic guide: 100 ISO in bright sunlight; 400 ISO on a dreary day; and 800 or 1600 ISO for indoors or under floodlights.

BY UNDERSTANDING ISO, a photographer can set the camera for a moment like this. Shutter speed, aperture settings, and ISO settings combine to capture the bright light of the candle, the reflected light of the little fairy's face, a hint of her wings, and nothing else in the background.
Rich Reid Oak View, California, U.S.

▶Shutter Speed

▶FOR MORE ON
PHOTOGRAPHING
ACTION,
BLUR EFFECT
& PANNING,
SEE PAGES
162-7.

THE SHUTTER SPEED CONTROLS the amount of time the curtain in the camera (or overlapping metal leaves in some lenses) remains open—and that time is adjustable. You can select a shutter speed, or you can allow an automatic mode of the camera to do so.

The number of the shutter speed indicates how long the shutter allows light to remain on the sensor at any given aperture size. Shutter speeds are indicated in seconds and fractions of a second and are usually displayed on the LCD data panel of the camera. Common shutter speeds include, from slow to fast: 1 second, 1/2 a second, 1/4 second, 1/8 second, 1/15 second, 1/30 second, 1/60 second, 1/125 second, 1/250 second, 1/500 second, and 1/1000 second.

FAST OR SLOW?

A fast shutter speed can freeze the action of a sporting event or children at play. A slow shutter speed will blur that action. This does not mean that a fast shutter speed should always be used for action photography, because slow shutter speeds can be used creatively in that situation. Too slow a shutter speed is the most common culprit for blurry photos, but blur can also occur when you move the camera at the time of exposure.

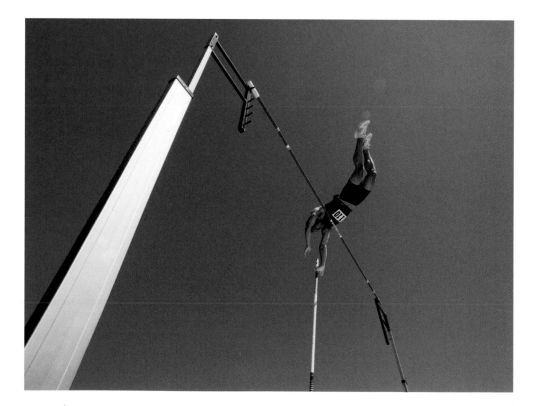

▶▶**Be cautious about shutter speed.** If the subject is dark and the meter indicates a slow shutter speed, you may want to consider using a tripod instead of hand-holding the camera to keep from blurring your image.

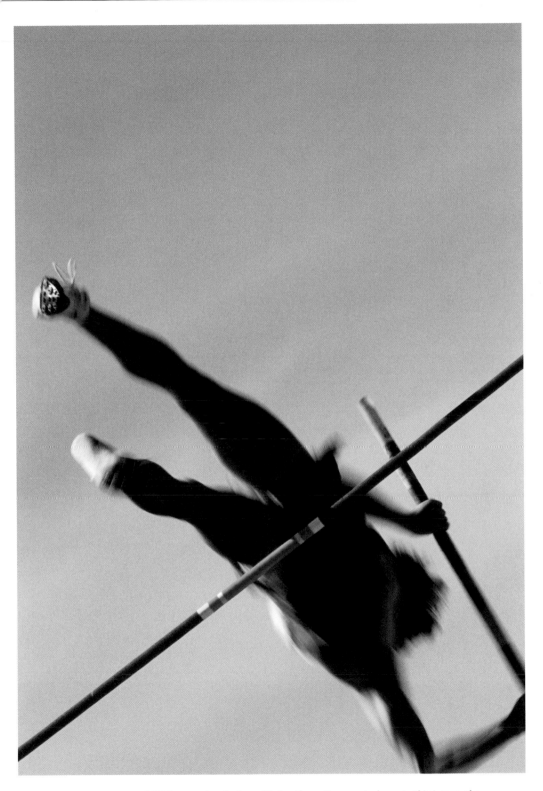

A FAST SHUTTER SPEED, 1/250 second or faster, will stop the action precisely, as in this image of a pole-vaulter (opposite). A longer shutter speed, such as 1/50 second or slower, can create a blur (above). **Alrendo/Getty Images** (opposite); **The Image Bank/Getty Images** (above)

▶Controlling Shutter Speed

▶ FOR MORE ON
THE CHALLENGE
OF ACTION
PHOTOGRAPHY,
SEE PAGES
288-9.

STOPPING MOTION requires a blink of an eye, not a stare. If you hold the shutter open too long (slow speed), a moving subject will form multiple images on the sensor screen. We see this as a blur. Shooting without flash, a speed of 1/500 or faster is needed to freeze action. If the shutter speed is slower than 1/125, a tripod or other brace is recommended. A wider-angle lens can be handheld at slower speeds, but at speeds of

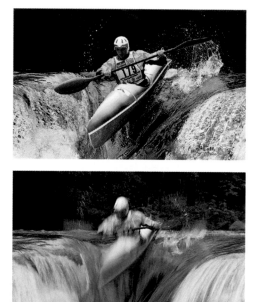

1/60 or slower, any handheld camera can cause out-of-focus shots.

EQUIVALENT EXPOSURE

Understanding the relationship between shutter speed, aperture, and ISO is essential. A camera operating on a higher ISO requires less light through the aperture and a shorter exposure from the shutter.

Aperture and shutter speed act in inverse relationship to one another. It's logical that a speed of 1/100 is half the speed of 1/200, and twice the speed of 1/50. But apertures also double or halve. An aperture of f/2.8 is twice the size of the next higher stop, f/4, and half the size of the next lower stop, f/2. If you slow the shutter speed by one stop (adding light) and want to keep the same exposure, you must close down the aperture (taking away light) by one stop. Conversely, if you want to enlarge the aperture (adding light) you must increase the shutter speed (taking away light). This concept is called reciprocity or equivalent exposure.

SUCCESSFUL ACTION PHOTOS of the same subject can be captured with fast or slow shutter speeds, so long as you select the corresponding aperture. **Bruce Dale**

SLOW SHUTTER SPEEDS	AVERAGE SHUTTER SPEEDS	FAST SHUTTER SPEEDS
USE THESE SPEEDS TO INTENTIONALLY BLUR OR PAN A SUBJECT, OR AVOID THEM TO MINIMIZE BLUR	THESE ARE SAFE SPEEDS TO USE WHEN YOU ARE PHOTO-GRAPHING MOST "AVERAGE" SUBJECTS	THESE ARE GOOD FOR FREEZING ACTION
1/4 SECOND	1/60 SECOND	1/5000 SECOND
1/8 SECOND	1/125 SECOND	1/1000 SECOND
1/15 SECOND	1/250 SECOND	1/2000 SECOND
1/30 SECOND		

A PERFECT EXAMPLE OF CONTROLLED SHUTTER SPEED, this photograph evokes the sense of rushing water one would get on the scene. There is blurred motion in the surf, but the standing rocks are sharp all the way back. With a slower shutter speed, the photographer could use a small aperture for depth of field. **Alaska Stock Images** Homer Spit, Kachemak Bay, Alaska, U.S.

▶Light & Exposure

▶**FOR MORE ON CORRECT EXPOSURE, SEE PAGES 50-1, 124-31, 134-5.**

EXPOSURE IS NOTHING LESS than the total amount of light allowed to fall on the sensor or film plane during one shutter cycle (usually one photograph).

An image is said to be "overexposed" when there is loss of detail in the brightest areas—when these are solid white. Such spots are also known as "blown out" highlights. An image is "underexposed" when there are no details in the shadow areas—when these are seen as solid black. These areas are also known as "blocked-up shadows."

The "correct" exposure, of course, depends on what effect the photographer is looking for: A higher or darker tonality, often in a series of photographs, can augment the overall feel of the subject. For example, magazine pictures about a breezy beach vacation home will seldom look right in heavy, underexposed photographs.

In the film era of photography, professionals would routinely "bracket." That is, they would shoot a frame with the calculated correct exposure, but compensate for possible errors by quickly clicking off three or four more shots at slightly larger and smaller apertures.

Today's digital cameras not only calculate more precise exposures but also show what your photograph will look like on the LCD screen, so bracketing is less necessary. Still, exposure is difficult to read on LCD screens, so expensive cameras can automatically bracket in three consecutive frames: the assumed correct exposure, a larger aperture, and a smaller aperture.

▶▶ **To get to know your settings,** place some simple object, like a vase or a cup and saucer, in front of an uncluttered background. Take one picture at every combination of settings on your digital camera and study the differences.

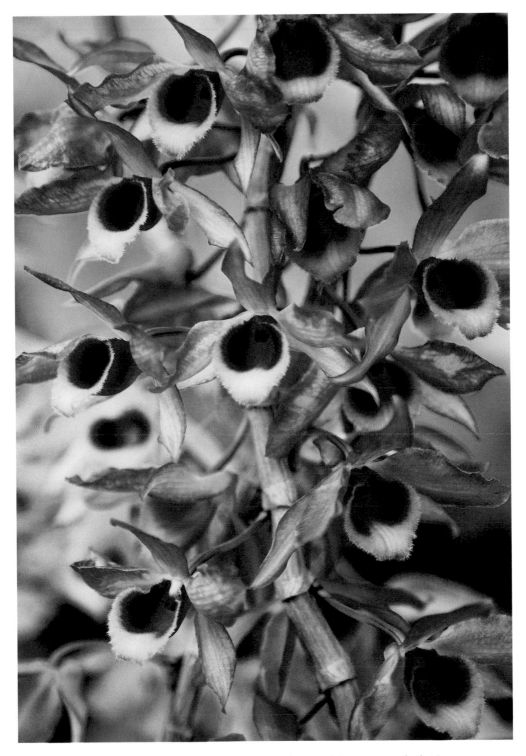

WASHOUTS, OR BRIGHT WHITE SPOTS, as will occur when a photograph is overexposed—that is, when the shutter and aperture settings let in too much light (opposite above). Underexposed photographs may come out unrepresentatively dark (opposite below) because the settings did not let in enough light. The correct exposure settings, combining shutter speed, aperture, and ISO, brings out the best in your subject (above). **Taylor S. Kennedy** Hawaii, U.S.

▶Camera Modes

▶ **FOR MORE ON APERTURE & DEPTH OF FIELD,** SEE PAGES 62-5.

▶ **FOR MORE ON SHUTTER SPEED,** SEE PAGES 70-3.

▶ **FOR MORE ON NIGHT PHOTOGRAPHY,** SEE PAGES 362-3.

AS EASY AS manufacturers try to make them, camera modes are not always obvious. For example, who would know that the green rectangle on this Canon DSLR mode wheel (see below) means fully automatic? But it does. And the often-used acronym AE? It stands for "automatic exposure" and signifies that the camera—not the photographer—will be setting the exposure. For example, inside a building it is far darker than outside, something most people don't realize because their eyes quickly adjust when they go from one to the other. But if the subject is inside, a camera set on auto mode will generally set itself at a higher ISO speed and change other settings so more of the available light inside is used, rather than simply filling in with flash. This makes a more natural-looking photograph

FULLY AUTOMATIC

Often a capital *P* on the camera's mode choice is also a largely automatic program. It tells the camera to set the ISO, aperture, shutter speed, focus, and flash modes, but will offer the photographer more settings or functions—white balance settings, various flash commands—than the rectangle. It tends to be a safe mode that will produce sharp, well-exposed photographs, but at the expense of the creativity that different settings can offer.

AUTOMATIC ZONE MODES

Found on every digital camera, these modes represent a combination of shutter speed and aperture generally appropriate for common photographic situations.

PORTRAIT

This setting will choose a wider aperture (a smaller f-stop number) to reduce the depth of field, so faces won't compete with their surroundings for attention. It may also change the exposure settings so the faces are exposed correctly, in preference to the rest of the frame. A telephoto lens will complement this setting.

ACTION/SPORT

When you want to stop action at a football game or tennis match, this setting will choose a fast shutter speed to freeze the action. The camera's "action" mode will also change other settings to ensure the shutter speed is 1/500 or faster.

LANDSCAPE

This setting is the opposite of the portrait program. It's designed to reduce the size of

▶▶ **When shooting landscapes,** set your camera to aperture priority and select a small aperture setting, such as f/22 or f/8. This will give you a wide depth of field, ensuring that much of the scene is sharp.

the aperture (larger f-stop number) so as much of the scene as possible is in focus. A wide-angle lens is its companion tool.

NIGHT

This setting will raise the ISO and lengthen the shutter speed so more of the available light at night will be harnessed. Without this mode, there might be no detail around the people or places you are photographing.

ADVANCED PRIORITY MODES

These are still automatic modes, but they allow you to set either the shutter speed or aperture manually. The camera then determines the other setting on its own.

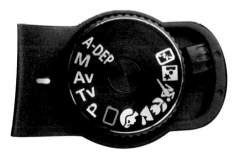

Often the camera will not change ISO automatically using these settings.

- **APERTURE PRIORITY** Usually an "A" or "Av" (for "aperture value") on the dial, this automatic setting lets you pick the aperture; the camera will automatically choose a corresponding shutter speed to correctly expose the scene. This is a good setting if you want to control the depth of field of a photo by selecting either a small aperture number (for little depth of field) or a larger one (for greater depth of field). Note that results from aperture settings can change from one lens to another.

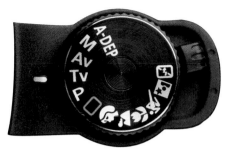

For example, an aperture value of f/5.6 for a macro lens may result in a blurred background, yet a telephoto might not yield the same outcome.

- **SHUTTER-SPEED PRIORITY** Usually a "T" or "Tv" (for "time value") on the dial, this setting is the reverse of aperture priority. You pick the shutter speed, and the camera selects the right aperture for your scene. This comes in handy when you want to pan a shot using a slow shutter speed (say 1/30 or slower) or if you want to freeze an image using a very fast shutter speed (faster than 1/500).

EXPERT MODES

- **MANUAL** Usually an "M" on the dial or menu, this mode lets you set the ISO, shutter speed, and aperture. The camera will not make any of its own adjustments to these settings. Typically, you should use the camera's light meter to adjust exposure based on how you want the photograph to look.

- **AUTOMATIC DEPTH OF FIELD (A-DEP)** This mode calculates a wide depth of field automatically between a near subject and far subject. It is effective for group photos and landscapes.

- **FLASH OFF** This setting is automatic, but will not trigger the built-in flash unit that normally activates in dim light when using the other automatic settings.

WHAT MAKES THIS

CARNIVAL AT KANSAS STATE FAIR Joel Sartore Hutchinson, Kansas

A GREAT PHOTOGRAPH?

THE FIRST THING you have to know is that Joel is from the Midwest, and his photography is at its best when he is making pictures of subjects he has grown up with.

SUBJECT Anybody who has been on a Ferris wheel knows you cannot make a picture of what you feel when you are on the wheel, because it will be blurry. This image evokes the feeling of movement and expresses the carnival in an entirely different way.

COMPOSITION To show what it feels like to be on a Ferris wheel, Joel had to compose the picture from above the wheel's center—some 50 feet up. In order to reach that vantage point, he arranged for a cherry picker, a piece of construction equipment with a man-bucket and extendable arm. The result: a perfect composition.

LIGHT Joel used the available light to capture the carnival through the back of the spinning wheel, turning it translucent. There was no way to light everything behind it—and no need to do so.

EXPOSURE This image required a long exposure time. First Joel opened the wide-angle lens to a moderate aperture. Then he adjusted the shutter so it would stay open for at least 30 seconds, thus recording the motion of the spinning lights.

—James P. Blair
NATIONAL GEOGRAPHIC
PHOTOGRAPHER

3 Composition

THE CAMERA has no "Composition" settings or buttons, and there are no silver bullets for nailing the perfect arrangement of elements in a frame. To succeed in composition, a photographer must rely on his or her "eye," or artistic sensibility, experiment to find what works, and study the work of other successful photographers and two-dimensional artists.

Certain rules of composition seem logical and are considered universal; they are the same rules by which any artist or designer achieves a desired harmony of parts. Most of the rules are strategies to concentrate the viewer's eye on the right subject, create a sense of balance and proportion, or tap the emotion that you intended. But there is no substitute for creativity. Despite the many situations where you can apply a rule of photo composition, there are others where you can break the rules and still make the photo work.

STRATEGIC PHOTOGRAPHIC COMPOSITION can produce a dynamic image that conjures feelings of tension, excitement, melancholy, intrigue, or any number of other emotions.
Jodi Cobb Jaipur, Rajasthan, India

▶Focal Point

▶ **FOR MORE ON CONTROLLING DEPTH OF FIELD, SEE PAGES 62-5.**

EVERY PHOTOGRAPH has a point of interest—and that point should be clear to the viewer. We look at photographs in much the same way we read text—from left to right and top to bottom in Western culture. The viewer's eyes should not roam aimlessly around the frame. They should be guided to the point of interest. But that point should not always be in the center of the frame. Such shots can seem static, and thus boring. An off-balance composition can be very entertaining to the eye.

A focal point placed just to the left of center, for example, guides the eye to explore the remainder of the frame, where secondary information such as weather and environment can be used to round out the mood and fullness of the shot.

CLOSER, CLOSER

"Get closer" has become one of photography's mantras, and it usually holds up. Make the object of your shot stand out. If you can't move closer physically, use a longer lens.

Always think about what you are trying to say with an image. If you are making a photograph of an isolated farmhouse on the prairie, it must be large enough so that people can see what it is, but it shouldn't fill so much of the frame that the viewer loses the sense of its environment.

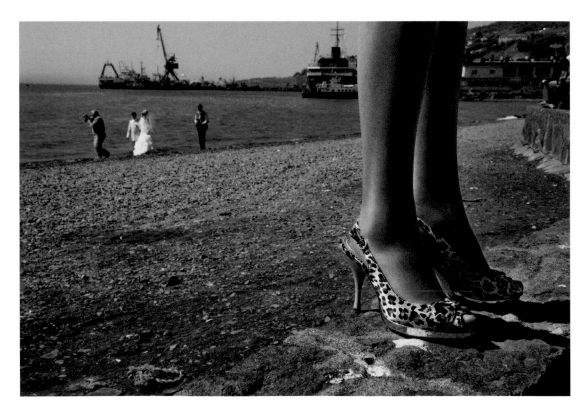

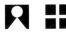

DESPITE ACTION FAR AWAY, the photographer selected these high-heeled shoes as his focal point, teasing the viewer with the incompleteness and disjointedness of the image. The juxtaposition of shoes, the bride on the beach, and industrial machinery across the water makes the composition a crazy patchwork. **Randy Olson** Petropavlovsk, Kamchatka, Russia

THE BALTIMORE ORIOLE investigating an orange in the foreground—clearly this photo's focal point—creates an energetic counterweight to the bird out of focus behind. **Mark Lewer/NG My Shot**

▶ Framing

▶ **FOR MORE ON COMPOSITION, SEE PAGES 42-5.**

BECAUSE MOST OF US hang pictures on the wall and peer through windows, we have a well-developed sense of frames. But just as a hanging frame enhances a photograph, a frame element within the picture itself can enhance or emphasize the point of interest. A "frame" in these terms is an object in the foreground that lends depth to the picture. It might be a branch with leaves, the mouth of a cave, a window, a bridge or column, or a colorful doorway.

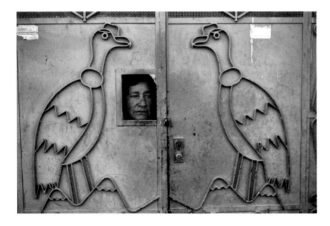

FRAMES SHOULD SUIT SUBJECT

Framing objects should be part of the environment, have aesthetic value, and be appropriate to the subject. Just as a Rembrandt painting is unlikely to benefit from being displayed in a thin aluminum frame, a centuries-old mosque should not be framed by new concrete covered with graffiti.

The interior frame should not draw the viewer's eye away from the center of interest. If it is much darker than the subject, or in deep shade, it may be rendered as a silhouette. The frame should be either in sharp focus or completely blurred. For architecture, it's best to keep it sharp. For horizontal landscapes, a foreground of flowers or bushes can frame the background while hiding irrelevant clutter or space.

▶▶**Don't use the camera rectangle** to frame all your pictures. Look for other framing possibilities within the scene, such as an arch or the shaded walls of a canyon.

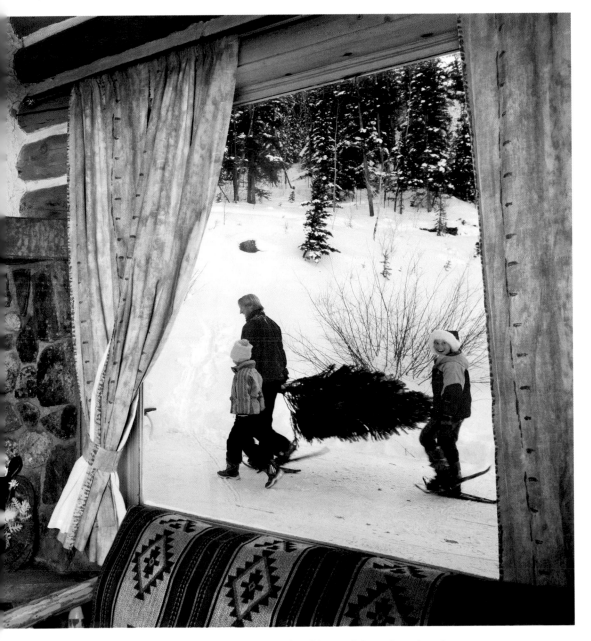

COMPOSITIONAL FRAMING can be achieved overtly, with architectural elements such as doorways and windows (opposite and above), or more subtly, with natural elements such as trees or rocks.
Robert Clark Puqio, Peru (opposite) **Alaska Stock Images** Colorado, U.S. (above)

▶The Rule of Thirds

▶FOR MORE ON
STILL LIFES,
SEE PAGES
314-7.

IF THE CENTER OF ANY PICTURE is not a satisfying resting place for the eye, where is the best resting place? Artists, designers, and photographers have learned to follow the helpful concept known as the "rule of thirds." Imagine that the camera's viewing screen is etched with four grid lines (as in the photo below), resembling a tic-tac-toe game. As you look through the viewfinder at a scene, place the subject at one of the imaginary grid intersection points, often called a "sweet spot." This gives the image an overall dynamic balance. You can also place a center of interest and a counter-point at opposing intersections.

Balance the composition so that both sides are pleasing but not of equal size, shape, or color. A small area of vivid color in one part of the picture will balance a larger area of less intense hue. A small animal will balance a large inanimate object. It will usually be clear which intersection is best, because whatever else is in the frame will either strengthen or detract from the image.

▶▶**To get an idea** of how effective off-center composition is, glance at some magazine covers. You'll notice that the subject's head is usually in the upper right of the frame so that our eyes travel first to the face and then left and down.

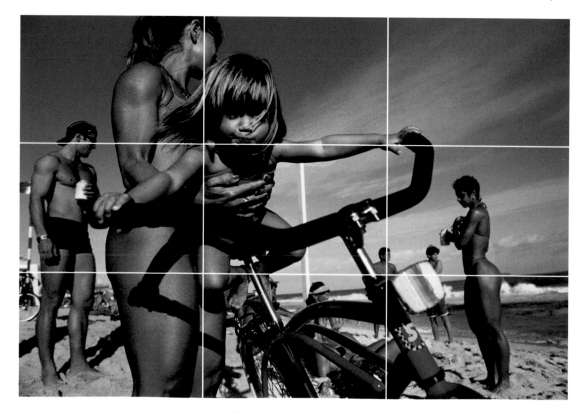

IMAGINE YOUR PHOTO divided by lines into nine parts. Composition works best when the focal point occurs near one of the "sweet spots" where lines meet. **Jodi Cobb** Rio de Janeiro, Brazil

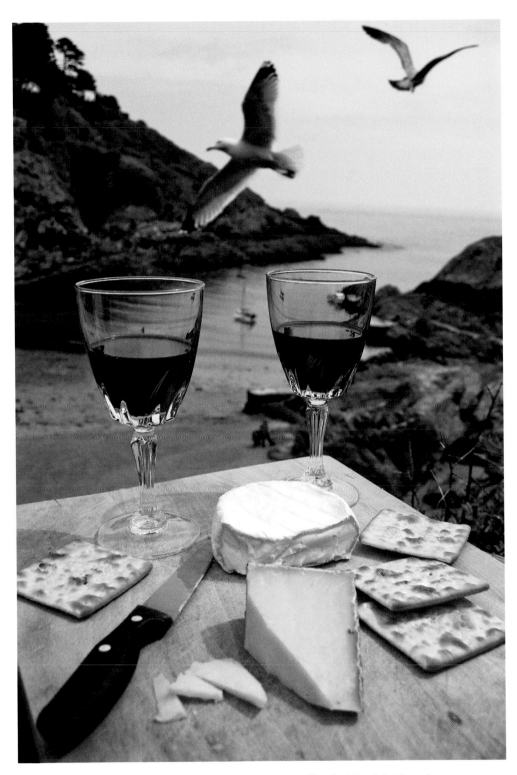

EVEN WITHOUT A GRID IMPOSED, this photograph clearly exemplifies the idea of dividing a frame into nine parts, three on a side. Were it not for the photographer capturing the moment when one bird was flying right into one of the parts' intersections, this would not be so strong an image.
Jim Richardson Polperro, Cornwall, U.K.

▶Leading Lines

▶FOR MORE ON
DEFINING
COMPOSITION,
SEE PAGES
42-3.

▶FOR MORE ON
PHOTOGRAPHING
BABIES
& CHILDREN,
SEE PAGES
240-5.

▶FOR MORE ON
CAPTURING
THE CITY,
SEE PAGES
348-9.

LEADING LINES ARE LINEAR ELEMENTS in a composition that can carry the viewer's eye to the point of interest. They also create a three-dimensional quality on a two-dimensional image, through perspective. The painted center stripe on a highway, for example, seems to get smaller as it recedes, both as you're driving and as seen in a photograph. Conversely, a strong line badly positioned will tend to take the eye off to the edge of the picture and shatter the composition.

Landscapes and cityscapes are full of linear elements—roadways, train tracks, fencerows, ridgelines, tree branches, rivers and streams, boulevards, and rows of lights. Perhaps there is a driveway snaking its way to a farmhouse, or a fence slicing through the wheat, or the sweep of a curb, as in the photograph on the right, which ties two people into a relationship that otherwise may have been overlooked. Most subjects contain strong lines, some as obvious as a river, others as insubstantial as a shaft of light or a fold in a scarf.

Leading lines are most effective as diagonals, and they work particularly well when the lines originate from the bottom corners of photographs: a winding road, for example, leading to an old church, or the Great Wall of China starting in the bottom corner of your frame and then leading the viewer's eye into the center of the picture. Depth of field is important when composing leading lines. If the line begins at the bottom of the frame, both the line and the main subject should be in focus.

Lines also have a more subtle effect on the viewer. What mood do you want to convey? Lines will help you do so. Horizontal lines usually convey serenity. Vertical ones emphasize power, and diagonal ones imply action.

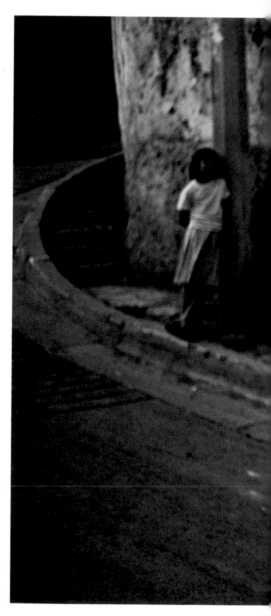

▶▶**Leading lines help carry your eye across the image,** making it look and feel more three-dimensional. Winding roads, power lines, staircases, and fences are just a few of the features that can add this element to an image.

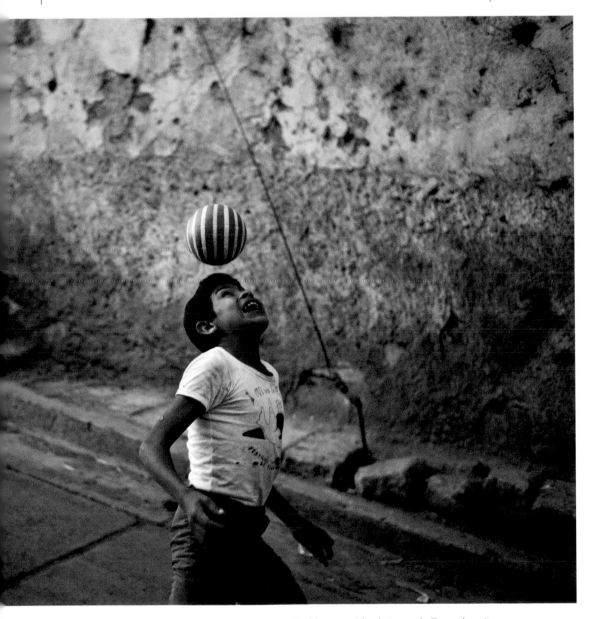

A MOMENT OF JOY combines with elegant composition in this streetside photograph. To see how it works, trace the many lines that work to bring the parts together: the curb, the stairs, the post, the pavement, the cable—and the invisible lines drawn from the girl's and the boy's eyes to the ball.
David Alan Harvey Tegucigalpa, Honduras

▶ Horizon Line

▶ FOR MORE ON DISCOVERING THE COUNTRY, SEE PAGES 350-1.

▶ FOR MORE ON AERIAL & PANORAMIC PHOTOGRAPHY, SEE PAGES 366-9.

TO PRESERVE A SENSE OF DYNAMISM in a landscape photograph, the horizon line should not be exactly in the middle of the frame. Such a placement can give the picture an unwanted limpness, a too-perfect balance that conveys a sense of repose, or inaction. Better to place the horizon line on one of the two horizontal "rule of thirds" levels, so there is opportunity for implied visual movement.

Another rule of thumb that is often broken: Horizons must be straight, parallel to the edges of the picture frame, unless the photographer is attempting to invoke a mood of dizziness or disaster.

USING THE SKY TO BEST ADVANTAGE

The sky can be an important element in landscapes, either as the main subject or as something that sets the mood of the picture. A big sky may reinforce the feeling of isolation or the small scale of other objects. Skies create mood, as in classical paintings.

■ **BLUE SKY** With a bright, contrast-heavy sky with puffy white clouds, the horizon may look better along the imaginary line at the bottom third of the frame.

■ **WHITE SKY** You will probably want to minimize the size of a dull, white sky.

■ **SKY AS CENTERPIECE** Dramatic skies can be the focal points of landscape pictures; rolling storm clouds, a shaft of sunlight piercing a dark sky, a rainbow—all are photographic elements that can be prominent in the composition. They can also overwhelm a primary foreground subject.

▶▶ **Play around** with the position of the horizon: upper, middle, and lower sections of the frame. Then decide which composition creates the most interesting perspective.

A HORIZON LINE through the middle of a photograph can produce a sense of balance that lacks dynamism but may invoke serenity. **Mirja Kronenberg/National Geographic My Shot** Tunisia

A SOLO FIGURE silhouetted against the infinity of a big sky, with the horizon line at the bottom of the frame, conveys a powerful sense of isolation. **Sumeet Kumar/National Geographic My Shot**

A VISUAL SENSE OF TIME: The polar bear's long journey across vast stretches of sea ice is evoked by placing the horizon line near the top of this frame. **Paul Nicklen** Svalbard, Norway

▶Positive & Negative Space

▶FOR MORE ON
PATTERNS
& TEXTURES,
SEE PAGES
100-1.

A PHOTOGRAPH is essentially a rectangular canvas on which the photographer composes an image. It is important to remember that the entire frame, not just the elements you intend to feature, makes up that final picture. The "extra" space, frequently ignored by the beginning photographer—the sky, the field, the wall—also forms part of the image. Often that negative space can be used as a creative or provocative part of the overall design. The goal of the photographer is to recognize both types of space—positive and negative—and use them to complement each other. The terms are not used here in the black-and-white sense, but as a way to describe primary and secondary parts of the composition.

EMPTY SPACE AS OBJECT

Using negative space is particularly appropriate when communicating a sense of isolation or loneliness—a lone plant in the desert or a rock jutting from the sea, for example. Think of the empty space as an object, like any other element, and then think about its placement. You want to keep the subject and its scale in the balance that best reinforces your message.

▶▶**On a clear, blue day,** try shooting from below your subject and up toward the sky. The negative space surrounding the subject will make it really stand out.

THIS PHOTO'S NEGATIVE SPACE, composed of multiple women in burkas, looms literally and metaphorically over the shoulder of this young Muslim girl. **James Nachtwey** Sulawesi, Indonesia

THE PINNACLES of Bryce Canyon National Park in Utah stand sentinel against the negative space of a clear blue sky. **John Eastcott & Yva Momatiuk** Bryce Canyon National Park, Utah, U.S.

▶ Sense of Scale

▶ FOR MORE ON PHOTOGRAPH- ING HIKING & BACKPACKING, SEE PAGES 298-301.

WE HAVE ALL SEEN PHOTOGRAPHS of the Leaning Tower of Pisa in which a person in the foreground seems to be holding up the tower with his hands. Such a photograph is a trick of scale, a play on the relative size of objects in the frame. If posed side by side, the tower of course would be much bigger than a man.

Photography can sometimes distort scale, especially when objects are not recognized. Archaeologists and other scientists who gather unfamiliar artifacts often place a simple ruler beside the object before photographing it. Knowing the exact length of 12 inches allows the viewer to visualize the size of the artifact.

DOES IT READ?

When we look at landscape photographs, our minds make a series of mental adjustments based on previous experience. We've seen so many pictures of the Grand Canyon, for example, that we can easily work out its size. It's much more difficult to estimate the size of unfamiliar places or features.

When the subject is of indeterminate size—a mountain, a body of water, a stone wall—a sense of scale can be achieved by including something of known size, such as a person, a car, a tree, or an animal, in the picture beside it. A human figure standing next to an oak lets us know just how big the

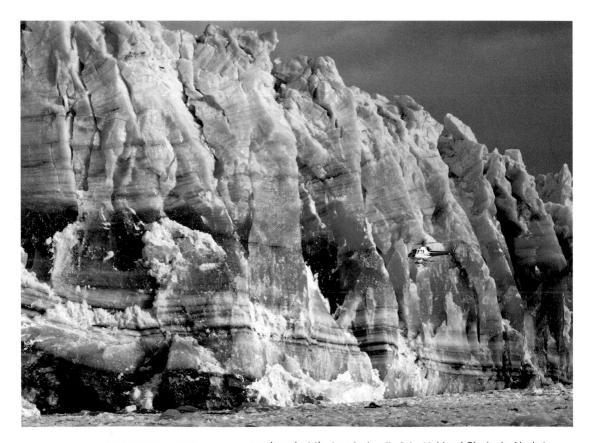

A HELICOPTER SHOWS as a mere speck against the terminal wall of the Hubbard Glacier in Alaska's Bay of Disenchantment. **Chris Johns** Wrangell-St. Elias National Park, Alaska, U.S.

tree is, and a cow standing in a field helps us comprehend the extent of the pasture. Photographing a cliff, a photographer might wait until some hikers pass along the trail to show its sheer magnitude. Giant excavation machines might seem ordinary until a picture reveals that a workman's head reaches only halfway up one of the tires. Lacking that sense of scale, a picture sometimes is not intelligible. "It doesn't read," a photo editor would say.

PERSPECTIVE HELPS

Sometimes perspective allows us to clarify scale. The location of the base of an object in an image is a clue to its distance from the camera viewpoint.

In landscapes, the ground or ground plane visually rises toward the horizon. The higher up in the ground area of the picture the base of an object is located (up to the horizon), the farther away it seems from the viewpoint.

▶▶ **When photographing vast landscapes** or large objects, juxtaposing something familiar in size—such as a person, an animal, or a landmark—helps the viewer understand how large the main subject is.

THIS WALL OF BEIJING'S Forbidden City seems more formidable thanks to the sense of scale provided by the bicyclist in the foreground. **James Stanfield** Beijing, People's Republic of China

☐ Steve McCurry: MY PERSPECTIVE

THERE'S A LESSON I've learned over and over: don't get hung up on what you think your "real" destination is. The journey is the destination.

My journey into photography began in 1978, when I left on what I thought would be a two-month trip to India. Why India? I was drawn by the beauty, the chaos. The rich mosaic of color, religions, and culture was a whole new world for me. Since then, I have been to India more than 85 times and traveled throughout Asia and the world.

The scenes I have witnessed in India are an inspiration for the photographer: festivals with masses of people as far as the eye can see; ancient traditions demanding a dignified reverence; deep hues tattooed onto faces; patterns printed onto clothing and ancient symbols painted onto walls. In India, as elsewhere in Asia, a connection to the past seems to hold beliefs steadfastly in place while modernity tugs in the opposite direction.

Much of my work is the result of patience and perception. In everyday life, we are distracted by the "tyranny" of the immediate—ordinarily, we might not notice the emotion in a child's eye or the way light carves action out of a shadow. Sometimes a scene requires the camera to linger until "the moment" enters the frame. —S.M.

RECOGNIZED UNIVERSALLY as one of today's finest imagemakers, **STEVE MCCURRY** is best known for evocative color photography. He has covered many areas of international and civil conflict, including Beirut, Cambodia, and Tibet. His 1985 *National Geographic* cover photograph of an Afghan refugee girl is described by many as the most recognizable photograph in the world today; in 2002, he returned to Pakistan and found her, now a wife and mother.

Men on wooden stilts fish on the south coast of Sri Lanka.

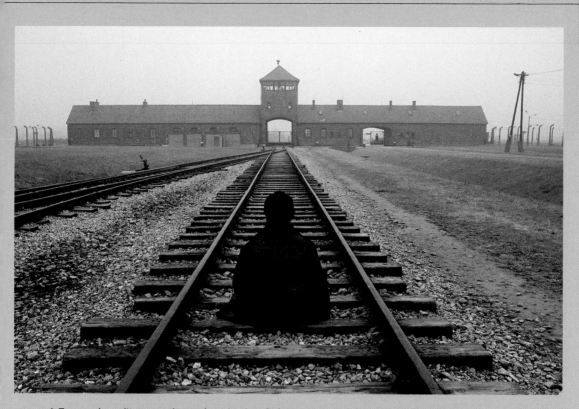

A Zen monk meditates on the tracks going into Birkenau, near Auschwitz, in southern Poland.

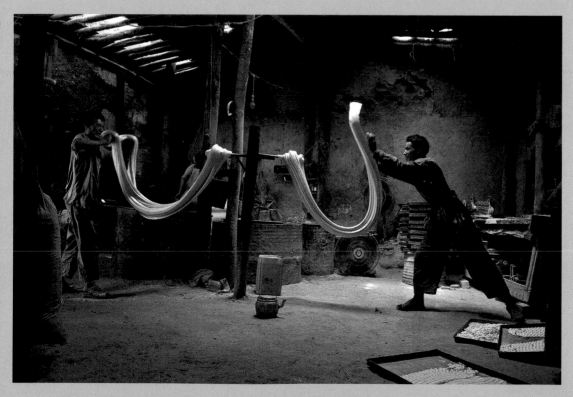

In a factory in Kabul, Afghanistan, men work diligently turning sugar into hard candy.

▶Color

▶ FOR MORE ON
COLOR & LIGHT,
SEE PAGES
28-9.

COLOR IS THE MOST SIGNIFICANT ELEMENT in composition, because each color carries its own "visual weight," the extent to which it commands the viewer's eye in an image. Color photographs that work in good compositions may be lifeless if shot in black-and-white, because of the color weight of certain hues.

For example, even a small spot of vivid color or a patch of white creates a center of interest if backed by large areas of duller tones. A spot of bright green in an otherwise dun landscape will carry as much visual weight as a large boulder. Despite their contrast in size, they will balance each other in a composition.

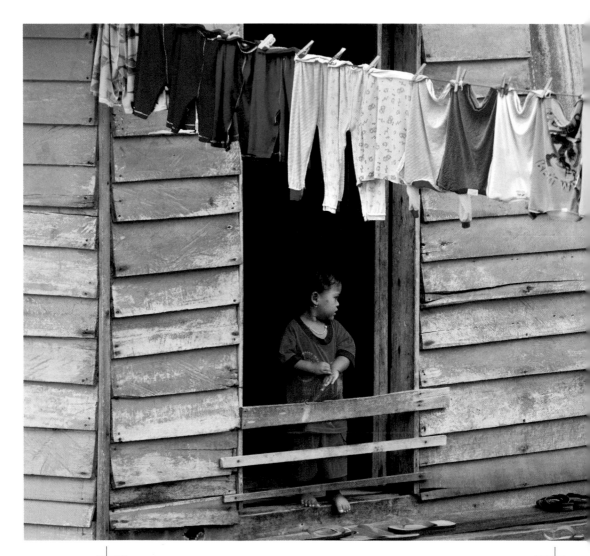

▶▶ **Since we usually look for details,** it can be harder to see blocks of color or shape. Squint a bit. Details will blur, and you will see things as masses.

BLOCKS OF SHAPE AND COLOR

Blocks of color of the same hue or different hues of about equal tonal value can enhance and give depth to an image. The repetition of color and shapes will be pleasing and invite the viewer into the frame.

Colors can give a warm or cold feeling to a picture, reflecting our preconceived views on color. A winter scene can be enhanced by the use of blue in the picture to give that chilly feeling, for example, or a red beach umbrella on golden sand can evoke the feeling of warmth. But rigid rules can be misleading or irrelevant when applied to color choice: The photographer must trust his or her aesthetics or taste.

VIBRANT COLORS, when employed as leading lines (opposite), can draw a viewer's eyes all around a photograph. Color can also fixate a viewer's eyes on a single focal point (above).
Mauricio Handler　Dinawan Island, Sabah, Malaysia
Christopher Hill　Kinsale, County Cork, Ireland

▶Patterns & Texture

▶FOR MORE ON
DETAILS,
SEE PAGES
282-3.

▶FOR MORE ON
MACRO
PHOTOGRAPHY,
SEE PAGES
146-7, 374-5.

LIFE IS FILLED WITH PATTERNS, most of which we overlook. But in photography, the repetition of forms or shapes is an important compositional technique. Wavy lines in sand, icicles hanging from a bough, or shadows in the forest—if well photographed, such natural patterns become unexpected abstractions of otherwise ordinary shapes.

A well-chosen element that interrupts a pattern will be forcefully highlighted in the frame: a yellow apple in a tub of red ones, say, or one tree trunk of a different color in the woods. These interrupting shapes not only bring attention to themselves but also reinforce the pattern by standing out from it.

USE THE RIGHT LENS

The right lens is important in the creative use of patterns. A telephoto lens will accentuate the repetition by compressing repetitive objects such as tree trunks. A wide-angle lens might be better for showing the pattern of squares in an aerial of farm country.

By photographing texture—the three-dimensionality of a surface—you can greatly enhance the authenticity of an image, especially if the texture is emphasized with the use of sidelight, as at sundown. In such light, all the irregularities of a wall or a piece of wood will stand out in relief.

▶▶**Patterns create** rhythm and movement. Be aware of the way repeating elements in nature and man-made structures can make seemingly ordinary objects come alive.

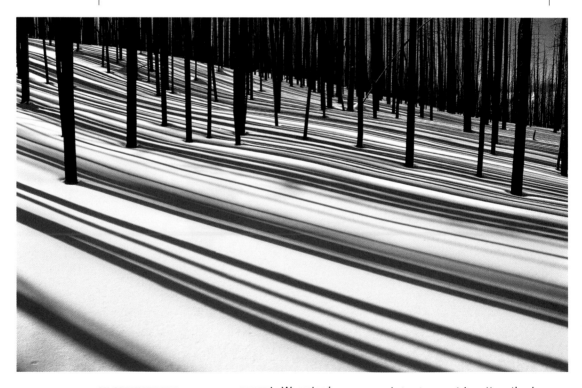

AN ORDINARY SNOW-COVERED FOREST in Wyoming becomes an abstract geometric pattern thanks to sidelighting. **Sumio Harada/Minden Pictures** Wyoming, U.S.

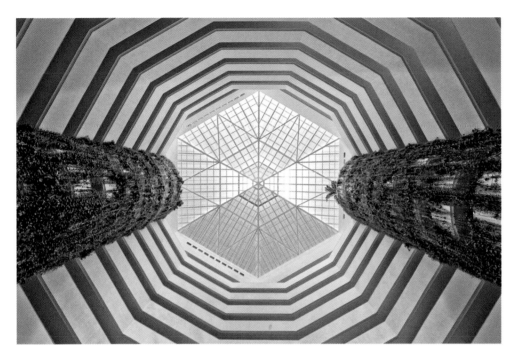

A VIEW UP TO A GLASS CEILING in a resort in Cancún, Mexico, becomes a kaleidoscopic work of art in the photographer's eye. **Mike Theiss** Cancún, Mexico

A SIMPLE BIRD'S-EYE VIEW of growing plants takes on an otherworldly quality with the right decisions on light and composition. **James Forte** Santa Barbara, California, U.S.

▶Close-ups

▶**FOR MORE ON CANDIDS, SEE PAGES 252-3.**

MOVING VERY CLOSE TO A SUBJECT is like entering another world of vision. The gossamer wings of a dragonfly suddenly become stained-glass windows; the ridges of a child's fingers reveal delicate patterns. With modern DSLRs, that world is available to most photographers who have patience.

Depth of field is critical in close-up work, or macrophotography, since the closer a camera gets, the shallower the depth of field becomes.

To clearly depict small subjects, use as small an aperture as the light will offer, f/8 or smaller. Firmly brace the camera or put it on a tripod, and focus on the foreground center of interest. The rest of the picture can dissolve into fuzz as long as the focal point is sharp.

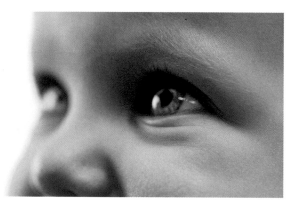

FLOWER STRATEGIES

It's also important to line up the subject's main features with the camera's plane of focus: Keep them as close to parallel as possible. For example, if you're shooting a flower, tilt the camera body so it's in the same plane as the angle of the blossom.

Early or late in the day is the best time to shoot close-ups outside, because the low sun provides good sidelighting and the wind tends to die down. Even a little breeze can make a flower petal dance in the frame.

▶▶ **Start wide** and work your way in closer and closer. Sometimes small details can reveal more about your subject than a wider, more distant image.

THIS PHOTOGRAPH CAPTURES A FLEETING SYMBOL OF LOVE, showing the relationship of parent and child in a sensitive and unusual way. The child's hand does not grasp but gently caresses—or lets loose, depending on how you interpret the picture. Details (opposite) make for memorable portraits.
Jim Webb Washington, D.C., U.S. **Brian Gordon Green** Germantown, Maryland, U.S.

▶Layering

▶▶**Let different points of interest** fill the foreground, middle ground, and background. A well-composed, layered image gives more than one place to rest the eye.

 TIMING WAS ESSENTIAL to get this photograph right. The photographer likely used a wide-angle lens focused at about ten feet from the camera. That choice brought both the action reflected in the mirror and the action in the background into focus together. The photograph layers them together into one complex image. **Randy Olson** Shenzhen, People's Republic of China

▶ FOR MORE ON DIGITAL LAYERS, SEE PAGE 179.

SOME PHOTOGRAPHS are essentially flat, but others may have two, three, or even four layers to express meaning or build substance into an image. Layering a photograph is a technique in which a photographer uses the illusion of depth to convey multiple parts of a theme, or even the narrative of a little story. In a layered photograph, there may be critical information in the foreground, middle ground, and background.

FILL THE FRAME

A simple example would be a chewed-up teddy bear in the foreground along with the family member who discovered it, and the humbled and guilty dog in the background. Newspaper and magazine photographers especially are often instructed to make good use of the whole frame to show context. If the city mayor is speaking at the local school, for example, a layered photograph might have a student in the foreground, the speaker in the middle, and the chalkboard with pertinent writing in the background. Layers can also create coherence or specify priorities by alternating soft and sharp planes of focus.

FILL THE FOREGROUND

Everything in the frame needs to say something about, or at least complement, the subject, even if it's negative space or background. While shooting landscapes, photographers often leave nonpurposed space in the foreground. The concept of layering suggests that they add objects of interest, germane to the main theme or feeling, to give a sense of perspective and weight. The element can be something as simple as the scree on a mountainside or a dune's sloping sand, as long as it says something about the landscape. This foreground element can also lead the eye to the point of interest.

▶Point of View

▶**FOR MORE ON A SENSE OF STORY, SEE PAGES 292-3.**

GOOD PHOTOGRAPHY is seldom a sedentary activity. Pros will twist themselves into small holes, teeter on stepladders, or scale tall buildings to get the best angle. They will lie on their backs or stomachs and dangle from light poles.

A change in the point of view, perhaps an angle of only a few degrees to the right or left, or up or down, can significantly transform a photograph. To learn about angles, never be satisfied with the first shot.

GETTING THE ANGLE

Lying on the ground or kneeling is particularly successful when photographing pets or children. Being low is far less threatening to the child than looming over him. Group shots, on the other hand, can often be enhanced by shooting from a balcony or other higher place; from there, a photographer can see every face.

Experimenting with points of view means going a step beyond in photographic thinking. Your subject doesn't always have to be the new baby or the vacation at the beach. Shoot something for its own sake. Climb a tree, wade out to the middle of a stream, use flowers or other objects in the foreground, try another lens or a slower shutter speed. You will often capture something more than what postcards show— something original and quite personal.

▶▶**Explore the possibilities** and vary your approach. What will a high viewpoint convey? A head-on shot? Pretend you're shooting a photo essay.

THE TUTU BECOMES THE FRAME for this miniature ballerina, since the photographer chose to stand directly above her to take the shot. **Joel Sartore** Dallas, Texas, U.S.

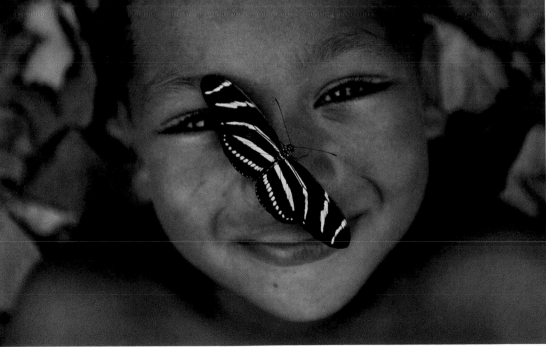

THE SAME SUBJECT MATTER—in both these cases, a butterfly—can be used to much different effect, depending on point of view. Both required exquisite timing.
Joel Sartore Los Angeles, California, U.S. Lincoln, Nebraska, U.S.

▶Break the Rules

▶ FOR MORE ON
THE ART OF
PHOTOGRAPHY,
SEE PAGES
38-9.

DO ARTISTS HAVE RULES? Yes and no. Artists have rules that they can follow, but after they have thoroughly learned what these rules are, they can sometimes disregard them altogether. Painter Salvador Dalí had command of realistic painting before he introduced abstract floppy clocks into his work. Composer Arnold Schoenberg mastered classical sonatas before turning to atonal music that defied musical rules.

The principles for composition in photography, as outlined in this chapter, may be called "rules," but in reality they can only be guidelines. They have been proven to work well, and they are based on accepted principles of design.

The guidelines create a solid foundation to fall back on when there is uncertainty, but when we start allowing guidelines to rule every decision, our images themselves can become predictable. For an artist, this is anathema.

PORTRAIT PHOTOGRAPHERS have long been told to "avoid the bull's-eye" and not center the subject in the frame.
Keenpress Svalbard, Norway

IN A PHOTO THAT BREAKS THE BULL'S-EYE RULE, head and hands vie for attention as a young Ethiopian girl holds out lustrous coffee beans. **Michael Hanson** Yirgacheffe, Sidamo, Ethiopia

■ **AVOID THE BULL'S-EYE?** Well, not necessarily. A center stance implies a directness and lack of guile in the subject that would be lost with an artful imbalance and its tension.

■ **THE RULE OF THIRDS?** Sometimes just follow your emotions and place the subject where it looks right.

■ **DON'T SHOOT BETWEEN 10 A.M. AND 3 P.M.?** Sure, the light will be contrasty, but some themes call for that attribute. A police action, for example, might benefit from the harshness.

■ **KEEP THE HORIZON LEVEL WITH THE CAMERA PLANE?** Usually—but spin it around occasionally and see what happens; capture the madness of a skewed world. That's the artist's prerogative and even obligation.

Commercial photographers will differentiate between "shots from the heart" and "shots for the pocket," knowing that while rules usually result in pictures that pay the bills, they can also stifle artistry. Other successful photographers can wield the rules like a painter with a palette of oils, blending the guidelines of composition with personal interpretation, for results that often border on the magical.

In the end, there are no formulas for this wonderful talent; it must come from practice, understanding, and hard work.

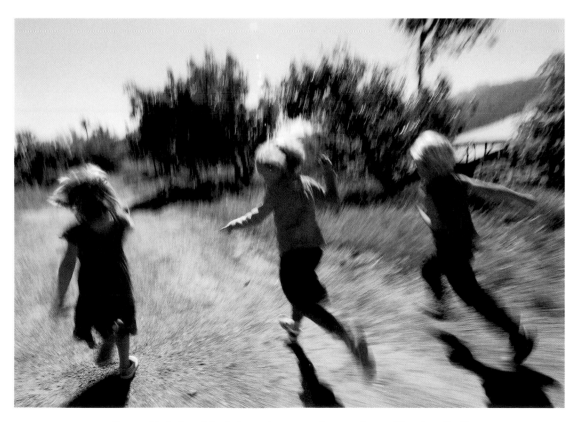

CAMERA SHAKE, often avoided, gives this photograph a sense of energy, fun, and freedom, like the children it portrays. **Rich Reid** Ojai, California, U.S.

WHAT MAKES THIS

GEISHA Jodi Cobb Kyoto, Japan

A GREAT PHOTOGRAPH?

JODI COBB creates such strong photographs that they become universal icons—once seen, never forgotten. Her approach is to get as deeply involved with the subject as possible and wait until the people accept her before she begins her work.

SUBJECT What is apparent in Jodi's picture of the geisha is that the real subject is the young woman underneath the rice powder and made-up lips. Though only her lips, chin, and neck are shown, somehow the viewer senses the vulnerable young woman beneath the mask of makeup.

COMPOSITION This composition defines sensual through the soft, elegant curves of the geisha's lips and chin, and the slight curve of the neck. The shock of red lips against the more muted colors is artistically just outside the usual division of a picture into nine parts. Jodi could have included more of the geisha's face, but the tight precise framing makes this an iconic photograph.

LIGHT The light balances the subject perfectly, quiet and direct. The light is diffuse, mysterious. We're not sure where it's coming from.

EXPOSURE There were no tricks used to capture this image. What's important here are the colors: the contrast of the red and white, but also the reality of the blue kimono, which adds a dynamic quality.

–James P. Blair
NATIONAL GEOGRAPHIC
PHOTOGRAPHER

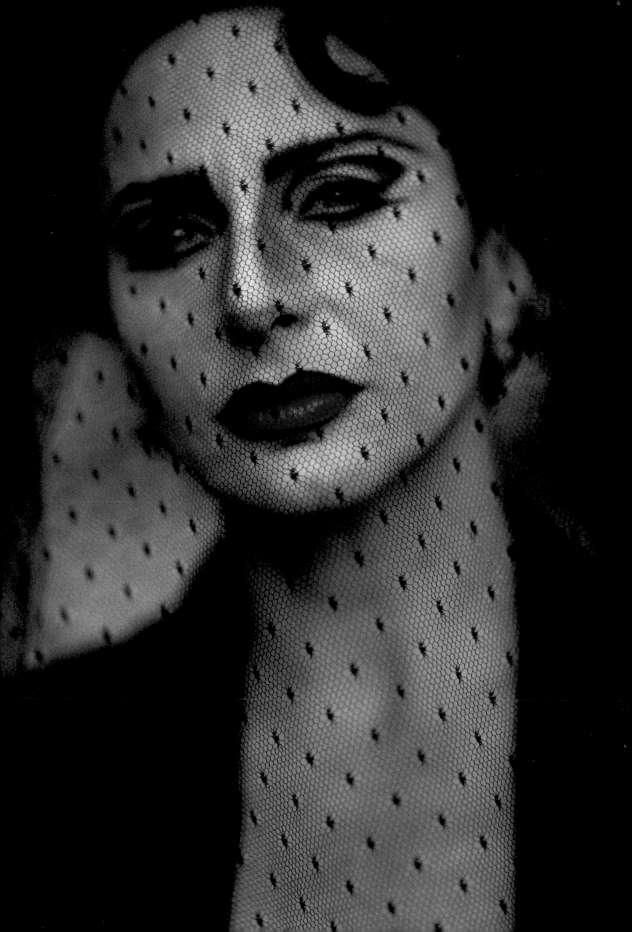

4 Light

THE RANGE OF CREATIVE POSSIBILITIES for photographic technology and art is virtually infinite, since it includes everything that reflects light—everything a human eye can see, and then some. Photographers can find subjects by simply looking out the window or taking the dog for a walk. Some photographers go nowhere without their cameras, because they realize that good pictures will often form without prologue, emerging from life's kaleidoscope unexpectedly.

Light, the revealing medium of all this serendipity, surrounds us with shadows and subtleties, penetrating glare, and glorious flames. We bask in this light show, surrounded by its revelations; we have only to capture, organize, and catalogue them. The task is not as daunting as it sounds. In previous chapters, we have dealt with the science and technology of cameras and the art of composition. This chapter will seek to explain how photographers learn to see more than they ever thought possible.

A DIFFUSE LIGHT, source unknown, penetrates the mysterious veil of this photograph.
William Albert Allard Siracusa, Sicily, Italy

▶ Awareness of Light

▶▶**No exposure guidelines** are accurate in all situations. There are too many variables. That's the reason to bracket, shooting subjects at several exposure settings.

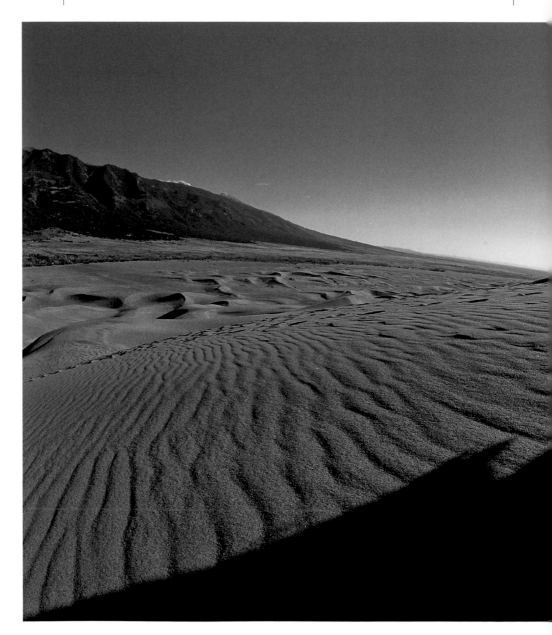

 IT'S ALWAYS THE RIGHT TIME OF DAY to take a photograph, no matter whether the sun is in front of you or behind you. It's simply a matter of fitting the picture to the light. In this case, the photographer captured just the right moment, as the figure shaded the oncoming sun.
Greg Dale Great Sand Dunes National Monument, Mosca, Colorado, U.S.

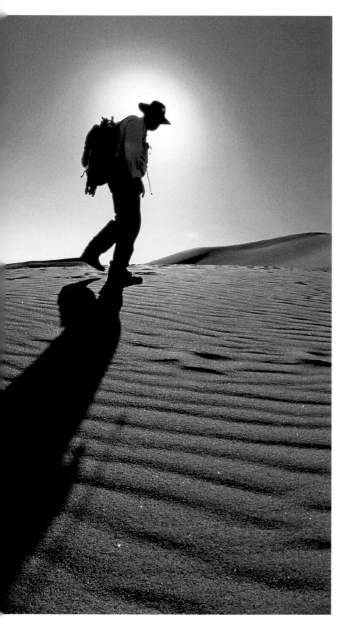

▶ **FOR MORE ON COLOR & LIGHT, SEE PAGES 28-9, 46-9, 98-9.**

CASUAL PHOTOGRAPHERS often follow rules of thumb as if they were law. If the sun is out, one such rule says, place it behind the camera so there is plenty of light on the subject. While this is good advice for a lot of situations, it obscures the possibilities of other setups and suggests that illumination can be used only one way. But light has a host of variables and values and can be used more creatively. The serious photographer must train herself to be aware of the nuances of light—its patterns, highlights, and shadows—and use them to add feeling and mood to her pictures, along with personality.

The Personality? Absolutely. Carmine red has ferocity and panache. Light blue is restful and young. Evening light is mild and contemplative. The awareness of light must include the ability to recognize its personalities that complement human emotion, because an emotional reaction is exactly what a photograph is intended to provoke.

AT NATURE'S MERCY

Artificial light for indoor photography brings its own engineering problems to the shoot and, if badly used, often leaves an inauthentic quality to the picture. Its personality tends to be "artificial." Outdoor photography has fewer such traps, but without the control of an indoor environment, a photographer is often at the mercy of the elements. Clouds will not stand still on command, and the sun takes its time moving to a more advantageous position in the sky. We are stuck with what we have—in what is called ambient light. The measure of a photographer's skill in part is how he or she uses what light is available. In a sense, there are few unacceptable light conditions; there are only challenges for the versatile photographer.

▶The Quality of Light

▶FOR MORE ON
THE COLOR
OF LIGHT,
SEE PAGES
120-1.

THE QUALITY OF LIGHT, one of photography's most important values, is always changing. Each time of day has its own light quality, as do various kinds of weather and indeed the different seasons.

"Hard" lighting comes from a single point source: the sun, a spotlight, a flash, or a bare bulb. With its high contrast, this kind of lighting is often used to suggest an unvarnished realism. Brilliant sunlight, particularly at midday, produces sharp-edged shadows and high contrast. Sunlit areas show bright colors, while shaded ones turn nearly black. Although this combination of extreme light and dark can make strong compositions, much detail may be lost in both shaded and highlighted areas, because the sensor simply cannot hold detail in both areas. Colors, however, can be accurate and intense, unless the light is so harsh that it washes out parts of the image with glare.

UNDER A CLOUDY SKY

"Soft" lighting is largely nondirectional; it seems to wrap around the subject. Soft light has neither extremely bright highlights nor dark shadow areas; the subject casts a faint shadow, if any. Because glare is not a problem, both subtle tones and rich hues are well reproduced. Photographs made in very soft light are seldom dramatic, but portraits often benefit from such gentle treatment.

▶▶**Get out on the streets** at dusk after a rain. Look for streetlights, neon signs, and car lights reflected on glistening pavement. Try some long exposures using a tripod.

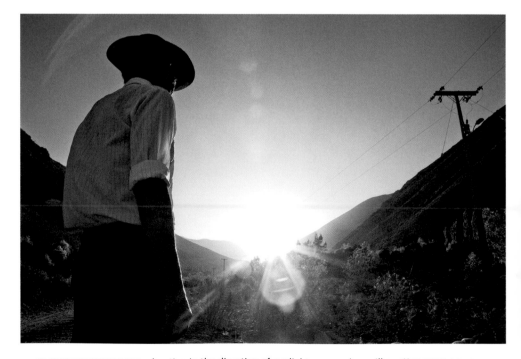

IN CERTAIN SITUATIONS, shooting in the direction of sunlight can produce silhouettes more powerful than any of the details that may be lost. **Michael Hanson** Chile

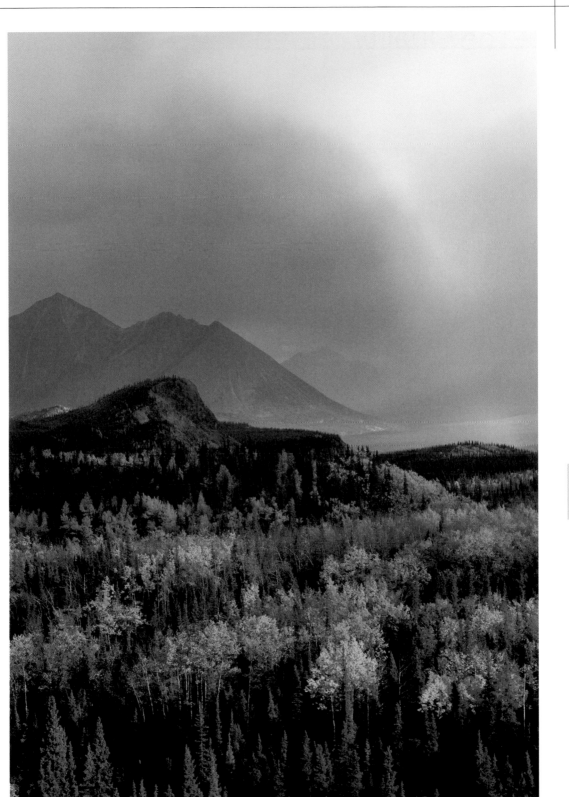

THE SOFT LIGHT on a cloudy day has a quality all its own, here creating a mosaic of autumn colors, from a field and blooms to rainbow above. **Michael S. Quinton** Denali National Park, Alaska, U.S.

▶The Direction of Light

▶FOR MORE ON SHOOTING AT NIGHT, SEE PAGES 126-7, 130-1, 362-3.

SINCE EARTH REVOLVES around the sun, the direction of light is basic to the rhythms of life, and it can be one of the photographer's most powerful tools. Each direction of light source—top light, front light, sidelight, backlight—can be identified with certain emotions: bright light is cheery, for instance; low blue light is somber. Deep shadows evoke mystery, and halos from backlighting makes angels of children. Our own eyes are most comfortable with the evening sun at our backs, shining from an angle of about 45 degrees. This angle is often seen as ideal for a photographic record. It produces a naturally sculpted appearance, good form and detail, and rich colors.

THE MAGIC HOURS

The lower the sun, the longer the shadows and the warmer the light. Sidelighting from a low, golden sun brings out shape, tone, and texture. Photographers call the hours around daybreak and sunset the "magic hours" of photography, when the sun casts its most benevolent light, romanticizing even the coarse, and coating the most banal objects with significance.

By comparison, top light, or sunlight at midday (between 10 a.m. and 3 p.m.), tends to be bleak and contrasty, producing deep shadows with no detail and washing out highlights. It should be used judiciously.

Although backlight throws a subject into shadow, it can also create dramatic effects, casting the edges of subjects in glowing outlines, or turning them into silhouettes. Backlight can bring out qualities difficult to see otherwise: the veins of leaves, the texture of icicles, the downy fluff of hair on a baby's head.

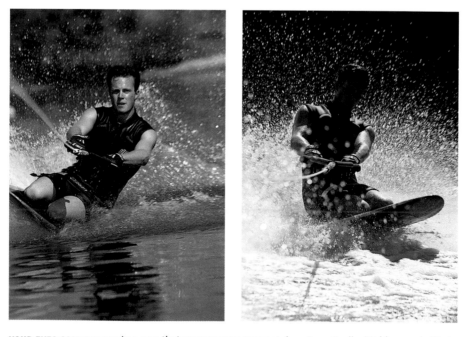

YOUR EYES COMPENSATE in a way that your camera may not do automatically. Midday sun behind the photographer illuminates the subject (left), but when the subject is between the photographer and the sun, a photograph taken without special settings results in disappointing shadows (right). Peter K. Burian

SOMETIMES SHADOWS CAN BE DRAMATIC, as in this photo of boys jumping off a dock backlit by the sun's golden glow reflecting off sea and sky. **Mauricio Handler** Mabul Island, Sabah, Malaysia

UNCOMPROMISING MIDDAY SUN can also enhance a photograph when contrast is key to the impact of an image. **Joel Sartore** New York, New York, U.S.

▶The Color of Light

▶**FOR MORE ON WHITE BALANCE, SEE PAGES 132-7.**

ALL LIGHT has a "temperature"—the measure of how it changes color when its source is heated. Confusingly, the temperature of color rises from low to high as it changes from what we perceive as warm colors, such as red, to cool colors, such as blue. These values were first measured in the late 1800s when British physicist William Kelvin heated a block of carbon; as it glowed, it produced a range of colors at different temperatures, from dim red to bright blue-white. The coldest heat was red, the hottest white. In his honor, color temperatures are described by "degrees Kelvin."

SUNSET COLORS COOL?

Our eyes tend to compensate for subtle changes in color temperature throughout the day, but the digital sensor measures facts and adjusts internally to the temperature range of colors in a given frame.

- **"WARM"** sunrise and sunset light is often in the 1000K to 3000K range.

- **A MATCH FLAME** burns at 1700K, a very low light temperature.

- **HOUSEHOLD TUNGSTEN BULBS** measure between 2500K and 2700K, a lower value but a warmer color than a fluorescent at 3200K.

- **HALOGEN BULBS** measure about 3000K, and a studio floodlight burns at 3400K.

- **THE "COOL" LIGHT** of an overcast sky can be the hottest light temperature, from 6000K to 10,000K.

THE MORNING SUN washes this frozen landscape in a red glow of low-temperature light.
Octavian Radu Topai/National Geographic My Shot

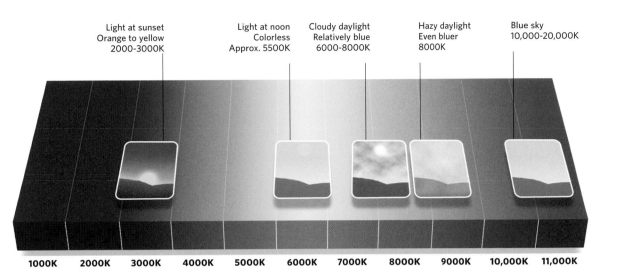

Light at sunset
Orange to yellow
2000-3000K

Light at noon
Colorless
Approx. 5500K

Cloudy daylight
Relatively blue
6000-8000K

Hazy daylight
Even bluer
8000K

Blue sky
10,000-20,000K

| 1000K | 2000K | 3000K | 4000K | 5000K | 6000K | 7000K | 8000K | 9000K | 10,000K | 11,000K |

PHOTOGRAPHERS OFTEN CONSIDER color temperature, which is a scientific concept different from the aesthetic description of "cool" and "warm" colors used in art and fashion today. Cycles and conditions of daylight affect the temperature of light, expressed in units called kelvins.

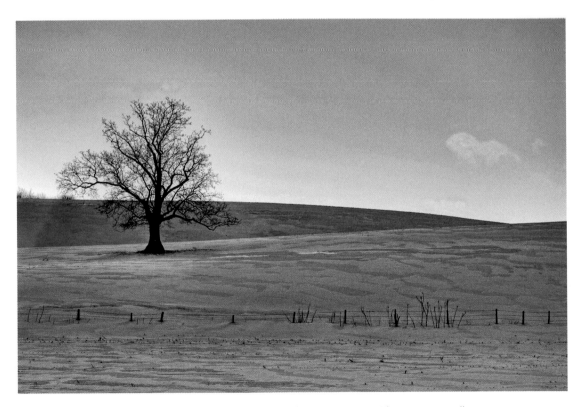

THE SUN DROPS beneath the horizon of another frozen landscape, casting a mid-temperature yellow haze across the horizon line. **Matt Champlin/National Geographic My Shot** New York, U.S.

☐ William A. Allard: **MY PERSPECTIVE**

IT WAS A *NATIONAL GEOGRAPHIC* assignment to photograph bison that introduced me to the American West and specifically to Montana in 1966—the start of a love affair with the region, one that continued with subsequent assignments for more than a decade.

The subject of the cowboy, quintessential symbol of America's frontier, held great appeal for me. I was attracted both to the landscape in which they live—the rare sight of open country sprawling beneath grand mountains—and to their independence, or at least the appearance of it. If a cowhand decided that things might be better farther down the road at a different outfit, he could literally pick up his saddle and bedroll and set off to find out. That kind of self-sufficiency appeals to many but exists for very few in American life today. Not only could I witness and document their rugged independence, I could relate to it—for my life as a photographer and writer has also given me the opportunity to go down many roads just to see what was there.

I have found freedom in simply wandering and allowing myself to be open to serendipity while exploring an unknown road or a bar or café in a strange town, always looking around the edges of an event where the pictures might be better than the event itself. —W.A.A.

ONE OF THE FEW photographers of his generation whose entire professional body of work is in color, **WILLIAM ALBERT ALLARD** has contributed to National Geographic publications since 1964. He has contributed some 30 stories to *National Geographic* magazine, including "Rodeos: Behind the Chutes," "Welcome to Bollywood," and "Hutterite Sojourn." His most recent book, a retrospective published in 2010, is *William Albert Allard: Five Decades.*

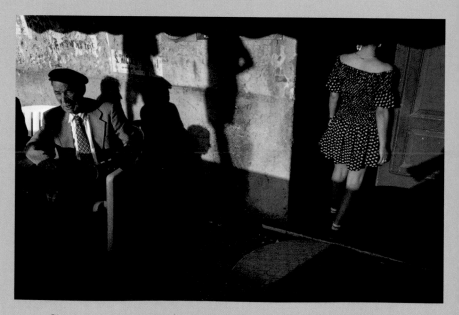

Giuseppe Vicario sits outside a Sicilian café, traditionally a men's gathering place.

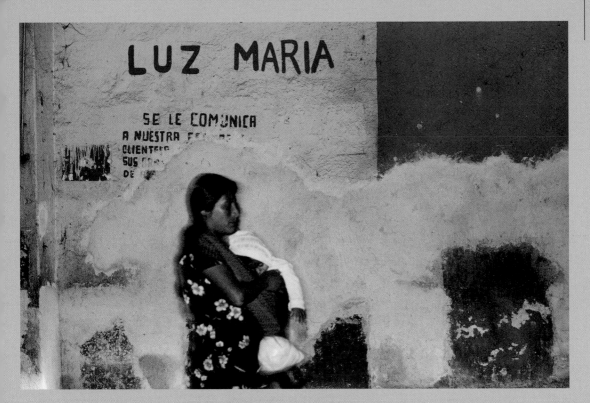

A woman carries her sleeping child past a graffiti-painted wall.

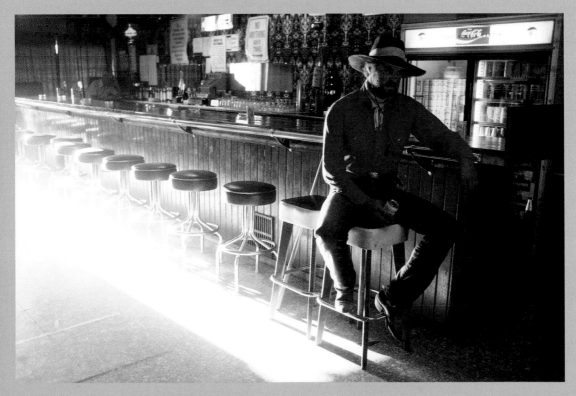

A cowboy enjoys a beer at the Miner's Club.

▶Bright Light Situations

▶FOR MORE ON
AVERAGE GRAY
& USING A
GRAY CARD,
SEE PAGE
134.

▶FOR MORE ON
SHOOTING
SNOW SPORTS,
SEE PAGES
304-5.

THE LOW LIGHT of the magic hours might be best for most images, but certain landscapes or portraits can benefit from midday light, especially if the effect you want is contrast and severity. But shooting at noon has its own limitations. The subjects probably will need sidelight to make them discernible. This is where a reflector or fill flash will help the foreground.

LENS FLARES

"Lens flare," a quirk of midday sun, happens because all but the simplest cameras contain lens systems with several elements. Flare is stray light that does not refract but reflects back and forth within the lens structure before reaching the sensor. Lens flares can be creative elements, but they seldom submit to the photographer's full control. If done right, lens flare accentuates the feeling of "hot," but it may also produce fog on the image.

OPEN THE APERTURE

When shooting in very bright overall light, such as on a sunny beach or in bright snow, the digital sensor cannot handle the exposure reading accurately. To compensate, adjust the exposure meter in the camera to the positive side: +1, for example, or +1/2. This tells the camera to open up the aperture, which seems counterintuitive because the scene looks bright enough already. But metering systems are calibrated to the brightness of average gray (18 percent). They will determine exposure so that the brightness of the whole image does not go beyond 18 percent gray. Snow and sand are brighter than that, so automatic metering will make the snow dark gray instead of white. By setting exposure compensation, you deliberately overexpose to give the snow or sand their normally light colors.

▶▶ **If you don't have an 18 percent gray card** with you to calculate exposure in a bright light situation, try taking a light reading of the palm of your hand.

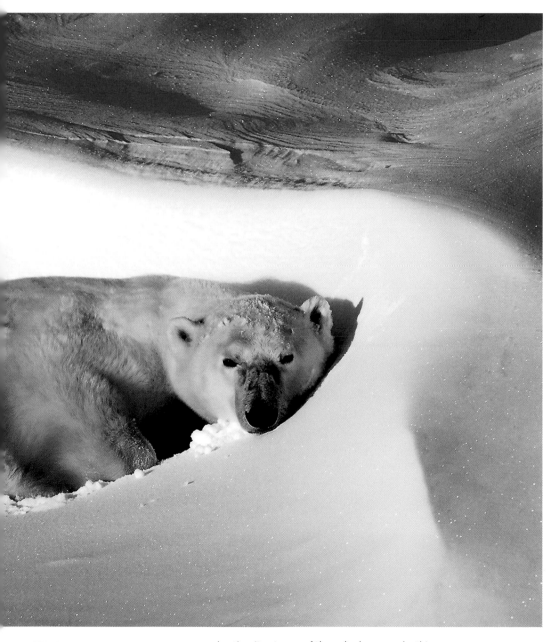

SUN AND SNOW, LIGHT AND SHADOWS—plus the direct gaze of the polar bear—make this a successful photograph. Bright sunlight against snow requires thoughtful exposure settings to prevent glare and gray. **David Schultz/National Geographic My Shot** Wapusk National Park, Manitoba, Canada

▶Low Light Situations

▶ FOR MORE ON
TAKING
PICTURES
DURING THE
HOLIDAYS,
SEE PAGES
326-7, 330-1.

MANY OF LIFE'S most meaningful moments happen in low-light conditions. Most film was not sensitive enough to record such scenes, resulting in grainy photographs. But sensors in high-end digital cameras have no such limits, with ISOs going up to 102,400. Friends around a campfire, city lights, twilight—all can be rendered with revealing detail, thanks to digital photography.

High digital ISO does suffer a loss of quality similar to what film exhibits at high speeds, however, and photographers shooting in low light should experiment to find the optimum ISO speed that maintains fine grain and color rendition. (Happily, color saturation—how vivid and intense a color is—actually increases in low light.) Something to keep in mind is that low speeds will require a slow shutter speed and a more limited depth of field, so a tripod may be needed. Low-light situations often result in surprising images, because slow shutter speeds may record blurs of slightly moving objects, as well as creating unexpected color shifts that were not apparent in the viewfinder.

▶▶ **Tape a small flashlight** under your camera or on top of the flash attachment to help you focus at night.

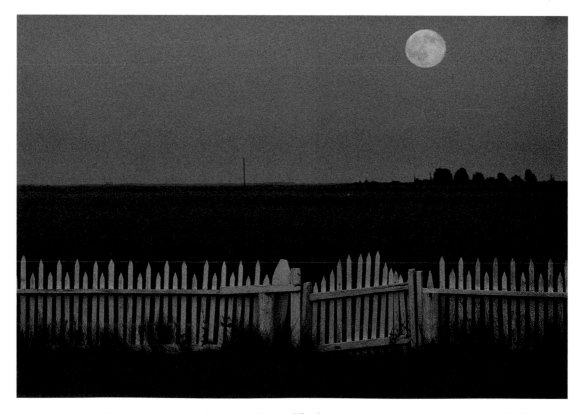

AN OLD PICKET FENCE takes on an otherworldly character under a full moon—a low-light situation requiring wide aperture and slow shutter speed. **Robert Madden** Smith Island, Maryland, U.S.

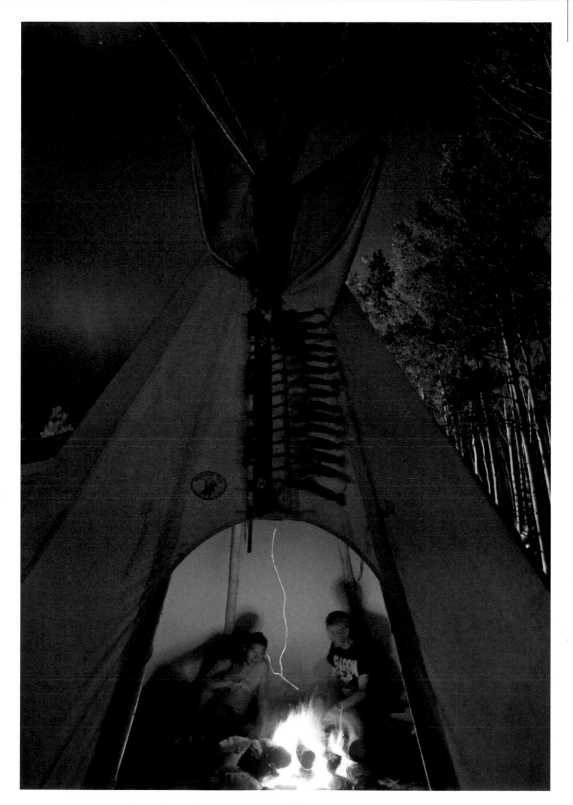

A SLOW SHUTTER SPEED, in tandem with a tripod, is essential for capturing a scene front-lit by the warm glow of a campfire. **Peter Essick** Fort McKay, Alberta, Canada

▶ Fog & Haze

▶▶ **If you use a flash,** consider the density of the fog or mist. If it's moderately thick, light from the flash will bounce off the water droplets and never reach the subject.

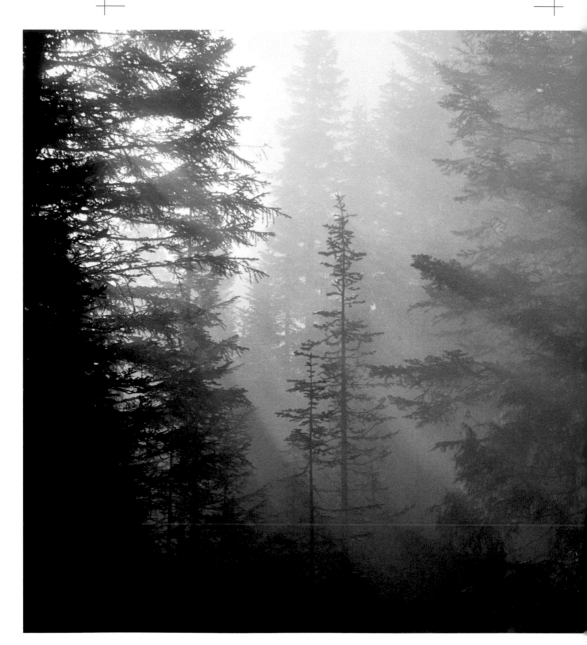

FOG AND MIST DIFFUSE light and make sharp focus difficult, but those conditions can lead to poetic expression and new views of how light filters into our world. Many photographers seek the muted light of fog, rain, haze, dawn, and dusk, preferring the gauzy look of such moments to the brighter shapes and colors of midday. **Alaska Stock Images** Mount Rainier National Park, Washington, U.S.

► **FOR MORE ON PHOTOGRAPHY THROUGH THE SEASONS, SEE PAGES 266-7.**

MISTY MORNINGS are friendly to photographers seeking the moody and mysterious. Fog usually forms in mid- to late evening and often lasts until early the next morning. It tends to rise near the surface of water that is slightly warmer than the surrounding air. In essence, fog is a natural diffuser, like a photographic "soft box." Fog acts as a filter, and its scattered particles serve as tiny light sources, so that the light arrives on the sensor from a much broader area. This is why, compared to a floodlight or the sun on a clear day, foggy light dramatically reduces contrast in the scene, reduces sharpness, and mutes colors into pastels. In such conditions, the overall look is softly romantic, especially in views of distant subjects.

MANY TYPES OF FOG AND MIST

Clouds, fog, and mist have varying densities and tonal qualities; they can be white or gray, thick or thin. Fog enveloping a highland forest or mist rising slowly from a lily pond can add dimension and a feeling of freshness to an image. Metering for light becomes crucial in these conditions. Pros will also bracket aperture stops, because a balanced exposure can be elusive. And just as with photographs in the snow, fog usually requires some positive exposure compensation.

QUALITY LENSES ARE IMPORTANT

It pays to have quality lenses when shooting in fog and mist; the better the lens, the better the light transmission and the more detail in the image. Although there are no steadfast compositional rules for photographing in fog, it often helps to keep at least part of the subject in the foreground. This allows you to include elements of more contrast and color, and it hints at what the rest of the picture actually looks like close up.

▶ The Nature of Artificial Light

▶ **FOR MORE ON PHOTOGRAPHING INSIDE, SEE PAGES 326-7.**

TWO HUNDRED YEARS AGO, the world was lit only by fire and by the sun. Flame was the only artificial light that enabled people to extend their hours of activity past sunset. The incandescent lightbulb and its successors changed all that. Since the turn of the 20th century, the production of man-made light—from the flash powder of early portraitists to Hollywood motion-picture sets—became its own science and art, separate from but complementary to photography. Today we make photographs in every kind of light, from studio floodlights to infrared to fluorescent.

LIGHT OF MANY HUES

The slower speeds of early films and shutters dictated that most photographs would need artificial illumination, or that subjects remain absolutely still for 30 seconds to a minute. Generations of flashbulbs, speed lights, and "slave units" that could light a space from several directions were developed for getting artificial light into the aperture. When photography was limited to black-and-white images, the color of light didn't matter, but soon multitudes of colored filters and diffusers were developed to bring out the desired qualities of subjects. In fluorescent light, a lens filter would turn the exposure into acceptable daylight tones. In the tungsten light of living-room lamps, a blue filter would tone down the amber quality and render the room into more recognizable degrees of Kelvin (the human eye, of course, had compensated for the color of the tungsten and did not fully realize that the light had been so strangely yellow).

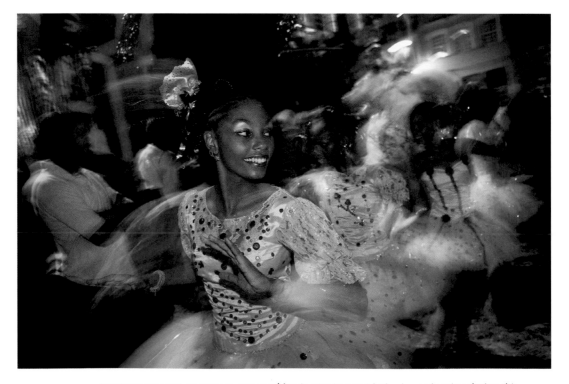

STREETLIGHTS AND CAMERA FLASH combine to create a swirl of color and action during this Brazilian Carnival. **David Alan Harvey** Salvador, Bahia, Brazil

Color balance and authenticity were the goals of studio lighting, a craft in which technicians would labor for hours to prepare a scene for the still photographer's shutter. Ambient artificial light in such venues as indoor sports arenas and neon-lit strips along suburban highways forced photographers to adopt different strategies for shooting.

THE CURSE OF RED-EYE

Casual photographers tend to use their camera-mounted flash units indiscriminately. Easy to trigger but difficult to master,

they often cause "red-eye," which makes friends look like zombies. Red-eye happens when the flash is too close and occurs too fast for the subject's pupils to close. Light enters the back of the eyes, which are full of blood vessels, and bounces back, reddened, through the pupil to the camera.

Many modern cameras have red-eye corrections, but you can also solve the problem by bouncing the flash off the ceiling or wall, losing a couple of f-stops in illumination but gaining good modeling and keeping light from bouncing straight back into the lens from a subject's eyes.

▶▶ **Shooting where there are many different types of light,** such as streetlights and fluorescents, will throw off your white balance setting. This isn't always a bad thing, but if you want to correct it, you might need to do it in postproduction.

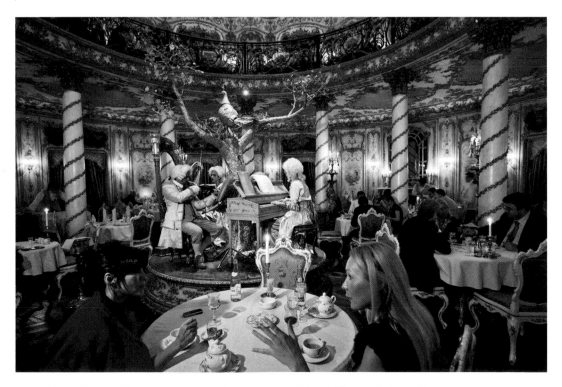

INCANDESCENT LIGHTING lends an amber quality—sometimes to great effect, as in this golden-toned picture taken in an elegant Russian restaurant. **Gerd Ludwig** Moscow, Russia

▶Range of Light

▶FOR MORE ON
LIGHT
& EXPOSURE,
SEE PAGES
28-9, 46-51,
74-5.

THE DIGITAL SENSOR of a camera acts much like color transparency film in terms of light sensitivity. In both cases, the parts of the image that receive too much light will burn out, and the parts that get little light will turn black. An image is recorded only if the light hitting the film or sensor falls within a range of five f-stops, with each stop denoting twice as much light as the previous one.

Our eyes see brightness values in a range of about ten stops—from the dimmest alley to the brightest beach. An average digital image has 256 brightness levels between absolute black (0) and absolute white (255). The value that meters read, 13 percent to 18 percent gray, is about 128, midway between, so an average scene of an average subject will be exposed at about the middle of the camera's dynamic range.

A HISTOGRAM is a graphical representation running from left to right, dark to bright, of the light levels in a photograph. This is the histogram of the photograph shown opposite.

DETAIL CAN BE LOST

A histogram displays all the brightness levels of the image, from dark to light, left to right. If high peaks slam up against the left or right sides of the graph, the image is "clipped"—it may contain areas of pure black or pure white, meaning no detail was recorded. A well-exposed image will have detail throughout the entire range of darks, midtones, and bright areas.

▶▶ **Be careful not to overexpose** the brightest highlights of a scene. You may need to underexpose by a quarter of a stop or more in order to get detail in your whites.

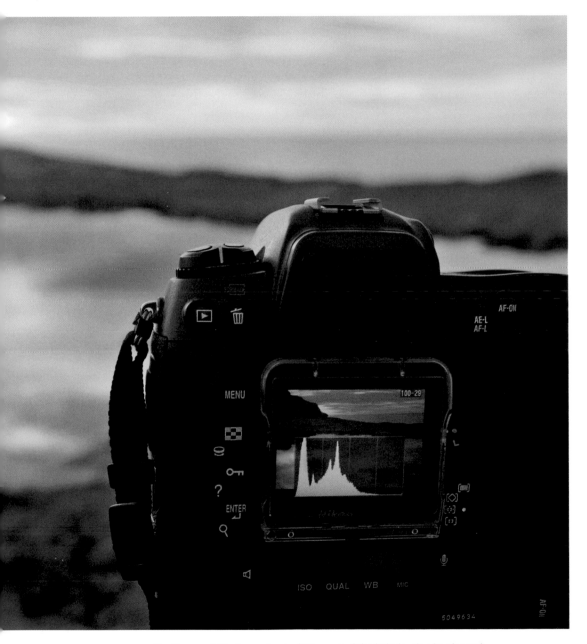

SOME DIGITAL CAMERAS offer the capability to read out a histogram of the light levels of a planned photograph—in this case, the nearby lake and the rocky coast beyond.
Ralph Lee Hopkins Baja California, Mexico

▶Exposure Challenges

METER READING (-1/3)

METER READING (0)

METER READING (+1/3)

HERE THE PHOTOGRAPHER shot three frames, bracketing by varying the exposure by a third of a stop (down one-third, above; up one-third, below). Subtle exposure differences—not right or wrong—emerge. **Peter K. Burian**

DESPITE THE SOPHISTICATED LIGHT METERS in DSLRs, some subjects remain difficult to expose correctly, especially those whose range of light (extreme dark or light) exceeds the sensor's ability—snow on a sunny day, for example, when the camera's sensor will attempt to average out the light and thus turn the brilliant white into gray. We can add light by setting the exposure compensation meter to a positive number such as +1. The LCD monitor can show the approximate quality, but not perfectly. Extreme light can also be evaluated with the camera's histogram, if "mountain peaks" crowd to either side of the frame.

BRACKET TO BE SAFE

When you're shooting once-in-a-lifetime pictures and the exposure must be sure, the simplest answer is to bracket: Change the aperture and shutter-speed settings and shoot again. Either set the mode to shutter priority (Tv) and vary the aperture by half- or full stops, or use aperture-priority (Av) and vary the shutter speeds.

USING A GRAY CARD

Photographers have long assumed that both film cameras and DSLRs use the same gray value (18 percent) to define the middle of the light spectrum. That value is actually closer to 13 percent in digital cameras, which means that the careful shooter would want to open up by a half-stop to get the most accurate reading.

Many photographers use a "gray card," simply a piece of gray cardboard that reflects 18 percent of the light—the kind of light reflected from a "normal" scene. They put the card under the same light as the scene and take a meter reading. This reading should result in the most accurate exposure for that scene.

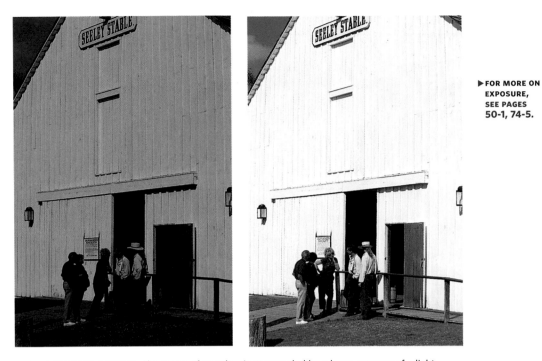

▶ FOR MORE ON
EXPOSURE,
SEE PAGES
50-1, 74-5.

WHEN A MIDTONE SUBJECT—the group of people—is surrounded by a large expanse of a light area—the white barn—the picture may be underexposed (left) unless the photographer increases exposure by 1.5 stops. In short, judge exposure by the shadows. Peter K. Burian

SCENE/SITUATION	METERING PROBLEM	SOLUTION
SNOW-COVERED SKI SLOPE	UNDEREXPOSURE WILL OCCUR (GRAY SNOW)	INCREASE EXPOSURE BY +1.5 STOPS
CHILD ON A BEACH, BRIGHT SURF AND SAND	UNDEREXPOSURE WILL OCCUR (CHILD WILL BE TOO DARK)	INCREASE EXPOSURE BY +1.5 STOPS
VERY DARK SUBJECT: 1) BLACK CAR FILLS MUCH OF THE FRAME OR 2) A SMALL PERSON OR OBJECT AGAINST A BLACK BUILDING	OVEREXPOSURE WILL OCCUR (GRAY SUBJECT)	DECREASE EXPOSURE BY -1.5 OR -1 STOP
LANDSCAPE; TWO-THIRDS OF THE FRAME IS HAZY BRIGHT SKY	UNDEREXPOSURE WILL OCCUR (FOREGROUND WILL BE TOO DARK)	INCREASE EXPOSURE BY +1 STOP
BACKLIGHTING—A PERSON OR OBJECT AGAINST THE SUN	UNDEREXPOSURE WILL OCCUR (SUBJECT MAY BE A SILHOUETTE)	INCREASE EXPOSURE BY +2 STOPS; AS AN ALTERNATIVE, USE FLASH (IF POSSIBLE)
SPOTLIT PERFORMER SURROUNDED BY A LARGE DARK AREA	OVEREXPOSURE MAY OCCUR	DECREASE EXPOSURE BY -1 STOP
LANDSCAPE WITH SUN IN THE FRAME	SEVERE UNDEREXPOSURE MAY OCCUR	INCREASE EXPOSURE BY+2.5 STOPS

NOTE: THE RECOMMENDATIONS FOR AMOUNT OF OVERRIDE NECESSARY—FROM A CENTER-WEIGHTED METER READING—ARE ESTIMATES. CONSIDER THESE ONLY AS A STARTING POINT FOR EXPERIMENTATION OR BRACKETING.

▶Choosing White Balance

▶**FOR MORE ON LIGHT & COLOR, SEE PAGES 28-9, 46-9.**

▶**FOR MORE ON THE COLOR OF LIGHT, SEE PAGES 120-1.**

ACHIEVING WHITE BALANCE is the process of removing unrealistic color casts so that objects that should appear white are rendered white in a photograph, regardless of their actual hue. Our eyes see white, even if it's not there. The newspaper that we read under a tungsten lamp actually has picked up a yellow color, but in our eyes the paper is still white. We simply adjust and send the right "white balance" to our brains.

But in a photograph, if white is not really white, the rest of the colors in the scene will also be untrue variations. White-balance settings presume that the photographer wants the scene to look like a sunny midday, but the color of daylight changes from the glow of sunrise through the cooler colors of midday shade, then back to the golden tones of sunset. Thus many photographers don't bother using white-balance corrections outdoors, but take indoor lighting challenges very seriously.

WHITE-BALANCE SETTINGS

Cameras are not as skilled at adjustments as our eyes, but most offer a variety of white-balance settings. When the camera is set to automatic white balance (AWB), it renders colors "accurately" no matter whether you're shooting indoors, in bright sunlight, or on a cloudy day. But AWB should not be used without forethought. There are times when you want the color of the light to stay as it is, such as during sunrise and sunset. The AWB feature works reasonably well under many conditions, but poorly in others, especially under artificial light such as incandescent, halogen, or

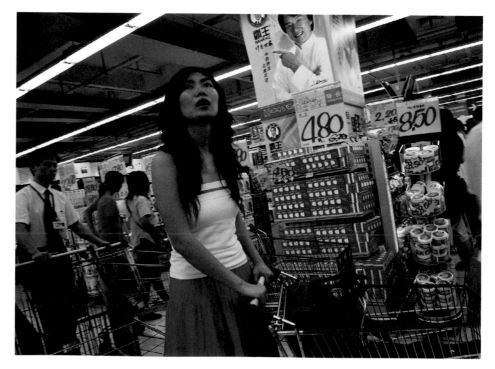

WHEN WHITE BALANCE is adjusted properly, the tones of white and colors appear as we expect them to, no matter what color existing light is creating.
Randy Olson Guangzhou, People's Republic of China

fluorescent. These light sources have a tint as well as a color temperature, and compensating for them is notoriously difficult.

PREPROGRAMMED WHITE BALANCE

Digital SLRs have various preprogrammed white-balance modes such as Flash, Sun, or Shade. These modes are easy to use, but they are just approximations of the actual color of the light—the digital equivalent of choosing between daylight and tungsten film.

White, which is actually the combination of all visible light colors, is used as the standard because it is neutral, and any shift of color is immediately seen. The gray card that many photographers carry for metering can also be used for setting white balance. Since the gray card has a neutral hue, any variation from neutral that the camera records must have come from the color of the light shining on it. This method is known as manual or custom white balance and is generally regarded as the most accurate for applications where color accuracy is critical. Some cameras also support direct input in degrees Kelvin, which defines the light more exactly.

▶▶ **Be aware of your camera's white-balance selection.** Different settings will yield different color balances. Though not foolproof, your safest bet is to go with the automatic balance selection on your camera.

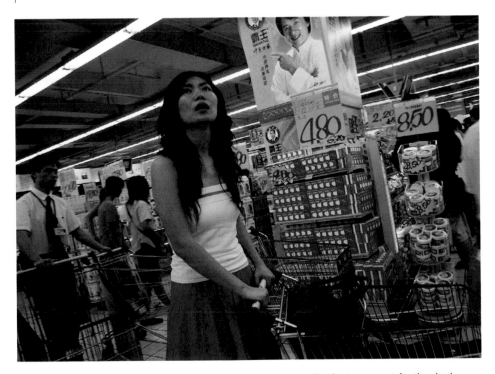

INDOOR LIGHTING, such as these fluorescents, tints what we see. Our brains correct for the shading, but the camera sees and, uncorrected, records odd colors.
Randy Olson Guangzhou, People's Republic of China

WHAT MAKES THIS

OIL LAMPS ON THE GANGES John Stanmeyer Haridwar, India

A GREAT PHOTOGRAPH?

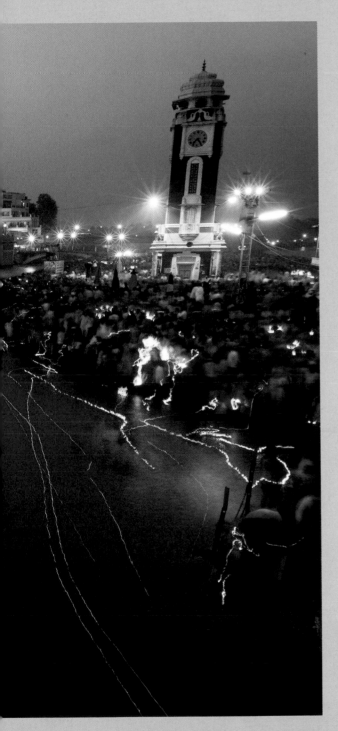

JOHN STANMEYER has traveled extensively, photographing in many regions of the world, especially Asia. Recently his work has focused on human rights and environmental issues.

SUBJECT This spectacular scene was shot from a bridge over the Ganges River during the Ganga Dussehra festival. The long threads of light on the river come from oil lamps carried in the current.

COMPOSITION A classic element of composition—perspective—is clear in this photograph, with the river flowing into the distance away from the viewer. The four towers of separate temples break up the composition like punctuation marks. Their intermittent positions help move the viewer's eye across the whole tableau.

LIGHT This photo was made during what photographers call the magic hour, when it is quite dark but there is still a little light in the sky. Thus the hill on the left can be silhouetted against the twilight. In another ten minutes, the scene would be completely black, and the hill would not be visible.

EXPOSURE The image is the result of careful balance, a compromise between the correct aperture of a wide-angle lens and the amount of time the shutter needed to remain open to capture all the elements, including the bright oil-lamp trails that add visual excitement.

–James P. Blair
NATIONAL GEOGRAPHIC
PHOTOGRAPHER

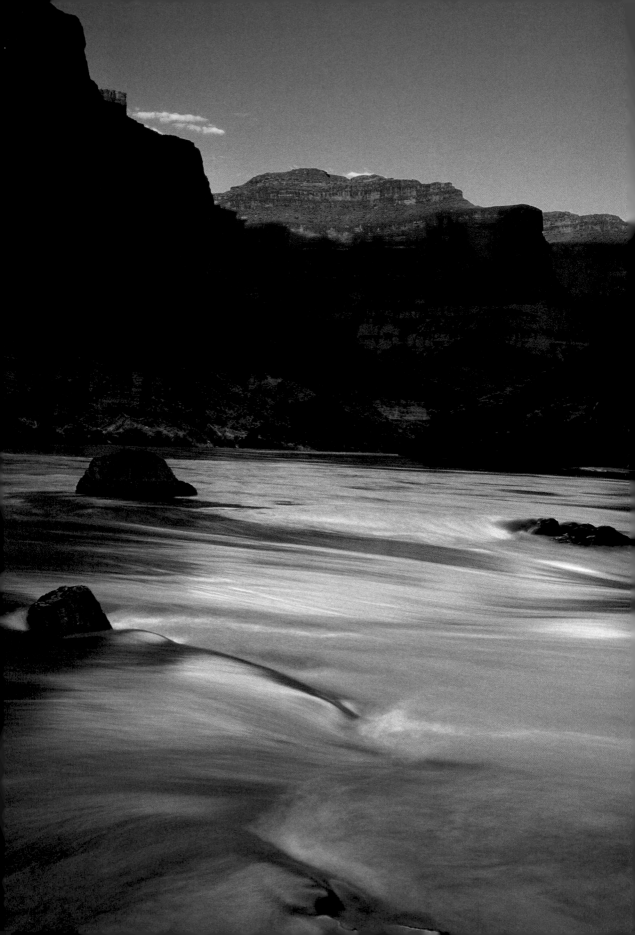

5 Beyond Auto Mode

MANY PHOTOGRAPHERS let the camera dictate what to do. The Automatic mode is reassuring, like living with our parents after college. The time comes, though, when we need to make decisions on our own. For photographers, this means moving the mode dial away from the comfortable green rectangle and exploring other tools of the camera system.

Digital SLRs are programmed to make pictures where film could never venture, but there are times when casual photographers make major concessions to quality, simply because they haven't learned how to enhance their exposures. Filters and flash occupy a smaller part of photography's arsenal than they once did, but they are still crucial for those seeking to expand their capabilities. Similarly, modern cameras have refined their in-package zoom lenses to satisfy many photographers, but a range of lenses are available to capture that elusive, compelling frame.

MOVING WATER, dim light at sunset, a long view, high contrasts—many elements in this photograph called for photographic know-how beyond the automatic settings on a digital camera.
David Edwards Grand Canyon National Park, Arizona, U.S.

▶ Lenses: What They Can Do for You

▶ **FOR MORE ON WHAT LENSES DO, SEE PAGES 30-1, 58-61.**

▶ **FOR MORE ON TYPES OF LENSES, SEE PAGES 144-51, 374-5.**

WHEN CAMERA COMPANIES introduced the first digital single-lens reflex (DSLR) cameras, they chose to keep the camera bodies compatible with the lenses that film-era photographers had gathered in their gadget bags. Although most DSLRs come equipped with excellent zoom lenses (typically 18mm–200mm), experienced photographers have largely continued to rely on their old friends—from wide-angle "fish-eye" 10mm lenses that will cover three walls of a small room, to 600mm telephotos capable of framing a nuthatch on a branch from 100 feet.

A LENS FOR EVERY NEED

Modern lenses are composed of as many as 20 glass elements and are usually focused by adjusting the distance from the lens assembly to the image plane. Lenses vary by the angle they cover (the width and height of the scene) and their "speed" (maximum aperture). As their focal lengths increase, their angle of view narrows, and objects in the scene become larger in the frame.

One leading camera company offers as many as 200 different lenses of varying speeds and focal lengths.

▶▶ **Long lenses tend to compress atmospheric haze,** producing a soft image without much contrast. In hazy conditions, try to move closer to the subject and switch to a shorter lens.

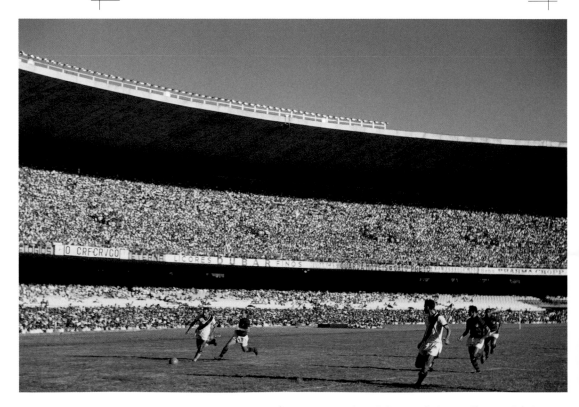

A STANDARD PHOTOGRAPHIC LENS can give you an overview of the crowd at a sporting event, but loses much of the detail of the players. **Charles Allmon** Rio de Janeiro, Brazil

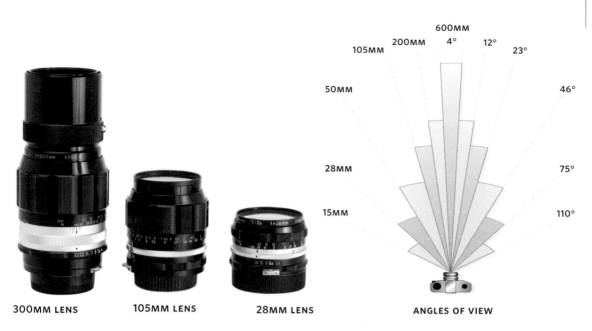

300MM LENS **105MM LENS** **28MM LENS** **ANGLES OF VIEW**

THE ANGLE OF VIEW represents the primary difference between what short and long lenses can do for you. Angle of view is the amount of a scene covered, designated in degrees, and ranges from wide, viewed by wide-angle lenses such as 15mm and 28mm, to narrow, viewed by telephoto lenses such as 600mm and above.

A TELEPHOTO LENS can take you off the sidelines of the playing field and right into the middle of the action. **Mike Theiss** Asunción, Paraguay

▶Telephoto Lenses

▶FOR MORE ON
CLOSE-UPS,
SEE PAGES
102-3, 282-3,
374-5.

▶FOR MORE ON
LAYERING,
SEE PAGES
104-5.

TELEPHOTO LENSES, like binoculars, tele-scopes, and spyglasses, are magnifiers and they can bring a small subject right into the heart of a picture. Professional pho-tographers usually own multiple telephoto lenses, depending on the sort of photogra-phy they expect to practice.

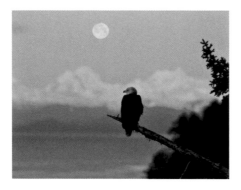

- **MODERATE-LENGTH TELEPHOTO LENSES** 85mm to 130mm (in 35mm film camera equivalent), often used for portrait work, since their narrow focus will be sharp on the subject but will blur the background. A 105mm lens is ideal for portraits.

- **MEDIUM TELEPHOTOS** 135mm to 300mm, useful for weddings and other events at a distance from the viewer. Also ideal for travel photographs.

- **LONGER TELEPHOTOS** 300mm to 400mm, for landscapes and wildlife photography, but expensive and often require tripods.

- **MORE POWERFUL TELEPHOTOS** Up to 800mm, used by professional photogra-phers. An 800mm f/5.6 lens can even be used for astrophotography.

TELEPHOTO LENSES are essential for taking wildlife photographs from a distance (above) or for getting that shot of action that takes place where angels fear to tread (below).
Alaska Stock Images Tongass National Forest, Alaska, U.S. **Bruce Dale** Río de la Plata, Argentina

TELEPHOTO LENSES can skew perspective, bringing distant objects into focus, combining elements, and allowing for new ways of seeing the world. **Medford Taylor** Washington, D.C., U.S.

▶ Macro Lenses

▶ FOR MORE ON
MACROPHOTOG-
RAPHY,
SEE PAGES
374-5.

▶ FOR MORE ON
DETAILS,
PATTERNS,
& TEXTURE,
SEE PAGES
100-1, 282-3.

PHOTOGRAPHING SMALL THINGS can be a series of surprises; our eyes don't often see the mandibles of a grasshopper or the fuzz on a leaf. Macro lenses, used for extreme close-up photography, bring small objects into focus from a very short distance and make them large enough to fill the frame.

Macros typically come in three focal lengths—50mm, 90mm, and a telephoto, 180mm. Macros with larger focal lengths allow greater distance between camera and object, which may help get better light on the subject, especially if you're using a flash supplement. Working inches away, the camera itself can block light. Using a lens with a longer focal length can also help with flighty live subjects such as butterflies.

Long-length macros, however, mean larger, heavier, and more expensive gear.

DOUBLING AS NORMAL LENSES

Macros can focus to infinity, but they are designed to focus at extremely short distances. A true macro lens should give a flat field, minimum distortion, and high sharpness at the closest distance. It should also provide a magnification of at least one-half the true size, though most true macro lenses will provide 1x (actual size). With 1x, if your subject is a worm that's half an inch long, it will be the same size on the sensor. For even more extreme close-ups, you can purchase an extension tube, or bellows, that fits between the camera and lens.

▶▶ **Move slowly when shooting macro photos** of small animals. Get used to the lens's focal distance beforehand, so when you get close you can shoot in an instant.

EARLY MORNING is the best time of day for insect photography, since little critters like this one are immobilized until the morning dew evaporates. **Veerasak Punyapornwithaya/NG My Shot**

PHOTOGRAPHERS HAVE THE OPPORTUNITY TO MAKE CHOICES even with macro lenses, adjusting for a shallow or extended depth of field. Macrophotography brings details into focus, sometimes more clearly than one might recognize with the naked eye. This dried echinacea flower glows and bristles with its developing seed head. **David Evans** Becket, Massachusetts, U.S.

▶ Wide-Angle & Fish-eye Lenses

▶ FOR MORE ON PANORAMIC PHOTOGRAPHY, SEE PAGES 368-9.

▶ FOR MORE ON APERTURE & DEPTH OF FIELD, SEE PAGES 62-5.

THIRTY PEOPLE are squeezed against the wall of a small banquet room for a group shot of their high school reunion. With a wide-angle lens, the scene becomes manageable. Wide-angles—versatile lenses with expansive fields of vision—come in focal lengths from 10mm to 35mm as well as in a variety of zooms. They offer stability and a much greater depth of field, allowing handheld shots at slow shutter speeds. In addition, they offer opportunities for layering and complex compositions. But they also can alter proportions, exaggerating the foreground and diminishing the background. If wide-angles are tilted up or down, vertical lines will appear as if they're converging—an effect known as "keystoning."

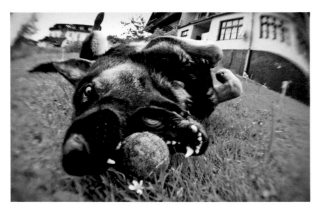

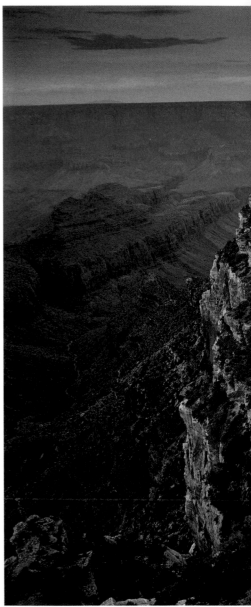

FISH-EYE LENSES can be used to dramatic—and sometimes comic—effect, but they do distort details along the edges of a photograph.
Matej Stasko/NG My Shot Vysoké Tatry, Slovakia

FISH-EYES

Wide-angle lenses with a field of view of 180 degrees or so (focal length: 10mm) are called fish-eye lenses. These can produce dramatic pictures but will distort the image; straight lines on the edges will appear as curves. Fish-eyes have limited uses, such as shooting the inside of a submarine.

▶▶**Lens flare** can be a problem with wide lenses. Use your hand or some cardboard to screen the lens from the sun—but make sure the screen is out of the frame.

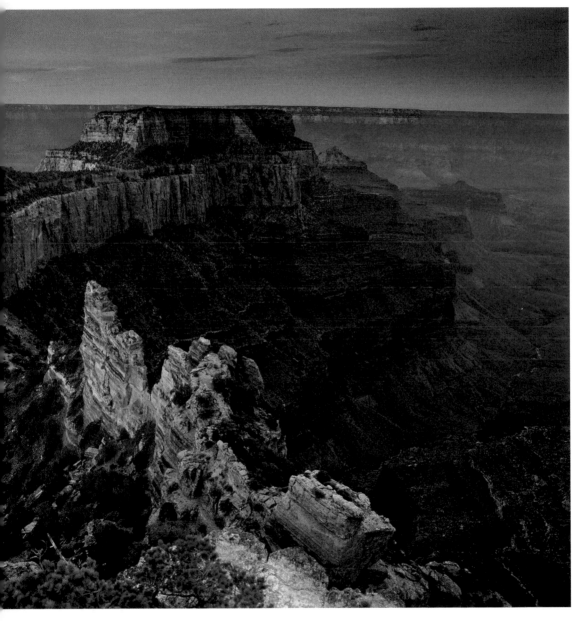

A WIDE-ANGLE LENS allowed this photographer, working from above in a plane or helicopter, to bring in the full sweep of nearby landforms and canyons far away. The glint of sunlight low on the horizon to the left turns the colors a magical combination visible briefly and only at certain times of day. **Tim Fitzharris/Minden Pictures** Wotans Throne, Grand Canyon National Park, Arizona, U.S.

▶ Zoom Lenses

▶▶ Read specifications when selecting zoom. Optical zoom is preferable to digital zoom. With the latter, image resolution drops substantially as you zoom in.

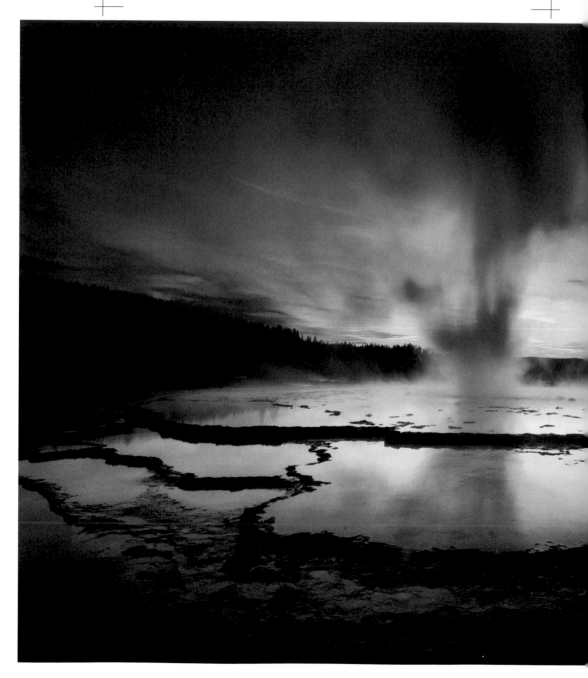

A GOOD ZOOM LENS can bring the view right up to the edge of one of the smoking geysers of Yellowstone National Park. **Michael Melford** Yellowstone National Park, Wyoming, U.S.

▶ **FOR MORE ON ANGLE OF VIEW IN LENSES, SEE PAGES 142-3.**

ZOOM LENSES bring freedom from the hassle of carrying extra lenses. One lens with a range between 18mm and 200mm can allow you to change focal length without changing lenses and to virtually change the distance from your subjects without taking a step. Zoom lenses are super for travel, where every extra pound counts.

NOT AS SHARP?

Some zooms cover only telephoto ranges, such as from 70mm to 300mm. Others have only a wide-angle range, say from 17mm to 35mm. A disadvantage of zoom lenses is that they tend to be slower (f/4 or f/3.5) than comparable fixed lenses, limiting their use in low-light situations. Photo purists also point out that the angle of refraction in a zoom lens is never precisely equal to its angle of reflection—and so pictures will never be quite as sharp.

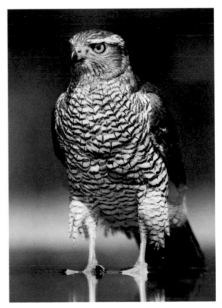

SKITTISH BIRDS (such as this northern goshawk) make a telephoto or zoom lens best for those photographing them in the wild.
Dickie Duckett/FLPA/Minden Pictures Hungary

▶ Using Filters

▶ **FOR MORE ON THE NATURE OF ARTIFICIAL LIGHT, SEE PAGES 130-1.**

DIGITAL CAMERAS have menu settings that replace many of the colored filters that photographers once lugged around, but two types of lens-mounted filters are still in common use by all serious photographers: ultraviolet (UV) and polarizing.

USE A POLARIZING FILTER to help avoid the distraction of light reflecting off a surface.
John G. Agnone Falls Church, Virginia, U.S.

UV FILTERS

UV filters are nearly clear glass filters that attach to the end of a lens. In outdoor photography, they filter out ultraviolet rays, cutting off excess haze and reducing blue tones in the image. They can be kept on the camera most of the time, since they also protect the lens from scratches and other damage.

Very strong UV filters can cut off some colors of light, causing a yellowish cast, and may require some color compensation.

POLARIZING FILTERS

Polarizing filters are used in both color and black-and-white photography. They can deepen the blue sky in color photography and darken the sky in black-and-white. They cut through the haze to reduce glare and reflections, and give photographs extra drama and contrast.

A polarizer is usually screwed to the end of the lens and is rotated to the angle that gives the desired effect in the viewfinder. It works by allowing light only from that angle to enter the lens, blocking random light vibrating from other angles.

The effect of shooting through a polarizing filter is to partially or completely remove the glare from reflective objects, moisture, or particulate matter in the air.

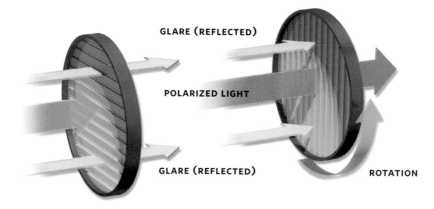

GLARE (REFLECTED)

POLARIZED LIGHT

GLARE (REFLECTED)

ROTATION

WHEN ROTATED TO THE CORRECT ANGLE, a polarizing filter reduces or even removes reflective glare.

A COLORED FILTER can modify the palette of a photograph. The photo of autumn foliage above was taken without a filter, whereas the photo below was taken with an enhancing filter, producing richer reds and oranges. Peter K. Burian

▶▶ **Don't leave cameras, and especially long lenses,** pointed directly into the sun for very long. You risk burning a hole in the shutter in the same way that a magnifying glass can set a piece of paper on fire.

□ Chris Johns: MY PERSPECTIVE

"IF YOUR PICTURES AREN'T GOOD ENOUGH, you aren't close enough," said the renowned war photographer Robert Capa. Getting close can be risky, but given the possibility of an experience like being eye to eye with an elephant, it's one I was willing to take. Early in my career, that one-on-one connection was largely with people, but over time I began to find it with wild animals and landscapes.

Regardless of whom or what I was photographing, the key was to spend time with the subject. I knew the elephant that touched me. I'd been living in the crater and photographing him for months—keeping a respectful distance, never pursuing him, waiting for him come to me. When he finally did, I quietly held my ground. I discovered we both had something in common: curiosity. In large part, that is why I picked up a camera when I was in college. I've always been curious, but also somewhat shy. The camera gave me an excuse for observing and making my own discoveries. Capturing them on film was frosting on the cake.

I am no longer a photographer, and I am often asked if I miss it. "Of course," I reply. "Who wouldn't?" But as editor in chief of *National Geographic* magazine, I'm now the one committed to giving photographers the time they need to get close to their subjects. —C.J.

NATIONAL GEOGRAPHIC magazine assignments have taken **CHRIS JOHNS** all over the world. Named National Newspaper Photographer of the Year in 1979, he worked on newspapers in Topeka and Seattle, began freelancing in 1983, and joined the staff of *National Geographic* in 1995. He photographed and wrote *Wild at Heart: Man and Beast in Southern Africa; Valley of Life: Africa's Great Rift;* and *Hawaii's Hidden Treasures.* In 2005, he became the Editor in Chief of *National Geographic* magazine.

A Namibian woman takes a puff on a hand-rolled cigar.

The early morning mist serves as a backdrop to this curious giraffe.

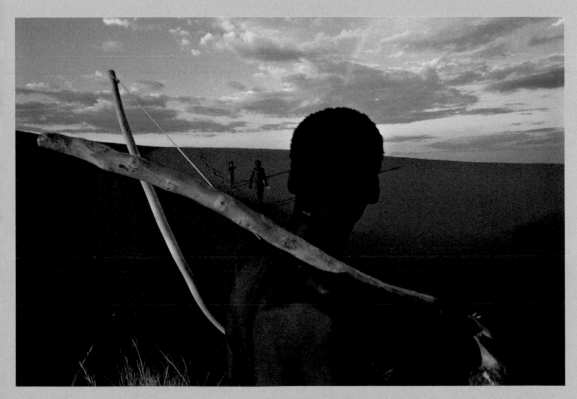

Bow in hand, a San hunter looks out over the Kalahari Desert in Botswana.

▶Using Flash

▶FOR MORE ON
CONTROLLING
FLASH,
SEE PAGES
158-61, 362-3.

PERHAPS THE FIRST THING to know about flash photography is that it can be compatible with natural light and authenticity. Flash is so often misused: We've all seen too many red-eye pictures and ones with harsh illumination and dark shadows. Direct flash can be just right for paparazzi or news photographers at night—when the glare of a flash can serve as an accusatory spotlight, but many photographers today use flash sparingly, not as a modus operandi. Good flash use, like good editing, should be

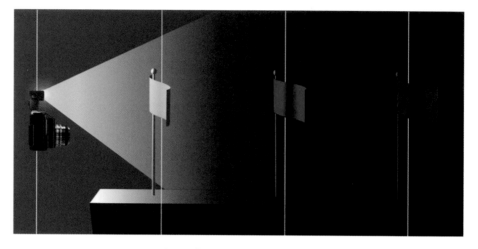

THE LIGHT OF YOUR FLASH must physically bounce off the subject matter to make any difference in the outcome of your photograph.

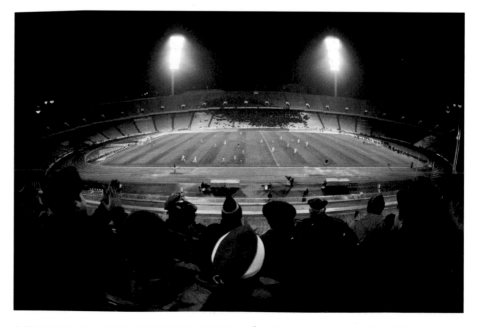

A FLASH WILL NOT ILLUMINATE DISTANT OBJECTS, such as the players on an athletic field when you are sitting up in the bleachers. **Steve Raymer** U.S.S.R.

subtle, barely noticeable to the viewer. Its practical aim and contribution is simply to add enough light to make the subject look more normal.

FLASH MUST BOUNCE AND RETURN

A frequent error in using flash is the notion that the light is going to reach objects far away. We've all seen flash units popping from the nosebleed seats in sports stadiums, since many people leave flash on as a default mode or their digital cameras sense that there is not enough light, so the flash fires automatically. But flash units work only when they are strong enough to reach a subject and reflect back onto the sensor.

If the flash built into a DSLR is set at its fastest speed, ISO 3200, the light is effective for about 70 feet. Shooting with a medium ISO such as 200, the distance falls to 15 or 20 feet. A camera-mounted flash also has the disadvantage of being stationary; most serious photographers use detached flash units, which are not only more powerful but also can be held at different angles and distances.

▶▶ **Keep your flash close at hand.** Just a light touch of electronic flash can add a sparkle to a person's eye or pump up color in a drab scene.

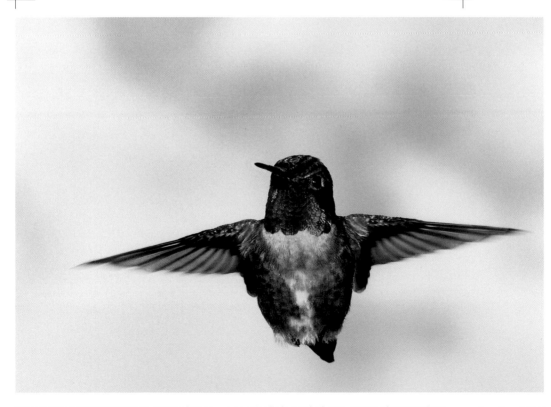

CAPTURING A HUMMINGBIRD'S WINGS has long been the holy grail of stop-action photographers. This photograph was likely taken in broad daylight but with a flash set as fast as a wink—perhaps down to 1/8000 second—to capture this elusive moment. Igor Kovalenko/NG My Shot

▶Controlling the Flash

▶**FOR MORE ON TAKING PORTRAITS, SEE PAGES 234-45, 252-3, 340-5.**

ELECTRONIC FLASH is one aspect of digital photography that has not been successfully internalized into the camera itself. The results of flash cannot be previewed on an LCD screen, nor accurately predicted. Camera-mounted units are fine for casual snaps of friends and family, but have limited range and power. A flash attached to the camera's "hot shoe" or a handheld flash can offer more power and control. But using electronic flash well—achieving natural-looking images—is quite tricky. Nearly everyone has to read the manuals provided by the camera maker and the

electronic flash company. Experimenting with flash was arduous with film-based photography because of the mathematical calculations and the long time it took to get the film processed. Digital cameras only partly eliminate these problems.

BOUNCING FLASH

An independent flash unit can bounce light off ceilings, walls, or reflectors, thereby making the light look more natural—much softer and with fewer shadows. We can also mute the otherwise harsh color of

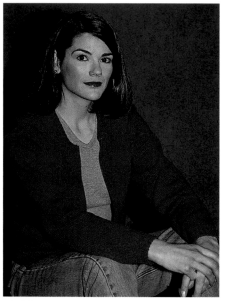

DIRECT

OFF-CAMERA DIRECT

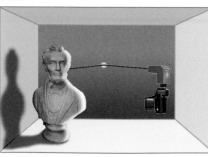

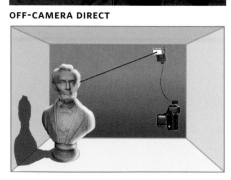

A DIRECT, HEAD-ON FLASH can produce a harsh "deer in the headlights" look (above left). Mounting the flash away from the camera (above right) can work better. **Mark Thiessen**

flash units by using a diffuser cap that fits on the flash window, or by simply placing a handkerchief or tissue paper in front of the flash. If there's time, inexpensive, wireless, secondary lights known as "slave units," triggered by the "master" flash, can provide light from any second direction. The slave can give extra depth to a portrait—for example, by backlighting the subject's hair.

Another bothersome flash problem is the bright foreground and black background we often get because the flash has correctly exposed the subject but has not reflected back the rest of the frame. A slower shutter speed will freeze the subject within the time of the shutter exposure, while background details and colors will fill out the frame with the ambient light.

▶▶**There is not only one f-stop** that will provide a correct flash exposure. At each f-stop, the exposure will be correct over a range of distances.

CEILING BOUNCE

WALL BOUNCE

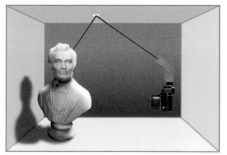

BOUNCING THE FLASH off the ceiling (above left) or a wall (above right) often produces a more natural-feeling light. **Mark Thiessen**

▶ Fill-in Flash

▶ **FOR MORE ON THE DIRECTION OF LIGHT, SEE PAGES 118-9.**

FILL FLASH is just what its name implies—artificial light meant to illuminate a subject close to the camera that would otherwise be too dark, relative to the rest of the scene. This requires calculations for two settings:

■ **THE FLASH UNIT** should be set to expose the subject correctly at a given aperture.

■ **THE SHUTTER SPEED** should be calculated to correctly expose for the background or ambient light at that aperture setting.

If used well, fill light is nonintrusive; the viewer should not even be aware that it was used.

For fill light, the flash shouldn't operate at full strength. Most DSLRs have through-the-lens (TTL) setting options, accessed by a "flash exposure" icon, which can vary the amount of light the flash generates. Some cameras are also equipped with flash-exposure bracketing, which allows three successive pictures with varying flash strength. More advanced cameras have a fully automatic "fill-flash" mode.

It's important to know the shutter speed at which the camera will synchronize with the flash unit; 1/60 or 1/125 are generally used. If the flash unit does not fire while the shutter is open—no picture. But since these sync speeds are rather slow, pros will lower their ISO settings, or the image will be overexposed.

▶▶ **To create a pleasing lighting ratio,** use a flash meter to ensure the key light is twice as bright as the fill light.

WITH EXISTING LIGHT (left), shadows may darken areas. Full flash (center) can help, but fill flash (right) allows sunlight to be the primary light source, a more subtle correction. **Peter K. Burian**

CREATING A MODERN-DAY PORTRAIT reminiscent of a Renaissance painting, the photographer used fill flash to sharpen the details of this young farmer and her basket of greens, keeping the distant mountains an out-of-focus backdrop that simply emphasizes the sharpness of her features.
Alaska Stock Images Juneau, Alaska, U.S.

▶Photographing Action

▶ **FOR MORE ON ACTION PHOTOGRAPHY, SEE PAGES 288-91, 294-5.**

NOT EVERYTHING being photographed will stand still and pose. Things move, jump, run, and ride—from kids on the beach to dirt-bike racers to wild animals. However, specialized electronic strobes will stop a bullet in midflight. Insect and bird photographers use flash at very close range because the resulting durations—as short as 1/30,000 second with some units—can freeze just about any action.

But even with ambient light, we can freeze most action; alternatively, we can blur the background to accentuate the speed of our subject, or blur the subject itself to symbolize motion.

When photographing sports or other action, we can shoot at "peak motion," when the subject appears to be nearly motionless between up and down. Freezing the subject in mid-act may be the most important and common technique, partly because it can reveal details about the nature of motion that often elude the naked eye, for example, capturing the aeronautic maneuvers of a kingfisher as it lands on a sycamore branch.

SPEED IS RELATIVE TO CAMERA

The speed of the subject is dependent not only on its actual motion but also on its distance from the camera, the direction of travel, and the focal length of the lens. The faster the subject, the closer it is to the camera, and the longer the focal length, the faster the shutter speed need be to freeze motion.

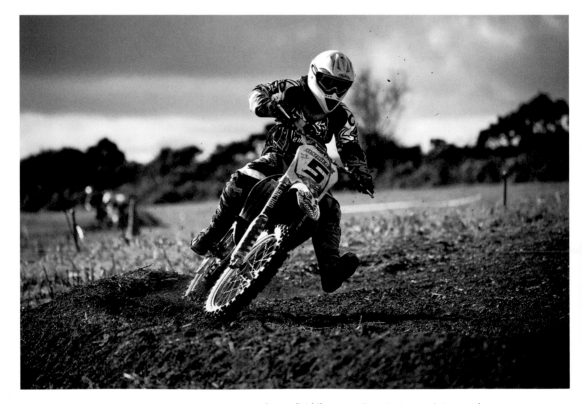

FREEZING ACTION MIDSTREAM—as when a dirt bike racer slows just enough to round a corner—can reveal details missed by the naked eye. **Robin Hynes/National Geographic My Shot** Isle of Man, U.K.

Most action can be stopped with a shutter speed of 1/500. With this selection, the subject will generally not move enough during the exposure to form multiple images on the sensor, which are the essence of blur.

■ **IF FREDDY IS RUNNING STRAIGHT** at you in good light, the movement relative to the camera is minimal, so a speed of 1/500 might be perfectly adequate.

■ **IF HE'S RUNNING HORIZONTALLY** across the frame, however, a faster shutter speed such as 1/1000 will be needed.

■ **A SUBJECT THAT IS CLOSER TO THE CAMERA** will be covering space across the digital sensor frame faster than one that is far away, so we may even need a shutter speed as fast as 1/2000, as long as light level permits it.

■ **IF THE AVAILABLE SHUTTER SPEED** is not adequate, a higher ISO—such as 800—will allow you to gain you a few more shutter stops and get a faster shutter speed. High ISO may result in a little "grain" in the image, but that might be better than a blurry subject.

▶▶**If your subject is running through the frame,** make sure to compensate for the speed at which he or she is moving before you press the shutter. Otherwise, you may cut off part of the subject you want to show.

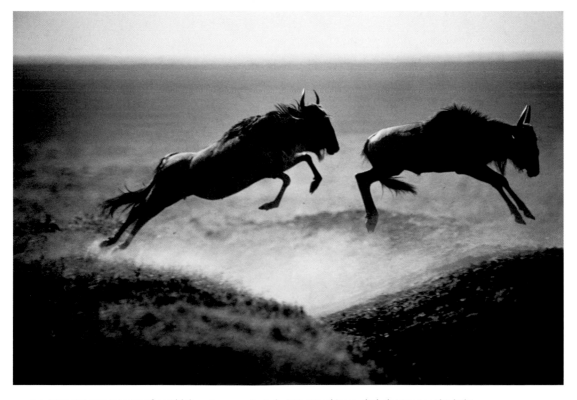

TO CAPTURE THE SPRINT of a wildebeest, a very fast shutter speed is needed, decreasing the light reaching the sensor and necessitating a higher ISO. **Bruce Dale** Marsabit Game Reserve, Kenya

▶Blur Effect

WHEN DOES A MISTAKE become a creative image? When we accidentally photograph a moving object without the proper settings, yet nevertheless find a pleasing picture on the screen. Blurring can be infuriating, a sign of a wasted shot, but intentional blurring can also be a usefully artistic technique. Our eyes see much of the world out of focus; we are used to a blurred landscape flashing by on the highway. Sharp is what we expect in reading type.

ISOLATE THE SHARP

The most obvious way to create blurred motion is with shutter speeds slower than 1/60. The action will float across the sensor, trailing multiple images. Another technique is to hold part of the image sharp. This can be accomplished by "slow-sync flash" settings that fire a flash in the middle of a long exposure. A similar image emerges if we put the camera on a tripod and open the shutter for a minute or more; the moving parts around the subject will become blurred, but the stationary objects will remain crisply in focus.

STREAKS OF HEADLIGHTS

Another situation for blurring for effect is on city streets at night—where cars appear only as streaks of headlights while buildings stay in focus. The moving water of rivers and fountains is often blurred to give a smooth, milky appearance of movement; stop-action tends to render water in a visually unnatural state—not moving. Blurring can also be useful at sporting events, especially motorsport races. A speeding car gives no hint of movement when it's frozen in action—it could be parked. But if we choose a lower shutter speed and blur the wheels, the picture will gain a sense of energy and speed.

▶FOR MORE ON SHUTTER SPEED, SEE PAGES 70-3.

▶▶ Try different shutter speeds to see how each setting affects movement. Start with one-thirtieth of a second and move down all the way to two or three seconds.

AS CROWDS MILL, the king remains at the center, unswerving. A slow shutter speed and steady focus, thanks to a tripod, captures the movement of museum visitors around the object they are viewing. Even the reflections in the glass case blur, but the sculpture inside stays sharp.
Kenneth L. Garrett Cairo, Egypt

▶Panning

▶FOR MORE ON CONTROLLING SHUTTER SPEED, SEE PAGES 72-3.

MOVING THE CAMERA usually results in unwanted blur, but if we move it intentionally to track a moving train, airplane, or runner, we can produce dynamic images that simulate action. This technique is called panning, and it will result in a semisharp moving subject against a totally blurred background, giving the impression that the entire scene is hurtling along.

ONE FLUID MOTION

The technique is to follow the subject with the camera as it passes in front of you, continuing to follow it as you press the shutter and even after the shot is taken. It should be one fluid motion, as if you were on a motion-picture camera track. To ensure smooth results, follow these steps:

- **PREFOCUS THE CAMERA** at a point where your subject will pass.

- **MAKE SURE THE BACKGROUND** has a compatible light and is not too full of clutter that might appear as unwanted shapes or streaks that spoil the effect.

- **SET SLOW SHUTTER SPEEDS,** perhaps as low as 1/15 or 1/30.

▶▶ **If hand-holding your camera** while panning, keep your elbows tucked close to your body to stabilize the camera as you move. This will help you follow in a more fluid motion so the subject stays somewhat sharp while the background is blurred.

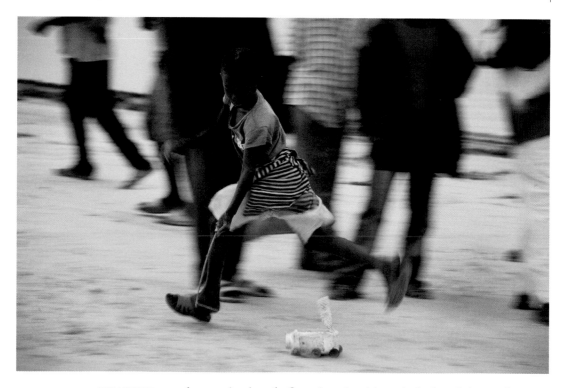

THE EXCITED RUN of a young boy from the Congo is captured dramatically through the use of panning.
Skip Brown Lower Zaire River, Democratic Republic of the Congo

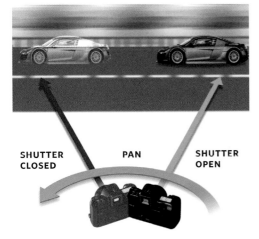

SHUTTER PAN SHUTTER
CLOSED OPEN

PANNING IS A SIMPLE IDEA and a photographic technique that can produce dynamic and unique images of things in motion. It takes much practice to master the technique, however, so that the series of exposures join into one image of fluid motion.

■ **KEEP YOUR FEET STILL,** and rotate the top half of your body as you track your subject.

For a more dramatic pan, the front of the subject should remain somewhat focused and the back end should blur into a long streaking tail, creating a sensation of movement. Good pans take practice.

FOCUS TRACKING

Focus tracking is similar to panning in that the camera follows a moving subject, but it is an automatic function that results in a sharp picture of a moving object rather than a creative blur. The program calculates the speed of the subject, and the camera itself focuses and positions the lens to capture the still center of the motion..

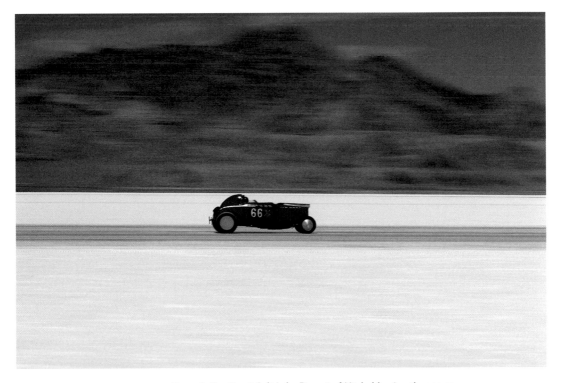

A CUSTOM-BUILT RACE CAR zooms through the Great Salt Lake Desert of Utah, blurring the scenery like a fleeting memory. **Walter Meayers Edwards** Bonneville Flats, Utah, U.S.

▶ The Value of a Tripod

▶ FOR MORE ON PACKING TO TAKE PICTURES WHILE TRAVELING, SEE PAGES 336-7.

TRIPODS ARE A NECESSITY for most kinds of slow-speed photography—or for any time you cannot hold a long lens steady. Professional sports photographers, for example, need sturdy tripods to support their bulky super-telephoto lenses. Tripods allow the camera to pan smoothly to track a moving subject, while the camera is held steady along the other axes. Monopods—one-legged supports—can give the flexibility to quickly move up and down, and a quick-release mount allows quick removal of the camera for handheld shooting.

■ 10 WAYS TO STABILIZE A CAMERA

1. Use a beanbag to brace the lens on a flat surface.

2. Lean the camera on any stable object, such as a bottle or glass in a restaurant.

3. Make a support by holding your opposite shoulder and put camera in the crook of your elbow.

4. Brace the camera against a door frame.

5. Hold your breath while pressing the shutter.

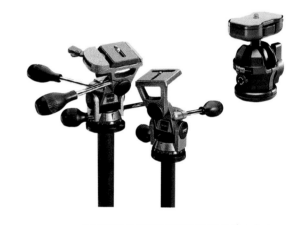

A TRIPOD IS A VERSATILE TOOL in the photographer's kit bag, often equipped with adjustable telescopic legs, multidirectional controls, and a quick-release mount.

6. Lean against a solid object for added stability.

7. Always use the viewfinder as opposed to the "live view" on the LCD.

8. Wrap the camera strap tightly against your hand or elbow.

9. Make sure you are standing in a stable and grounded position.

10. While sitting on the ground, rest the camera on your knee—effectively making a T.

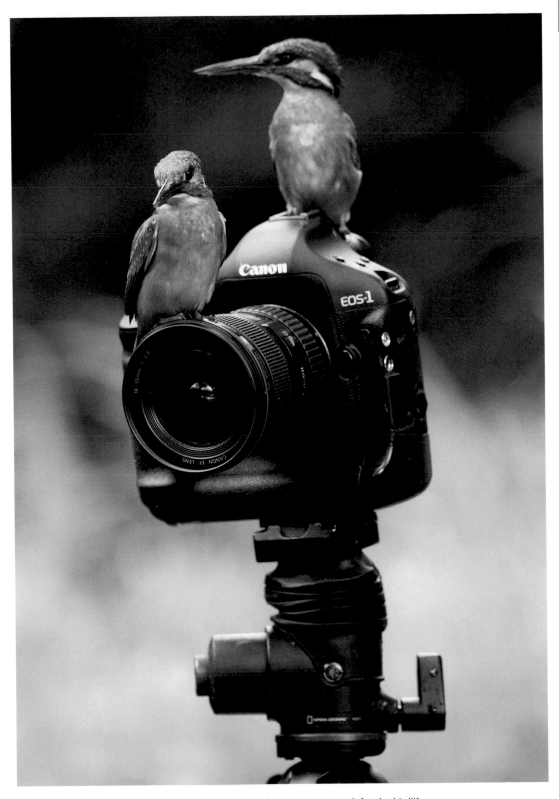

HERE'S ANOTHER USEFUL FUNCTION of a tripod-mounted camera: as a perch for the birdlife you are trying to photograph! **Joe Petersburger** Lábod, Hungary

□ WHAT MAKES THIS

DUSTED WITH RED POWDER, GANESH CHATURTHI Steve McCurry Mumbai, India

A GREAT PHOTOGRAPH?

THIS PHOTOGRAPH, made during the Hindu festival of Ganesh Chaturthi, was taken by one of the finest photojournalists working anywhere. Steve McCurry has spent many years getting to know the land and people of South Asia.

SUBJECT "Who are you?" This is the question in the eyes of the boy. He is looking beyond the camera to the sensitive human being holding it. At the same time, the photographer helps us look beyond the unnatural color of festival powder to see the human being inside

COMPOSITION You feel the power of the vertical column, which anchors the boy and strengthens the diagonal tilt of his face, allowing us to look straight into his eyes. Behind the boy is another figure, who balances the composition and drives you back to those powerful eyes.

LIGHT In the inner-city slums of Mumbai, there is often very little daylight. Steve needed to use a wide aperture to capture this informal portrait accurately.

EXPOSURE For the eyes to come across with such strength, the exposure had to be just right. The surest way to accomplish that is to measure with an incident light meter—thus the perfect exposure. If the light had been measured from the red dye alone, the image would have been overexposed.

–James P. Blair
NATIONAL GEOGRAPHIC
PHOTOGRAPHER

6 The Digital Lightroom

THE OLD PHOTOGRAPHIC DARKROOM, with its amber safe light and pungent odor of fixer solution, is nearly as obsolete as the village blacksmith's shop. Digital photography and computer software have liberated most photographers from the chamber of darkness, from caustic chemicals and "souping" photo paper in messy trays. Great photographs can now be processed and enhanced on your laptop, even while you're lying in bed or sitting in an airport. Adobe Photoshop is the common software used to process "raw" or compressed photo files, and this chapter will take you through the basic steps of preparing photographs on Photoshop, using a single image so you can see the differences clearly. The image is a snowy portrait of Muldoon, a member of National Geographic photographer Joel Sartore's family. By following Muldoon's adventure through the software, you can see how to make your photographs look their best.

A YOUNG GIRL proudly lifts a photograph from the "good ol' days," when darkroom processing was necessary to display every trophy shot. **Lynn Johnson** Silt, Colorado, U.S.

▶ Computers & Cameras Today

TODAY'S TECHNOLOGY enables us to be technicians; modern cameras allow us to examine and judge each image through the entire process, to trash images if they are poor, and to keep consistent quality control. The technology has also miniaturized the equipment; everything we need for superb pictures fits into a briefcase.

Digital cameras, even those that are gratuitously called "point-and-shoots," now come with high-quality lenses and bodies stuffed with advanced electronics. These smaller and simpler cameras don't offer the creative options of larger digital single-lens reflex (DSLR) versions, but remain useful for even advanced photographers, who often have a need to be unobtrusive.

Then, at home, in the digital lightroom, photographic software, linking the camera to the computer operating system, simplifies editing, sorting, and filing.

MEET MULDOON, National Geographic photographer Joel Sartore's dog, who is the star of this chapter. Muldoon is particularly good at smiling for the digital camera.
Joel Sartore Nebraska, U.S.

AN EASY-TO-ACCESS computer interface allows the photographer to scan, pick, and choose the images worthy of further manipulation. The rest go into the digital recycle bin.

▶Raw Files

VIEWING A RAW FILE on your computer, you can learn many details about the photograph: color temperature, shutter speed, aperture settings, and file size.

7–55@17.0 mm)

ghlights R: --- G: --- B: ---

Settings: [Camera Raw Defaults ▼] - ▶

Adjust Detail Lens Curve Calibrate

White Balance: [As Shot ▼]

Temperature 5500

Tint +10

Exposure ☑ Auto +0.35

Shadows ☑ Auto 29

Brightness ☑ Auto 52

Contrast ☑ Auto +34

Saturation 0

(Save...) (Cancel)

(Open) (Done)

THE RAW FILE FORMAT is exactly what it sounds like: a process that produces "uncooked" or unprocessed images within the camera. Digital cameras, unless we set them otherwise, will produce images in compressed-file formats such as JPEG. These compressed files are the software's best reading of the ideal image in terms of color temperature, tonality, hue, and white balance. This, of course, may be entirely different from what the photographer sees, or wants to see. The compression process drops much detailed information, whereas a raw image contains the complete information package to be processed as we like. Raw files are sometimes called "digital negatives," because they are to digital photography what unprocessed negatives are to the film process.

But raw files are huge, two to three times the size of compressed files, and take up more space on the memory card. Raw files are not for people who hope to squeeze as many photos as possible out of the card. In more expensive DSLR cameras, the raw-file system is proprietary, exclusive to that camera manufacturer, although there is a groundswell to expedite a standard raw format for all equipment.

Raw files give the photographer great latitude in handling and editing. Even if he or she missed the correct exposure in the field, software editing can correct it. A raw image will contain detail in all of the tones—from the bright areas (highlights) to neutral areas (midtones) to dark areas (shadows)—color integrity, color saturation, and an overall crisp image. The Camera Raw plug-in feature that will appear on the Photoshop screen (see left) usually gives a histogram, a preview screen, and a series of controls, beginning with white balance and ending with saturation.

▶Auto Adjustments

THROUGH AUTO ADJUSTMENT, the computer software examines highlights and shadows and adjusts overall brightness, but it may cause weird color shifts or make the subject too dark or light.

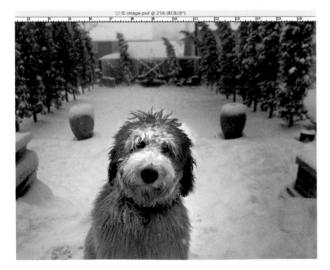

PHOTOSHOP SOFTWARE allows us to make many of the same corrections as the palette for raw files. The goal of all these corrections is to achieve tonality—the most pleasing relationships between shadows, midtones, and highlights. The tools in a Photoshop Image menu include an Auto Levels selection that automatically enhances the image according to the program's own standards. There are two other automatic settings, for contrast and color, plus several more controls that give the individual photographer a chance to use his own judgment—for contrast, color, brightness, hue, and color saturation.

▶Layers

BY LEARNING TO MANIPULATE LAYERS, you will have a way of watching your digital adjustments as they change the appearance of your photograph, then picking and choosing what works best.

THE CONCEPT OF LAYERS is one of the advanced tools of photo-editing programs such as Adobe Photoshop. Layers, as the word implies, consists of images electronically stacked on each other. Also called "adjustment layers," these can be separate photographs or just parts of an image. In simpler terms, they are like plastic overlays, either clear or opaque. By stacking these layers together, we can make adjustments to our images without losing the integrity of the original photograph, or we can create entirely new images.

In most digital editing, data can easily be lost with a series of small changes. With the layers system, though, there is no fear of losing anything, because the changes are embedded in the layers and not actually parts of the original image.

Any levels, curves, hue/saturation, or contrast information that we need can be placed on a layer. Layers change the look of pixels underneath them without actually touching them, so nothing is destroyed in the process; everything can be retrieved as necessary. Another helpful attribute of layers is that we can go back and edit them—even after we've moved on to new layers—by double-clicking the adjustment icons.

▶FOR MORE ON LAYERING IN COMPOSITION, SEE PAGES 104-5.

▶Exposure

▶ **FOR MORE ON UNDER- & OVEREXPOSURE, SEE PAGES 74-5, 134-5.**

THE WORD "EXPOSURE" applies to different processes. It's the combination of settings on the camera that makes a good picture, but it's also a correction tool in the Photoshop arsenal that offers a second chance to get it right. When working with a raw image, the exposure setting will simulate the actual settings used when the photograph was taken, which provides a lot of latitude. But when working with a compressed file (JPEG), the exposure settings can adjust only the overall brightness of the image, and we often lose crucial details because any changes also readjust all the other tones. The adjustment values correspond to the same f-stop setting on your camera: +1 equals a one f-stop increase in exposure, while –2 would equal a two-stop decrease. The gamma-correction slider changes contrast in the image, and the offset slider darkens the shadows and midtones, with little effect on highlights.

EXPOSURE SETTINGS change the overall brightness of an image, but adjusting exposure on JPEGs rather than raw files can lose a lot of crucial details and tone, as shown above.

▶ Levels

LEVELS ARE A DIFFERENT and more accurate method to adjust the shadows, midtones, and highlights of an image in a way that controls the amount of change in each. The program enables us to make changes to the specific tones of an image, thereby reserving detail in those we wish to leave unchanged.

Click on the Image menu and open the Levels tool. This presents a histogram that charts the tonal range: dark to the left, bright to the right. There are no pure blacks or pure whites in the image if the shape does not lean against the sides of the box.

Beneath the histogram are three triangles of black, gray, and white—representing the tones they alter. When we adjust the black or white, the midtone slider moves as well; this maintains the relationship of the midtones to the highlights and shadows. If that doesn't work, we can readjust the midtones back to their original position. A good method is to begin with the slider that controls the areas most important to the photograph, and then adjust the other two. If the adjustment is not satisfactory, we can go to Edit and undo the Levels effect.

▶ **FOR MORE ON RANGE OF LIGHT & HISTOGRAMS, SEE PAGES 132-3.**

▶▶**Use the latest version** of your image-editing software. You can update most software on the Internet, either through the software's Help menu or through the website.

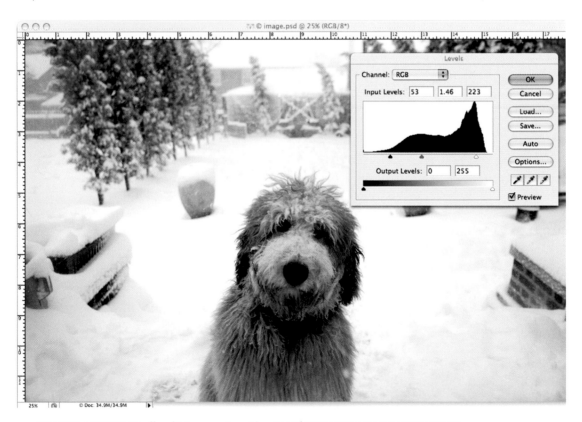

THE LEVEL ADJUSTMENT offers histograms to guide you and represents a more accurate way to adjust the shadows, midtones, and highlights of an image, controlling change in specific areas.

▶Curves

CURVES IS THE MOST precise tool for adjusting exposure in Photoshop. It controls the light or dark tones of an image separately, without disturbing or changing the level of the others. Curves opens from the Image menu under Adjustments. It gives us a chart with a diagonal line that goes from lower left to upper right (see below). The line represents all the tones of the image, from the deepest shadows on the lower left to highlights at the upper right

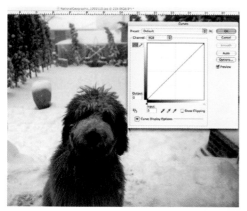

If you grab the line with the cursor, you can move it up (left) and down (right), changing the tones of the photo. Moving the curve up makes the image lighter; moving it down, darker. As the curve gets steeper, contrast increases.

To adjust just one part of the image, move the cursor over that part and option-click (Mac) or control-click (PC). This will place an "anchor point" on the line in the position that corresponds to the tone that you've selected. There are then two choices:

- Move the anchor point itself to adjust that tone to its surroundings, or

- Keep the anchor in place on the line, and adjust the line to change tones around the anchor.

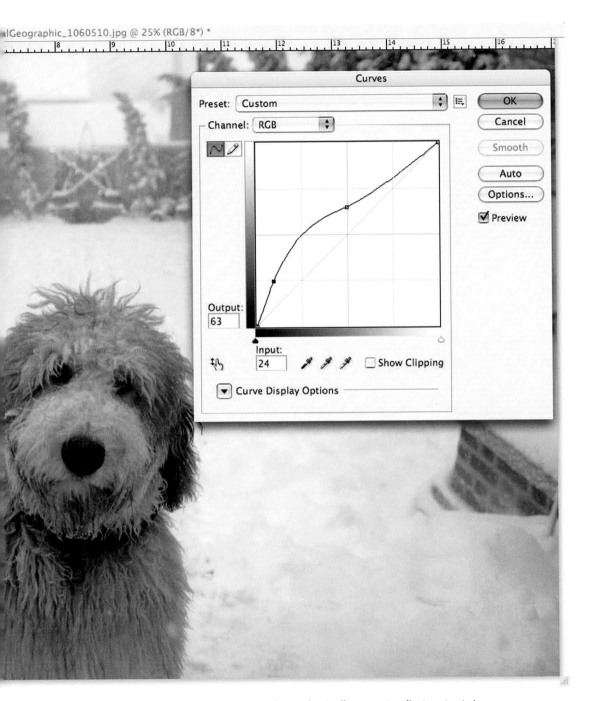

THE ADVANTAGE OF THE CURVES FUNCTION in Photoshop is that it allows you to adjust contrasts in light and dark in proportion to one another in a single operation. Instead of washing out the snowy background while lightening the details of Muldoon's face and fur, the photographer can select particular areas of a photograph in which to anchor the function and localize changes there.

☐ Joel Sartore: MY PERSPECTIVE

YOU MIGHT THINK I've lived a glamorous life in my two decades on assignment for *National Geographic* magazine. After all, I've been obliged to eat llama head, guinea pig, piranhas, and live beetles. I've been chased by bees, grizzlies, musk oxen, and a variety of bad guys. I've been deafened by a fungus, been bitten by three dogs at once, and had a flesh-eating, microscopic parasite blow a big hole in my leg.

To be sure, the job has its hazards. But in all my years of roaming Earth with a camera, perhaps the one thing that haunts me more than anything else is this: The world is a very crowded place. Humans number almost seven billion now, and that has real and devastating consequences for the natural world. As a photographer, I've seen that the intricate connections between all species— from the smallest insects to the largest trees—are fragile and threatened. As I see it, my job is to get people to care while there's still time.

Regardless of location and advances in technology and equipment, the basic foundation of good photography never changes. From polar bears to penguins, from cowboys to carnival workers, each has a story to tell. And a great image will always stop people in their tracks. That's the real prize—and power—of photography. —J.S.

IN HIS 20 YEARS with National Geographic, JOEL SARTORE has focused especially on endangered species and land use issues. His most recent book is *Rare: Portraits of America's Endangered Species* (National Geographic, 2010). He is committed to conservation, especially in the Great Plains, where he has lived his whole life. Joel Sartore was named the 2010 Photographer of the Year by the North American Nature Photography Association.

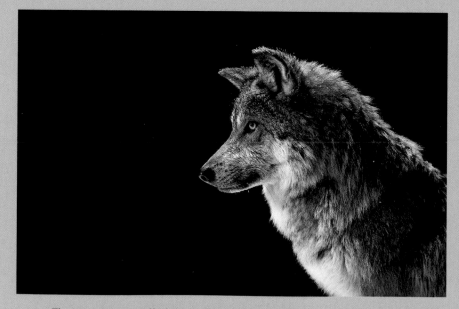

The Mexican gray wolf, photographed here in captivity, struggles for survival in the wild.

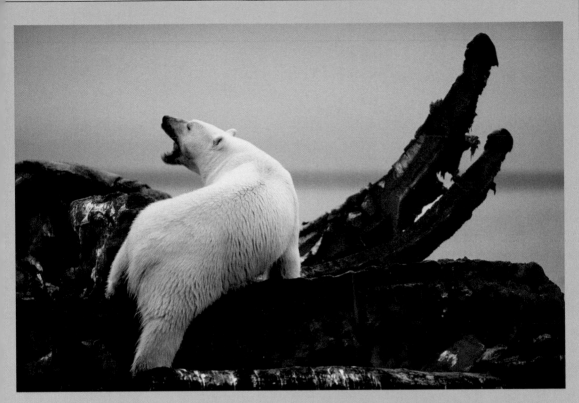

A polar bear feeds on the jaws of a bowhead whale harvested by natives in the Arctic National Wildlife Refuge.

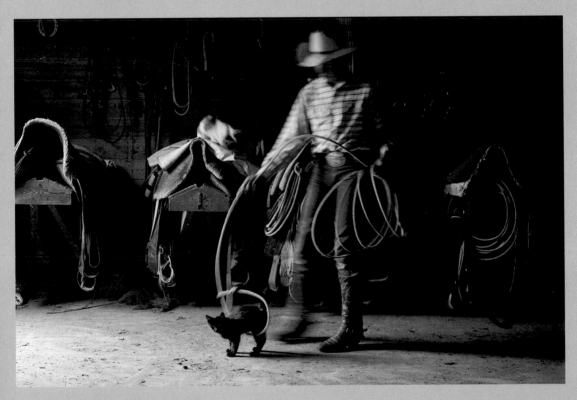

Justin Johnson of Post, Texas, hones his roping skills.

▶ Hue & Saturation

▶ FOR MORE ON
LIGHT & COLOR,
SEE PAGES
28-9, 116-7,
120-1.

THE ABILITY TO MODIFY and correct color processing has been a boon for photographers over the past 15 years. Color processing had long been a hit-or-miss proposition, with print color decisions often made by an anonymous minilab employee. The photographs that came back from the lab were often far from what we might have imagined or wanted. Now the color of the computer image can be manipulated and enhanced by an increasing number of controls on Photoshop and other software. (Transferring those tonal details to paper prints is the subject of another body of knowledge.)

Pulling down the Photoshop Image menu (see below) reveals that color modification has three basic controls: Hue, Saturation, and Lightness:

■ **HUE** adjusts the purity of the color—the difference between cobalt blue and aqua blue, or the exact blue of someone's sweater.

■ **SATURATION** fine-tunes the intensity and deepness of a color.

THE HUE OF A COLOR determines its shade—greenish yellow or reddish yellow, for example. Adjustments in hue can have a big impact on how your photo looks, especially with skin tones.

■ **LIGHTNESS** is a control that will brighten an image, though pros use it sparingly because it is so one-dimensional; increasing or decreasing the lightness will impose the same effect over all the tones in the image, somewhat like a neutral-density filter but muddier. A better program to control the brightness in an image is Levels.

Many people start the color modification process with saturation control—and promptly overdo it. More saturation makes the colors look much more vibrant, but soon they turn downright garish. A reasonable saturation level will often be around +10 to +15 on the slider scale. If the image has too much color, we can add saturation, but adding to an image with very bland colors can make the color itself look artificial.

The hue adjustment can create radical effects with just a little push, too. Hue should be corrected on an image with incorrect or unwanted color cast—for example, if you shot a vase of flowers in tungsten light, and you now want to show its true, daylight color.

COLOR SATURATION means how much color there is. Here, the lower photo of Muldoon has too much saturation. His tans look orange because saturation drew out the golden tones in his coat.

►Cropping

►**FOR MORE ON THE RULE OF THIRDS IN COMPOSITION, SEE PAGES 86-7.**

CROPPING IS the admission of a mistake in composition. Some purists dislike cropping; they believe that the full frame should stand on its own, like a finished canvas. For example, if the portrait of a young woman on the streets of Paris is marred by a bright yellow car that entered the frame as you pushed the shutter, is the picture more authentic if we leave in the car? Some even insist that their images retain the black borders of the frames that surround them, just to make the point. They think that cropping undercuts the integrity of the image.

But for the everyday photographer, cropping can be a positive way to enhance an image. It is a way of cutting to the quick—zeroing in on what's important and rejecting what may be distracting or superfluous—and increasing the power of an image.

The Photoshop cropping tool is wondrously simple. It allows us to see a preview of the intended crop by darkening each portion of the image as we shrink or expand the area to be cut. Photoshop also displays figures for width and height, to help us crop to a specific size.

►►**Rename photo files** when you download or scan them. That's the best time to change file names from something like 983818.jpg to grandcanyon1.jpg.

WITH THE CROPPING TOOL, you can choose a shape *after* you shoot a picture. With some applications, you can set specific ratios so your final image is cropped to a certain shape, such as an 8x10 print.

▶ Sharpening

PHOTOSHOP CAN ADD sharpness to a photograph through "edge contrast," where light and dark areas meet. The sharpening tool is called Unmask, found from the Filter menu. It has three controls: Amount, Radius, and Threshold:

- **AMOUNT** defines the amount of contrast increase at the edge between light and dark.

- **RADIUS** adjusts how far from these edges the increase in contrast is made, or how finely the sharpening is applied.

- **THRESHOLD** determines what areas of contrast will receive the sharpening; a small number means areas with lesser contrast will be sharpened.

Start with a radius of around 1 and a Threshold somewhere above 100 percent. Experimenting with this tool is the best way to learn how to use it.

▶ **FOR MORE ON FOCUS, SEE PAGES 58-9.**

SHARPENING A PHOTOGRAPH will allow many small details to flourish within the image, details captured but not necessarily visible.

EVEN A CLEAR PHOTO can often be improved by sharpening. Sharpness involves a trade-off with the graininess or "noise" in a photograph. Use it too much, and the image begins to lose its smooth tones.

▶ Converting to Black and White

▶ FOR MORE ON
CHOOSING
BLACK & WHITE,
SEE PAGES
372-3.

IN SOME PHOTOGRAPHS, color is the dominant value; without it, the image would not work. For black-and-white photographs, however, we shoot with a different eye: Composition and illumination values become dominant. Some color photographs would fail if they were converted to only black, white, and shades of gray. Others would gain; these are the ones we would convert with Photoshop's built-in tools.

Although the black-and-white format is less frequently used, these photographs remain valid and often powerful. Photoshop's tools don't just turn the values to gray across the board; they also allow us to customize the values of gray to match the colors that make up the photograph, thus giving us more control. Photoshop allows us to do the conversion in several ways. The simplest and quickest requires only a few clicks. Start with the Image menu and choose Adjustments. In the Adjustments menu, click on Desaturate, and finally on Grayscale. A variation of black-and-white conversion is toning, which adds a slight tint of brownish or sepia color to the grays. Toning is often used to add an old-fashioned feel to the photographs.

▶▶ **When buying a printer,** consider: type of printer, connectivity, paper-handling capacity, printing speed, paper path and thickness range, ink type, and cost of printing.

SOME IMAGES BENEFIT from the character and emotion of black-and-white photography, but you don't have to go back to using film, since computer manipulation of digital photographs makes converting from color to black-and-white a simple lightroom task.

▶ Dodging & Burning

DODGING AND BURNING have long been darkroom procedures that allow film photographers to control an exposure literally with their hands. Dodging, or lightening an area of the image, involves waving an object, usually an opaque disc, under the beam of the darkroom projector to keep light from reaching the emulsion. Burning, or darkening an area, means adding light to parts of the emulsion by shielding all but certain spots. This is usually done with a piece of cardboard that has a hole in it, or with your hands, artfully letting only a small beam of projector light reach the image. A common use of dodging would be to brighten an individual's face so that his features can more easily be seen. An example of burning would be to darken parts of an image whose lightness is distracting to the main subject.

In digital photography, these functions keep their names, are integral to the suite of Photoshop tools, and are manipulated by mouse movements. Dodging and burning allow us to selectively work on shadows, midtones, or highlights and are tuned for small changes. Depending on the specific version of Photoshop or plug-in, select a "brush" with a feathered edge, and set the exposure, or strength, of the tool between 5 and 6 percent to start. Both of these steps assure that the changes will be subtle. The changes can be made directly onto an image, but a safer way is to place them on a separate layer, or overlay. From there, they can be harmlessly discarded if necessary.

▶ FOR MORE ON PRINTING BASICS, SEE PAGES 192-3.

COMPUTERS MAY AID IN DODGING AND BURNING, but they are still tricky processes. Here, after the photographer dodged Muldoon's snout, it looks as if there is a light shining on him from above.

▶ Printing Basics: Resolution

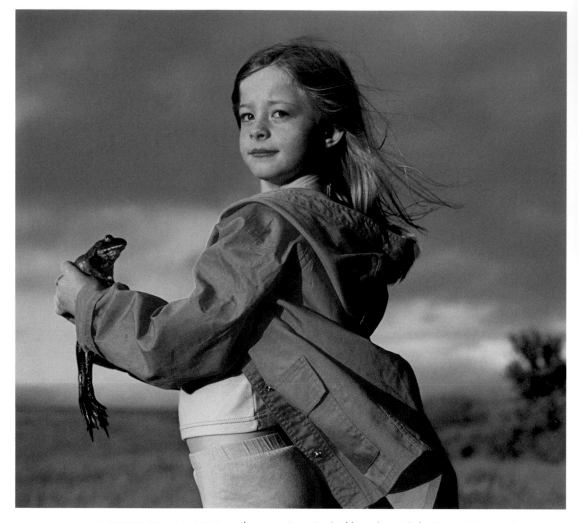

A PICTURE CAN LOOK SHARP on the computer yet print blurry (opposite), since printing requires more pixels for the same size.　**Joel Sartore**　Nebraska, U.S.

▶ **FOR MORE ON ISO & SENSORS, SEE PAGES 68-9.**

THERE ARE THREE kinds of resolution to consider: camera resolution, image resolution, and print resolution. The first two are electronic and are measured in pixels. The last, print resolution, is based on placing bits of ink on something—such as a piece of paper—and that process is measured in dots. A dot can be considered the real-world equivalent of an electronic pixel.

Print resolution is the number of dots per inch that are being printed to a page. More dots means a higher-resolution image. The more dots per inch required to print, the more pixels you will need to print at a given size.

To know the biggest print you can make on your 200-pixel-per-inch printer, you figure out how wide it can be (2,128 pixels divided by 200 pixels per inch = 10.64 inches) and how high (1,416 pixels divided by 200 pixels per inch = 7.08 inches). You can make it bigger, but detail will decline.

▶▶**Inkjet printers are optimized** at 300 pixels per inch (ppi), but most models produce excellent results even at 240. Lower resolution allows larger prints without significantly increasing the size of the image file, cutting your risk of losing image quality.

▶ Storing & Sharing

▶▶ **Proper storage of photographic prints** involves three factors: cool temperatures, a dust-free place, and air circulation.

PRESERVATION is as much an artistic endeavor as it is an organizational tool. Which pictures become the ones family members remember and why? **Joel Sartore** Nebraska, U.S.

▶ FOR MORE ON
SHARING,
SEE PAGE 395.

ELECTRONIC FILES all of a sudden seem ethereal when they're lost to power failure or computer error. That's why the goal should be to have two copies of everything in storage.

They can be on two separate hard drives or, better yet, an extended archival drive that connects by way of a USB port or fire wire plugged in only when it's being used, to protect against damage from power surges.

Images can also be stored online; there is no equipment to buy, the images are quickly accessible, and they are stored at a location unconnected to your own system.

DISC STORAGE

Perhaps the safest way is to transfer the archives to CDs or DVDs, pack them in their jewel cases, and store them upright where it's not too damp or hot. Compact discs can deteriorate just like our old paper-and-glue photo albums. It's important to keep not only the bottom of the discs clean and scratch-free but also the tops. Disc tops can also be damaged by identifying stickers and permanent markers (markers made specifically for this purpose are commercially available). And don't store the discs in a stack, with other things piled on top of them; the weight can distort them over time.

YOUR OWN ALBUMS

Sending high-resolution photographs online in bulk is often impossible because of the large size of the files, but many software packages and companies such as Shutterfly and Picasa offer ways to share photos with friends. Other firms offer ways to build digital photo albums and greeting cards—even books.

□ WHAT MAKES THIS

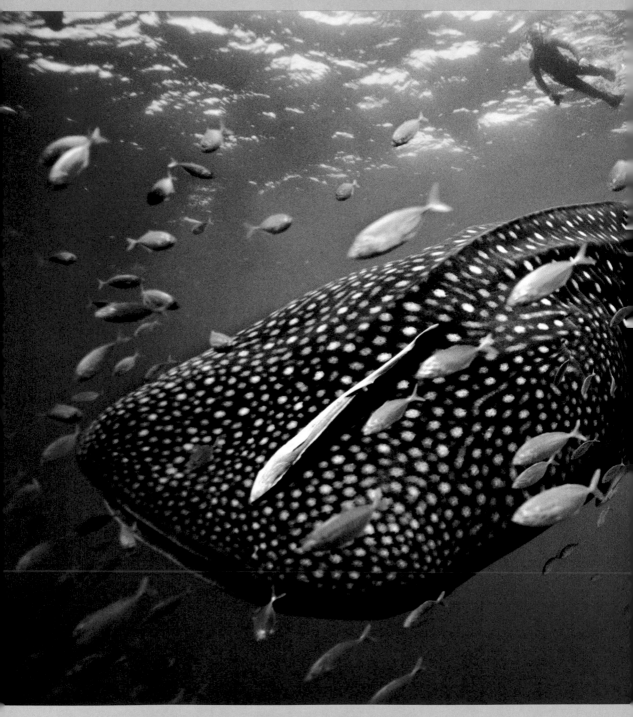

WHALE SHARK Brian Skerry Australia

A GREAT PHOTOGRAPH?

THIS IS AN AMAZING, otherworldly image. It shows the mastery of Brian Skerry at photographing marine life.

SUBJECT The largest fish in the sea, whale sharks can grow to more than 40 feet, weigh 40 tons, and live for 70 years. The small fish in the photo are safe from the filter-feeding giant, whose trademark polka dots provide a measure of camouflage from big predators. Even for experienced divers, a scene like this is likely a once-in-a-lifetime opportunity.

COMPOSITION Brian made all the classic elements work: the silhouette of the diver, who watches the shark and its entourage pass; the three-quarter view of the scene; and the movement from one side of the frame to the other. The angle at which the shark approaches the photographer is thrilling.

LIGHT Light is tricky underwater: Even near the surface, natural light has a tendency to turn everything bluish. But in this case, that's exactly what Brian wanted.

EXPOSURE An aperture of F8 and a shutter speed of 1/125 of a second are perfect settings for this photograph. It often happens that your best shot comes when you have only one chance to get the picture. Getting the settings right in a hurry, especially underwater, is not something many people can do—but Brian Skerry did.

—James P. Blair
NATIONAL GEOGRAPHIC
PHOTOGRAPHER

Part II

TIME LINE OF PHOTOGRAPHY

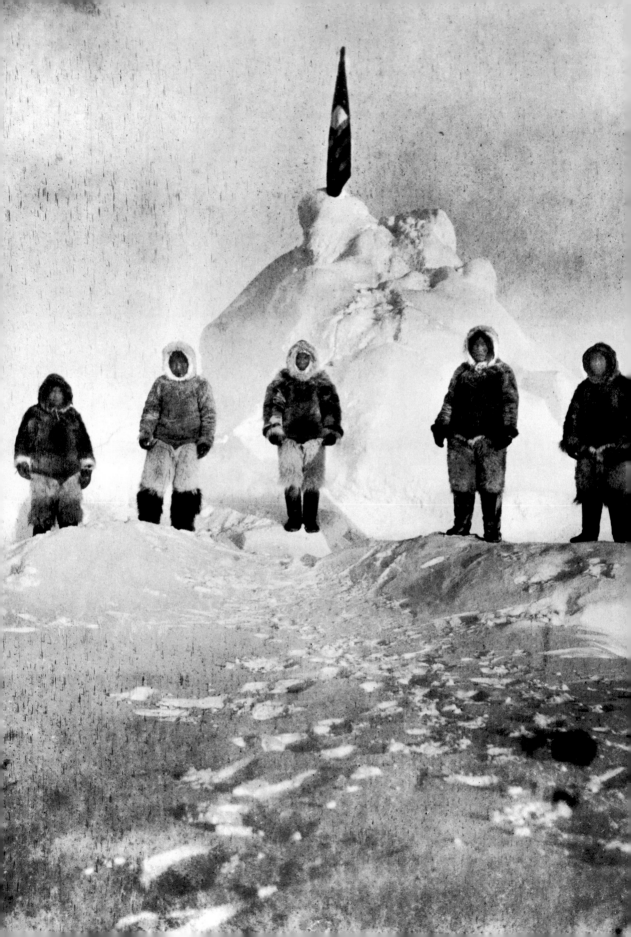

Centuries of Seeing

THE ANCIENT GREEKS considered *mimesis*, or the imitation of nature, to be the soul of art, but only centuries later did the technology exist to record images without the artist's interpretation. By the middle of 19th century, thanks to advances in chemistry and optics, cameras were recording every aspect of experience imaginable, from family gatherings to explorers' discoveries, from dancers in the limelight to soldiers on the battlefield. Photography came to be seen as an art medium in itself, while also becoming an essential tool of science, expanding our ability to peer out into the galaxies and into the microscopic world, recording phenomena never before seen. Now, in the 21st century, photographic media define our very identities, having become commonplace and essential in communication, entertainment, science, art, and everyday life.

FROM POLE TO POLE: Once explorers could, they photographed their accomplishments—such as this shot of Robert Peary and his team at the North Pole in 1909.

▶Up to 1810

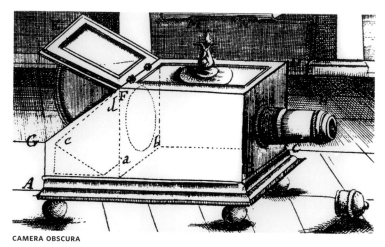

CAMERA OBSCURA

1490
Camera Obscura

IN PRACTICE since ancient times, the camera obscura—literally, "dark chamber"—is noted by Leonardo da Vinci in his notebooks. Venetian Daniello Barbaro suggests it as a drawing aid at about the same time.

"Light entering a minute hole in the wall of a darkened room forms on the opposite wall an inverted image of whatever lies outside." —Leonardo da Vinci

1490

1500 1550 1600

1796
Lithography

LOOKING FOR CHEAPER ways to publish his writing, German actor and playwright Alois Senefelder develops a printing process based on the repellency of oil and water, which he calls "lithography." With this plan, he believes he can "earn a decent living" and "become an independent man." The process is the first to use stone instead of copper plates.

LITHOGRAPH ENGRAVER

1727
Light & Silver Chloride

IN GERMANY, Johann Heinrich Schulze discovers that a mixture of chalk, nitric acid, and silver salts darkens in sunlight. His discovery, combined with the camera obscura, lays the foundation for photography.

CARL WILHELM SCHEELE

1777
Light Sensitivity of Silver Salts

IN HIS BOOK *A Chemical Treatise on Air and Fire*, German-Swedish chemist Carl Wilhelm Scheele publishes the results of his experiments with oxygen and nitrogen and notes that sunlight reddens nitric acid and blackens silver chloride.

"Paper impregnated with silver chloride blackens unequally under the different colors of the spectrum and much more rapidly under the influence of the violet rays." —Carl Wilhelm Scheele

1727 **1777**

1700 1750 1800 1810

1796 1802 1807

1802
Silver-Coated Paper

IN ENGLAND, Thomas Wedgwood, son of the famous potter, and Humphry Davy, pioneering chemist, discover that paper coated with silver nitrate turns black when exposed to sunlight. Unable to fix the images, they can view them only in near darkness.

"When a white surface, covered with solution of nitrate of silver, is placed behind a painting on glass exposed to the solar light, the rays transmitted through the differently painted surfaces produce distinct tints of brown or black." —Thomas Wedgwood & Humphry Davy

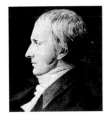

THOMAS WEDGWOOD

1807
Camera Lucida

WILLIAM HYDE WOLLASTON invents the camera lucida ("light chamber"), a four-sided prism on a small stand, as an optical device for sketching. An artist looks through the prism to see a subject in front of it reflected onto drawing paper below.

CAMERA LUCIDA

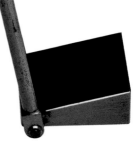

▶1811-1839

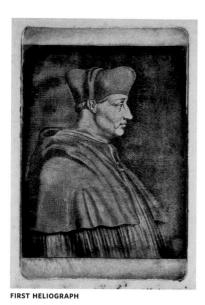

FIRST HELIOGRAPH

"I have succeeded in obtaining a picture as good as I could wish . . . and I ca tell you, the effect is downright magical." —Joseph Nicéphore Niépce, 1824

1822
Heliography

IN FRANCE, Joseph Nicéphore Niépce produces the earliest permanent images using bitumen, a naturally occurring tarlike substance. He coats a glass with bitumen, holds an engraving against it, and exposes it to sunlight. The bitumen hardens where light passes through the drawing lines, and the image remains.

1826
First Permanent Impression

USING A CAMERA OBSCURA Niépce burns a permanent image of a landscape onto a chemical-coated pewter plate. The black-and-white exposure takes nearly eight hours and fades significantly, but an image remains.

1822
1820

1826
1825

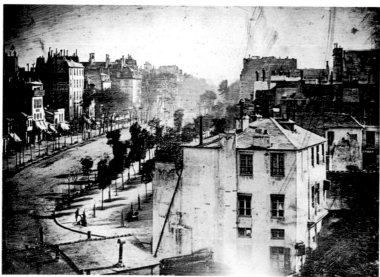

FIRST PORTRAIT OF A STREET

1839
First Photograph of a Person

DAGUERRE photographs a Paris street from his window using a camera obscura and his daguerreotype process. The long exposure time—several minutes—blurs moving objects, but a man getting a shoe shine remains still long enough to become the first person ever photographed.

"Daguerreotypy will never lend itself to portraiture, because the images are too true to nature to please the sitters, even the most beautiful. It has not the least taste for flattery." —François Arago, 1839

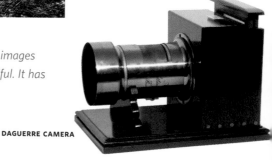

DAGUERRE CAMERA

1837
Daguerreotype

LOUIS-JACQUES-MANDÉ DAGUERRE makes the first *daguerreotype*, "The Artist's Workshop." Two years later he publishes details of the new process. Daguerreotypes yield images of great clarity, yet further exposure to light makes them fade.

FIRST DAGUERREOTYPE PHOTO

"Painting is dead from today on." —Paul Delaroche, 1839

1837 ▲

1835 ▼ 1840

1839

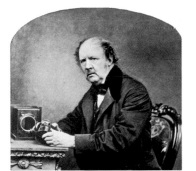

SIR JOHN HERSCHEL

1839
Photographic Fixative

SIR JOHN HERSCHEL, son of the British astronomer William Herschel, develops the process of using "hyposulphite of soda," or hypo, to dissolve the silver salts that cause the image to continue fading in light, thus fixing the image.

1839
Photograms

UNAWARE OF Daguerre's work in France, British scientist William Henry Fox Talbot develops another technique, pressing plants and other flat materials against paper treated with light-sensitive materials and exposing them to sunlight. Where objects cover the paper, it remains white; the uncovered areas turn black. He called the results "photogenic drawings."

1839
First Photo of the Moon

AMERICAN JOHN DRAPER captures the first photograph of the moon through a 12-inch telescope. It takes 20 minutes to make the exposure.

FIRST PHOTO OF MOON

"By means of this contrivance, it is not the artist who makes the picture, but the picture which makes itself." —William Henry Fox Talbot, 1839

▶1840-1849

1840
Calotype Negatives

SCIENTIST William Henry Fox Talbot exposes light-sensitive paper in a camera obscura and develops the latent images with a solution of gallic acid. The negative images need only a minute of exposure time and can be used to print any number of positives.

CALOTYPE

1841
Improved Lenses and Portable Cameras

AUSTRIAN MATHEMATICIAN József Petzval develops an improved lens, which allows more light to enter the camera and improves sharpness of focus for portrait photography. He works with fellow Austrian Friedrich Voigtländer, who also devises a portable camera box for travelers.

"The correct focusing of the image on the ground glass is easily accomplished by the screw attached to the lenses." —Friedrich Voigtländer

1840 ▲ 1841 ▲ ▌1842 ▌1843 1844 ▲

1845
First Photo of the Sun

TAKING ADVANTAGE of a relatively new technology, the daguerreotype, French physicists Hippolyte Fizeau and Léon Foucault made the first successful photographs of the sun on April 2, 1845. The original image, taken with an exposure of one-sixtieth of a second, was about 4.7 inches (12 centimeters) in diameter and captured several sunspots, visible in this reproduction.

FIRST PHOTOGRAPH OF LIGHTNING

FIRST SUN IMAGE

1847
First Photograph of Lightning

AMERICAN PHOTOGRAPHY pioneer Thomas Martin Easterly makes a daguerreotype of a lightning bolt. Primarily a portraitist, Easterly also photographs landscapes, an unusual subject for daguerreotypes.

1847-1856
First War Photography

DURING the Mexican-American War, Charles J. Betts travels to Mexico and advertises his willingness to photograph "the dead and wounded." Great Britain sends several photographers to cover the Crimean War (1855–56) and make the first official war photos; only one, Roger Fenton, returns with good results: 350 images, mainly portraits.

FROM *THE PENCIL OF NATURE*

1844
The Pencil of Nature

WILLIAM HENRY FOX TALBOT publishes the first book illustrated with photographs, calling it the "first attempt to exhibit an Art of so great singularity which employs processes entirely new, and having no analogy to any thing in use before."

1845
Famous Faces

MATHEW BRADY, best known for his American Civil War coverage, begins his effort to photograph famous people in his New York daguerreotype studio. Daniel Webster, Edgar Allan Poe, Walt Whitman, and Abraham Lincoln, among others, pose for Brady.

EDGAR ALLAN POE BY MATHEW BRADY

"The plates of this work have been obtained by the mere action of Light upon sensitive paper . . . without the aid of any one acquainted with the art of drawing." —William Henry Fox Talbot, *The Pencil of Nature,* 1844

1845
1846
1847
1848
1849

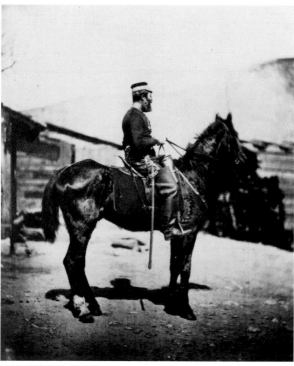

EARLY WAR PHOTOGRAPH

1849
Stereographs

SIR DAVID BREWSTER develops a stereoscope that can be mass-produced, and stereographs become popular. The device holds two images of the same scene taken from vantage points only inches apart, simulating the perspective of human eyes. Held by the stereoscope side by side and perceived through a viewer, the two-dimensional images appear three-dimensional.

STEREOGRAPH

▶1850-1859

1850
Albumen Silver Prints

FRENCH PHOTOGRAPHER Louis Désiré Blanquart-Evrard introduces the first commercially available paper print produced from a negative. Coated with egg white (albumen) and sensitized with silver nitrate, the prints are glossy and finely detailed.

"There is a great talk of taking pictures in artificial light. This may be very well in theory, but it will not, in my opinion, do in practice."
—Notes of the Birmingham (England) Photographic Society, 1857

1851
Panoramic Photography

PHOTOGRAPHERS line up multiple daguerreotype plates side by side to create a panoramic view of a scene. An 1851 image of San Francisco may be composed of as many as 11 plates.

LANDSCAPE PHOTOGRAPHY

1850 ▲ **1851** ▲ 1852 ▼ 1854

1853

1851
Nude Photography

FRENCH PHOTOGRAPHER Félix-Jacques-Antoine Moulin serves a month in jail for photographing nudes. Court documents call the images "so obscene that even to pronounce the titles . . . would be to commit an indecency." The two women in the photos stand together without any hint of eroticism.

TWO RECUMBENT WOMEN BY FÉLIX-JACQUES-ANTOINE MOULIN

PORTRAITURE

1853
Beginning of Portraiture

FRENCH CARICATURIST Gaspard-Félix Tournachon, known by the pseudonym Nadar, begins photographing famous Frenchmen and printing their likenesses as lithographs. His plain backgrounds and diffused light win praise from the *Gazette des Beaux Arts,* France's leading art review of the time.

"An important end and aim of photography is to improve the public taste, and to elevate and reform Art." —William Crookes, editor of *Photographic Notes,* 1856

1851
Wet Collodion Process

ENGLISHMAN Frederick Scott Archer invents the wet plate process for producing glass negatives. Many times faster than any previous method, it results in clear, highly detailed prints and will eventually replace the daguerreotype process.

COLLODION PRINT

1855 1856 1857 ▼ 1858 1859

1853
Tintype Process

INVENTED IN FRANCE by Adolphe Alexandre Martin, the tintype (or, more accurately, ferrotype, since the print surface was made of iron) was a faster, cheaper version of the daguerreotype and made photographic portraits available to the middle and lower classes.

"Landscape photography! How pleasantly the words fall upon the ear of the enthusiastic photographer." —James Mudd, English photographer, 1858

1858
First Bird's-Eye View Photo

INSPIRED BY INTERESTS in aeronautics, journalism, and photography, Nadar climbs into a tethered balloon in Paris and creates the first aerial photograph.

FIRST AERIAL PHOTOGRAPH

TINTYPE

▶1860-1879

FIRST COLOR PHOTO

"Why are there no longer any miniaturists? For the very simple reason that . . . photography does the job better." —Jean François Antoine Claudet, 1865

1861
First Color Photo

SCOTTISH PHYSICIST James Clerk Maxwell creates a rudimentary color photograph by passing a black-and-white image through red, green, and blue filters and superimposing the three photos of a ribbon on a single screen.

1865
Flash Photography

JOHN TRAIL TAYLOR develops a safer way to use magnesium flash powder, thus inventing the first widely used flash technique. Contained in a protective holder and ignited by hand, this volatile powder produces a brilliant white flash of light, followed by a characteristic large puff of white smoke.

1861 | 1865 | 1869
1860 | 1862 | 1864 | 1866 | 1868

YELLOWSTONE SURVEY PHOTO

PICTORIALIST PHOTO

1869
Pictorialism

BRITISH AUTHOR Henry Peach Robinson sees photography's potential as an artistic medium and names this approach pictorialism. He helps found the Linked Ring group in his efforts to expand photography beyond its early documentary use.

"Many a commonplace scene . . . requires only the proper lighting, and perhaps a figure of the right kind in the right place, to make it beautiful."
—Henry Peach Robinson, 1888

▼ ■1872 ■1874 ■1876 ▼ ■1879
1871 **1878**

1871
Photographic Survey of Yellowstone

THE U.S. GEOLOGICAL and Geographical Survey of the Territories commissions William Henry Jackson to photograph the American West in 1870. He sends photos of Wyoming to Congress in 1871, and a year later Yellowstone, the nation's first national park, is established.

1871
Dry Plate Printing

R. L. MADDOX, an American physician, devises a method of preparing glass plates with gelatin emulsion that allows photographers to prepare their plates days or even weeks before using them—a key step toward the invention of photographic film.

1878
First Action Photos

ENGLISHMAN Eadweard Muybridge makes motion sequences of animals and humans. His galloping horse series—shot with 12 cameras outfitted with trip wires—proves that horses' hooves all are off the ground momentarily in each stride. Muybridge's work leads the way to cinematography.

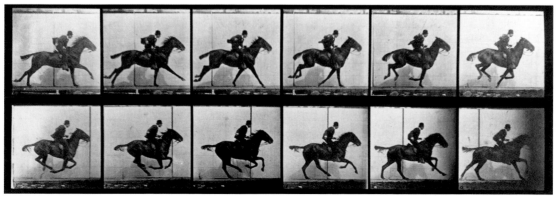

EARLY MOTION SEQUENCE

▶1880-1899

FIRST TORNADO PHOTO

1884
First Photograph of a Tornado

THE FIRST IMAGE of a tornado is taken, according to the U.S. National Weather Service, about 22 miles southwest of Howard, South Dakota, on August 28, although the photographer's name was not recorded.

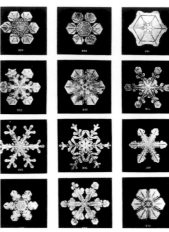

EARLY SNOWFLAKE MICROGRAPHS

1885
First Photomicrograph of Snowflakes

PASSIONATE ABOUT SNOWFLAKES, Vermont farmer Wilson A. Bentley makes the first photomicrographs of snowflakes and shows that no two are alike. Over time, he photographs more than 5,000 snowflakes using a telescope and a bellows camera.

1880　1882　**1884**　**1885**　1886　**1888**

"They were serving a Thanksgiving dinner free to all comers at a charitable institution in Mulberry Street, and more than a hundred children were in line at the door . . . when I tried to photograph them." —Jacob Riis, 1902

1890
Social Conscience Through Photography

JACOB RIIS'S BOOK *How the Other Half Lives* features pictures of the tenements on New York's Lower East Side. One of the first times photography is used to promote social justice, Riis's work marks the beginning of photojournalism as well.

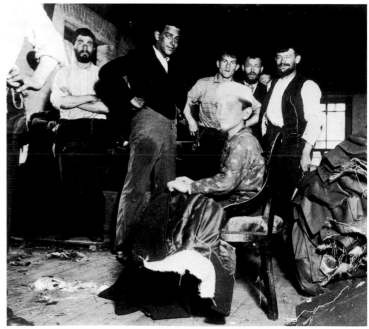

SWEATSHOP WORKERS

FIRST KODAK CAMERA

USING AN EARLY KODAK

1888
Kodak #1 Camera

INVENTED BY GEORGE EASTMAN, a former bank clerk, the simple box camera with preloaded film sets off a national craze in amateur photography. Once the film is exposed, the entire camera gets sent back to the factory for processing.

"The idea gradually dawned on me that . . . we were starting out to make photography an everyday affair . . . to make the camera as convenient as the pencil." —George Eastman

1890 ■1892 ■1894 **1896** ■1898 ■1899

1890
First Photo in
National Geographic

WHILE THE THIRD ISSUE, in 1889, included a relief map of North America, the March 1890 issue of *National Geographic* depicts Herald Island in the Arctic Ocean with the magazine's first real photograph.

FIRST PHOTO IN *NATIONAL GEOGRAPHIC*

1890
Frances Benjamin
Johnston
Opens Studio

FRANCES BENJAMIN JOHNSTON, one of the first American women to gain prominence as a photographer, earns a reputation as one of the country's first photojournalists. In her Washington, D.C., studio, she would photograph a number of American Presidents.

1896
Photographing
Indigenous Cultures

A PHOTOGRAPH of a Zulu bride and groom published in the November issue of *National Geographic* becomes the magazine's first picture of a bare-breasted woman, establishing a precedent for publishing images of indigenous peoples without censorship.

ZULU BRIDE AND GROOM

"Photographic portraiture should prove as charming and congenial as a field for artistic effort as a woman could desire."
—Frances Benjamin Johnston, 1897

▶1900-1909

1900
Brownie Camera

COSTING ONLY A DOLLAR, George Eastman's Brownie camera reaches 100,000 in sales in the first year. The box camera comes with a 15-cent removable film container and is so simple to operate that photography quickly becomes a popular pastime.

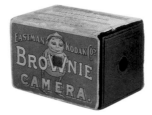

EARLY BROWNIE CAMERA

1901
Eastman Kodak Company

EASTMAN KODAK COMPANY of New Jersey forms, with George Eastman as its president. Later, the company shortens its name to Kodak.

1902
Photo-Secession

"PHOTO-SECESSION" was the name of a group founded by Alfred Stieglitz to show photography to be fine art. They published a quarterly, *Camera Work*, and opened a gallery called the Little Galleries of the Photo-Secession, on Fifth Avenue in New York City. The group dissolved over disputes between whether doctoring negatives was acceptable or not.

"You press the button, we do the rest." —Early Kodak advertising slogan

1900 ▲ **1901** ▲ **1902** ▲ ▪1903 ▪1904

1906
First Wildlife Photos in *National Geographic*

NATIONAL GEOGRAPHIC introduces wildlife photography with George Shiras's article "Photographing Wild Game With Flashlight and Camera," containing night- and daytime photos taken in Michigan's Upper Peninsula.

1907
Autochrome

AFTER TWO DECADES of work, Auguste and Louis Lumière create the first color photograph. They use a glass plate covered with tiny dyed grains of potato starch and then make a positive color transparency, the resulting image viewed by shining light through it.

"Many advocates of hunting with the camera have been heard of late."
—George Shiras, 1906

EARLY NIGHT FLASH PHOTO

"Soon the world will be color-mad, and Lumière will be responsible."
—Alfred Stieglitz, 1907

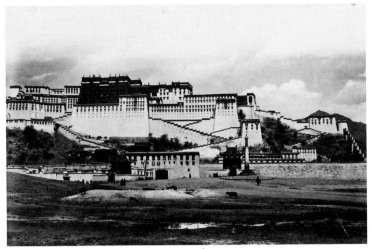

SCENE FROM TIBET, PART OF *NATIONAL GEOGRAPHIC*'S FIRST PHOTO SERIES

1905
First
National Geographic
Photo Series

NATIONAL GEOGRAPHIC publishes its first stand-alone photography series, a photographic tour of Lhasa, Tibet, that runs 11 pages in the January issue. Later, Editor Gilbert H. Grosvenor reveals that he expected the pictorial would get him fired.

1905 ▲ ▼ ▼ 1908 ▼
 1906 **1907** **1909**

1909
First Photos
of the North Pole

ROBERT E. PEARY, his assistant Matthew Henson, and four Inuit men take photographs to prove their claim that they reached the North Pole after a 37-day dogsled journey over 475 miles of ice. The feat was immediately questioned by skeptics, who said Peary's navigation and reckoning were dodgy and that the round-trip could not have been completed so quickly. The veracity of their claim still remains in doubt, and later studies suggest they were about 60 miles short of the actual Pole.

NORTH POLE EXPEDITION PHOTO

"In the afternoon of the 7th, after flying our flags and taking our photographs, we went into our igloos and tried to sleep a little, before starting south again." —Robert E. Peary in a letter to his wife, 1909

▶ 1910-1929

1911
Rotogravure Printing

THE CYLINDER ROTARY-PRESS roto-gravure (rotary photogravure) is invented, making it easier, faster, and cheaper to print photographs in magazines.

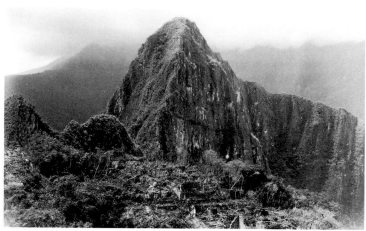

EARLY PHOTO OF MACHU PICCHU

"A new method of color photography, embodying extraordinarily brilliant results, has just been demonstrated . . . A plain negative, as in ordinary photography, is taken and a lantern slide is made from it, and . . . the picture in natural colors is faithfully reproduced."
—*New York Times,* March 28, 1912

1911 ▲ **1912** ▲

IIIIIIIIIIIIIII ▮1910 III ▮1916 IIIIIIIIIIIIIIIIIIIIIIIIIII ▮1918 IIIIIIIIII

▼
1914

1914
First Color Photography in *National Geographic*

THE JULY issue of *National Geographic* contains the magazine's first Autochrome photographs, "16 Pages of 4-Color Work," as promised on the cover. In April 1916, more than 100 images illustrate a feature called "The Land of the Best," a coast-to-coast tour of the United States advocating the establishment of a national park system.

1922
Infrared Film

KODAK creates high-speed, heat-sensitive infrared film for military and scientific use.

FIRST COLOR PHOTO IN *NATIONAL GEOGRAPHIC*

"The picture makes one wonder which the more to admire—the beauty of the flowers or the power of the camera to interpret the luxuriant colors so faithfully." —"A Ghent Flower Garden," *National Geographic,* July 1914

1912
First Photos
of Machu Picchu

NATIONAL GEOGRAPHIC SOCIETY supports Yale University professor Hiram Bingham's excavations at the ancient Inca city of Machu Picchu in Peru. Bingham's photos in *National Geographic* are among the first published of the mysterious Inca citadel.

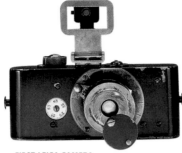

FIRST LEICA CAMERA

"They scarcely believed the story I told them of the beauty and extent of the Inca edifices. When my photographs were developed, however, [they] were struck dumb with wonder and astonishment." —Hiram Bingham, 1922

1914
First Handheld
35-millimeter Camera

GERMAN MECHANIC Oskar Barnack invents the first precision miniature camera. Small, portable, and easy to use, the 35-millimeter camera is flexible enough for any kind of photography, artistic or journalistic. Its commercial development hindered by World War I, the Leica camera would come onto the market in 1925.

■1920 ■1922 ■1924 ▼ ▼ ■1928 ■1929
 1925 1926

1925
First Commercial
Flashbulb

GERMAN INVENTOR Johannes Ostermeier patents the first commercially available flashbulb and names it the Vacublitz.

FIRST UNDERWATER COLOR PHOTO

FIRST UNDERGROUND COLOR PHOTO

1925
First Underground
Color Photo

THE DOME ROOM in New Mexico's Carlsbad Cavern marked the first underground color photograph ever shot, published in the September 1925 issue of *National Geographic*.

1926
First Underwater
Color Photo

ICHTHYOLOGIST WILLIAM LONGLEY and National Geographic staff photographer Charles Martin use a raft filled with magnesium flash powder to illuminate the reefs of Florida's Dry Tortugas and make the first undersea color photographs, published in the January 1927 *National Geographic*.

▶ 1930-1939

1930
Landscape Photography

ANSEL ADAMS, considered to be one of the best landscape photographers for his work in the American Southwest, decided to dedicate himself to photography. Within five years, Adams had made a name for himself, mostly for his articles on photography written for popular photography presses. As the popularity of his work increased, he used his position to help promote photography as fine art.

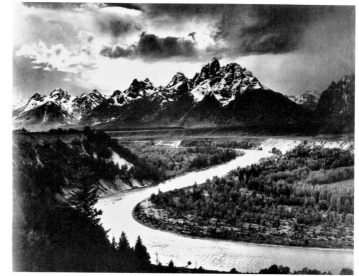

PHOTO BY ANSEL ADAMS

1930 ▲ 1931 1932 1933 1934

1935
Photographs of Earth's Curvature

THE *EXPLORER II* helium balloon rises to 72,395 feet—a world altitude record for human flight—and Capt. Albert Stevens's photos taken from it show the curvature of Earth for the first time.

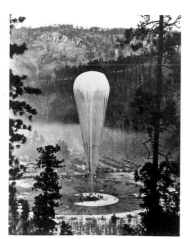

BALLOON FOR HIGH-ALTITUDE PHOTOGRAPHY

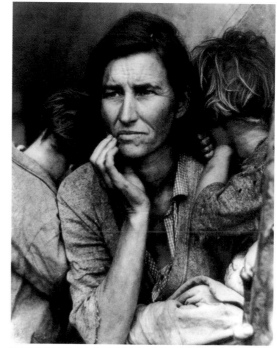

DEPRESSION-ERA PHOTO BY DOROTHEA LANGE

"Photography takes an instant out of time, altering life by holding it still."
—Dorothea Lange

1930
First Aerial Color Photo

NATIONAL GEOGRAPHIC Assistant Editor Melville Bell Grosvenor made the first aerial color photograph when he took this shot of the Statue of Liberty by circling the monument in a Navy Airship ZM C2. The photograph, which was published in the September 1930 issue, led the National Geographic Society to adopt the Finlay process, then the newest method for producing color photographs.

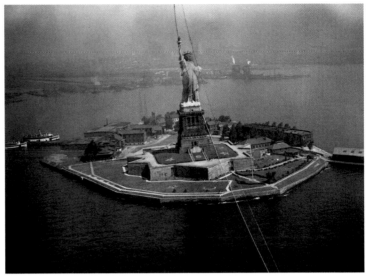

FIRST AERIAL COLOR PHOTO

1935 1936 ▮1937 ▮1938 ▮1939

1935
Photographing the Depression

THE FARM SECURITY ADMINISTRAtion hires Roy Stryker to run a historical section, and Stryker eventually hires Walker Evans, Dorothea Lange, Gordon Parks, Arthur Rothstein, and others to photograph rural hardships over the next six years.

1935
Kodachrome

KODAK research laboratories invent Kodachrome film for color slides, or transparencies, ushering in a new era in photography. Coated with three emulsions sensitive to the three primary colors, Kodachrome is the first commercially available amateur color film.

1936
Life Magazine Appears

LIFE—the first U.S. newsmagazine devoted to photojournalism— comes out weekly beginning with the November 23 issue. Its first cover shows the concrete pylons of a spillway connected to the U.S. Corps of Engineers' Fort Peck Dam in Montana, photographed by Margaret Bourke-White.

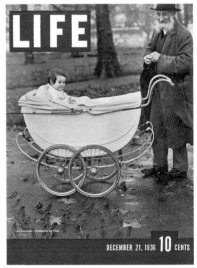

EARLY COVER OF *LIFE*

"The pictures are there, and you just take them. The truth is the best picture, the best propaganda." —Robert Capa, 1937

▶1940-1949

1940s
First High-Speed Photography

MIT ENGINEER Harold E. Edgerton perfects high-speed stroboscopic photography, which freezes movements too rapid for the eye to see. *National Geographic* publishes several of the images, including bullets frozen in midflight and stilled hummingbird wings.

EARLY HIGH-SPEED PHOTOGRAPH

1940 ▲ **1942** ▲ ▮1941 ▮1943 ▮1944

1946
First Photo from Space

RESEARCHERS at Johns Hopkins's Applied Physics Lab strap a 35mm camera to a German V-2 missile. It snaps a picture every second and a half as the rocket shoots 65 miles above Earth, revealing a black-and-white wedge of planet framed by the blackness of space.

"In photography, the smallest thing can be a great subject."
—Henri Cartier-Bresson, 1952

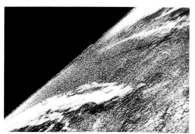

FIRST SPACE PHOTO

1947
Magnum Founded

ROBERT CAPA, George Rodger, Henri Cartier-Bresson, and David "Chim" Seymour form Magnum, the first photographic collaborative owned by the photographers themselves. Moved by what they witnessed in World War II, the founders create the agency as a platform to present their individual visions.

POLAROID

1947
Polaroid Process

THE POLAROID COMPANY—originally Land-Wheelwright Laboratories—produces a camera with black-and-white film that develops in just 60 seconds. Eventually, Polaroid pares the processing time down to 15 seconds, making the camera even more popular.

CHESTER CARLSON

1942
Xerography Invented

CHESTER CARLSON receives a patent for electrophotography, the technology at the heart of photocopying machines.

1942
Color Negative Film

KODACOLOR, the first practical color negative film, is introduced by Eastman Kodak.

1945 1946 1947 1948 1949

MOUNT WILSON OBSERVATORY AT PALOMAR

1949-1956
First Survey of the Night Sky

NATIONAL GEOGRAPHIC teamed up with the California Institute of Technology for the Palomar Observatory Sky Survey, a seven-year project to produce the first photographic map of the Northern Hemisphere's night sky. The work was done at the Palomar Observatory in California using "Big Schmidt," a new, 48-inch camera telescope, and resulted in a comprehensive study of the heavens that led to the discovery of many new stars and galaxies. Its findings are still used by astronomers today.

1949
Disposable Cameras

ENGINEER A. D. WEIR invents the first disposable camera. Called a Photo-Pac, the cardboard camera is available at drugstores and comes loaded with film.

"After you take your eight exposures, you drop the entire unit in the mailbox. A few days later the mailman brings your prints and negatives. For helping to convert Uncle Sam's mailboxes into darkrooms, we're sending Mr. Weir a $50 Prize Gadget Award."
—Mechanix Illustrated, September 1949

▶1950-1969

1955
The Family of Man in Photographs

EDWARD STEICHEN curates "The Family of Man," an exhibition of 408 photographs that opens at New York's Museum of Modern Art and travels to 69 other venues around the world, becoming the most famous photographic art exhibition ever.

"FAMILY OF MAN" EXHIBIT

"We are seeking . . . hard-to-find photographs of the everydayness in the relationships of man to himself, to his family, to the community, and to the world we live in."
—Edward Steichen, inviting submissions for "The Family of Man," 1952

1950 1952 1954 **1955** ▲ **1956** ▲ 1958 ▼ **1959**

1959
Nikon F SLR Camera

INSTANTLY POPULAR as a single-lens reflex (SLR) camera of professional quality, the Nikon F enters the market in March, marking the rising prominence of Japanese companies in the photographic equipment industry.

"Here at last is a color-slide projector so convenient, so easy to operate, that you'll feel like a guest at your own shows!"
—Kodak Carousel Projector advertisement, 1962

KODAK | CAROUSEL STACK LOADER

PROVIDES ADDED VERSATILITY FOR KODAK CAROUSEL PROJECTORS
- Shows slides in stacks as received from processing.
- Accepts up to forty 2x2-inch cardboard or extra-thin plastic slides.
- Easy top-loading and unloading.
- Gravity lowers slides . . . never pushed, pulled nor forced.
- Fits CAROUSEL 600, 650, 700, 750, 800, 850, 860, AV900 and EKTAGRAPHIC Projectors.

EARLY SLIDE PROJECTOR

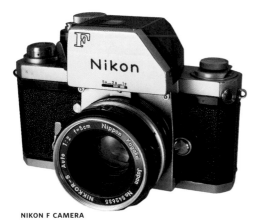

NIKON F CAMERA

RESEARCH SUBMERSIBLE

1956
Pioneering Underwater Photography

ABOARD THE RESEARCH SHIP *Calypso* with Jacques Cousteau, National Geographic photographer Luis Marden pioneers many techniques still used in underwater color photography today. He shoots some 1,200 photos, the largest collection of underwater color images ever taken.

"Cousteau had the most original mind I have ever encountered. He was like a Wright brother; and here I was working with him." —Luis Marden

1962 1964 1965 1968 1969

1961 **1963** **1966**

1961
Carousel Slide Projector

KODAK introduces the carousel slide projector with a rotary tray carrying 80 slides and dispensing them automatically into the projector.

1963
Instant Color Film

POLAROID markets the first instant color film, with a development time of 60 seconds.

EARTH FROM THE MOON

1963
Instamatic Camera

KODAK introduces the Instamatic camera, an inexpensively manufactured, easy-to-use camera with cartridge-loaded film. By 1970, Kodak sells more than 50 million Instamatics.

1966
First Photo of Earth From the Moon

ON AUGUST 26, the Lunar Orbiter I takes the first photo of Earth from the moon, 236,000 miles away. Only the half of Earth from Istanbul to Cape Town appears in the image; the other half is shrouded in darkness.

KODAK INSTAMATIC

▶1970-1984

1971
Photographing Endangered Species

PHOTOGRAPHED by Dr. George Schaller in the early 1970s, the first shots of snow leopards in the wild include this female *Panthera uncia* perched on a snowy crag in Pakistan's Chitral Valley. *National Geographic* published the first photographs of snow leopards in the wild in its November 1971 issue.

SNOW LEOPARD IN PAKISTAN

1971 ▲

▦1970 **1972** ▲ **1974** ▲ ▼ ▦1976

1975

1975
First Photo of Another Planet's Surface

THE UNMANNED RUSSIAN space probe Venera 9 orbits Venus for five months, while its lander sends 180-degree panoramas from the planet's surface, the first images successfully conveyed to Earth from another planet.

"The more pictures you see, the better you are as a photographer."
—Robert Mapplethorpe, 1977

VENUS FROM VENERA 9

"A photograph is not an opinion. Or is it?"
—Susan Sontag, *On Photography*, 1977

EARTH FROM APOLLO 17

1972
First Full-View Photo of Earth

WITH THE SUN at their backs, the Apollo 17 crew heads for the moon on December 7. Looking back, they photograph the perfectly lit Earth: the famous "Blue Marble" image of the planet.

CORNELL CAPA

1974
International Center for Photography

PHOTOGRAPHER CORNELL CAPA, brother of war photographer Robert Capa, founds New York's International Center for Photography, an influential photography museum, school, and research center.

"The camera is an instrument that teaches people how to see without a camera."—Dorothea Lange

▼
1977 ■ 1978 ■ 1980 ■ 1982 ■ 1984

1975
First All-Electronic Camera

KODAK RESEARCHERS construct a prototype digital camera. Much larger than a regular camera, it shoots black-and-white photographs at a resolution of 10,000 pixels (0.01 megapixel) and saves them to a cassette tape. Only semiportable, it displays its photographs on a television screen.

CRESCENT MOON AND EARTH

PROTOTYPE FOR FIRST DIGITAL CAMERA

1977
Earth and Moon in One Frame

A MONTH after takeoff, NASA's Voyager 1, a robotic space probe sent on a one-way exploratory mission into outer space, returns the first image of Earth and its moon together in one photograph.

▶1985-1999

1985
First SLR
With Autofocus

MINOLTA releases the Minolta Maxxum 7000, the first SLR camera with autofocus. Motorized autofocus lenses and a motorized film advance are both housed inside a lightweight plastic body, the focus controlled with buttons—all features presaging digital cameras of the future.

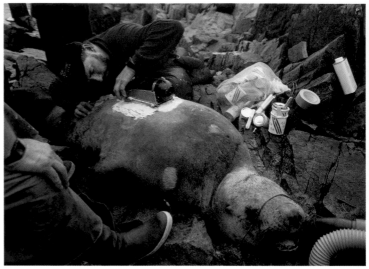

ATTACHING CRITTERCAM TO A SEA LION

1985 ▲ 1986 ▲ ▮1988 1990 ▲ ▼ 1991 ▮1992

1990
PhotoCD Technology

KODAK introduces the PhotoCD, a revolutionary new way to store images that helps establish a new standard for digital color photography. Within a few years, however, the JPEG format eclipses PhotoCDs as the industry standard.

1990
First Version
of Photoshop

THE INFLUENTIAL IMAGE-EDITING software Photoshop is first released by Adobe and sold as a mass-market product for less than $1,000.

1991
First Digital Camera

KODAK releases DCS, the first commercially available digital camera. Expensive and best suited for professional photographers, the camera uses a Nikon F-3 camera body fitted with an electronic image sensor. By 1998, more than 150 new digital camera models are released each year.

PHOTOCD

"Fundamentally, vision is not about which camera or how many megapixels you have, it's about what you find important. It's all about ideas."
—Keith Carter

FIRST COMMERCIAL DIGITAL CAMERA

1986
Crittercam

THE FIRST FIELDWORTHY "crittercam" is strapped to the back of a leatherback sea turtle at St. Croix. Marine biologist and filmmaker Greg Marshall eventually refines the mechanism, which will eventually reveal details of the daily life of whales, sharks, seals and sea lions, sea turtles, penguins, manatees, and other marine animals.

1990
Pale Blue Dot

AT THE SUGGESTION of science writer Carl Sagan, Viking 1 turns its cameras toward Earth 13 years after its launch as it reaches the edge of the solar system, more than 3.7 billion miles away. The resulting image, conveyed back to Earth, shows the planet as a "pale blue dot" within the banded darkness of deep space.

EARTH FROM 3.7 BILLION MILES

"Our posturings, our imagined self-importance, the delusion that we have some privileged position in the Universe, are challenged by this point of pale light." —Carl Sagan, 1994

1994 1996 1997 1998 1999

1994
First Consumer Camera-Computer Connection

THE APPLE QuickTake 100 becomes the first consumer-friendly color digital camera to work with a personal computer via a serial cable. Its resolution—640 x 480 pixels—allows on-screen viewing but not high-quality printing.

1997
First Photo Sent by Phone

PHILIPPE KAHN, at work on an early camera phone being developed by Sharp, sends an image of his newborn daughter Sophie to 2,000 friends, thus logging the first photograph taken and sent by phone.

1997-1998
Digital Camera Sales Explosion

MORE THAN 150 new digital camera models are released each year, manufactured by corporations all over the world.

1999
Memory Card.

MATSUSHITA, SANDISK, AND TOSHIBA collaborate on the first digital memory card for use in numerous camera models.

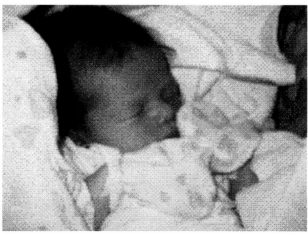

FIRST PHOTO SENT BY PHONE

▶ Since 2000

2002
First Images Seen From Hubble

NASA releases the first images from the Advanced Camera for Surveys (ACS) aboard the Hubble Space Telescope.

2003
First Photo of Earth From Mars

NASA'S Mars Global Surveyor captures the first view of Earth and its moon from Mars, a distance of 86 million miles away.

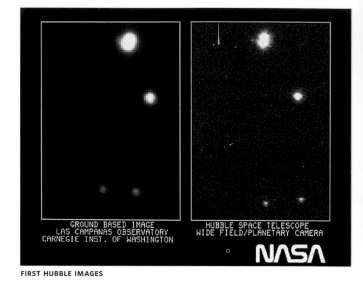

GROUND BASED IMAGE
LAS CAMPANAS OBSERVATORY
CARNEGIE INST. OF WASHINGTON

HUBBLE SPACE TELESCOPE
WIDE FIELD/PLANETARY CAMERA

NASA

FIRST HUBBLE IMAGES

| 2002 | 2003 | 2004 |

2000 2001

2004
Camera Phones

IT IS ESTIMATED that during this first year of commercial availability, as many as 29 billion images were taken on cameras built into cell phones.

EARLY COMMERCIAL PHONE CAMERA

2005
YouTube and Facebook Begin

SOCIAL NETWORKING on the Internet capitalizes on photos shared electronically.

SNOW LEOPARD CAPTURED BY DIGITAL CAMERA TRAP

2006
First Digital Camera Trap

METICULOUSLY ARRANGED at a watering hole by photographer George Steinmetz, the first digital camera trap shoot requires wired and wireless strobes, a digital SLR camera, and infrared remote camera traps. The elusive North American mountain lion shows up quickly, but it takes weeks for the trap to get just the right shot.

2010
First iPad

DESTINED to revolutionize the way people take, view, manipulate, and share photographs, the Apple iPad was announced by Steve Jobs in January 2010. Four million were purchased in its first three months on sale.

2003
First DSLR Priced
Under $1,000

CANON has good market success with its EOS Digital Rebel, the first high-resolution (6.3 megapixels) digital SLR priced under $1,000.

CANON EOS DIGITAL REBEL

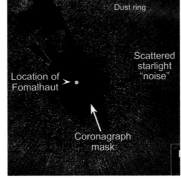

Dust ring

Scattered starlight "noise"

Location of Fomalhaut

Coronagraph mask

INFRARED PHOTO OF EXOPLANET

2004
First Photo
of an Exoplanet

AT THE European Southern Observatory, an infrared camera photographs a young planet 230 light-years from Earth and beyond the solar system. The planet appears as a red orb and orbits a dim failed star, or brown dwarf.

"Any attempt to define photography or to explain what the photograph 'is,' is always asking for trouble." —Damian Sutton

2005 **2006** 2007 2008 2009 **2010**

"What better way to honor the memory of the film than to use it to photograph iconic places and people?"
—Steve McCurry, 2010, on shooting the last roll of Kodachrome

KODACHROME FILM

2010
Last Roll
of Kodachrome

HEARING THAT Kodak was discontinuing its legacy film line, National Geographic photographer Steve McCurry asks to shoot the last roll manufactured. He starts using the 36-shot roll in New York, then travels to India and photographs a tribe on the verge of extinction.

EARLY IPAD

Part III

PHOTOGRAPHING YOUR WORLD

1 People & Pets

PHOTOGRAPHS OF FRIENDS, of loved ones, and of ourselves when younger embody our memories. They are physical evidence of our link with time, and among our most treasured possessions.

Yet photographing people, our most common photographic subject, is tricky. It's easy to get photographs of people, less so to make ones about them. Effective "people pictures," whether of relatives or strangers, convey both appearance and personality. They give an impression of who a person is.

The most important part of shooting photographs of people—or any other subject—is thinking ahead. What do you want your image to show and say? Once you know that, you can use the composition, lighting, and photographic techniques described in Part One and the special tips in this section of the book to help you explore different ways to shoot the photos you envision.

Jim Richardson North Dakota, U.S.

▶ Photographing People

▶ **FOR MORE ON PHOTOGRAPHING PEOPLE, SEE PAGES 252-3, 340-1, 344-5.**

WITH PEOPLE PICTURES, you always know what the center of interest is. But what do you want to reveal about the people you photograph? Posture, clothing, favorite environment, typical expressions, or telling behaviors? Once you have made that decision, you can be on the lookout for the telling moments when a person's character shines through.

Make sure to get close to your subject and be bold. If you see something interesting, don't be satisfied with just a wide shot. Think about the essence of what you are photographing and work closer and closer until you have isolated and captured it. And don't be shy—people are usually happy to show you what they do well.

▶▶ **If you practice with people** you know, you'll get more comfortable. Equally important, know your gear well enough to use it without thinking.

Avoid the bull's-eye. Don't always put the subject smack dab in the middle of the frame.

Move the camera around, placing the subject in different positions in the viewfinder.

Look for a composition that reveals something about the place as well as the person.

Jessica Cudney/National Geographic My Shot Kampala, Uganda

James P. Blair Greece

▶ Portraits

Alaska Stock Images Alaska, U.S.

A GOOD PORTRAIT gives a sense of the person's personality as well as the physical features. The expression in the eyes—mirth, seriousness, sadness—sets the tone. Composition and the person's relationship to the camera—full-body or very tight, looking right at the camera (as in the photo opposite) or glancing to the side—determines how formal the image will be. The face is important, but so are other factors.

▶ FOR MORE ON PORTRAITS, SEE PAGES 256-7.

Catherine Karnow Romania

▶▶ **If the subject is a stranger,** spend time chatting so you glimpse his or her personality before you begin making images.

The classic portrait lens is an 80mm. It's long enough to easily blur the background with a smaller aperture.

Use a shutter speed of 1/60 or faster unless you want a lot of blur.

▶ Family Pictures

Jodi Cobb　Nevada, U.S.

▶ FOR MORE
ON TAKING
PICTURES ON
HOLIDAYS AND
AT WEDDINGS,
SEE PAGES
328-31.

THERE IS NO BETTER GROUP on which to practice photography than your own family. No others will be so trusting or willing to indulge your ever-present camera or your experiments with lighting and lenses. When you are photographing strangers, either you get the picture or you don't. With your family, you can work on getting the moment right—again and again and again.

Family photos are also a great way to practice. Try making formal, informal, environmental, and group portraits—and ones with a unique twist. Think about the relationships between the different members of your family and look for images that express those connections. Have your equipment ready: something to hold your camera, a self-timer, and a place with good light.

▶▶ **Strive for images of personality,** not just physical appearance.

For groups, shoot several frames to make sure you get an image in which no one has his eyes closed.

If the background is busy, choose a smaller aperture to blur it.

Be careful using a wide-angle to shoot groups. The people at the edges may get distorted.

With a large group, raise the camera position to get a better view of everyone in the scene.

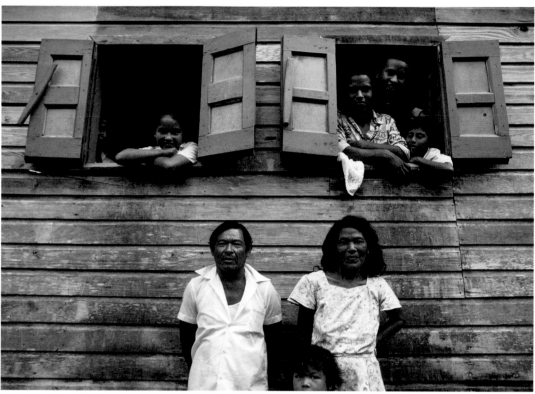

Jodi Cobb Dominica

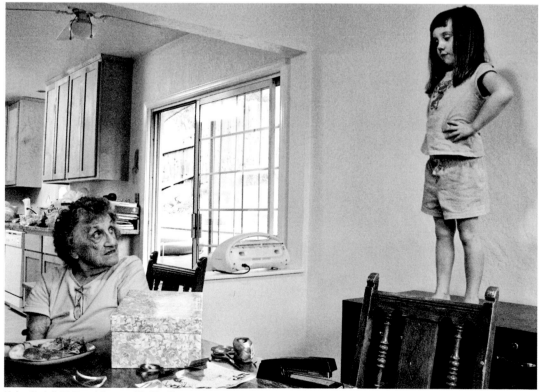

Helen Bedell/National Geographic My Shot California, U.S.

▶ Babies

▶ FOR MORE ON PHOTOGRAPH- ING CHILDREN, SEE PAGES 244-5.

▶ FOR MORE ON ANTICIPATING COMPOSITION, SEE PAGES 44-5.

THERE'S PROBABLY NO BETTER TIME than the first year of parenting to practice your photography. You have the cutest subject on Earth.

But babies are one of the toughest subjects, too, because they never, ever, hold still unless they're asleep. A slumbering baby provides candid, real moments, sublime and eternal. Try to find interesting angles (as in the photo below), and control the background. Put her on a quilt and shoot from above.

Look for emotion—any kind of emotion. Most people react to a crying baby like a fire alarm. But before you swoop in to pick up the baby, shoot a photo or two. It's the pictures of kids crying that remind us what it was like to be a parent with young children. They're entertaining, and they're emotional.

▶▶ **Find an area where the light** is soft and natural. It could be next to a window with a blind on it or in a room where light is bouncing off a wall.

Use the floor as a background. Get above your subject and shoot straight down to avoid the clutter in many houses.

Look for close-up details. Experiment and fill the frame with a hand, a foot, or a tuft of hair. What may seem like overkill at the time will yield a batch of pictures you'll look at with great affection.

Babies are floor- or bedbound, so get down and shoot on their level.

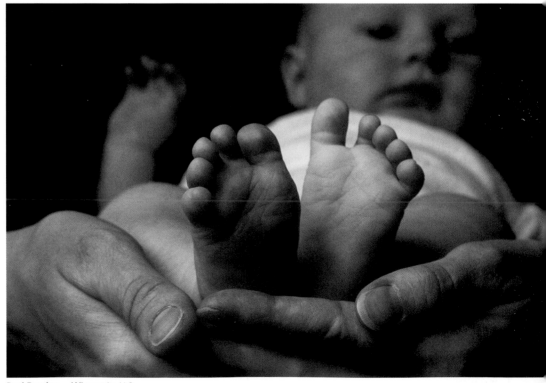

Paul Damien Wisconsin, U.S.

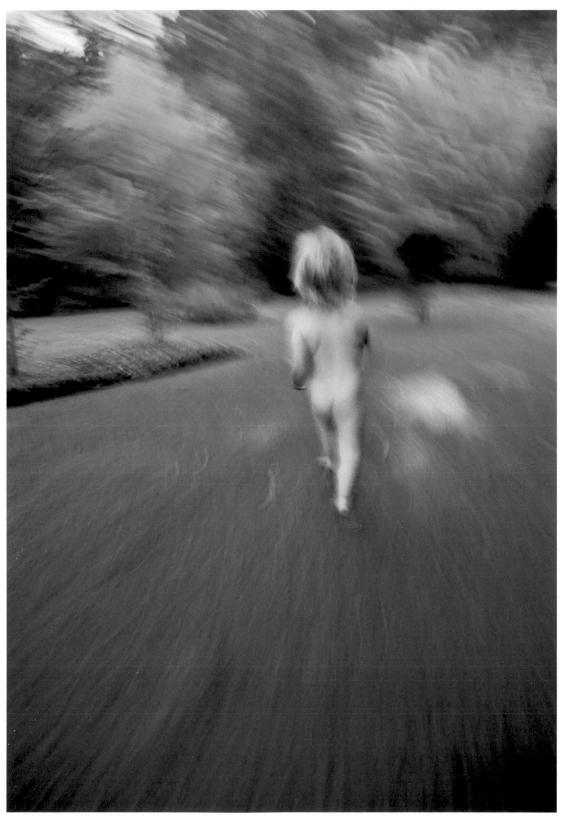

Jason Edwards Australia

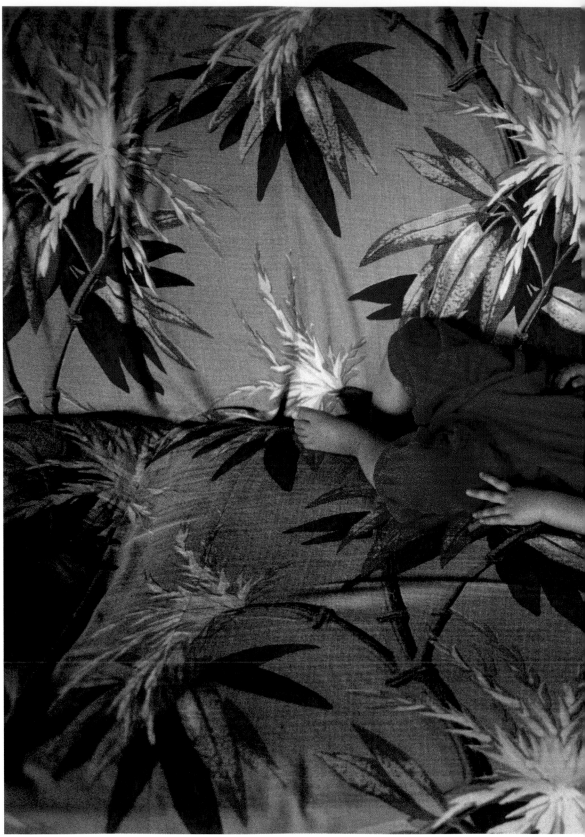
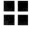

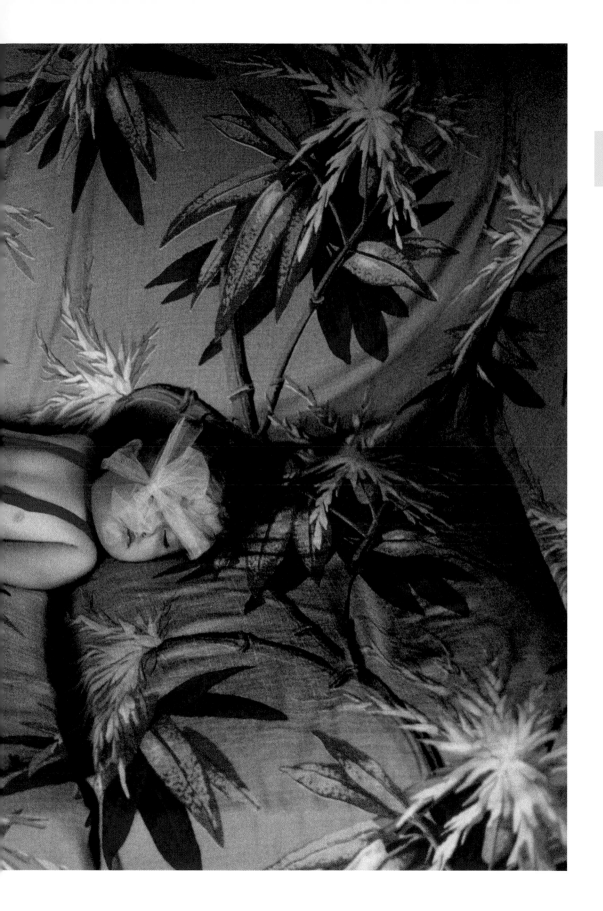

▶ Children

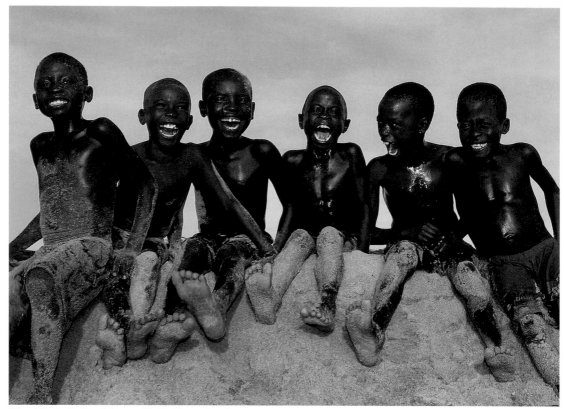

Miguel Costa/National Geographic My Shot Angola

▶ **FOR MORE ON POINT OF VIEW, SEE PAGES 106-7.**

▶ **FOR MORE ON TAKING PICTURES AT HOME, SEE PAGES 326-7.**

BRING OUT THE CAMERA and take lots of photographs when your children are young, and it will become second nature to them: not something to grin and pose for, but something to ignore. That's when the best kid pictures happen.

Ask your son or daughter to show you a favorite toy. If they want to look through the viewfinder, let them. They will soon forget about you and your camera and get back to what they were doing. Get down to their level. Look for the moment that expresses the feeling of the activity. If your kid is on a roller coaster, it's the mixture of fear and joy as it begins to plummet. If she's scored a goal, it is both the moment of the kick and the leap of celebration. Whatever it is, think about the activity and how best to portray it.

▶▶ **At a child's party,** the children will be passing around new toys, eating cake with their fingers, pulling at the strap of their party hat. It's a great time to get natural shots of them all.

Anticipate children's behavior. If they are playing baseball, set up near a base, compose your image, and wait for them to come running in.

To help children relax while you're photographing them, get down on their level and joke around.

 Feldy Suwito/National Geographic My Shot

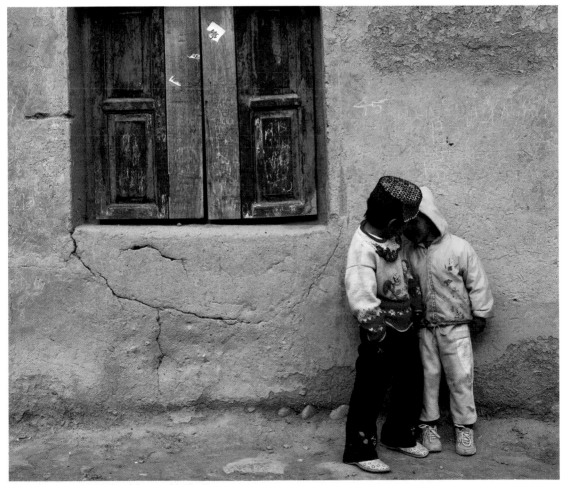

Chaerul Imran Bakri/National Geographic My Shot

☐ Jodi Cobb: **MY PERSPECTIVE**

IN THE 1960S, we believed we could change the world. That ideal drew me to journalism, and in a darkroom in New York City, I had an epiphany. As I watched my early efforts at photography develop slowly in the liquid, my future sharpened into focus. I knew then that images, not words, would be my métier. I began to focus on women breaking barriers: I shot America's first female coal miner and first woman jockey. I loved photographing people; now I aimed for images that told the wider story of human lives. Working for National Geographic gave me a broader canvas, and I soon found my photographic calling—documenting the realities behind the masks, veils, and curtains of cultures.

My work also took me into ugly backstreets where women and children are exploited daily. I photographed the horror of human trafficking, prostitution, and the exploitation of women and children. It's hard to look evil in the eye: no matter how inhuman their crimes, that person may still invite you to lunch. It's not easy to compose a photo when your heart is pounding with the knowledge that your subject would literally sell you into slavery, given the chance. But you remember then just why you started out in journalism: to change the world, even a little, by shining a light into some of its darker corners. —J.C.

JODI COBB has worked in more than 50 countries, primarily in the Middle East and Asia. She was one of the first photographers to cross China when it reopened to the West, traveling 7,000 miles in two months for the book *Journey Into China*. She has entered the hidden lives of women of Saudi Arabia and Japan, and she was the first woman to be named White House Photographer of the Year.

A man's back bears a heartfelt tattoo.

A traditional Saudi woman plays with less covered female companions.

Santa Clauses take the subway home after closing time.

▶ Cats & Dogs

▶ FOR MORE ON PHOTOGRAPHING ANIMALS, SEE PAGES 250-1.

▶ FOR MORE ON CLOSE-UPS, SEE PAGES 102-3.

PHOTOGRAPHING A PET? Get close, get low, and keep the background simple. If it's your own pet, you already know how it will react in different situations. Does it curl up to sleep in a particular place? Does it get the leash when it's time for a walk, or does it curl up and sleep on your daughter's bed? Have your camera ready.

Shannon O'Hara/NG My Shot New York, U.S.

▶▶ **Playtime is a great time for pet photos.** When the puppy grabs a slipper or chases a ball, grab the camera for some quick flash action.

Ask a friend to help by dangling a ball of yarn for a kitten or attracting the dog's attention.

Think ahead about lighting. For the dog at the foot of your bed, you might want to bounce a strobe off the ceiling. If the cat sleeps next to the fireplace, try a fairly low shutter speed and fill-in flash to capture both the sleeping feline and the flames.

Kevin Butler/National Geographic My Shot Idaho, U.S.

Jodi Cobb Italy

Jodi Cobb Italy

▶ More Animals

▶ FOR MORE ON
PHOTOGRAPHING
ACTION,
SEE PAGES
288-91.

ANIMALS MAKE IDEAL SUBJECTS for both candids and portraits, whether you're freezing the action as your dog catches a Frisbee in midair or shooting a barnyard animal out to pasture (as in the photo below). Think about typical behaviors, be patient, and wait for them to happen. And don't forget to shoot images that reflect the animal's relationship with different members of the family—with animals, as with people, it's the personality that counts.

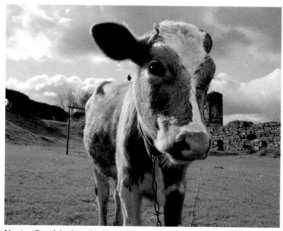

Nestor Bandrivskyy/National Geographic My Shot

▶▶ If your animal is black and fills most of the frame, your meter will want to overexpose. If it's white, it will underexpose. Take a reading off something in the scene that is the same as neutral gray.

Look for wildlife—squirrels, raccoons, rabbits, or birds—in your backyard. Set up a telephoto in a good position and wait for them to arrive.

Call your pet, and get it to look your way when you're ready to shoot. Offer treats as a reward for sitting still.

Mike Quinn/National Geographic My Shot New Jersey, U.

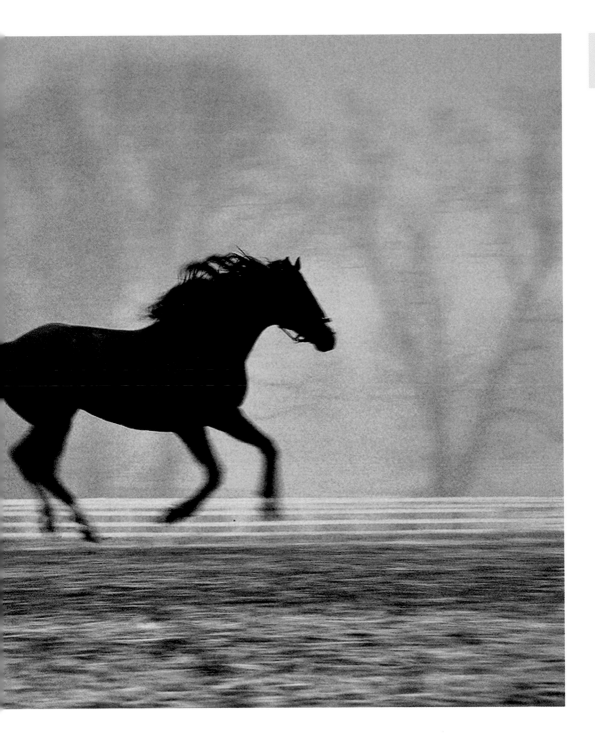

▶ Candids

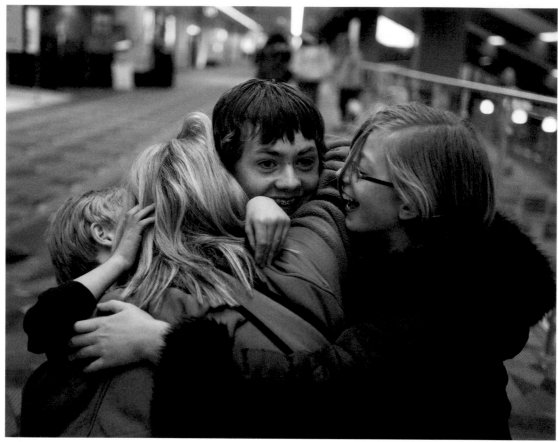

Joel Sartore Nebraska, U.S.

▶ **FOR MORE ON PHOTOGRAPHING FRIENDS WHILE TRAVELING, SEE PAGES 344-5.**

THE FRESH, UNGUARDED MOMENTS in candids often reveal something telling that formal portraits rarely capture. Keep your camera on hand. Think of yourself as a hunter after elusive prey, so unobtrusive that your subjects forget you're even there (as in the photo above).

Candid photographs can be of people we know or of strangers, in intimate situations or on crowded streets. Look around and find a place that gives you a good view of a scene. Perhaps you see a park bench in a beautiful setting, or a child caught up in an art project—whatever attracts you. Take up residence there, and wait for the elements to come together in a way that makes your image.

▶▶ **Use a long lens** so people in the scene don't see you immediately. Compose your image and get your shot before anyone notices you're there.

Look for a background you like, so you can capture spontaneous moments easily. Wait patiently for something striking to pass in front of it.

Smile and wave if strangers eventually notice you shooting photos. You want to be unobtrusive, but not unfriendly.

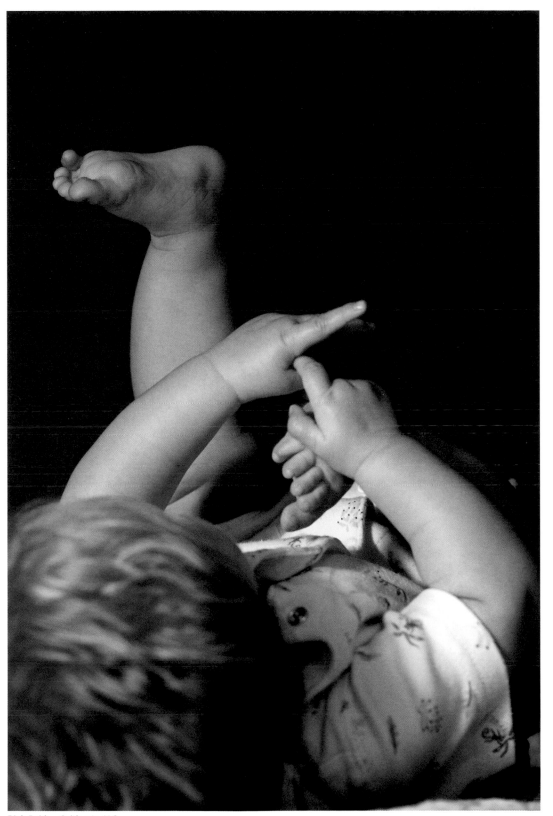

Rich Reid California, U.S.

▶ Street Shots

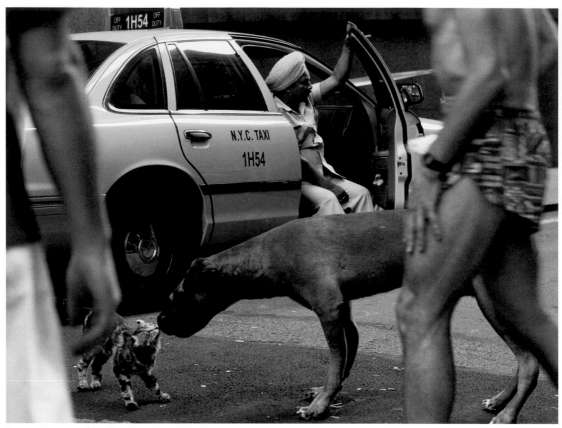

Tomasz Tomaszewski New York, New York, U.S.

▶ FOR MORE ON PHOTOGRAPH- ING PEOPLE YOU DON'T KNOW, SEE PAGES 340-1.

THE BEST WAY TO MAKE STREET PHOTOS is to wander around, get lost, and be open to the life and relationships passing in front of you. When something catches your eye, take a closer look and think of ways to capture the feeling that made you stop.

Sometimes the hardest part is overcoming shyness with strangers. It's all about attitude. Be friendly and ask permission to photograph people, and most will be happy to indulge you. If you don't want people to be aware of your camera, step back from the scene and use a long lens to isolate your subject from the background. You should have time to compose your image and get your shot before anyone notices you're there. When they do, smile and wave.

▶▶ **Find a blind** to be unobtrusive. It might be inside a store looking out through a doorway, or anywhere you can get out of the way.

Work your way into an activity—a festival, a parade—where people won't mind being photographed.

In some situations, getting close enough to use a wide-angle or regular lens may make the subject nervous.

Try to think of details of the subject's body or dress that will get your message across in a less obvious way.

Lynn Johnson

William Albert Allard Paris, France

▶ Environmental Portraits

▶ FOR MORE ON
PORTRAITS,
SEE PAGES
234-9.

▶ FOR MORE ON
CANDIDS,
SEE PAGES
252-3.

WITH ENVIRONMENTAL PORTRAITS, you're after an image of the individual, but also what that person does with her life, either as a hobby or profession. It's important to make time to scout the location beforehand. Visit subjects while they are working, and watch how they move around the room or other areas where they are working, what tasks seem to particularly engross them. Hanging out with your subjects gives them a chance to get used to you, as well. When you begin to shoot, try different angles. Every once in a while, ask your subject to look up. Make lots of frames, always watching for the moment that helps tell the person's story.

▶▶ **When you scout** the location, make mental notes of the clothes your subjects wear, the tools they use, and all the elements that are part of that aspect of their lives.

Be patient. When the person becomes involved in work or play, look for that expression of concentration.

Look for details that tell about your subject—the hands of a pianist, the feet of a runner, the prom shoes of a teenage girl. The abstraction says something about the individual.

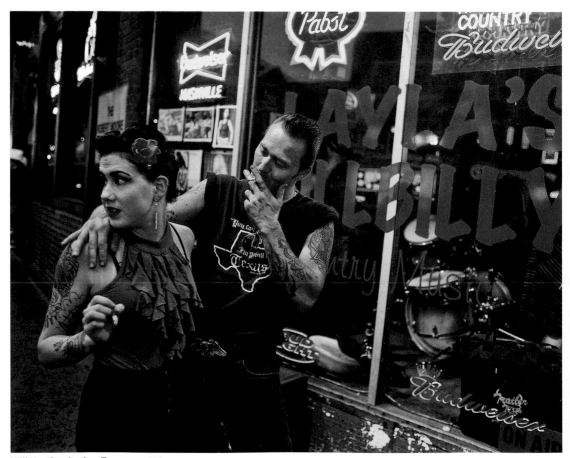

Will Van Overbeek Tennessee, U.S.

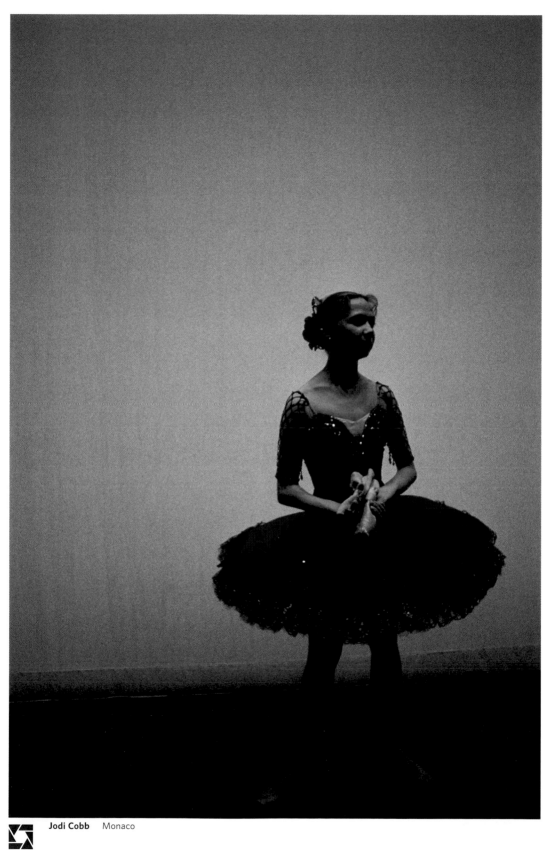

Jodi Cobb Monaco

☐ WHAT MAKES THIS

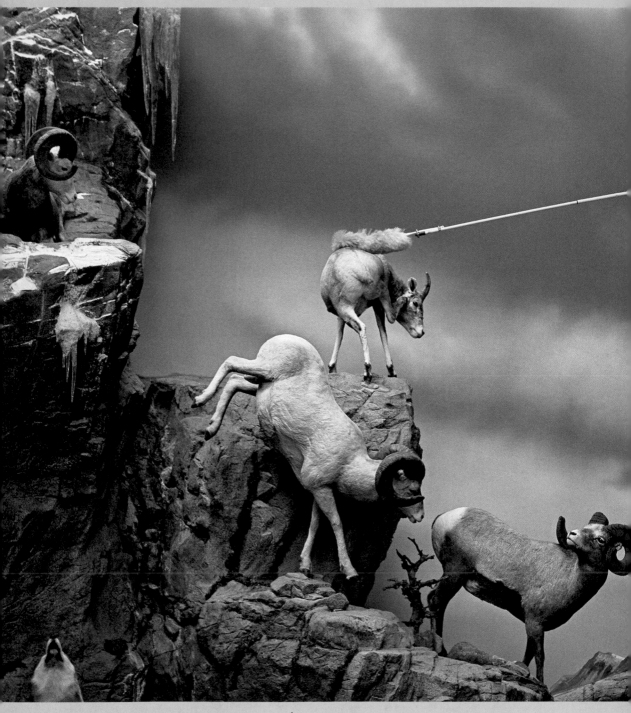

DUSTING OFF AT CABELA'S **Joel Sartore** Sidney, Nebraska, U.S.

A GREAT PHOTOGRAPH?

HUMOR IS A HARD THING TO CAPTURE in photography, but Joel Sartore is someone who can see the humorous potential in a situation and turn it into a great photo.

SUBJECT This image was shot in a sporting goods store in Joel's native Nebraska. Maybe it's not the most exotic of locations, but with an eye like Joel's—or with a little luck and a lot of practice—you would be able to recognize that these stuffed sheep would make a great picture.

COMPOSITION The strength of the image is that the composition moves in a circle, starting with the man, then moving down his pole to the mountain goat scratching its ear, and then on to the bighorn sheep below. The humor lies in the visual tension created by the goat being cleaned: It looks as if it's enjoying a good rub.

LIGHT Joel is an expert in all types of lighting. Here a soft top light makes this diorama almost lifelike. Strong, dramatic lighting would have taken away from the naturalness of the scene, and its humor would have been lost.

EXPOSURE The exposure for this photograph is straightforward: medium aperture. Because the scene takes place in a single plane, there is no great need for depth of field.

—James P. Blair
NATIONAL GEOGRAPHIC
PHOTOGRAPHER

2 Nature & Landscapes

NEXT TO PEOPLE, nature and landscapes are favorite photographic subjects. Images made while traveling or wandering through beautiful places conjure up memories of the spots we visited and what we saw. Photos viewed later call to mind all the senses we experienced in those places and in those moments. They communicate a sense of place.

But good nature photography is challenging. The three-dimensional and multisensational world is not easily converted to a small, rectangular, two-dimensional representation. Great photographs of nature and the out-of-doors may capture spaciousness or intimacy, dynamic energy or quietude, multiple layers of detail or exquisite simplicity of natural phenomena. There is no single rule for how to photograph natural settings and landscapes, unless it is to let the shapes, colors, and essence of the scene shape the picture.

Ian Flindt/National Geographic My Shot England

▶ Photographing Landscapes

▶ **FOR MORE ON LEADING LINES, SEE PAGES 88-9.**

▶ **FOR MORE ON HORIZON LINE, SEE PAGES 90-1.**

EVERY LANDSCAPE has its own qualities and ambience, its own personality. To capture and communicate that in a photo, look for a central element in the scene. Our eyes want something to focus on, some center of interest. A winding river, a dramatic shadow, or the angle of an outcrop will carry the viewer's eye into the picture.

Hike up the trails you see, climb a cliff, get down on your belly—the best angle might be in the middle of a stream or halfway up a mountain.

To shoot well-known places, be sure to get ready before you go. Study postcards and books to see those places as others have seen them—not to copy, but for inspiration.

▶▶ **Get out early.** Not only is the early morning light usually good, but you'll avoid the crowds that gather later at popular places.

Learn to appreciate overcast days. Their diffused light can make for increased color saturation in your images.

Don't meter the sky. It's usually bright and will cause you to underexpose the rest of the scene.

Clear the frame of elements such as power lines or radio antennas.

Krzysztof Bozalek/National Geographic My Shot

Joseph Mangiantini/National Geographic My Shot California, U.S.

▶ A Sense of Place

Guillaume Leray/National Geographic My Shot Italy

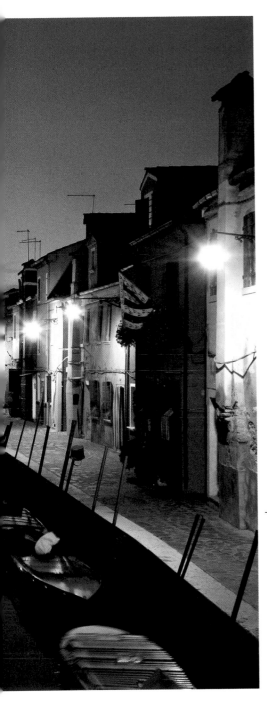

WE'VE ALL HAD THE EXPERIENCE: Driving through a scenic landscape, we shoot photos at every overlook, only to realize later how boring they are. Everything is there but the feeling. Why? Because landscapes are more than just geological formations, and good photographs evoke a sense of place.

When you decide what makes you want to photograph a place, think of adjectives to describe it—majestic mountains, desolate lighthouse, quiet canal (as in the photo opposite)—and include a detail in your photograph that conveys that adjective.

▶ FOR MORE ON AWARENESS OF LIGHT, SEE PAGES 28-9, 114-21, 124-7.

Vytautas Serys/National Geographic My Shot Sweden

▶▶ Use texture to communicate your personal impressions of the scene. Raking angles of early or late sun usually reveal texture best.

Be aware of where and when the sun will rise and set.

Try different lenses to learn how each one affects the view of the scene.

Look for foreground and other compositional elements that might enhance the scene.

▶The Seasons

Norbert Rosing Germany

▶**FOR MORE ON PHOTOGRAPHING WILDFLOWERS, SEE PAGES 280-1.**

▶**FOR MORE ON PHOTOGRAPHING GARDENS, SEE PAGES 312-3.**

LANDSCAPES LOOK different through the year—distinctions worth exploring through your photography. If you are making a picture of a mountain in the spring, include a field of pastel green in the foreground to accentuate the seasonal feeling. In the winter, you might include a frozen stream; in autumn, a path littered with curling leaves.

But try to avoid clichés. Flowers obviously say "spring" and icicles scream "winter." Try to find a different way of viewing these subjects—a different angle, a different lens, a different background. You want your images to reflect how the scene strikes you individually, to capture what made you want to photograph it.

▶▶ **Long winter shadows** add more contour and definition to an image.

Try shooting just before sunrise or moments after sunset for delicate light.

Use fill flash to bring out details in the foreground.

With a good tripod, you can be set up and ready when the lighting is right. But don't be afraid to handhold at slow shutter speeds—the serendipitous effects can be wonderful.

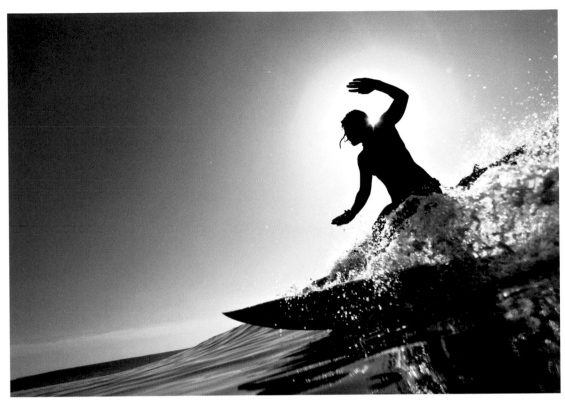

Tim Davis Mexico

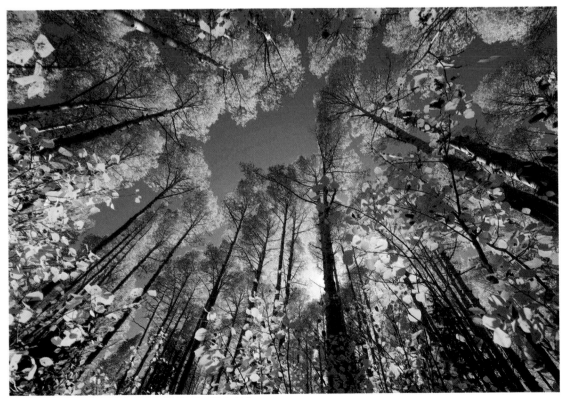

Robert Hooper/National Geographic My Shot Utah, U.S.

▶ Weather

EACH KIND OF WEATHER has its own mood and quality of light. It's up to you how you use those conditions in your photography. Take advantage of the soft, even lighting from overcast skies. Use a slow shutter speed to shoot flowing water without blowing out the highlights in the stream.

Or think how you want falling snow to appear. You can freeze it or blur it just like rain, but if the shutter speed is too slow, it can look like fog. Remember that mist and fog can be white or gray, thick or thin. If detail is important and the fog or mist is thick, move closer to your subject.

Pramod Bansode/National Geographic My Shot India

Michaela Budacova/National Geographic My Shot

▶▶ **Look for moments** when the sun is at the edge of clouds. It softens the foreground in a graceful way.

Remember that greens take on a magical quality after rain.

The bright white of snow fools meters. To avoid underexposing, take a reading from your subject, a gray card, or something else of equal tonal value.

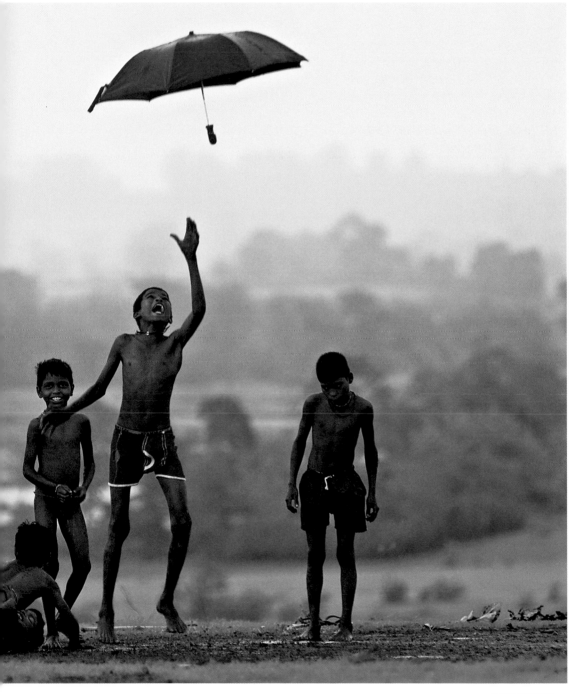

▶**FOR MORE ON PHOTOGRAPHING WATER, SEE PAGES 358-9.**

▶ Storms & Lightning

▶ FOR MORE ON
PHOTOGRAPHING
FIRE & FIREWORKS,
SEE PAGES
114-21, 124-7,
356-7.

WILD WEATHER drives an imaginative photographer outdoors. A brooding, stormy sky can enhance or dramatize your picture. Fast-moving clouds and shafts of sunlight alter a landscape from one moment to the next. Look around for subjects that really show the power of the storm, and then find ways to compose that accentuate the effects the weather is having on those subjects.

Dramatic skies, high winds, and horizontal rain make for very dramatic images. You can often get a good image of an otherwise dull landscape if there is a great stormy sky over it; the sky becomes the subject. Feel the power of a storm when you are in it, and find ways to convey that intensity with your camera.

Raindrops add atmosphere, especially in moody shots. Decide whether you want to photograph the rain frozen in place or streaking through the image. Raindrops usually won't show up well against something light, so try to offset them with something dark behind.

Martin Vavra/National Geographic My Shot South Carolina, U.S.

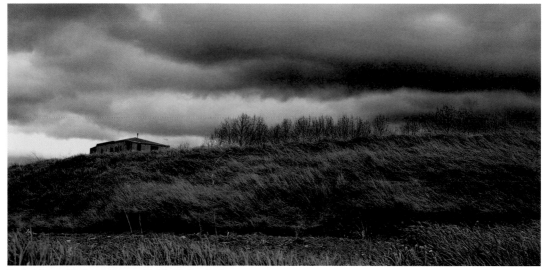

Rachel Angus/National Geographic My Shot Spain

▶▶ **If there is lightning** in the scene, you'll have to be patient as well as lucky: You never know where lightning is going to strike.

The sky is usually an important element of storm pictures, but be careful. A very dark sky can fool the camera meter into overexposing, while shafts of sunlight piercing the clouds can lead to underexposing.

Stand under some sort of overhang to keep your equipment dry. If that isn't possible, you can wrap a plastic bag around your camera, leaving one hole for the lens and another for your eye.

Look around and see how rain is affecting your scene. You might photograph water glistening on rocks, the richer color of moss or plants—or whatever makes it obvious it's raining.

☐ Paul Nicklen: **MY PERSPECTIVE**

MY DEFINITIVE EXPERIENCE as a photographer would come on a trip to document leopard seals, fierce mammals that dominate Antarctic waters. Leopard seals are often unfairly cast as villains since they have been known to occasionally puncture inflatable boats and harass people. I wanted to capture a different side of the animal, a wish profoundly fulfilled when an enormous female found me in her terrain and figured me for an incompetent, helpless predator.

At our first meeting, she took my head and camera in her mouth as a threat display; I was terrified. But the most amazing gesture followed: She released me, swam away, and reappeared with a live penguin. Was she trying to feed me? Eventually she brought weak penguins, then dead penguins, then partially consumed penguins, pushing them toward the lens of my camera, which it seems she mistook for my mouth. As she continued her campaign for four more days, I realized this episode would allow me to expose this top predator as a doting, venerable creature.

My mission extends much deeper, of course, than merely changing or challenging perceptions. I believe hard facts are not enough; people need to experience the wonder and beauty of these regions for themselves. My photography can bring the polar realms to life on the printed page—and, I hope, inspire the passion needed to preserve them. —P.N.

SINCE 1995, **PAUL NICKLEN** has specialized in photographing the poles and their inhabitants, from Steller sea lions in the Aleutian Islands to minke whales off Australia's coral reefs. With an emphasis on underwater photography, he excels in working in harsh environments and cross-cultural situations. His most recent book, *Polar Obsession,* was published by National Geographic in 2009.

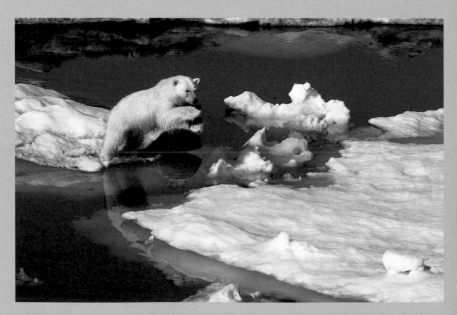

A young male polar bear leaps onto drifting pack ice near Svalbard, Norway.

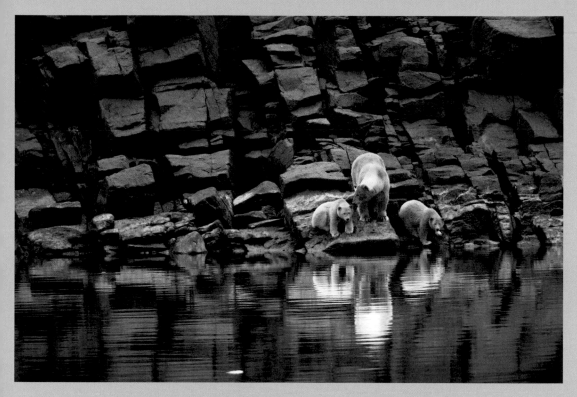

Without ice, a mother bear and cubs are stranded on a rocky shoreline near Svalbard, Norway.

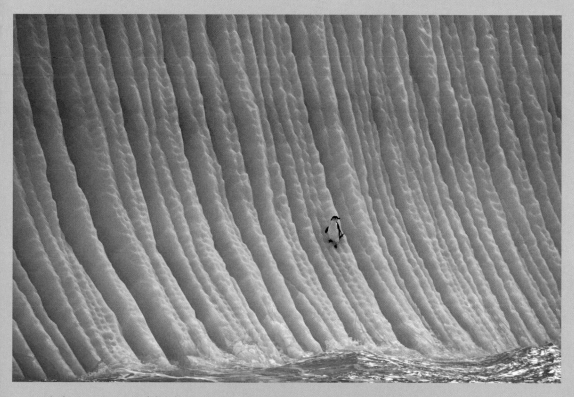

A chinstrap penguin slides down the slope of an iceberg in South Georgia.

▶ Animals in the Wild

IT'S A COMMON EXPERIENCE: You see an animal you want to photograph, but just as you move in, it's gone. Timing is everything. When you first see your subject, photograph it from where you stand; then edge in slowly. You want to make sure you get the shot you have, rather than rushing in and getting nothing at all.

Use a long lens for tight shots. For a sense of place, photograph the subject in its habitat. If you have a tripod, use a slow shutter to create a feeling of movement.

Elliott Neep England

▶▶ Game animals blend into the landscape, so be careful about your background. Wait to shoot a deer, for example, until it is outlined against the sky or a distant light-colored field.

Use a shallow depth of field for close-ups to blur out background distractions.

Close-ups are better if there's a catch light in the eye. Try shooting late or early in the day with the animal facing the sun. Or use a flash set on a dim, fill-flash level.

Balazs Buzas/National Geographic My Shot Tanzania

▶ FOR MORE ON
PHOTOGRAPHING
ANIMALS,
SEE PAGES
248-51.

▶ Birds

James Galletto/National Geographic My Shot

▶ **FOR MORE ON CHOOSING THE RIGHT LENS, SEE PAGES 30-1, 142-51.**

YOU DON'T HAVE TO TRAVEL to faraway or exotic places to photograph birds—you can get started in your own backyard. The main thing is to get close by learning about the day-to-day lives and travels of your subject.

Look for large numbers of birds on public beaches or in parks, refuges, and other areas where they are used to seeing people and will be more approachable. Offer food at a backyard feeder, and practice shooting from inside your house. Birds that won't come to a feeder will find a birdbath or drip pool a powerful magnet. To get close to wary birds, take your time when you approach, don't look directly at them, and stop now and then to let them become accustomed to your presence.

▶▶ **The best lens for** bird photography is a telephoto with a focal length of 400mm or greater. A 70mm-to-300mm zoom works well for birds that can be approached closely. Use a tripod for lenses longer than 300mm.

Always keep the bird's eye in sharp focus. It's what people usually notice first in a photograph.

Try for a natural background without man-made objects such as utility poles, wires, fences, and buildings, which compete for attention.

Andy Kenutis/National Geographic My Shot Minnesota, U.S.

James Galletto/National Geographic My Shot

▶ Wildflowers

▶ FOR MORE ON CLOSE-UPS AND MACROPHOTOG-RAPHY, SEE PAGES 102-3, 146-7.

THINK ABOUT THE CHARACTER of the wild-flowers you find, and look for a point of interest. It might be the shape of a blossom (as in the photo below) or splashes of color receding into the distance. Compose the image to accentuate it. Try different lenses and angles. Get down low to shoot tall flowers against the sky, or stand above flowers to find a neutral background.

▶▶ Take advantage of sunsets. The soft, golden light will make a meadow of wildflowers glow.

Wind can wreak havoc with your subject. If it sets the flowers in motion, be patient and wait for a lull.

Look for masses of flowers to add drama. If it's winter, even dried seed heads on the frozen ground make an interesting textured subject.

Watch your step. Some of your subjects may be endangered species. Never uproot or cut wildflowers, and be careful not to trample the plants.

Candy Caldwell/National Geographic My Shot Iceland

Ralph Lee Hopkins Arizona, U.S

Ralph Lee Hopkins Arizona, U.S.

▶ Details

▶ FOR MORE ON
PATTERN IN
COMPOSITION,
SEE PAGES
100-1.

OFTEN A DETAIL can say as much, or more, about a place as a wide shot. It can be anything: the way water has eroded a rock, a deer footprint in snow, the pattern of bark on a tree. To draw more interest, look for ways to break up textures and patterns with an irregular shape or color—a green gourd against a pile of orange pumpkins, for example.

Be on the lookout for abstract patterns in landscapes. When you find them, choose your lighting and viewpoint carefully. Low light shows texture. Use a downward camera angle to raise or eliminate the horizon.

You can tinker with the background in order to accentuate the patterns of interest. Remove a distracting twig or arrange a log or some large leaves. Shoot when the dew is on the blossom. Some spray it with an atomizer, but that's cheating.

▶▶ **Try different angles**—above, below, from the side—to find the most interesting composition.

Details don't have to be extreme close-ups. A tight shot of snow-covered branches and part of a tree trunk could reveal the character of a winter forest.

If texture or color is important, light the subject to enhance it—low, warm light for the contours of a texture; soft, diffuse light to enhance color saturation. Isolate textures, patterns, or repeating elements

Make sure you have enough depth of field to show the details, but not so much they blend into the background.

Chris Hill Northern Ireland

Alaska Stock Images Alaska, U.S.

Jason Edwards Australia

WHAT MAKES THIS

ALBATROSS **Frans Lanting** Steeple Jason Island, Falkland Islands

A GREAT PHOTOGRAPH?

FRANS LANTING is among the finest nature photographers working today. He is also a gifted writer with deep admiration for all living things, plant or animal, and concern for their success and survival.

SUBJECT Frans chose to do a story on the albatross because there has been so little documentation of these magnificent birds. Getting to this breeding ground on Steeple Jason Island, part of the Falkland Islands chain, was a challenge in itself.

COMPOSITION This is basically three pictures. There is a picture of the vast sky and sea, a picture of an albatross in flight, and a close-up portrait of an albatross: Tight close-up, medium shot, and long shot, all in one photograph. The charm lies in the spaciousness of the landscape that the birds inhabit. See what a different photograph it would have been if Lanting had framed it to be just to the right of the flying bird.

LIGHT In the Falkland Islands the sun never gets very high, and the weather is notoriously unpredictable. What light there is is a soft light, not direct sunlight, coming from the upper right-hand corner.

EXPOSURE To make the photo, Frans used a wide-angle lens, a large aperture, and a relatively slow shutter speed. The focus is definitely on the portrait of the bird, because the rest of the image goes soft—just a little out of focus—and evokes distance.

—James P. Blair
NATIONAL GEOGRAPHIC
PHOTOGRAPHER

3 Action & Adventure

ADVENTURE PHOTOGRAPHY represents a kind of photography that is often shot by participants, which opens up its own set of challenges and triumphs. Being a participant in the adventure gives you a front-row seat to the action. You can use your proximity to help you focus on both the subject matter and the emotion of the events as they develop. Great adventure photography touches a nerve in everyone who sees it, giving a shimmer of the sense of adventure experienced by those who were there in the scene.

You will find that a simple camera will work for most action sports and adventure situations, but you may come across situations that require special strategies for shooting. You will also need to heed possible environmental hazards to yourself and your equipment. Safety, for both you and the people you are photographing, is your highest priority. No photo is worth putting yourself or others in harm's way.

Ralph Lee Hopkins Arizona, U.S.

▶ The Challenge

▶ FOR MORE ON PHOTOGRAPHING ACTION, SEE PAGES 162-5.

▶ FOR MORE ON THE DIRECTION OF LIGHT, SEE PAGES 118-9.

WE CARRY CAMERAS into every environment the world has to offer. Some are dangerous and require a lot of preparation to ensure that you get into and out of them safely. Many are physically grueling; others require great patience.

Take care of the logistics and survival elements first. Tailor your camera gear for the particular trip, and try to anticipate the situations you'll face. You can choose specialized lenses if, for example, you know you will be hiking in narrow slot canyons where you might want a wider lens. You might decide to bring a lightweight tripod for low-light photography. But think about all your equipment's weight and bulk—you have to carry yourself and your camera gear through this adventure.

▶▶ **Be open to serendipity.** Allow events to unfold naturally even if they aren't going the way you envisioned them.

Zoom lenses are the workhorses of outdoor adventure photography. They allow you to change perspective without having to move an inch.

Maintaining your equipment is critical on long trips or trips to areas of high humidity or temperatures.

Give your cameras a complete cleaning if you've been shooting in rain or blowing sand.

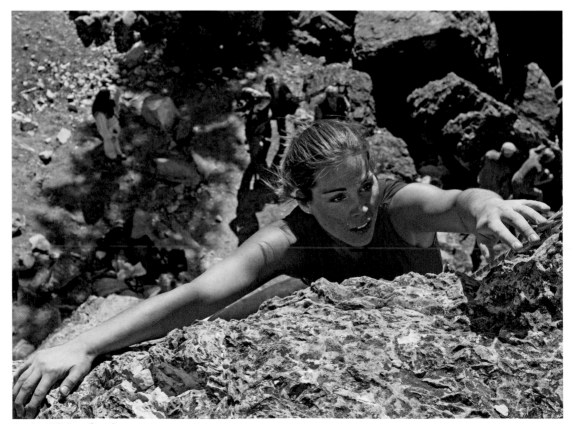

Gordon Wiltsie Canada

Jim Harding New Zealand

▶ Timing

Brooke Whatnall Australia

▶ FOR MORE ON
ANTICIPATING
GOOD
COMPOSITION,
SEE PAGES
44-5.

THE MORE YOU SHOOT fast-action sports, the more tuned in to the activity you will become, and speed will naturally follow. Anticipate the best place to position yourself. Rehearse the subject's trajectory through the frame. If you've already practiced the camera movement, when the person or object is in motion, it's just a matter of following it in the frame (as in the photograph opposite).

▶▶ **Sharpen reaction time** by practicing at the local sports field, the skateboard park, or on a bike ride around the block.

A fast motor drive is a sure way to catch more action.

Without a fast autofocus, prefocus on a spot where, for example, a skier or race car will shoot past you, using a tree branch or some other unobtrusive object.

Compose your frame carefully so you don't cut a head or arm out of the photos, despite movement.

Stacy Gold Maryland, U.S.

Syafiq Sirajuddin/National Geographic My Shot

▶A Sense of Story

▶FOR MORE ON
SEEKING THE
AUTHENTIC,
SEE PAGES
338-9.

ADVENTURE PHOTOGRAPHY is about telling a story, and story line determines the important photo moments of a trip.

Shooting great adventure photography requires balancing photography with participation, as well as a keen observation of unfolding events. Your reward will be powerful photos that clearly illustrate the story of your adventures. The behind-the-scenes photo is integral to building your photo story, too. Your subjects—your crew and friends—will be the players that give your story the personal touch.

Matt Moyer Idaho, U.S.

▶▶**Keep in mind** five basic questions of storytelling: Who? What? When? Where? How?

Try POV (point-of-view) shots, shooting from unusual angles.

Pay attention to backgrounds and foregrounds—they can be very effective storytelling tools.

When shooting portraits, try backing up a little to include the environment around the person.

**Lukasz Warzecha/
National Geographic My Shot** Greece

▶ Athletic Events

▶ **FOR MORE ON POINT OF VIEW, SEE PAGES 106-7.**

PHOTOGRAPHING A TRACK MEET (as in the photo opposite) or a baseball game is the same as shooting an adventure story. If you begin with a rough idea of what you want to shoot, then you can decide what equipment you might need. The more you shoot, the more tuned in to the activity you will become.

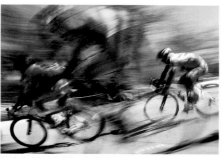

Rich Reid California, U.S.

▶▶ **Must-have gear** for shooting in the sun on an open playing field includes a hat, water, and an energy bar.

Switch off your autofocus to photograph through netting or similar screening—behind a soccer goal, for example. Such obstructions usually foil autofocus cameras.

Set the camera high enough on the tripod so you can pan and follow-focus easily and comfortably.

Try a POV shot from the athlete's perspective. It will bring the viewer into the action of the scene.

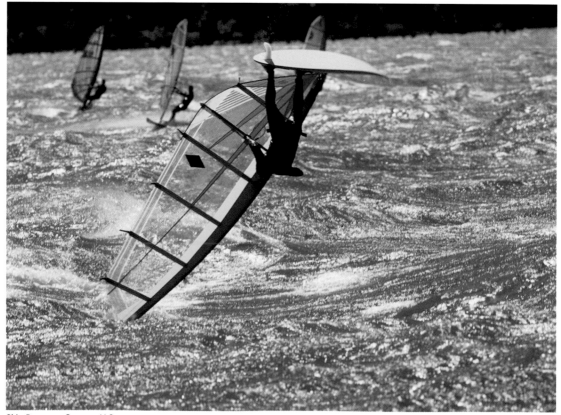

Skip Brown Oregon, U.S.

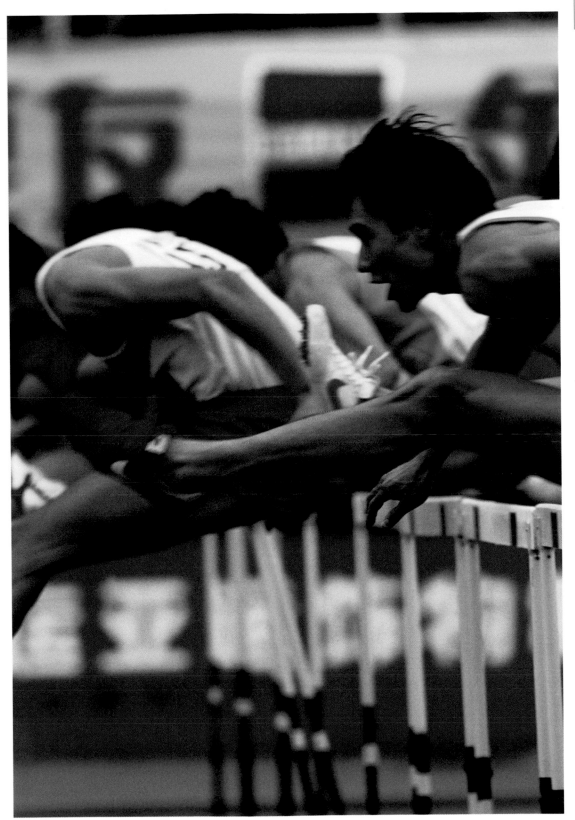

Michael Nichols People's Republic of China

David Doubilet: MY PERSPECTIVE

I MET MY HERO, Jacques Cousteau, at the premiere of his Oscar-winning documentary *The Silent World*. This extraordinary film opened the world's eyes to the sea, and I was mesmerized. I told him I wanted to be an underwater photographer. He grinned and with his Gallic shrug said, "Why not!"

Not long after that, when I was 12, my father bought me a Brownie Hawkeye camera. My dad was a doctor and a scientist, so we rigged up the Brownie in an anesthetist's bag clamped inside an old diving mask, which I shot through. The results were terrible—I could just about see my feet. I wasn't discouraged; my father taught me that the most important thing in life was to be curious about the world. My mother nurtured a sense of adventure and a sense of humor, which I've certainly needed in my line of work. Shooting undersea is like taking an assignment in New York City under a thick fog, and you may have only 20 minutes to get the story.

We envision the seas as an extraterrestrial environment, yet most of our planet—and much of its life—is underwater. It's frightening that my pictures might become documents of places soon to be lost. I hope my work has helped readers to view the seas not as some far frontier but as a vital part of our planet, to be treasured and preserved for future generations. —D.D.

DAVID DOUBILET has photographed in the ocean depths of such places as Japan, Tasmania, Scotland, and the northwest Atlantic, as well as in freshwater ecosystems such as Botswana's Okavango Delta and Canada's St. Lawrence River. He has photographed stingrays, sponges, and sleeping sharks in the Caribbean, as well as shipwrecks in the South Pacific, in the Atlantic, and at Pearl Harbor. His first *National Geographic* article appeared in 1972, and he has been contributing ever since.

Australian sea lions play in sea grass near Little Hopkins Island, South Australia.

A fisherman peers down into floodwaters of the Okavango River in Botswana.

A double-headed wrasse and other fish swim in the southernmost coral reef in the world, New South Wales, Australia.

▶Hiking & Backpacking

Bill Hatcher Utah, U.S.

▶FOR MORE ON
LANDSCAPES,
SEE PAGES
262-3.

▶FOR MORE ON
THE COLOR
OF LIGHT,
SEE PAGES
120-1.

GETTING THE FACE may sound obvious, but, in fact, most people shooting groups in motion tend to shoot the backs of people because they themselves are traveling in the line. The fix is to hustle up ahead, getting face shots as people approach or wider images as they move past. But don't be afraid to break the rules if you see something special that works (as in the photo opposite).

Make sure you get people looking at the view, not at you. How many photos have you seen of people standing before an overlook gazing at the camera? Better to shoot people engaged in the scene. You want pictures of beautiful places and of people having a blast there. Look for secondary shots to round out your story—tents in a meadow, a table with fresh food, a close-up of hands holding a map.

▶▶ **Avoid changing lenses** in blowing dust or sand. Wait until the storm passes.

Before heading into remote areas, consider what you need to keep using your digital camera on the trail—power for the rechargeable battery, power for hard drives (which also run on rechargeable batteries), and a way to protect fragile memory cards.

Take care of yourself. With your camera, your pack will be among the heaviest. So you have to be in at least as good physical condition as the others in your group.

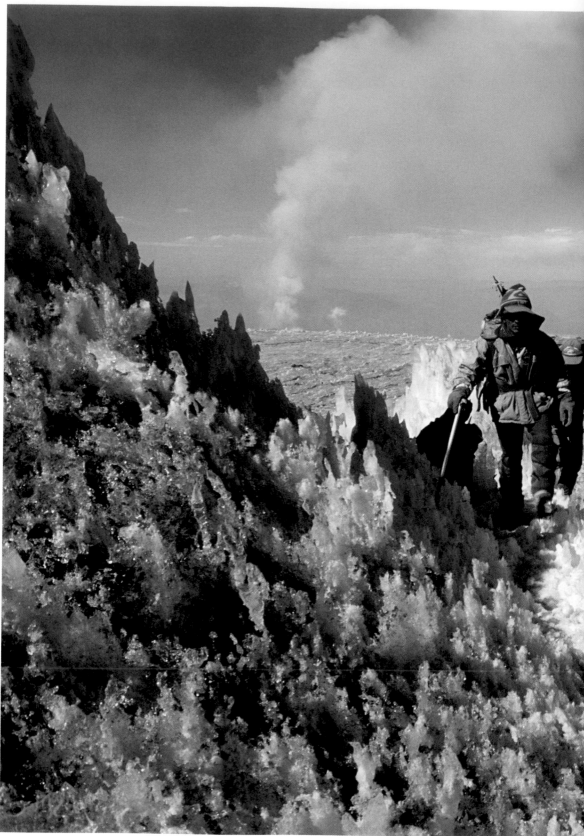

 Stephen Alvarez Peru

▶ Water Sports

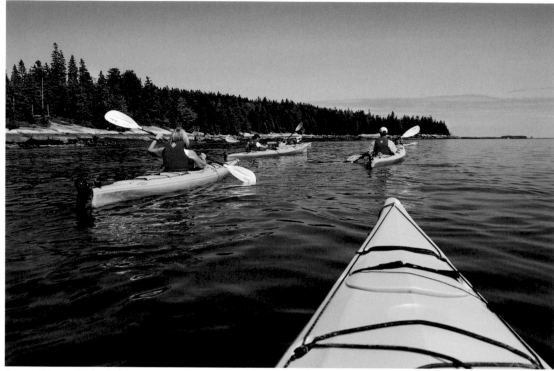

Anne B. Keiser Maine, U.S

▶FOR MORE ON
UNDERWATER
PHOTOGRAPHY,
SEE PAGES
360-1.

MANY BOATING, KAYAKING, AND SURFING photos are taken from shore. How far you are from your subject will determine which telephoto you need. To shoot boats in rapids, position yourself on the bank in a place that has a clear view of the action. The shot has to be tight enough to show the boaters' faces as they're screaming.

When you're in a boat, your position is essentially fixed, so using a zoom lens is very important. If your camera gets splashed, use a towel or chamois to dry it, and set it in the sun to dry it completely.

The best lens to use for shooting in a boat or raft is a wide-angle zoom lens. Be sure to hold on and brace your feet on the side of the boat when you drop into a rapid or plunge into a wave. Boat motion in waves and rapids can be very violent, not unlike riding on a bucking rodeo horse.

▶▶ Look for reflections on the water during sunset and sunrise.

Fresh water is corrosive, salt water more so. A waterproof bag or case is a must if you're photographing surfing, rafting, sailing, and most paddle sports.

On flat water, a plastic bag with a hole cut for the lens is enough protection for your camera. Consider getting an underwater housing if you need total splash protection.

Boats on moving water can be beautiful. Experiment by adjusting your camera to slower shutter speeds.

Mark Raycroft Canada

George Grall Mexico

▶ Snow Sports

SPEED IS OF THE ESSENCE in ski and snow-board photography. Carrying your camera in a backpack can make it hard to access, so instead use a hip pack that has a waist belt and shoulder strap.

If snow is a main component of the shot and you're using the in-camera meter, overexpose the snow by +1¾ stops to +2⅓ stops. With a handheld meter, spot-meter the subject for correct exposure.

Alaska Stock Images Alaska, U.S.

▶▶ **Keep a brush handy** on cold, snowy days to keep the snow off your lens. That way, you'll be ready to shoot at any moment.

On very cold days, be careful not to breathe on the camera or lens. Condensation from your breath will freeze instantly on the metal and glass.

Be ready to shoot lots and lots of photos. When you photograph fast-action sports, only a few photos will be sharp and composed in the frame.

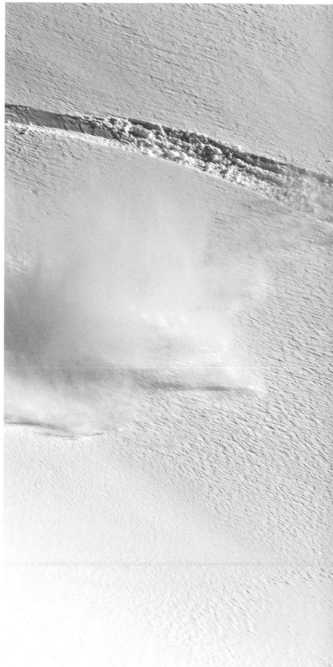

Alaska Stock Images Alaska, U.S.

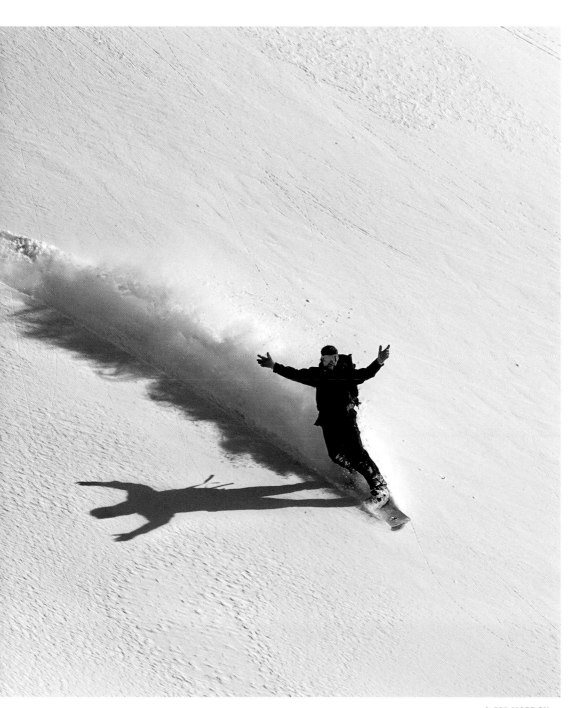

▶FOR MORE ON
PHOTOGRAPHY
IN BRIGHT LIGHT
SITUATIONS,
SEE PAGES
124-5.

WHAT MAKES THIS

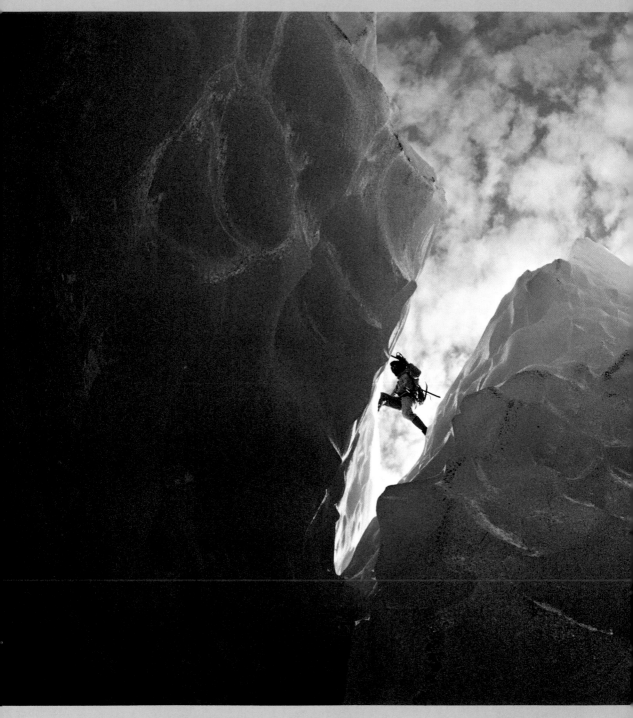

TWO ICE CLIMBERS **James Brandenburg** Columbia Ice Fields, Alberta, Canada

A GREAT PHOTOGRAPH?

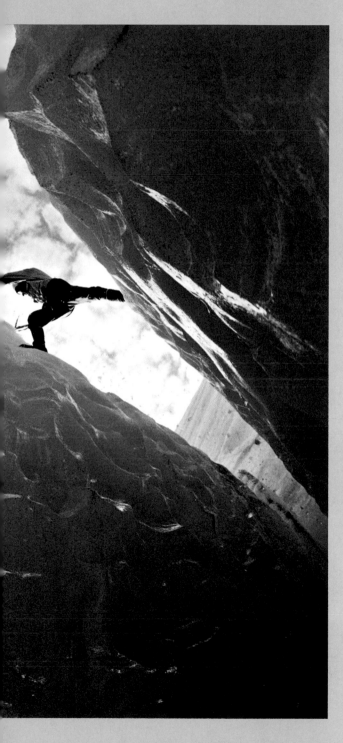

JIM BRANDENBURG is one of the most fear-less photographers I know—the only thing that matters is getting the picture. This shot is a great example

SUBJECT As climbers cross a fractured glacier, Jim has taken it upon himself to show how risky that is by shooting the scene from deep inside a crevasse.

COMPOSITION This is a strongly composed, dynamic photograph, the knife-blade gaps converging in a pinnacle of danger. Jim saw what he wanted and recognized that there was only one way to get it.

LIGHT His vantage from below caught the climbers at the perfect moment. The sky is overcast, so the exposure needed for both sky and ice was also correct for the climbers. Had the camera been exposed to the glacier's normal brightness, the climbers wouldn't be visible. Exposing for the light on the top of the glacier allowed the interior of the crevasse to go a deep blue.

EXPOSURE Here experience counts for everything. Jim knew the correct exposure for the light on top before he descended into the crevasse. He made a slight adjustment for the aperture, so that the ice would be blue instead of underexposed black. To capture the action of the climbers leaping across the chasm, he used a high shutter speed..

–James P. Blair
NATIONAL GEOGRAPHIC
PHOTOGRAPHER

4 Familiar Places

ONCE YOU BEGIN to look at the world for photographs, everything begins to take on new character and interest. You become differently aware of your surroundings, looking at them with a fresh eye. Your neighbors' gardens, the office buildings you pass every day, even common objects like coins or key chains—all can make compelling images.

To sharpen this new take on familiar surroundings, strive for the unexpected, whether that means shooting the kids in the kitchen before a formal Thanksgiving feast or focusing on a detail instead of an entire building. Think what household objects might make interesting still lifes; notice the detail in the forest floor or a corner of an abandoned parking lot.

For family events, use common sense and know the limits at solemn gatherings. As always, think about what you want to communicate, and then find the scenes, shapes, colors, and expressions that help you do that.

Krista Rossow New Mexico, U.S.

▶Architecture

▶ FOR MORE ON
CAPTURING
A CITY,
SEE PAGES
348-9.

NOTHING CAPTURES the character of a town or city like its buildings. Use them to advantage in your photo. Pedestrians help give scale to large buildings (as shown below). A driveway curving up to an old Victorian carries the eye to the house. Flowers surrounding a statue add contrast and color as a foreground element.

For skyline shots, try to find a location with an uninterrupted view. Look for angles where the sun shines through a gap in the buildings. Use a long lens to isolate part of a building.

Quang Tran/National Geographic My Shot Washington, D.C., U.S.

▶▶ Use the distortion you get when the lines of tall buildings converge at the top of your frame to accentuate the soaring quality of a skyscraper.

Compose your building shots with a compelling foreground element to add interest, scale, and depth.

Use a polarizing filter when photographing buildings with lots of glass in order to avoid unwanted glare.

Adam Regan/National Geographic My Shot

▶Gardens

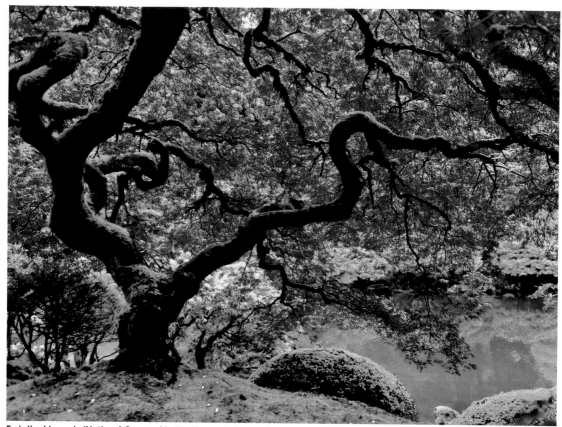

Emir Ibrahimpasic/National Geographic My Shot Oregon, U.S.

▶**FOR MORE ON THE RULE OF THIRDS IN COMPOSITION, SEE PAGES 86-7.**

GARDENS ARE READY-MADE objects of beauty, but photographing gardens takes some careful crafting. Find something significant to catch the eye—a figure, a prominent physical feature, a pond, or a splash of color (as in the photos opposite and above). Remember the rule of thirds as you frame your composition and make your choices. Draw the eye to your chosen point of interest by using leading lines.

Choose lenses carefully for garden photography. It's tempting to use a wide-angle lens to take in a wide swath of the scene, but the disadvantage of that choice is that everything within a wide shot is usually in focus, so the images can be flat unless composed dynamically.

▶▶ **Telephoto lenses isolate the details** of nature. Often something small says as much or more about a place than a wide view.

Find an element that interrupts a pattern. It might be one tree trunk of a different color or a protruding rock that breaks the symmetry of concentric circles in the water.

Patterns can be less obvious, too. Blocks of color, either the same hue or different ones of about equal tonal value, can lend depth.

Diane Cook and Len Jenshel New York, U.S.

Richard Nowitz Massachusetts, U.S.

▶ Composed Still Lifes

▶ FOR MORE ON COLOR AND PATTERNS IN COMPOSITION, SEE PAGES 98-101.

STILL-LIFE PHOTOGRAPHY is truly an art form—something like painting or sculpture with the camera. Basically, it is the art of photographing an object or a group of objects in a setting and finding a composition in the interaction of the objects' shapes, lines, and colors.

Whether it's complex studio lighting or simply a household desk lamp, lighting matters a great deal in still-life compositions. Try to maintain some control over the direction of the light. Unless the existing light is very bright or you're using flash equipment, you will probably want to use a slower shutter speed. A tripod also allows you to maintain the position of your camera—and therefore your composition—as you adjust the lighting.

▶▶ **Choose the right background.** Construction paper and thin poster board stay stiff, but they can curve and create shadows.

Black velvet is one of the most light-absorbing materials around.

White paper diffuses harsh light and works well as a reflector outdoors in bright sun.

You can rely on natural light alone if you position the subject near a window. Curtains soften the sunlight, and the natural shadows fall in the same direction.

Justin Guariglia Indonesia

Michael Melford Portugal

▶ Discovered Still Lifes

Michael Melford Zanzibar

▶ FOR MORE ON
CAPTURING
A SENSE OF
PLACE,
SEE PAGES
264-5.

SIMPLE WORKS OF ART are all around you. Sometimes all it takes is careful framing or shooting from a different perspective to bring out an arresting juxtaposition of shapes, colors, or textures that was there all the time. It might be a basket of vegetables, a stone wall with a curling vine, or a pile of shoes by the bedside. Usually you need no special equipment to take great still lifes—just a good eye to see the possibilities around you.

▶▶ **When the sun is low,** look for places where long shadows cast the subject in relief, adding an abstract quality of the composition.

Squint to see potential subjects as an arrangement of textures, colors, or shapes.

Try different frames and different perspectives when you find a subject of interest.

Kenneth Ginn Cuba

Todd A. Gipstein Maine, U.S.

☐ James Stanfield: MY PERSPECTIVE

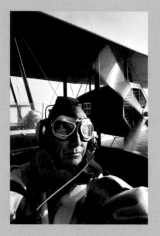

THE PHOTOGRAPHER'S JOB is to enter into another person's world unobtrusively. Once you establish a bond of trust, you become invisible, and your photography begins to peel back the layers of a life.

I first learned to tap into the human heart halfway through a story on the Potomac River. The images I had were pretty, but they lacked depth. So I started living with folks along the riverbanks. I joined a coal miner. I lived with fishermen, with a hermit. Then I met Carolinas Peyton, an 88-year-old farmer who ran a 62-acre plot with his daughter Lydia, two great-grandsons, and a pair of ornery mules. I began to share their lives in a rich, rewarding way. My photographs started to say something, developing depth and layers of meaning. National Geographic's director of photography, Bob Gilka, took note, and I was soon shooting stories in far-flung, forbidding places.

Recently an immense sense of gratitude stilled me while tending tomato plants in my Chincoteague Island garden in Virginia: What a privilege it's been to experience those places that most of mankind will never see. To cross deserts on camels with Tuareg tribesmen; to see whole continents from a biplane; to retrace history and to witness history in the making; to see so much, so that others may understand the world a little better. —J.S.

PHOTOGRAPHING for National Geographic since 1967, JAMES STANFIELD has covered subjects as diverse as the coronation of Iran's shah, the power and allure of chocolate, and royal life in England's Windsor Castle. He has illustrated several books: *Inside the Vatican, The Greatest Flight,* and *Eye of the Beholder,* a retrospective of his career. Four times named White House Photographer of the Year, in 1999 he won a career achievement award from the National Press Photographers Association.

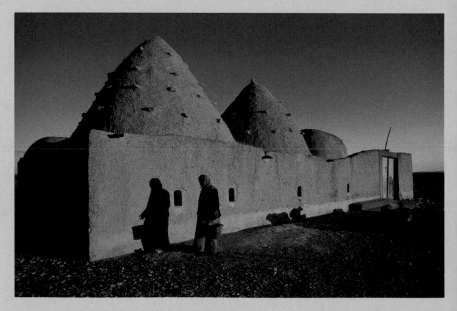

A woman walks past a sunlit mud-brick housing complex in Syria.

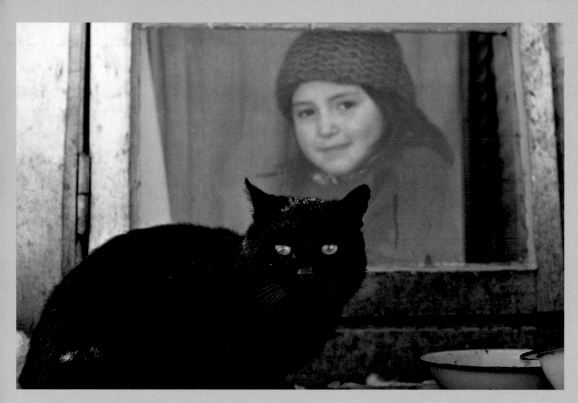

A girl peers through a window, past a cat on the ledge, in Puerto Williams, Navarino Island, Chile.

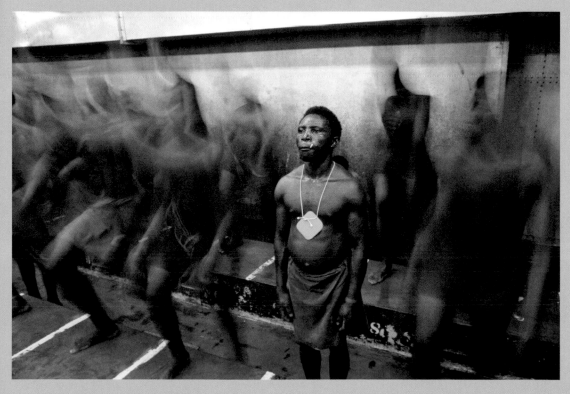

South African mine workers train in a heated room to prepare for mine conditions.

▶Fashion

WHEN YOU PHOTOGRAPH FASHION every element of the photo—the model, the clothes, the hair, the composition, and even the angle—contributes to the vision. Think about the pose; make sure your model knows what you're after. Pick a location that reinforces your idea—maybe a beautiful beach for resort clothes or a wooded backdrop for sportswear.

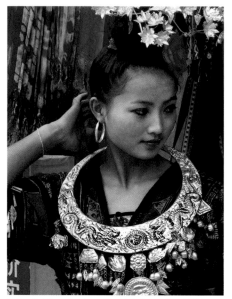

O. Louis Mazzatenta People's Republic of China

▶▶ Hang a piece of seamless cloth from the ceiling in your home to make a simple studio backdrop.

Look through current magazines to get a feel for the latest trends in fashion photography.

Don't be afraid to move your model around. You're the director as well as the photographer for the shoot.

Consider different angles—below, above, from the side, from behind.

William Albert Allard New York, U.S.

▶ **FOR MORE ON ARTIFICIAL LIGHTING, SEE PAGES 130-1.**

Fritz Hoffmann People's Republic of China

▶Food

▶ FOR MORE ON
THE VALUE OF
BREAKING THE
RULES,
SEE PAGES
108-9.

WHEN SHOOTING FOOD, what matters most is that it should look fresh. The easiest photos are often the ones you get at outdoor markets, where street vendors may be cooking up sizzling local delicacies with ample sunshine to light your composition. To photograph food indoors, you'll need to plan ahead and be ready to shoot quickly once the food is ready.

Drew Rush Wyoming, U.S.

▶▶ **Plan the entire composition.** A simple background and just a few props, if any, make the food stand out the best.

Photograph food near a window, if possible, where the soft, indirect light makes it look the most natural.

Try brushing a little vegetable oil on any dull-looking food surface to add shine—a trick of the trade from professional food photographers.

Select colorful food items, and avoid whites and browns if you can.

Taylor S. Kennedy Canada

Taylor S. Kennedy Canada

▶Life at Home

BEING IN THE RIGHT PLACE at the right time and having close-up, intimate access to your family is what home photography is all about. To get started, think carefully about what each member of your family likes to do. Does your daughter obsess over puzzles? Does your son do his homework at the kitchen table? Those moments don't last forever. Seize the opportunities.

Look for the places in your house with the best light. Keep your camera set on autoexposure and autofocus. Then when someone does something interesting, you'll be ready.

Keenpress Iceland

▶▶**Avoid flash indoors.** Nothing wrecks a subtly lit scene like the harsh, direct light of a flash. To compensate, set a high ISO and keep a steady hand for the lower shutter speed.

When you can, shoot outdoors when the sun is close to the horizon or the sky is hazy or cloudy. Harsh midday sun makes people squint.

Find the best background. When you see a good subject, turn in a complete circle and look for the best direction from which to shoot.

 Rich Reid California, U.S.

▶**FOR MORE ON
STORING &
SHARING
PHOTOGRAPHS,
SEE PAGES
194-5.**

▶ Weddings

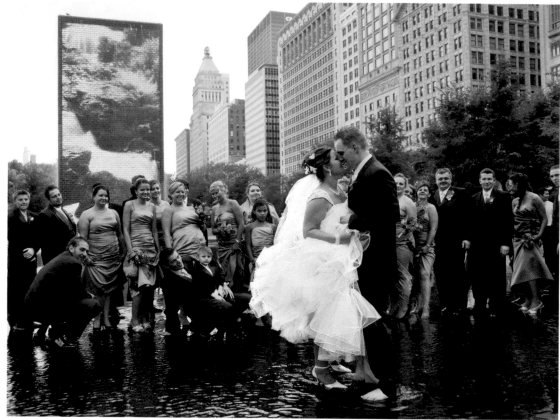

Annie Griffiths Illinois, U.S.

▶FOR MORE ON PHOTOGRAPH-ING PEOPLE, SEE PAGES 234-9.

WEDDING PHOTOGRAPHY comes in many styles, and the style you choose should match the personalities of the couple being honored. A reserved bride and groom may feel more comfortable with portraits, while another couple may not want to sit for pictures. Whatever style you choose, try to scout the wedding location beforehand so you know what sort of light and backgrounds you will have to deal with.

Think of the wedding as a story that your photographs will tell. Go to the bachelor party. Catch the bride as she is getting her hair done. Keep an eye out for serendipitous moments. Try different angles. Get on the floor for a kid's-eye view; try to find the right angle for the most intimate shots.

▶▶ If you need to use flash, use bounce flash or at least a diffuser (even a paper napkin) to soften the light and avoid strong shadows.

A longer telephoto such as a 200mm helps you photograph candid moments without being obtrusive.

Bring along a small, lightweight stepladder to give you an overview of events and a different perspective.

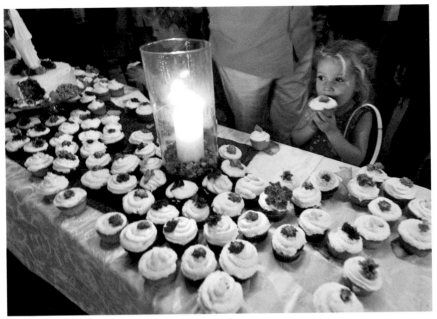

Rich Reid California, U.S.

Carolyn Drake Uzbekistan

▶ Holidays

▶ FOR MORE ON
FRAMING A
COMPOSITION,
SEE PAGES
84-5.

ON HOLIDAYS, look for the moments that express the feeling of the day and then make pictures that convey them. If it's Thanksgiving, you can shoot a few people at the dinner table eyeing the turkey, or record the hectic preparations before guests arrive. At Halloween, costume preparations or a glowing pumpkin capture the season (as in the photo below).

When shooting indoors, use ambient light whenever you can. But there will be times when it's important to use flash to get a well-exposed photograph. You want to be ready when the children first find their Christmas stockings or when guests raise a toast for the New Year. Bounced or fill-in flash will let you move around and capture the action and expressions.

▶▶ **Flash might distract people** and upset the holiday mood you want to record. Adjust your ISO and shutter speeds to allow you to use whatever light is available.

You almost always need a higher ISO indoors—especially if you aren't using flash.

Choose a wide-angle lens with a large aperture for best results indoors

For a tree with lights, combine flash, ambient, and indoor lighting. The flash lights up the tree, and a slow shutter captures the lights on the tree.

Joel Sartore Nebraska, U.S.

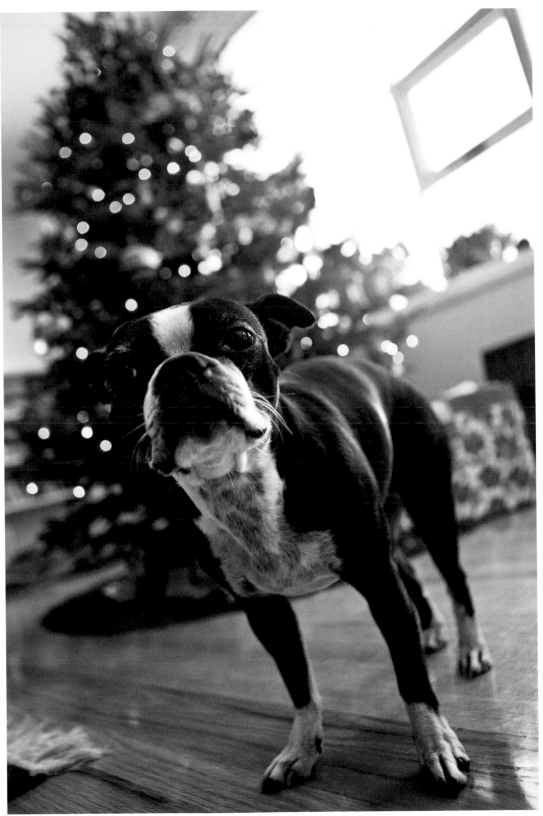

Hannele Lahti Virginia, U.S.

WHAT MAKES THIS

HUTTERITE SWINGS William Albert Allard Surprise Creek Hutterite Colony, Montana. U.S.

A GREAT PHOTOGRAPH?

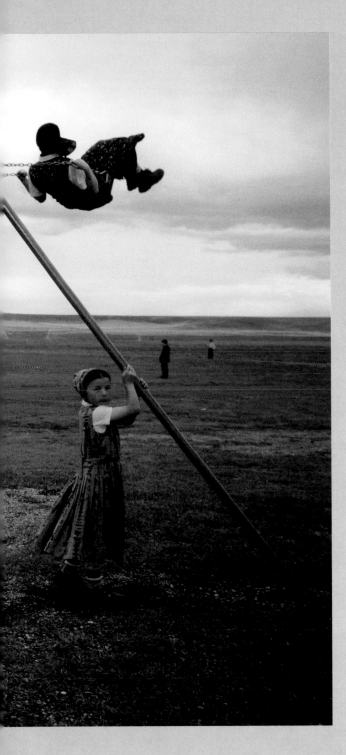

BORN IN MINNESOTA, Bill Allard found himself drawn westward in the 1970s, and since then he has returned to that part of the United States, whether on assignment or because of his own lifelong friendships and fascinations.

SUBJECT Bill has a way of seeing the precise instant to press the shutter. This is a Hutterite colony in the farming and ranching region of central Montana, where he has become personally close to the community. This photograph is about freedom— the freedom to fly, to dare.

COMPOSITION The structure of this photo is as complex as it is simple— three triangles and a connecting diagonal. It's a glorious moment, two girls flying in the leaden sky. The little sister, waiting for her turn on the swing, holds the composition together.

LIGHT Bill photographs what is there and uses the light to strengthen the image. On a bright day, this picture would have been very different, with too many distracting shadows that would take away from the composition.

EXPOSURE A shutter setting of 1/250 and a wide-angle lens set at f/4 are just right to capture the scene. Bill has focused on the little sister and knows he has enough depth of field to keep the boys playing ball in the background sharp.

–James P. Blair
NATIONAL GEOGRAPHIC
PHOTOGRAPHER

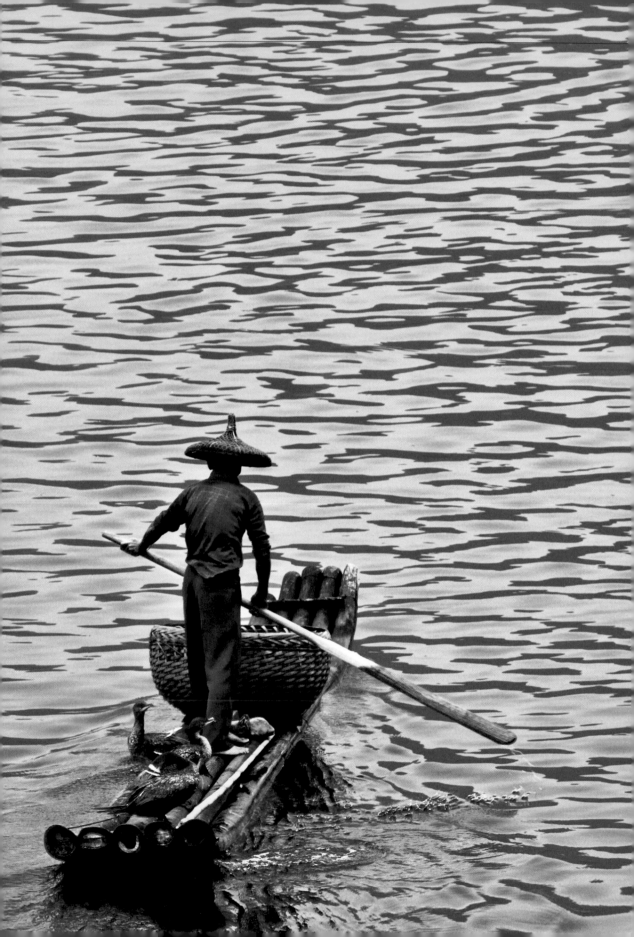

5 Traveling

TRAVELING—whether to a different corner of your own state or to some faraway country—is always an eye-opener. Everything seems to grab our attention, and we notice things we just take for granted at home: the way people dress, the work they do, the look of the land. Travel brings a heightened sense of awareness and sharpens the eye. With a bit of careful planning, your travel pictures will communicate this feeling of the marvels of the unfamiliar.

It pays to do your homework before you travel—not only to choose hotels and form an itinerary but also to be ready to take the best pictures possible. Before you leave, read everything you can get your hands on about your destination and think carefully about what kind of photographs you want to take. Decide how much you want to make your photography be the focus of your travels, because it might influence your choices of where to go, what to do, and even when to be awake at certain places.

Luca Vignelli/National Geographic My Shot People's Republic of China

▶ Packing to Take Pictures

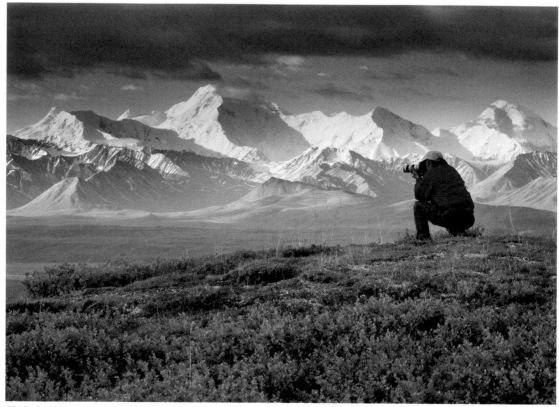

Alaska Stock Images Alaska, U.S.

▶ FOR MORE ON
CHOOSING
YOUR LENS,
SEE PAGES
142-51.

BEFORE YOU EMBARK ON YOUR NEXT JOUR-
NEY, think about what equipment is essen-
tial to get the kind of photos you want to
shoot and how much extra weight you can
handle. While compact point-and-shoot
cameras mean you need no additional cam-
era equipment, you won't have the control
you would with a digital single-lens reflex
(DSLR) and several lenses, and often the
pictures won't be as good.

Most professional photographers travel
with at least two DSLRs, usually identi-
cal models that take the same lenses. Pro-
fessionals generally mix and match zoom
lenses with fixed-focal-length lenses,
depending on what they're planning to
shoot. Filters, flash units, memory cards,
and cables fill out the camera bag.

▶▶ **Bring a few filters.** The basics
include ultraviolet filters to protect
the lens, polarizing filters that cut
glare and haze, and graduated density
filters to balance the range of darks
and lights.

One or two zoom lenses, with
a coordinated combination of focal
lengths, are a practical alternative to
numerous fixed-focal-length lenses.

Bring at least one backup for
every replaceable part, such as batter-
ies and memory cards.

Ed Kashi Pakistan

Joel Sartore Nebraska, U.S.

▶ Seek the Authentic

▶ FOR MORE ON
STREET
PHOTOGRAPHY,
SEE PAGES
254-5.

TODAY'S TRAVELERS are intrigued by the authentic. We like places that still have their own distinctive identity—culture, heritage, environment. Photography, particularly travel photography, has a role to play in helping to document what's left of the authentic.

Authentic culture is sometimes as close as the nearest market or festival, and these are likely to be on the tourist trail. But often you have to arrive early or leave late to really see life as the people live it. The best photographs of another culture will be founded on relationships that you establish with the people there. Show respect and appreciation; spend some time getting to know the place and letting its people come to know and trust you.

▶▶ **Research your trip** in advance and find out how you will be received. Always ask permission before shooting.

Go early and stay late to take advantage of the quiet hours if lots of tourists are visiting your destination.

Learn a few words of the local language, and express genuine interest in the people you meet. Engagement creates rapport.

Hire a guide to take you places that tourists don't normally go. Choose someone of the local ethnicity—they know the language and customs.

Daniel Lefort/National Geographic My Shot India

Chasen Armour/ National Geographic My Shot Tanzania

Yves Schiepek/National Geographic My Shot Vietnam

▶ Photographing People You Don't Know

▶ FOR MORE ON
THE QUALITY
OF LIGHT,
SEE PAGES
116-7.

WHILE TRAVEL is about destinations, as often as not our travel photographs feature people as subjects. Their manner, dress, and activities reveal as much about a place as its architecture and topography.

Start with people you naturally encounter on your travels—your cabdriver, a shopkeeper, a hotel clerk. People are proud of their work, and it's often easier to photograph them in that context than it is in a private moment. When you're ready to approach a total stranger, remember there's a reason that person caught your eye. Express your curiosity, and you'll find most people willing to talk. Before long, you can get around to asking if you can shoot some pictures. Approached in the right way, few people will refuse, and many will be delighted.

▶▶ **Befriend people first,** and then take the picture. That makes the encounter into a rich and rewarding experience.

People in heavily visited areas may ask for money to be photographed. Use your own judgment. Those who do so may well be anything but authentic.

In cultures where photography is uncommon, show your subjects the picture on the camera's display screen. It lets them know what you're up to.

Aaron Huey Slovenia

Anne Kohl/National Geographic My Shot New York, New York, U.S.

Keenpress France

▶ Photographing People You Do Know

IT'S A NATURAL THING to want to take photos of the people you travel with, especially in front of key landmarks. For pictures that both of you will treasure, use your imagination to go beyond the obvious: Find an interesting angle; watch for moments of activity, not just poses; look for a way to capture the fun of traveling together (as in the photo opposite).

Chai CS/National Geographic My Shot Malaysia

▶▶ Make photos of people near famous statues or well-known landmarks special. Find an unexpected point of view, long depth of field, or humorous interactions with the landmark.

Photograph friends engaged with the destination, not just staring at you. Photograph them looking at the view, inspecting the flowers, or pointing the way instead of just smiling at you.

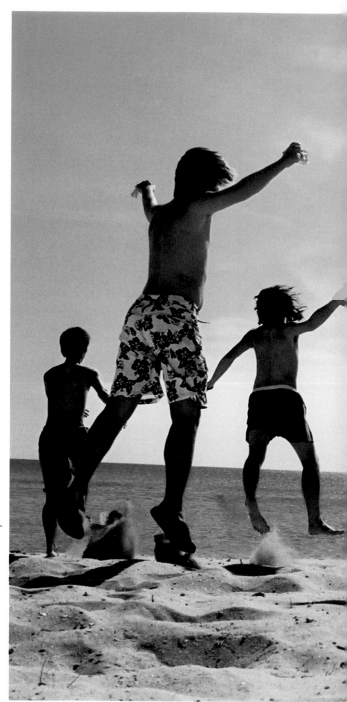

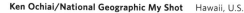
Ken Ochiai/National Geographic My Shot Hawaii, U.S.

▶**FOR MORE ON CANDIDS, SEE PAGES 252-3.**

▢ Mike Yamashita: **MY PERSPECTIVE**

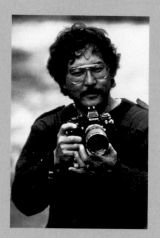

AS A YOUNG PHOTOGRAPHER, I grabbed any assignment in any location, eager to build my portfolio, but over time I have naturally been drawn back to Asia. It is there that I feel most at home. With rapid change overtaking most of Asia, I look for the permanent beauty in the natural world, to show nature as it is, and as I hope it will always be.

Before embarking on any assignment, I try to compose the images of a story in my mind. This is where the groundwork for photographer's luck is laid—it takes a lot of research to know what you're looking for.

Once I have my "shoot list," I begin the hunt. Sometimes that might involve hiking for hours or waiting a day for a mountain mist to clear. It might require returning to a site many times for just the right early morning light or even waiting for a change of seasons. Often, though, the real key to success is to be ready and open to seeing the photograph when you least expect it.

With film going the way of dinosaurs and change the only constant, photographers now need to think beyond the magazine page and embrace new media, new technology. But one thing about photography will never change: the ability of a powerful image to tell a story. —M.Y.

MICHAEL YAMASHITA has combined his dual passions of photography and travel for more than 25 years, shooting for *National Geographic* and, more recently, with his film production company, Saga Pictures. Specializing in Asia, Yamashita has covered Vietnam and the Mekong River, Marco Polo's journey to China, the DMZ between North and South Korea, and Japanese culture from samurai to fish markets. A frequent lecturer and teacher, Yamashita has received numerous awards, and his photography has been shown in major exhibitions throughout the world.

Five Colored Lake reflects a tree in Jiuzhaigou National Park, China.

A tourist approaches China's southernmost point, Hainan.

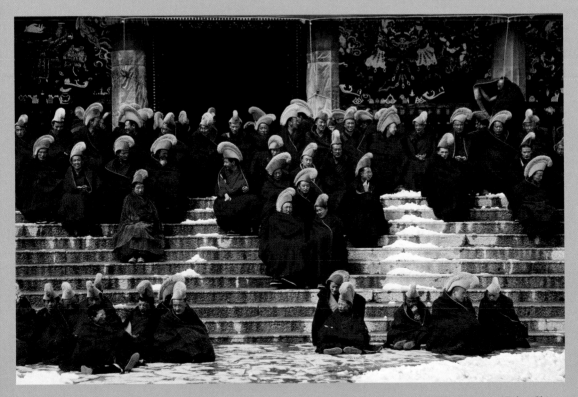

Monks of the Yellow Hat sect of Tibetan Buddhism gather for prayers at the Lebrang Monastery in Xiahe, China.

▶Capturing the City

▶FOR MORE
ON TAKING
PICTURES OF
ARCHITECTURE,
SEE PAGES
310-11.

CITIES ARE DIFFICULT SUBJECTS. Look for ways to photograph the experience instead of its the structures. Famous sites make good background elements, but structures alone can seem dead unless you find a novel approach.

Another key is to develop a shooting list: a checklist of the neighborhoods, buildings, parks, or places vital to the city that you want to be sure to photograph. Then, when you arrive, spend a day scouting out those areas. Look for ways to add a sense of place to your images—for instance, a rainy street scene (as in the photo opposite) can capture more character than a sunny straight-on of a famous landmark.

▶▶ **Be mindful of distances** and transportation options in large, sprawling cities. Use subway and street maps, or a GPS, to plan your route.

Break down your shooting list by time of day—perhaps markets in the morning, romantic scenes at dusk, and the theater district at night.

Shoot interiors—restaurants, shops, or galleries—at midday, when the existing light is harsh outside but at its peak inside.

Markus Urban/National Geographic My Shot New York, New York, U.S.

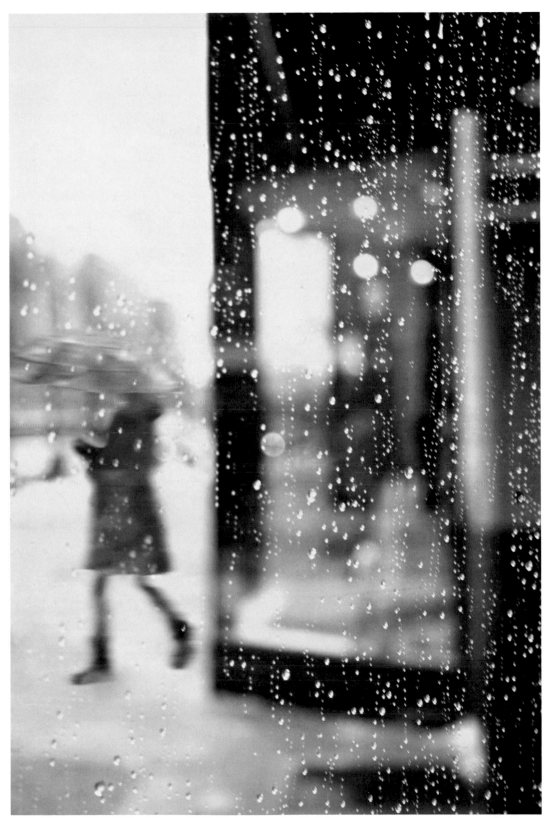

Yasmin Shirali/National Geographic My Shot Massachusetts, U.S.

▶ Discovering the Country

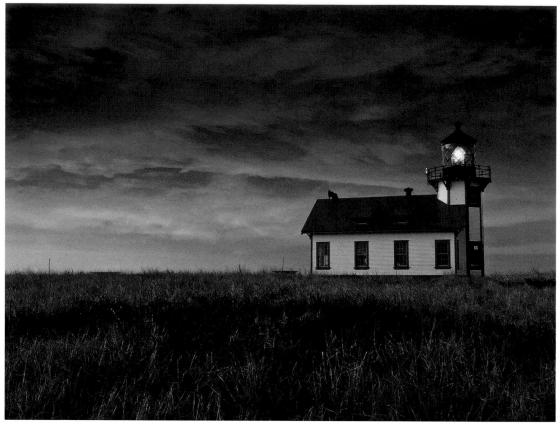

John Chamberlin/National Geographic My Shot California, U.S.

▶ **FOR MORE ON LANDSCAPES, SEE PAGES 262-3.**

▶ **FOR MORE ON PHOTOGRAPHING ANIMALS IN THE WILD, SEE PAGES 276-7.**

TRAVEL IS ABOUT ESCAPE, and the urge to get away often leads to the countryside. Make the most of photo opportunities there, doing pretrip research just as you would when photographing a city.

Most likely you'll travel by car. Drive slowly. It's easy to zoom past good pictures. Subjects can be more subtle, less in-your-face, than those in cities. Stop often. Talk to local people in small-town diners and cafés, and it can open doors. People who live quiet lives may welcome the attention of a stranger taking pictures.

To do justice to wide-open landscapes, try using a wide-angle lens or shoot a panoramic photograph. Consider unconventional framing for an uncommon view.

▶▶ **Avoid the obvious.** If everyone else is photographing a spectacular sunset, turn around and shoot the scene in the waning sunlight. That's where the best light is.

Use silhouettes. Backlighting from the late afternoon sun can create dramatic images.

Shoot when the ocean is bluest. In the Caribbean, that means shooting at midday instead of dawn or dusk, when light bounces off rather than enters the water.

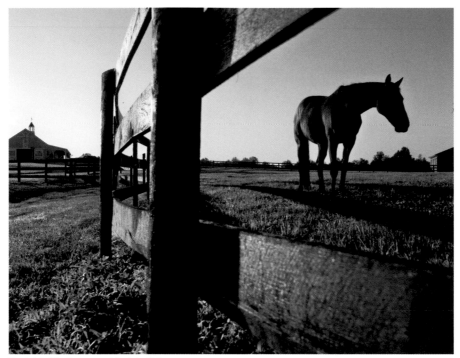

Daniel R. Westergren Virginia, U.S.

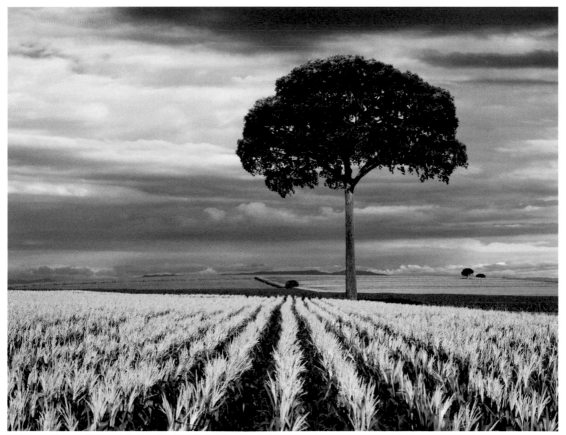

Christiano Pessoa/National Geographic My Shot Brazil

⬚ WHAT MAKES THIS

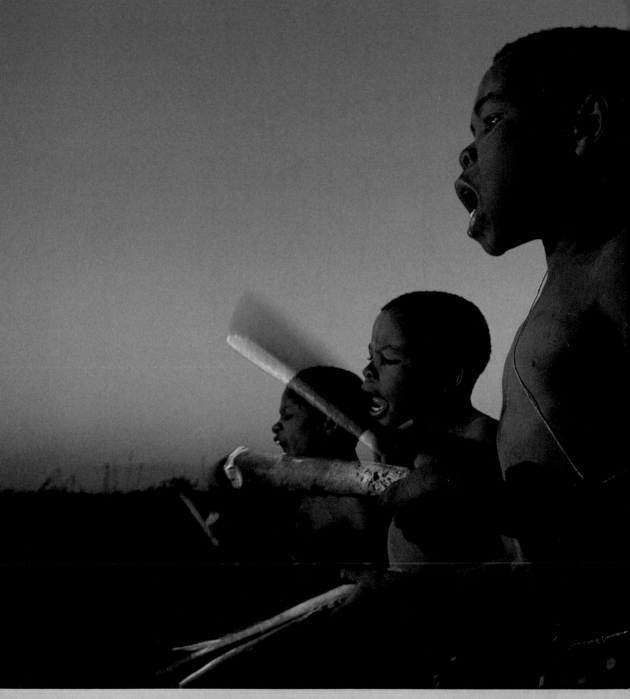

EVENING CEREMONY **Chris Johns** Lukulu, Zambia

A GREAT PHOTOGRAPH?

CHRIS JOHNS'S love of Africa made it possible for him to be part of a coming-of-age ritual performed by the Luvale tribe in Zambia.

SUBJECT This is a private celebration, and Chris had clearly gained the trust of the people, including these three boys, to be able to capture such an important moment so intimately.

COMPOSITION Repetition is the key here. Each boy stands at approximately the same distance from the next. Each has his mouth open in song. The light illuminates each of their chests in the same way, and the angles of their arms are virtually the same.

LIGHT The photograph was taken in late evening light, and the boys were singing in front of a campfire. A strobe flash with an orange gelled filter helped bring out exactly what Chris saw, ghosting the boys' sticks as they sang.

EXPOSURE Chris chose to use a smaller aperture to keep the boys sharp. He slowed the shutter down so there would be movement in the sticks the boys are using to keep time. As a result, a double image of the first boy's stick slightly covers the head of the last boy. Seeing this slight movement gives us a sense of the living, moving ritual.

–James P. Blair
NATIONAL GEOGRAPHIC
PHOTOGRAPHER

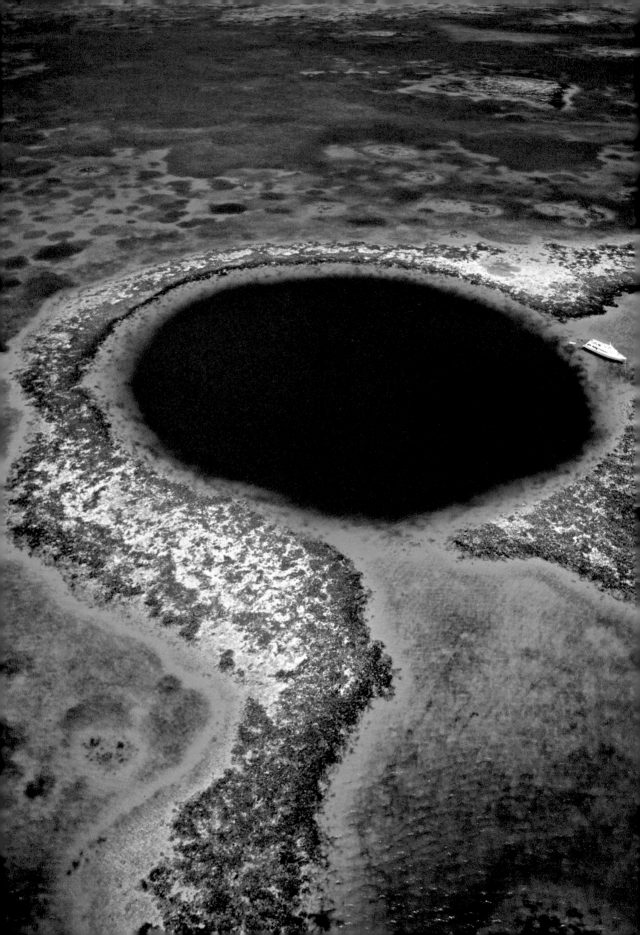

6 Special Techniques

SOME KINDS OF PHOTOGRAPHY require more specialized techniques and equipment than others. Whether you want to shoot fireworks, colorful species underwater, or the terrain from a low-flying aircraft, knowing your subject and preparing for the challenges it presents is critical. You don't need to be a professional to use the techniques described in this chapter, but you will need to spend a lot of time becoming adept with your camera.

Shooting digitally, you can look at each image as you take it and think about what changes in lighting, perspective, or equipment could help improve that very shot, then try again. But it's important to keep in mind that cameras, lenses, and other hardware are tools. It's only when a photographer combines equipment with sensibility—a fine eye and imagination—that photographs both *of* and *about* a subject are created.

Kevin Schafer Belize

▶ Shooting Fire & Fireworks

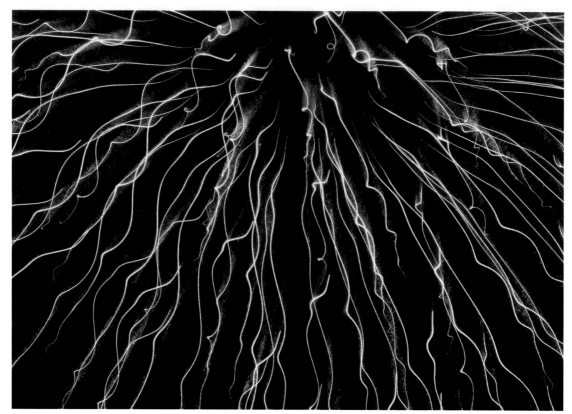

Pete Ryan Canada

▶ **FOR MORE ON CONTROLLING SHUTTER SPEED, SEE PAGES 72-3.**

▶ **FOR MORE ON TAKING PHOTOGRAPHS IN LOW LIGHT SITUATIONS, SEE PAGES 126-7.**

PHOTOGRAPHING FIREWORKS IS DIFFICULT, but not impossible. It just takes planning and some extra equipment: a tripod for long exposures and a self-timer or release cord to activate the shutter without shaking the camera.

Prefocus on the area where the fireworks will explode, and put your camera on manual mode. Begin at ISO 100 with the aperture at f/11 and the shutter speed at half a second. If that's too dim, increase the shutter-speed duration but don't change the aperture.

Low light makes photos of fire a challenge, too. If you have to shoot at night and there are people in the photo, be sure to meter their faces—metering the fire will underexpose the scene.

▶▶ **Use a wide shot** if the fireworks are spread out over a lot of the sky.

Look for fireworks over water. Reflections will make your images even more dramatic.

To photograph people around a fire, try to shoot at dusk when there's still a little bit of light.

With long exposures, people in the scene will blur easily if they move.

Use a strobe if you want to light detail in the foreground of your fireworks photo.

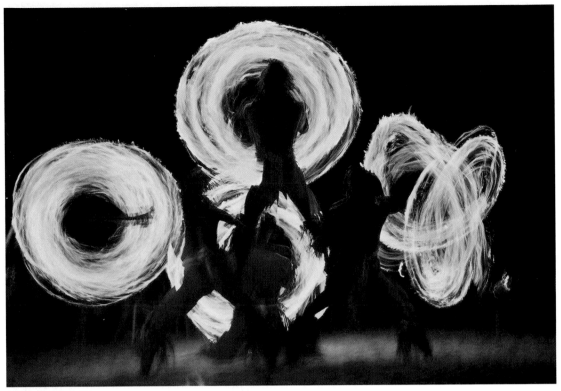

Jodi Cobb Bora Bora

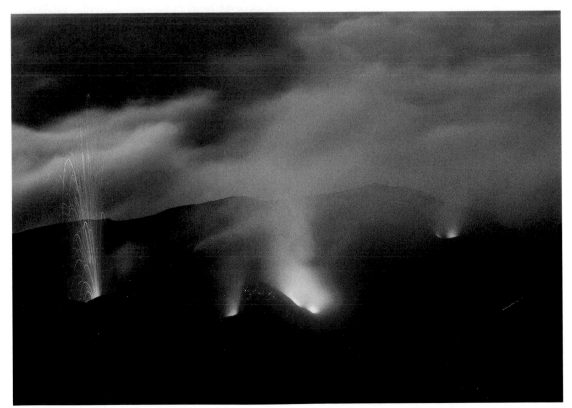

Treyer Sonja/National Geographic My Shot

▶Shooting Water

▶FOR MORE ON
ACHIEVING
A BLUR EFFECT,
SEE PAGES
164-5.

IF THERE'S A RIVER OR STREAM in the scene you are shooting, think about its character and how to convey that. Also consider whether the water should be the center of interest or simply an element of composition.

Look carefully for reflections. Some can enhance the image—such as the colors of autumn leaves—but others may be distracting. Move to include or eliminate them, or return when the sun is at a different angle.

For waterfalls, decide whether to freeze or blur the movement. Freezing water as it spills over a fall is usually the best way to communicate its power, especially with big cascades. Blurring a waterfall communicates a different sensation—the white blur of streaming water feels soft and serene (as in the photo opposite).

▶▶ **To freeze a waterfall,** you need a shutter speed of at least 1/250. If you don't have enough depth of field, try a wider lens and move closer.

To blur a waterfall, try a shutter speed of 1/8 or so. Use a tripod and a release cord or the camera's self-timer to avoid camera shake. Watch for wind blowing trees or bushes that are in the frame.

Reflections in water are darker than the objects being reflected. Use a graduated neutral density filter to balance the exposure above and below the reflection line.

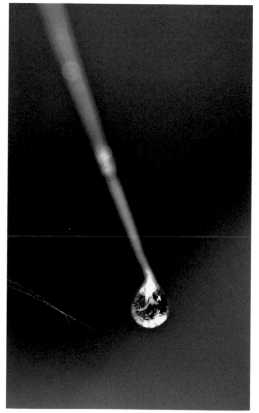

Rich Reid Canada

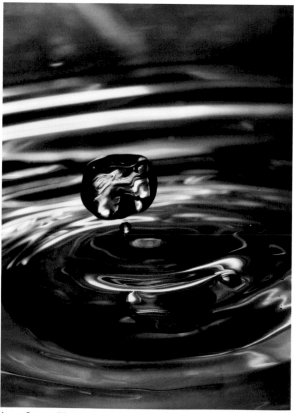

Jorge Suarez/National Geographic My Shot

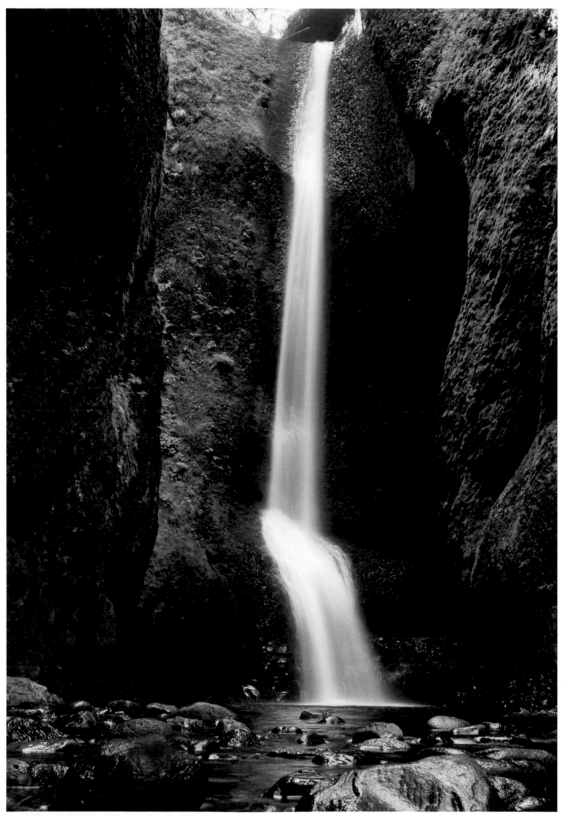

Roy Underwood/National Geographic My Shot Oregon, U.S.

▶ Underwater Photography

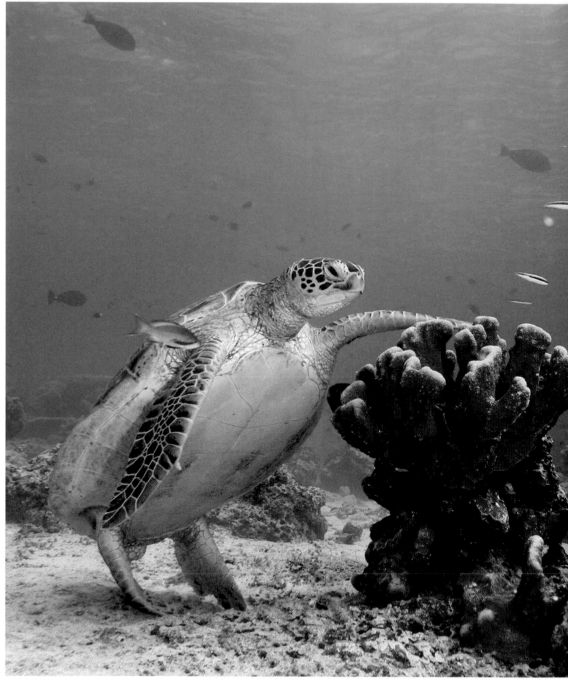

David McKee/National Geographic My Shot

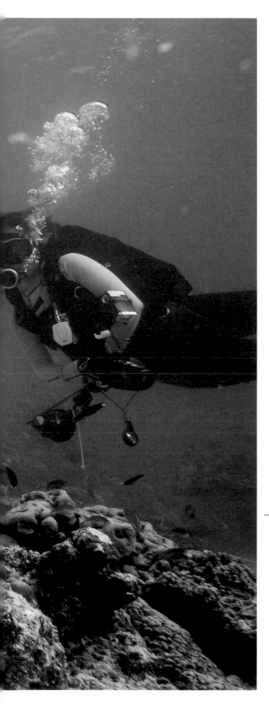

UNDERWATER PHOTOGRAPHY reveals a world most of us never see. But it's logistically challenging, and because of light conditions, you can work for only a short time each day. You'll also need a special underwater housing to keep your camera dry.

▶FOR MORE ON LIGHT & EXPOSURE, SEE PAGES 28-9, 48-51, 74-5.

Try to shoot at midday, when the sun's rays beam straight down into the water. As you descend, the light dims. Increase exposure from your daylight reading about one stop for every ten feet of depth. Work within about ten feet of your subject. At greater depths, you'll need strobes for color.

Michel Braunstein/National Geographic My Shot Brazil

▶▶ **Master the art** of bringing lighting equipment underwater by practicing in a swimming pool.

Refraction limits the angle of view of lenses underwater, making a 35mm about the same as a 50mm on land.

Dive down and get close to creatures instead of floating on the surface for close-up views of animals and colors that few people ever see.

▶Shooting at Night

Jodi Cobb Italy

▶FOR MORE ON
ARTIFICIAL
LIGHT,
SEE PAGES
130-1.

▶FOR MORE ON
CONTROLLING
DEPTH OF FIELD,
SEE PAGES
62-5.

NIGHT SHOTS ARE BEST MADE IN MOON-LIGHT—when the moon is full or almost full—or in the first hour of dusk. Even then, the frames you make will require long exposures, so you'll need a tripod and a cable release or camera timer to keep from shaking the camera.

If you plan to shoot just after sunset, scout the location ahead of time to look for elements to silhouette against the sky. The rich royal blue of a sky after sunset on a cloudless day and the orange and pink sky after sunset on a cloudy one make gorgeous backdrops for all sorts of things.

For moon pictures, the best time is just as it rises and is big but not too bright. There will be plenty of ambient light on the land. In a city, look for the moment when the darkening sky and city lights are evenly balanced, so that you get detail in both.

▶▶ **Bracket your exposures** to be sure you have the shot you want. At night, there are often sources of light in the frame that can fool the meter.

Try long exposures that let cars pass all the way through the frame, and you'll get rivers of white and red lights weaving through a city.

If you're shooting something up against the moon, open up a stop or two to avoid underexposure and ensure the moon will be white.

For sunsets, long lenses give you a big solar disk. Similarly, you'll need a telephoto to keep the moon from being a tiny white spot in the sky.

Brian Yen/National Geographic My Shot

Peter Vancoillie/National Geographic My Shot Iceland

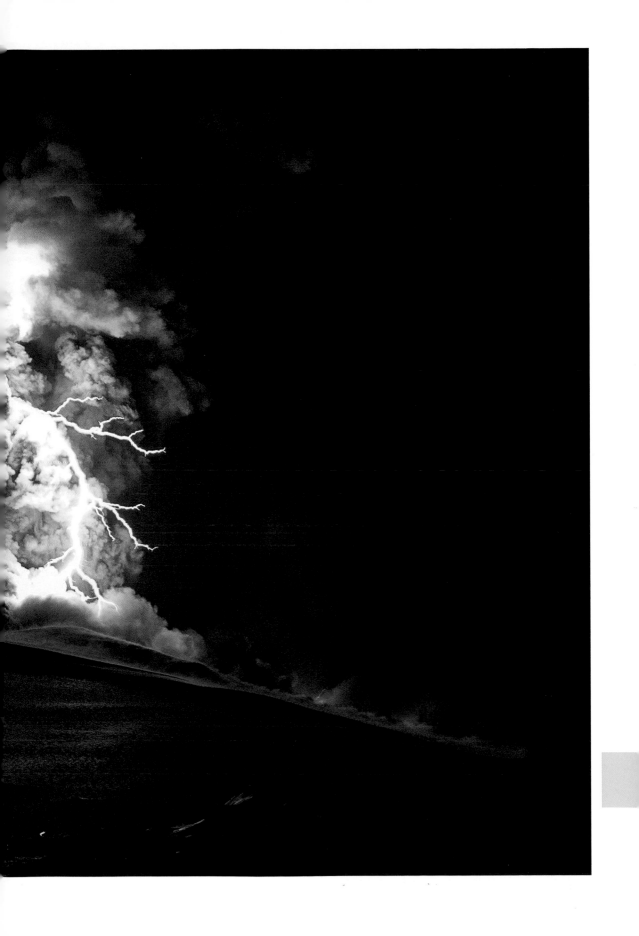

▶ Aerial Photography

Joe McNally New York, U.S.

AERIALS CAN BE TRICKY because you're moving when you shoot them, so use a shutter speed of 1/250 or faster. The best are made from a vehicle that flies low and at slow speeds. On jets, ascent and descent offer the best chances, though if you're over some huge feature, like mountains, you may get good images from cruising altitude.

Mark Thiessen Wyoming, U.S.

▶▶ **Patterns are especially revealing** from the air, whether they are the rectangles of agricultural fields or the symmetry of sand dunes.

High often equals hazy in aerial photography, so stay low—usually about 1,000 feet aboveground.

Fly in the morning if you can. The air is not only clearer then but also often less bumpy.

▶ FOR MORE ON CONTROLLING DEPTH OF FIELD, SEE PAGES 62-5.

▶Panoramic Photography

▶ **FOR MORE ON PANNING, SEE PAGES 166-7.**

▶ **FOR MORE ON USING A TRIPOD, SEE PAGES 168-9.**

THERE ARE PANORAMIC CAMERAS, but you can create even more spectacular panoramas by piecing together a series of panned shots. Consistency is the key—consistency of perspective, exposure, and white balance. Don't move or zoom in or out between shots. Keep the whole image in mind.

A good rule of thumb is to overlap the images by 25 to 40 percent to give your software adequate information to accurately merge the images later.

▶▶ **Before you shoot,** pan the area you plan to photograph to make sure the horizon stays level.

For best results, use a tripod. If you shoot a lot of panoramas, it's worth investing in one with a liquid level built in.

Once you've made your exposures, check them in the viewer. Some cameras even have in-camera stitching so you can preview and save the panorama as well as the individual frames.

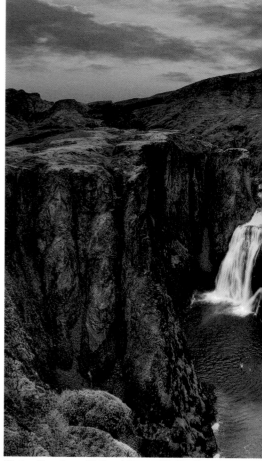

Kjartan Sigurdsson/National Geographic My Shot Iceland

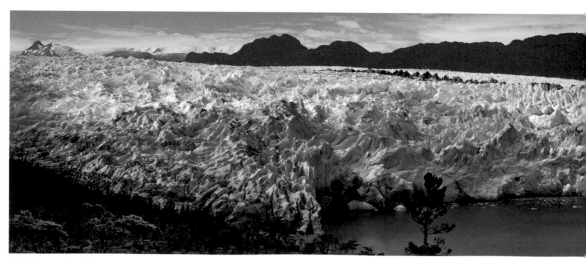

Maria Stenzel Chile

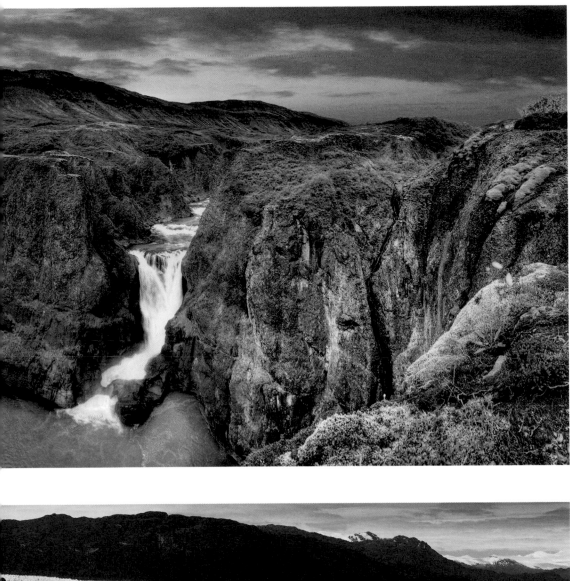

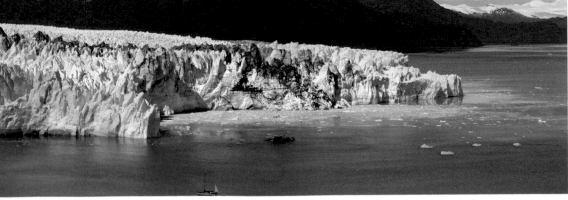

□ Frans Lanting: MY PERSPECTIVE

WHEN I'M TEETERING IN A TREETOP, vulnerable to a lightning strike or dodging a swarm of wasps, I'm in my element. Such isolated, inaccessible places often harbor a rich pageant of life—and so I'm drawn to them. Even getting to some of the habitats is often an exercise in itself.

When I first plotted an assignment to photograph macaws in Peru's Amazon rain forest, I had to find a way to reach the tree canopy. An 80-foot-tall scaffold had to be custom built—a ton of steel was trucked over the Andes and carried upriver by cargo canoe. My team and I then followed the birds, disassembling and reassembling the tower at far-flung nests, fruiting trees, and clay licks. The most harrowing moment, though, came as a thunderstorm crept up and I suddenly realized my own perch was effectively a large lightning rod. When the skies would darken, I scrambled down before it might attract an electrifying bolt.

Still, enduring these logistical hassles goes to the heart of why I do this work: to be an ambassador for wild places and creatures. My mission for the last three decades has been to make photographs with the power to both move and educate readers. I'm still hopeful that we can strike a balance between man and nature—and aspire to a more sustainable coexistence. —F.L.

"NO ONE TURNS ANIMALS INTO ART more completely than FRANS LANTING," wrote the *New Yorker.* The BBC named him Wildlife Photographer of the Year in 1991. His work has been commissioned frequently by the National Geographic Society, where he has served as a photographer in residence, and it often appears in exhibitions, magazines, and books, including his own titles, such as *Eye to Eye, Penguin, Jungles, Life: A Journey Through Time,* and *Forgotten Edens.*

A whisk fern growing in the Hawaii Volcanoes National Park.

The Maasai people of Tanzania prefer their traditional dress and follow traditional customs.

A colony of black-browed albatrosses at Steeple Jason Island in the Falklands.

▶Choosing Black and White

▶ **FOR MORE ON SEEING THE LIGHT, SEE PAGES 46-9.**

▶ **FOR MORE ON DIGITAL BLACK AND WHITE, SEE PAGE 190.**

BLACK-AND-WHITE PHOTOGRAPHY allows the photographer to present an impressionistic glimpse of reality that depends more on elements such as composition, contrast, tone, texture, and pattern. In the past, photographers had to load black-and-white film in the camera. But with digital photography, you can convert your color images on the computer or, on most cameras, switch to black-and-white mode—good for practice but not the best for quality.

Andrej Pirc/National Geographic My Shot Slovenia

▶▶ **Shoot raw files instead of JPEGs,** if your camera allows it, so you don't drop the detailed information you'll need to process images as you like on the computer.

Shoot with the lowest ISO possible to decrease the amount of noise in the darker tones.

If you shoot in digital color, you can convert the images to black-and-white on your computer and retain the color file as well.

A filter lightens its own color and darkens complementary colors. Working in digital, you get the same effect through processing.

AJ Wilhelm/National Geographic My Shot Washington, D.C., U.S.

Alexandar Terzic/National Geographic My Shot

▶ Macrophotography

▶ **FOR MORE ON MACRO LENSES, SEE PAGES 146-7.**

MACROPHOTOGRAPHY is photography magnified. Most often the subject is nature—flowers, insects, plants (as in the photos here). In general, a photograph is considered macro if the subject on the image sensor is five times life size, requiring lenses and accessories that enable you to focus much closer than normal. These range from simple and relatively inexpensive supplementary lenses to more expensive dedicated macro lenses. Some common lenses have a macro function built in.

Another consideration is depth of field, which decreases the closer you get to the subject and the higher your magnification goes. As a general rule, use an f-stop no larger than f/16 to get all or most of the main subject in focus. But with the small aperture, your shutter speeds will be longer, which makes a good tripod essential.

▶▶ **With such a small depth of field,** even a whiff of breeze throws everything off.

Check your background to be sure that it sets off the subject and has no distracting objects. If you don't like what you see, slip a piece of colored paper behind the subject. With the shallow depth of field, your subject will be sharp and the background muted.

Experiment with flash to fill in shadows—often a problem in macrophotography. Try bouncing your flash off another object for more subtle lighting.

Alaska Stock Images Alaska, U.S.

Kenneth Bibbee/National Geographic My Shot

Jerry Zitterman/National Geographic My Shot

Veerasak Punyapornwithaya/National Geographic My Shot

▶Infrared Photography

Sue Cullumber/National Geographic My Shot

▶FOR MORE ON
LIGHT & COLOR,
SEE PAGES
28-9.

INFRARED IS LONG-WAVELENGTH LIGHT that lies beyond the visible spectrum. You can capture infrared radiation with your camera to achieve otherworldly images, in which warm and cool subjects produce bright and dark tones, respectively. In infrared photography, leaves, grass, and clouds are typically bright, while bark, sky, rocks, and water appear dark.

For these unusual results, place an infrared filter (which looks black) on the lens of an unmodified digital camera. Long exposure times and a tripod are needed, and focusing will be difficult. Or you can have your digital camera's built-in infrared cutoff filter replaced with an infrared filter; then you can shoot without external filters and with faster shutter speeds.

▶▶ **You never know how an infrared image will come out,** so be ready to experiment.

Ideal shooting conditions for infrared photography are often the exact opposite of those for visible light photography. Best results are often found at midday, in strong sunlight.

Convert your color images to black and white on the computer to remove the red cast.

Bill Hutchinson/National Geographic My Shot

▶ High-Dynamic-Range (HDR) Photography

IN HIGH-DYNAMIC-RANGE (HDR) PHOTOG-RAPHY, you shoot the same composition several times at widely varying exposures. Then you combine the images into one picture that is properly exposed across the tonal range, from dark areas to bright ones. The process eliminates the inky blacks and blown-out highlights of a high-contrast scene, with details appearing in all areas of the composition. The result is a rich, pleasing exposure closer to what the eye sees, unencumbered by the limited dynamic range of the camera's light sensor.

Set your camera for automatic exposure bracketing. Experiment with different exposure intervals between shots. Most commonly used are intervals of 1.5 or 2 stops. You may also use the camera's continuous shooting mode, taking three, five, seven, or more images with one push of the shutter release. Often just three shots are enough for a pleasing HDR result.

▶▶ **Combine the images on the computer,** using either standard image-editing software or specialized HDR software.

Use a tripod to prevent camera movement between shots.

Don't eliminate shadows—they lend definition and depth to a picture (as in the image at right).

HDR techniques combined with other digital manipulations can be pushed even further to achieve a hyperrealistic effect.

Zi Sheng Neoh/National Geographic My Shot Australia

▶ FOR MORE
RESOURCES,
SEE PAGES
394-5.

▶ Always Learning

Mike Theiss Nebraska, U.S.

▶ **FOR MORE ON DEPTH OF FIELD, SEE PAGES 62-5.**

▶ **FOR BOOKS & WEBSITES, SEE PAGES 392-5.**

WE HAVE MOVED out of the darkroom onto the computer, and much photographic creativity these days happens not just through the camera but also on the screen. You can take one photograph and then change and adapt it into all sorts of variants, combining imagination, know-how, and a few clicks of the keyboard and mouse.

Camera and software capabilities will continue to evolve, and an active photographer will want to keep up to date with new possibilities. But no matter how sophisticated technology becomes, a great photograph always begins and ends with the skilled eye of the photographer, focusing on the basics of interesting subject matter, thoughtful composition, awareness of lighting, and good exposure.

▶▶ **Find favorite photography websites** to keep informed on current art and technology.

Read photo magazines for updated information on equipment and technique.

Find a photographer whose work you admire and see if she or he offers a workshop you can attend.

Study masters of photography— from Ansel Adams and Henri Cartier-Bresson to the National Geographic photographers on these pages and in *National Geographic* magazine.

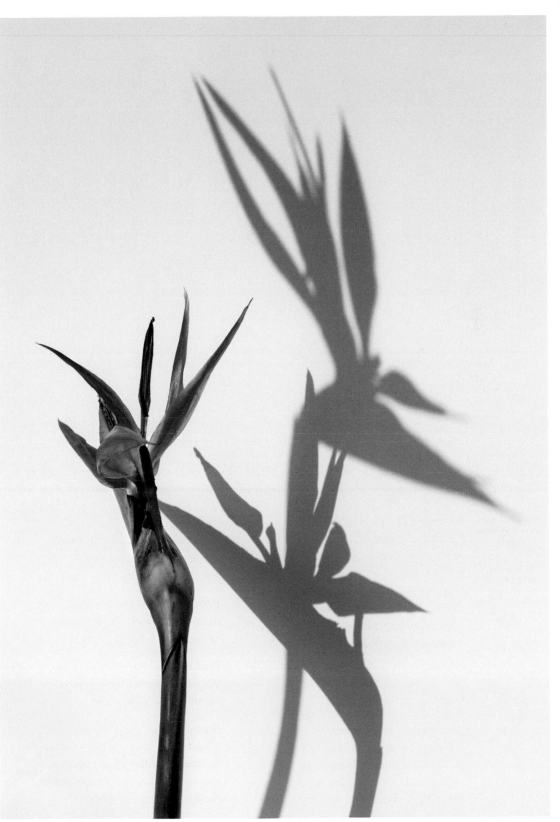

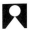 **Simon Littlejohn** Spain

☐ WHAT MAKES THIS

THROUGH THE GLACIER **Paul Nicklen** Hornsund, Spitsbergen, Svalbard, Norway

A GREAT PHOTOGRAPH?

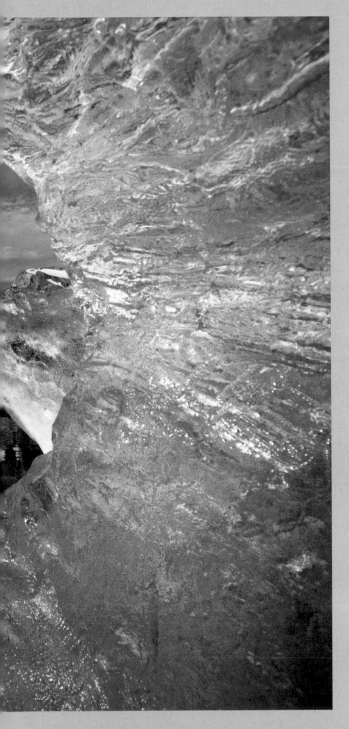

PAUL NICKLEN is an underwater specialist who works mainly in the Arctic and Antarctic. His interest in the subject of climate change led him to the northern islands of Norway and to this image of the landscape seen from the perspective of glacial ice.

SUBJECT The exposed crags of the Hornsund Fjord testify that summer in the region is no longer frigid. Now the sun melts the snow cover and opens a window in the ice for the photographer to show the world the effects of global warming.

COMPOSITION For this photo, Paul purposefully broke a cardinal rule by having the subject in the dead center of the frame. The resulting strong emphasis on the subject helps focus our attention. It makes us aware that global warming is happening right now.

LIGHT The bright summer sun is at just the right angle to light the fragile, cracked ice. The illuminated edges of the hole appear to be melting before our eyes, and the delicate surrounding ice refracts the light like fractured crystal.

EXPOSURE Paul used a small aperture to obtain the long depth of field, vital for the image to hold together. Notice that the ice crystals in the foreground and the distant rocks are all in focus.

–James P. Blair
NATIONAL GEOGRAPHIC
PHOTOGRAPHER

Part IV

RESOURCES

▶ Glossary

A

Aberrations Optical faults that cause a lens to produce an unsharp or distorted image. These can be corrected (and sometimes eliminated) by the optical design of a lens. Stopping down to smaller apertures also minimizes the effect of some aberrations.

Analog Nondigital; traditional film photography and camera technologies that do not rely on the electronic processing, recording, and retrieval of images.

Angle of View The amount of any scene that a lens "sees," measured in degrees; the shorter the focal length, the greater the coverage. Also called *field of view.*

Aperture The opening inside the lens that allows light to pass; this is adjusted in size (except in mirror lenses and a few others) by the diaphragm and is expressed in f-stop numbers, such as f/8. Aperture controls depth of field.

Aperture Priority AE A semiautomatic camera mode where the user sets the desired aperture and the camera sets the corresponding shutter speed for correct exposure. Also called *Aperture Preferred AE.*

Aspect Ratio The ratio of width to height in an image or image sensor.

AVI A common video format available on some digital still cameras.

B

BMP A digital file format (or bitmap) that is very similar to TIFF but can be read only by Windows-based PCs.

Bokeh The aesthetic quality visible in the blurred, or out-of-focus, areas of an image. The term comes from the Japanese word *boke,* meaning "blur."

Bounce Flash Light from electronic flash reflected from a wall, ceiling, or other surface instead of being aimed directly at the subject. This produces softer, more diffused lighting. Some flash units have a swivel and/or tilt head that allows the use of bounce flash with the unit mounted on the camera.

Bracketing Taking a series of photos, identical except in the exposure for each frame, so as to get at least one ideal exposure.

Byte A measurement of digital information.

C

Cable Release A mechanical or electronic cable used to trigger a tripod-mounted camera without touching it directly, to prevent shake or vibration.

Capture Format In digital imaging, the format used to save or record photographic data—JPEG or raw, for most digital cameras.

CCD (Charge-Coupled Device) The image-capture device in a digital camera, made up of millions of light sensors. The more sensors, the greater the number of pixels, and the higher the resolution, image clarity, and definition.

CCD Sensor A CCD combined with a light sensor reads the charge from the sensor's photosites to produce digital information for imaging. Most digital cameras have a CCD sensor or a CMOS sensor; each has its advantages and disadvantages.

Chromatic Aberration An optical flaw that occurs when a lens cannot bring all colors of light to focus at a common point—that is, the film plane—producing color fringing (extraneous colors around subject edges) and lower apparent sharpness. Most common in telephoto lenses at wide apertures, it can be corrected with low-dispersion glass and other optical technology.

Cloning In digital imaging, copying parts of an image area and using those to cover other areas to correct flaws such as scratches or dust specks. Cloning can also be used to add more of the same element (e.g., more leaves onto a branch) to the final picture.

CMOS Sensor A CMOS (Complimentary Metal Oxide Semiconductor) sensor converts light energy to voltage, which is then converted to digital information.

Color Temperature A measurement of the color of any given light source provided

in degrees Kelvin. "Warm" light, such as the light at sunset, has a low temperature, whereas "cool" (bluish) light, as on a heavily overcast day, has a high color temperature on this scale.

Composite A photo illustration made by combining parts or layers of different images.

Compression The process used to decrease the size of a digital image file by combining or averaging data.

Contrast The range of brightnesses of a subject; the difference between the lightest and darkest parts of an image. A scene with high contrast includes both extreme highlights and very dark shadows.

D

Depth of Field The zone or range of apparent sharpness in a photograph. Although only the focused subject (and other objects at the same distance) is truly sharp, the range of acceptable sharpness extends in front of and behind the focused point.

Depth of Field Preview A control found on some cameras that allows for the aperture to be stopped down (before the exposure is made) to the f-stop that may be used to take the picture. This allows the user to visually assess the range of apparent sharpness at several f-stops. Also called *stop down control*, an older term.

Diaphragm The mechanism inside a lens that controls the size of the aperture, using overlapping metal leaves.

Diffuser 1. A translucent material generally held between the subject and the light source to soften the illumination. 2. A filter for producing a softer effect, as in portraits. 3. An accessory for electronic flash that can be used to scatter (soften) the light.

Digital Zoom A camera function that digitally magnifies the center of a frame.

Distortion An optical flaw that causes straight lines near the edges of an image to be bent, either inward ("pin-cushioning") or outward ("barreling"). When the

perspective in a photograph appears very unusual, some will refer to this as "distorted perspective."

DPI (Dots per Inch) The density of information produced by a device, which defines the resolution level that a scanner or printer should produce. The more dots per inch, the higher the resolution.

DSLR (Digital Single-Lens Reflex) An electronically operated camera that uses mirrors to show the potential image through the viewfinder. When the shutter opens, the mirror lifts away, and the same view strikes the sensor.

Dynamic Range The range between the darkest parts of an image and the lightest ones. A wide range makes it difficult to expose for both dark and light areas.

E-F

Exposure Compensation A control found on most cameras with automatic mode that allows the user to overexpose (+ factors) or underexpose (–factors) from the metered value.

Extension Tubes Hollow mechanical spacers that fit between a camera body and the lens, used to increase the lens focal length and magnify the subject for close-up work. Automatic extension tubes maintain the camera/lens automation, though often not autofocus.

Fast A term used to describe either a lens with a very wide maximum aperture or highly light-sensitive film. Both allow for faster shutter speeds (than their "slow" counterparts) to make a correct exposure.

Fill-in Flash (Fill Flash) Extra light added by electronic flash to soften hard shadows, but without becoming the primary light source. Generally used in sunny conditions, fill-in flash is less bright than sunlight, producing a subtle effect while maintaining soft shadows.

Film Speed A numerical value assigned to each film type, denoting its relative sensitivity to light. High numbers denote very sensitive film,

often called "fast" because it allows for fast shutter speeds for a correct exposure. Low numbers denote less light-sensitive film, often called "slow," which requires slower shutter speeds for a correct exposure. *See also* ISO.

Filter A piece of coated or colored glass or plastic, placed in front of the camera lens, that alters the light reaching the film or sensor. Filters can modify the color or quality of the light, change the relative rendition of various tones, reduce haze or glare, or create special effects.

Flare A degradation of picture quality by stray light that does not form the image but reduces contrast or forms patches of light. Caused by reflections inside the lens and between the many lens elements, it is particularly problematic in backlighting, and most severe with lenses containing high numbers of optical elements (more air-to-glass surfaces). Flare can be reduced by multiple coatings of all elements, other internal technology, or the use of a lens hood to prevent light from striking the front element.

Flash-Exposure Compensation A control on some high-tech SLR cameras and/or flash units that allows the user to increase or decrease flash output in an automatic flash mode. Most often used to reduce flash intensity for a gentle fill-in flash.

Flash Memory A portable computer memory drive that can be used to store images.

Flash Meter An exposure meter designed for measuring the intensity of light produced by an electronic flash. Information from the meter is used to set an appropriate aperture–sync speed combination.

F-Stop A numerical value to denote the size of the lens aperture; the focal length divided by the diameter of the lens aperture. Regardless of lens size or focal length, the same f-stop number allows the same amount of light to be transmitted to the film. Wide apertures are denoted with small numbers such as f/2, small apertures with large numbers such as f/22. *See also* Diaphragm.

G-H

GIF A common digital file type (short for Graphics Interchange Format) used on the Internet for graphics—because of small file sizes—but less than ideal for photos because it has a limited color palette and discards color information when compressed.

Gigabyte (GB) A unit measuring digital information equal to 1,024 megabytes (MB).

Graininess Images on film are registered by light-sensitive silver halide particles or dye molecules, and their pattern (grain) is visible under high magnification. The higher the magnification, the more noticeable they become, as in oversize prints or slides viewed under a magnifier. Slow films generally have a much finer grain pattern than fast films.

Histogram A bar graph showing the relative number of pixels in different brightness ranges in a digital image.

Hot Shoe An accessory on the camera intended for mounting a flash unit. It contains electronic contacts that mate with the contacts on the "foot" of the flash unit. These contacts are required for transmitting data between the camera and flash unit and automatically trigger the flash when the shutter is released.

I

Image Stabilization Techniques and technologies that reduce camera movement at slow shutter speeds, thus decreasing blur in photographs.

Incident-Light Exposure Meter An accessory that measures the light falling onto the subject. Its recommended aperture–shutter speed combination is then set on the lens and camera. *See also* Reflected-Light Exposure Meter.

Interpolation Increasing digital-image file size by adding pixels; also increases resolution.

Inverse Square Law A physical principle that only a quarter of the original amount of light from a flash will reach the subject when the distance from the light source (flash) is doubled.

ISO A standard for image sensor rating. ISO is an abbreviation for International Standards Organization, which sets the standards, and it replaces the previous term ASA (American Standards Association), used to rate the speed, or light sensitivity, of film. Common sensor ratings range from ISO 25 to 1600, but many digital cameras reach as high as 10,000 and more.

J-K

JPEG Named for Joint Photographic Experts Group, this is the file format used by most current digital cameras for storing images in a compressed form to keep the files small. It is also a standard format on the Internet for photos due to its small file size and full-color palette. Variable degrees of compression can be used. Compression discards data: Minor compression has little effect on image quality, but high compression degrades it.

Keyword A label added to data attached to a digital image to help with computer searches. Also called *tags*.

L

Layer A technique available with some image-editing software by which different parts of an image can be layered one on top of another.

Lossless Compression in which no information is lost when the image is saved. The opposite of *lossy*.

Lossy Compression, as in JPEG files, in which information is lost and cannot be restored, which sometimes affects the quality of the image. The opposite of *lossless*.

M-N

Macro The close-focusing ability of a lens, or a lens with such capability. Strictly defined, the term is employed when a subject is reproduced five times life size (or larger) on the film frame.

Megabyte (MG) A measurement of electronic data storage equal to approximately one million bytes.

Megapixel (MP) One million pixels. The higher the number of pixels, the greater the resolution of a digital image. More megapixels equals more data.

Metadata Mechnical information automatically attached to each image by a digital camera.

Mirror Lens A special type of lens that offers a long effective focal length in a very compact barrel. By employing mirrors to fold the light path, the length of the barrel is substantially shortened. Also called a "cat" for *catadioptric*—the technical term for the most common design used in such lenses—it has a fixed aperture that cannot be changed.

Mirror Lockup A control found on some cameras that allows the reflex mirror to be raised—and held in the up position—before the exposure is made. This prevents internal vibration from mirror action but is necessary only in high-magnification photography at certain slower shutter speeds, usually around 1/4 to 1/15 second.

Moblog Content posted to the Internet from a portable device such as a cell phone; a concatenation of "mobile weblog."

MOV A common video format available as part of some digital still cameras.

Noise The digital equivalent of grain in film photography; the specks of color showing up as distortion in images that should have a smoother, more unified color. Noise occurs when photographs are shot with a high ISO in low light. The size and resolution of the image sensor also affect noise levels.

P

Panorama A picture offering an exceptionally wide field of view.

Perspective Control (PC) The movements of special lenses, or parts of a camera, intended primarily to place the film plane parallel to the subject in order to prevent apparent distortion of perspective. Such movements may be up and down or sideways and are most commonly used to prevent the "falling over

backward" look in architectural photography or to maximize depth of field in landscape photography. Also called *shift lens*.

Pixel Abbreviation for picture *(pix-)* element *(-el)*. These are the smallest bits of information that combine to form a digital image. The more pixels—current cameras are measured in megapixels—the higher the resolution.

Predictive Autofocus (Tracking Focus) A sophisticated autofocus system that continuously tracks a moving subject. Because there is a time delay between the moment when the shutter release button is pressed and the actual exposure, such systems predict the probable location of the subject at the instant of exposure and set focus to that point.

Prime Lens A lens with a fixed focal length, as opposed to a zoom lens.

R

Raw File A type of image file that captures the maximum amount of data possible, allowing photographers to process the image as they like. Also sometimes written RAW, not because it is an acronym but to match other acronyms.

Rectilinear Lens An ultrawide-angle lens that is corrected to render lines accurately, without the bending (barrel distortion) common with fish-eye lenses.

Red-eye Light from a camera's flash reflected by the retinas in a person's eyes. This effect is easily corrected by editing software or, more commonly, by functions within the digital camera itself.

Reflected-Light Exposure Meter A device that measures light reflected by the subject; can be an accessory or an in-camera meter. *See also* Incident-Light Exposure Meter.

Resolution A measurement of ability to resolve fine detail. With digital cameras, a measure (in pixels) of the amount of information included in an image, which determines the clarity and sharpness of a printed photograph.

Resolving Power A measure of the ability of a film or lens to reproduce intricate detail with high definition. Film manufacturers often denote this ability in lines per millimeter—the higher the value, the higher the resolution. Slower films generally have higher resolution than fast films.

S

Sensor An electronic chip containing pixels that are sensitive to light. The larger the sensor and the more pixels, the more information the sensor collects. *See also* CCD Sensor; CMOS Sensor.

Shutter The mechanism built into the lens or camera that regulates the length of time that light reaches the film to produce an image. It opens to expose the film to light entering through the lens aperture. After the exposure has been made, it closes.

Shutter Lag The delay between depressing the shutter button and exposing the image.

Shutter Priority AE A semiautomatic camera mode where the photographer sets the shutter speed and the system sets the f-stop required for a correct exposure, based on information from the in-camera exposure meter. Also called *Shutter Preferred AE*.

Shutter Speed The speed of the shutter as it opens and closes to allow light to hit the sensor. This is expressed in seconds or fractions of a second, such as 1/60 or 1/250.

Silica Gel Crystals that readily absorb moisture, used to keep photo equipment dry in humid or wet conditions.

SLR (Single-Lens Reflex) A camera design that allows the user to view the scene through the same lens that is used to take the picture. This type employs a reflex mirror to reflect the image to the viewing screen. A pentaprism is generally used, so the photographer sees the scene right side up.

Spherical Aberration An optical flaw most common in wide-angle lenses at wide apertures, where not all wavelengths of light focus on a common point. This is most visible as reduced

sharpness near the edges of the frame. It can be corrected by various optical methods, including the use of aspheric lens surfaces and by stopping down to smaller apertures.

Spot Meter A metering system that reads the intensity of light reflected by only a very small portion of the scene; may be built into the camera or an accessory device. It requires experience in the judgment of tonal values for predictable exposures.

Strobe An electronic flash unit that produces an intense, short-duration burst of light. Also called *stroboscopic lamp.*

Substitute Metering Taking a meter reading from a known midtone, such as a gray card, and holding that exposure value (aperture and shutter speed) when recomposing to take the picture.

Sync Speed The fastest shutter speed of a camera that can be used to ensure that the burst of flash is synchronized with the time that the shutter is open.

T

Teleconverter A device mounted between camera and lens to increase the effective focal length. The most common are 2x (doubler) and 1.4x. Also called a *tele-extender, lens converter,* or *lens extender.*

Telephoto A specific lens design that offers focal lengths longer than the standard, although this term is now used for any long lens. In the 35mm format, any focal length longer than 65mm is generally referred to as a telephoto.

TIFF A universal format (Tagged Image File Format) that can be read with imaging software on most computers. It is highly suitable for photos, because it has 16.8 million colors. If the file is compressed in its "lossless compression" mode, the image does not degrade. Some digital cameras can record images in uncompressed TIFF format, albeit in substantially larger files, to eliminate the loss of information that occurs during JPEG compression.

TTL Abbreviation for "through the lens," generally indicating that the camera's light meter cell reads the amount of light that has passed through the lens and will actually expose the film. This is most beneficial when lens accessories that reduce light transmission are used (filters, teleconverters, extension tubes, etc.).

Tungsten Lighting Continuous light provided by bulbs with tungsten filaments. Such lights make a subject appear yellow-orange in a photograph, unless a pale blue filter or a special tungsten balanced film is used.

TWAIN A software protocol that provides the interface for image-gathering devices, such as scanners and digital cameras, to communicate with software applications on the computer.

U-V-W-Z

Unsharp Mask In digital-imaging programs, a common tool for increasing the apparent sharpness of an image, generally used to bring scans up to the sharpness of the original image. If a photograph is out of focus, however, this tool cannot make it sharp.

USB A standardized computer port (Universal Serial Bus) that accepts cables for attaching accessories such as a printer, camera, memory-card reader, or disk drive.

Viewfinder An optical system that allows the user to view the image area that will be included in the final picture. Types vary significantly. Some allow for viewing through the lens that will actually take the picture, whereas others are near the lens and offer only an approximate view of the actual image area.

White Balance A control used to balance the color of the image to the scene's color so that the picture looks natural.

Wide-Angle Lens A lens with a focal length shorter than normal for the format. In 35mm, any lens shorter than 40mm is referred to as a wide-angle. This term is also used for lenses whose angle of view is wider than about 50 degrees.

Zoom Lens A lens that allows its focal length to be varied, shifting between longer and shorter focal lengths.

▶ Further Reading

BOOKS OF PHOTOGRAPHY
Published by National Geographic

Alexandra Avakian, *Windows of the Soul: My Journeys in the Muslim World* (2008)

Carol Beckwith and Angela Fisher, *Faces of Africa: Thirty Years of Photography* (2009)

Leah Bendavid-Val, *National Geographic: The Image Collection* (2009)

Leah Bendavid-Val, *National Geographic: The Photographs* (2008)

Leah Bendavid-Val et al., *Odysseys and Photographs: Four National Geographic Field Men* (2008)

David Burnett, *44 Days: Iran and the Remaking of the World* (2009)

David Douglas Duncan, *Photo Nomad* (2007)

Melissa Farris, *Deadly Instinct* (2011)

Annie Griffiths, *National Geographic Simply Beautiful Photographs* (2010)

Robert B. Haas, *Through the Eyes of the Condor: An Aerial Vision of Latin America* (2007)

Robert B. Haas, *Through the Eyes of the Gods: An Aerial Vision of Africa* (2005)

Robert B. Haas, *Through the Eyes of the Vikings: An Aerial Vision of Arctic Lands* (2010)

Kim Heacox, *National Geographic Photographs: The Milestones* (1999)

Heart of a Nation: Writers and Photographers Inspired by the American Landscape (2000)

In Focus: National Geographic Greatest Portraits (2004)

Inside China (2007)

John G. Mitchell, *National Geographic: The Wildlife Photographs* (2001)

Cathy Newman, *Women Photographers at National Geographic* (2000)

Ferdinand Protzman, *Live, Laugh, Celebrate* (2009)

Ferdinand Protzman, *Love* (2008)

Ferdinand Protzman, *Work* (2008)

Pam Spaulding, *An American Family* (2009)

Through the Lens: National Geographic Greatest Photographs (2003)

Visions of Paradise (2008)

Wide Angle: National Geographic Greatest Places (2005)

Published by Others

Edward Steichen and Carl Sandburg, *The Family of Man* (2002)

John Szarkowski, *Looking at Photographs: 100 Pictures From the Collection of the Museum of Modern Art* (1999)

John Szarkowski et al., *The Photographer's Eye* (2007)

BOOKS ABOUT PHOTOGRAPHY
Published by National Geographic

Aimee Baldridge and Robert Clark, *The Camera Phone Book* (2007)

Robert Caputo, *Photography Field Guide: Landscapes* (2007)

Robert Caputo, *Photography Field Guide: People & Portraits* (2002)

Robert Caputo, *Photography Field Guide: Travel* (2005)

Robert Caputo, *The Ultimate Field Guide to Landscape Photography* (2007)

Bill Hatcher, *National Geographic Photography Field Guide: Action & Adventure* (2006)

Anne H. Hoy, *The Book of Photography* (2005)

National Geographic Photography Field Guide: Digital (2003)

National Geographic Ultimate Field Guide to Photography (2009)

Richard Olsenius, *National Geographic Photography Field Guide: Black & White* (2005)

Organize Your Digital Life (2008)

Joel Sartore, *Photographing Your Family* (2008)

Rulon E. Simmons, *National Geographic Photographing Birds* (2006)

Scott Stuckey, *Ultimate Field Guide to Travel Photography* (2010)

Published by Others
PHOTOGRAPHY AS ART & SCIENCE

Tom Ang, *Advanced Digital Photography: Techniques & Tips for Creating Professional Images* (2007)

Tom Ang, *How to Photograph Absolutely Everything: Successful Pictures from Your Digital Camera* (2009)

Peter Burian and Sybex, *Mastering Digital Photography and Imaging* (2007)

Juergen Gulbins and Uwe Steinmueller, *The Digital Photography Workflow Handbook* (2010)

John Hedgecoe, *John Hedgecoe's Photography Basics* (2006)

Kenneth Kobre and Betsy Brill, *Photojournalism* (2008)

Barbara London et al., *Photography* (10th edition) (2010)

Bryan Peterson, *Bryan Peterson's Understanding Photography Field Guide* (2009)

Patrick Rice, *Professional Techniques for Black & White Digital Photography* (2005)

Andrew Rodney, *Color Management for Photographers* (2005)

Graham Saxby, *The Science of Imaging* (2nd edition) (2010)

COMPOSITION IN PHOTOGRAPHY

Alain Briot, *Mastering Photographic Composition, Creativity, and Personal Style* (2009)

Bert Krages, *Photography: The Art of Composition* (2005)

David Präkel, *Basics Photography: Composition* (2006)

David Präkel, *Basics Photography: Exposure* (2009)

David Präkel, *Basics Photography: Lighting* (2007)

Chris Rutter, *Mastering Composition With Your Digital SLR* (2007)

Ernst Wildi, *Master Composition Guide: For Digital Photographers* (2006)

THE DIGITAL LIGHTROOM

Steve Caplin, *How to Cheat in Photoshop CS5: The Art of Creating Realistic Photomontages* (2010)

Katrin Eismann and Sean Duggan, *The Creative Digital Darkroom* (2008)

Scott Kelby, *The Photoshop Channels Book* (2006)

Peter Krogh, *The DAM Book: Digital Asset Management for Photographers* (2009)

BOOKS ON THE HISTORY OF PHOTOGRAPHY

Published by National Geographic

Leah Bendavid-Val, *Stories on Paper and Glass: Pioneering Photography at National Geographic* (2001)

Anne Makepeace, *Edward S. Curtis: Coming to Light* (2001)

Cathy Newman, *Fashion* (2003)

Diana Walker, *The Bigger Picture: 30 Years of Portraits* (2007)

Nick Yapp, *100 Days in Photographs* (2007)

Published by Others

David Okuefuna, *The Dawn of the Color Photograph: Albert Kahn's Archives of the Planet* (2008)

Naomi Rosenblum, *A World History of Photography* (2008)

SOME BOOKS BY NATIONAL GEOGRAPHIC PHOTOGRAPHERS

Sam Abell, *Life of a Photograph* (2008)

William Albert Allard, *William Albert Allard: Five Decades: A Retrospective* (2010)

William Albert Allard, *Portraits of America* (2008)

Annie Griffiths Belt, *A Camera, Two Kids and a Camel* (2008)

Jodi Cobb, *Geisha: The Life, the Voices, the Art* (1998)

David Doubilet, *The Great Barrier Reef* (2002)

Michael Nichols and Mike Fay, *Last Place on Earth* (2 volumes) (2005)

Chris Johns, *Wild at Heart: Man and Beast in Southern Africa* (2007)

Steve McCurry, *Portraits* (1999)

Paul Nicklen, *Polar Obsession* (2009)

Joel Sartore, *Rare: Portraits of America's Endangered Species* (2009)

▶ Online Resources

NATIONAL GEOGRAPHIC PHOTOGRAPHY WEBSITES

National Geographic Photography:

http://photography.nationalgeographic.com/photography

National Geographic's website dedicated to spectacular photography. The site showcases amazing photos from around the world and provides invaluable photography tips.

National Geographic Photo Tips:

http://photography.nationalgeographic.com/ photography/photo-tips/

Learn from experts with photo tips from National Geographic photographers. Be sure to browse through the Tips Galleries and watch HD Video Tips for even more ways to capture your own National Geographic-worthy photo.

National Geographic Photo of the Day:

http://photography.nationalgeographic.com/ photography/photo-of-the-day/

Photo of the Day showcases inspiring photos from around the world and tips on how to achieve your own amazing photo. Be sure to submit your own photo to Your Shot, for a chance to become a featured Photo of the Day.

Your Shot:

http://ngm.nationalgeographic.com/your-shot/

Your Shot gives *National Geographic* magazine fans an opportunity to submit their own photos for possible publication. Participants vote for their favorite photo, and *National Geographic* publishes the two photos with the most votes each month.

My Shot:

http://ngm.nationalgeographic.com/myshot/

My Shot is the National Geographic photography community. You join by submitting your photos to Your Shot. Once a member, you can create and share albums, puzzles, and games based on photos you upload.

NG Kids My Shot:

http://kids-myshot.nationalgeographic.com/

Upload your best pictures, create your own My Shot page, and rate other photos in the new kids community from National Geographic.

OTHER ONLINE RESOURCES
Information, News, and Equipment Reviews

CAMERA LABS: *www.cameralabs.com*

A nonprofit, noncommercial photography site with product reviews, tutorials, a conversation forum, and other interactive features.

DIGITAL CAMERA RESOURCE PAGE: *www.dcresource.com*

A noncommercial review site specializing in consumer-end cameras priced under $5,000 and charting features to help compare camera models.

DIGITAL PHOTO: *www.dpmag.com*

Online edition of *Digital Photography* magazine with how-to and photo-sharing community features for all plus more for subscribers.

DIGITAL PHOTO PRO: *www.digitalphotopro.com*

Online edition of *Digital Photo Pro* magazine, with techniques, equipment, photography styles, and examples from top professional photographers.

DIGITAL PHOTOGRAPHY REVIEW: *www.dpreview.com*

A website dedicated to equipment reviews for the digital community with a buyer's guide and an active discussion forum.

DIGITAL PHOTOGRAPHY SCHOOL: *www.digital-photography-school.com*

An independent website with useful tips for semi-experienced digital camera owners.

EPHOTOZINE: *www.ephotozine.com*

A digital photography site with news, reviews, help page.

EUROPEPRESS.COM: *www.europepress.com*

A service catering to photography-related jobs with new technology information, portfolio help, and exhibition information.

EXIT: *www.exitmedia.net*

The online edition of the Madrid-based bilingual magazine devoted to contemporary photography.

ILLUSTRATED PHOTOGRAPHY: *www.illustratedphotography.com/*

A site with helpful tips, equipment reviews, and hotography contests through its online community.

PHOTO DISTRICT NEWS: *www.pdnonline.com*

An online resource from *Photo District News* magazine featuring industry news, analysis, and recent photographic work.

PHOTO.NET: *www.photo.net*

An online photography community featuring forums, equipment reviews, and tips for every photography opportunity.

PICTURE CORRECT: *www.picturecorrect.com*

This site provides valuable relevant information to photographers of all levels through tips, tutorials, and a shopping guide.

POPPHOTO.COM: *www.popphoto.com*

The online home of photography magazines *Popular Photography* and *American Photo*. This site features news, reviews, and informative blogs.

SHUTTERBUG: *www.shutterbug.net*

Online edition of *Shutterbug* magazine provides technique tips, reviews, and online galleries.

TWIN PIXELS: *www.twin-pixels.com*

A site dedicated to all things design, with tutorials, reviews, and tips for Photoshop, Illustrator, and photography.

ZOOM: *www.zoom-net.com*

A magazine/website filled with photography, gallery, and exhibition news and information.

Software

CREATIVE PRO: *www.creativepro.com/*

A site with abundant resources in forums, articles, and blogs for all photography-design needs.

PHOTOSHOPSUPPORT.COM:
www.photoshopsupport.com

A resource offering tutorials, plug-ins, and video training for the novice design user.

PLUGINSWORLD.COM:
www.pluginsworld.com

A frequently updated list of plug-ins for Photoshop and other software, such as InDesign and Illustrator.

Online Tutorials

ONLINE PHOTO TUTORIALS:
www.onlinephototutorials.com/

A site with free step-by-step instructions for taking pictures and using camera gear.

PHOTOGRAPHY INSTITUTE:
www.thephotographyinstitute.com

An online course in photography and the business side of the industry.

PHOTOSHOP TUTORIALS:
http://photoshoptutorials.ws

A valuable resource with a range of Photoshop and design tutorials from beginner to advanced.

Picture Hosting and Sharing

FLICKR: *www.flickr.com*

An online photo management and picture-sharing website offering organizational features at low prices.

FOTKI: *www.fotki.com*

A free social networking site hosting images and videos for sharing.

IPERNITY: *www.ipernity.com*

A site with an emphasis on global sharing that publishes blogs, photos, videos, and audio.

PHOTOBUCKET: *www.photobucket.com*

A site that provides photo, video, and album sharing and storage.

PICASA: *www.picasa.google.com*

Photo-editing software working with Google accounts for picture storage and sharing.

SHUTTERFLY: *www.shutterfly.com*

A website dedicated to organizing and storing digital photography.

SMUGMUG: *www.smugmug.com*

An independent website dedicated to sharing professional-quality images.

WEBSHOTS: *www.webshots.com*

A site offering free and premium memberships for storing, sharing, and printing photos.

Online Photo Editing

FOTOFLEXER: *http://fotoflexer.com*

A free online software that edits photos from popular picture hosting websites.

PHIXR: *www.phixr.com*

A photo-editing site with free account sign-up optional.

PICNIK: *www.picnik.com*

A website with easy-to-use and effective editing tools.

SPLASHUP: *www.splashup.com*

A photo-editing and -managing tool for everyone from beginners to professionals.

▶Contributors

James P. Blair joined the staff of the National Geographic Society as a photojournalist for the magazine in 1962. By the time he retired in 1994, he had provided the photography for 48 articles and three books. He has received numerous awards, including the Best Photographic Reporting From Abroad award from the Overseas Press Club of America, for his coverage of South Africa in 1976. His work is in the collection of the Museum of Modern Art, the Carnegie Museum of Art, the Portland Museum of Art, and elsewhere. He gives lectures on photography at home, abroad, and aboard cruise ships, including the N.G. *Endeavour,* a National Geographic/Lindblad expedition vessel. Blair wrote the commentary on "What Makes This a Great Photograph?" as well as the lengthier comments on photographs throughout Part I.

Scott S. Stuckey has devoted his career to both the textual and visual sides of journalism, beginning with his days as a reporter and photographer for a small daily newspaper in Kansas. Now, as managing editor of National Geographic *Traveler,* he writes about photography and works with some of the world's best photographers to produce award-winning feature stories. National Geographic Books published his *Ultimate Field Guide to Travel Photography* in 2010. Stuckey wrote the introduction and served as photography consultant for the entire volume.

Priit Vesilind retired after 30 years as senior writer and expeditions editor for *National Geographic* magazine. He holds a B.A. in English from Colgate University and an M.A. in photography from Syracuse University's Newhouse School. Specializing in underwater exploration and Cold-War northern Europe, Vesilind served in the U.S. Navy as a communications officer. The author of seven books, he was decorated by the government of Estonia for his contributions to that nation's indpendence. Vesilind wrote and edited Part I.

The editors also wish to thank the numerous authors and photography consultants who contributed to the National Geographic photography field guides that precede this volume, going back decades— key resource material essential to the completion of this book.

▶Illustrations Credits

▶ Index

National Geographic Complete Photography
Foreword by Scott S. Stuckey

Published by the National Geographic Society
John M. Fahey, Jr., *Chairman of the Board and Chief Executive Officer*
Timothy T. Kelly, *President*
Declan Moore, *Executive Vice President; President, Publishing*

Prepared by the Book Division
Barbara Brownell Grogan, *Vice President and Editor in Chief*
Marianne R. Koszorus, *Director of Design*
Carl Mehler, *Director of Maps*
R. Gary Colbert, *Production Director*
Jennifer A. Thornton, *Managing Editor*
Meredith C. Wilcox, *Administrative Director, Illustrations*

Staff for This Book
Susan Tyler Hitchcock, *Editor*
Robert Booth, *Text Editor*
Cinda Rose, *Art Director*
Adrian Coakley, *Illustrations Editor*
Elizabeth Jones, *Assistant Editor*
Priit Vesilind, *Contributing Writer*
James S. Blair, *Contributing Writer*
Scott S. Stuckey, *Photography Consultant*
Valerie May, *Contributing Editor*
Tiffin Thompson, *Researcher*
Dan O'Toole, *Picture Legends Writer*
Judith Klein, *Production Editor*
Lisa A. Walker, *Production Manager*
Robert Waymouth, *Illustrations Specialist*
Al Morrow, *Design Assistant*

Manufacturing and Quality Management
Christopher A. Liedel, *Chief Financial Officer*
Phillip L. Schlosser, *Senior Vice President*
Chris Brown, *Technical Director*
Nicole Elliott, *Manager*
Rachel Faulise, *Manager*
Robert L. Barr, *Manager*

The National Geographic Society is one of the world's largest nonprofit scientific and educational organizations. Founded in 1888 to "increase and diffuse geographic knowledge," the Society works to inspire people to care about the planet. National Geographic reflects the world through its magazines, television programs, films, music and radio, books, DVDs, maps, exhibitions, live events, school publishing programs, interactive media and merchandise. *National Geographic* magazine, the Society's official journal, published in English and 32 local-language editions, is read by more than 35 million people each month. The National Geographic Channel reaches 320 million households in 34 languages in 166 countries. National Geographic Digital Media receives more than 13 million visitors a month. National Geographic has funded more than 9,200 scientific research, conservation and exploration projects and supports an education program promoting geography literacy. For more information, visit nationalgeographic.com.

For more information, please call 1-800-NGS LINE (647-5463) or write to the following address:

National Geographic Society
1145 17th Street N.W.
Washington, D.C. 20036-4688 U.S.A.

Many of the photos in this book are from the National Geographic Image Collection. To purchase prints of our photos, please go to ngsprints.com. To license photos for professional use, please go to nationalgeographicSTOCK.com.

For information about special discounts for bulk purchases, please contact National Geographic Books Special Sales: ngspecsales@ngs.org

For rights or permissions inquiries, please contact National Geographic Books Subsidiary Rights: ngbookrights@ngs.org

Library of Congress Cataloging-in-Publication Data

National Geographic complete photography.
 p. cm.
Includes index.
 ISBN 978-1-4262-0776-1 (regular ed.) --
 ISBN 978-1-4262-0777-8 (deluxe ed.)
 1. Photography. 2. National Geographic Society (U.S.)
 I. National Geographic Society (U.S.)
 TR145.N28 2011
 779--dc22
 2010051755

Printed in the United States of America

11/RRDW/2